THE COMPLETE LANDSCAPE DESIGNS AND GARDENS OF

GEOFFREY JELLICOE

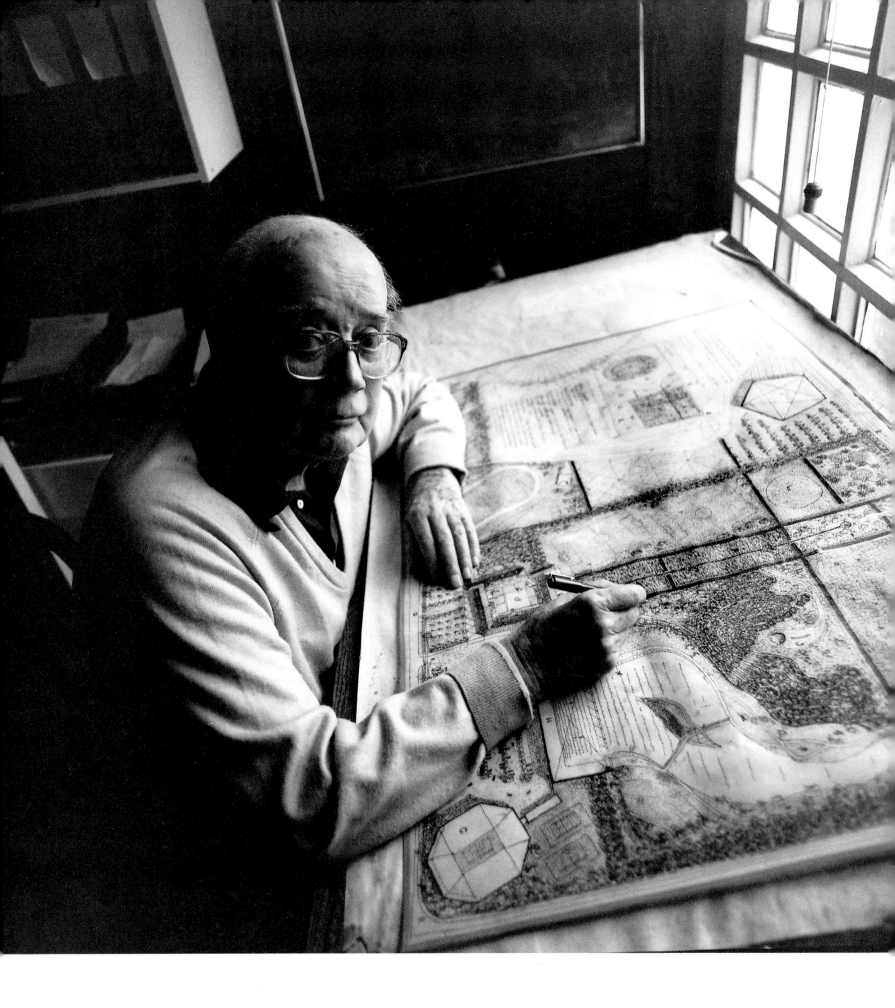

THE COMPLETE LANDSCAPE DESIGNS AND GARDENS OF

GEOFFREY JELLICOE

MICHAEL SPENS

Foreword by Geoffrey Jellicoe

Special photography by Hugh Palmer

With 243 illustrations,
108 in colour

THAMES AND HUDSON

Acknowledgments

The author and publisher wish to extend their special thanks to Sir Geoffrey Jellicoe for his unstinting commitment to the writing and compilation of this book since its inception some five years ago.
For special permissions, particular thanks are due to: H. M. Queen Elizabeth II for permission to reproduce the photographs of Royal Lodge, Windsor, and of Sandringham House, Mr and Mrs Simon Bowes-Lyon, Lord and Lady Jellicoe, Lord and Lady Pym and Mr Michael and Lady Anne Tree.
Numerous organizations and individuals have made available material for this book and have much facilitated the author's and publisher's task in obtaining photographs or have granted permission for special photography. The following deserve special thanks in this respect: Michael Bellingham of Blue Circle Industries PLC, Bruce Giddy, June Harrison, Sheila Harvey of the Landscape Institute, Harvey Koch of the Sutton Place Foundation, Mr and Mrs J. Lewis, Sheikh Mohammed Mansour, Mr R. Moorhouse, Mr and Mrs Adrian White, the Atlanta Historical Society, the Directors and Staff of the Ditchley Foundation, the Directors of Hartwell House, the Moody Foundation and Pilkington PLC.
The following offered particular encouragement to the author during the planning and writing of the book: Peter Atkins, Viscount and Viscountess Esher, Professor Vittorio Gregotti, Mr and Mrs Roger Mayne and Hal Moggridge.
All the plans, drawings and photographs illustrated in this book are used by kind permission of Sir Geoffrey Jellicoe, apart from the following: p.60 (above), p.61 (above), p.62 (above left), p.63 (full page), p.64 (above), p.65 (above left), (above right), (Blue Circle Industries PLC); p.16 (lower left), p.41 (above right), p.49 (lower left), (right), p.54 (lower left), p.67 (above), (lower left), (lower right), p.70 (above left), (lower left), (above right), (lower right), p.71 (full page), p.72 (above left), p.76 (above left), (lower left), p.77 (full page), p.78 (above), p.84 (above left), (lower left), (lower right), p.87 (above), (Landscape Institute – Jellicoe Archive); p.125 (above) (Aylesbury Museum); p.163 (above), p.164 (above), pp.165–66 (both pages), p.168 (above), p.169 (full page), (lower left), p.171 (above), (below), p.172 (below) (Sutton Place Foundation); pp.180–81 (both pages), p.182 (lower right), pp.184–185 (both pages), p.186 (all), p.187 (all) (Sir Geoffrey Jellicoe and the Moody Foundation), p.189 (Sir Geoffrey Jellicoe and the Atlanta Historical Society), p.190 (below) (Jamie Garnock), p.191 (right) (Sir Geoffrey Jellicoe and the Atlanta Historical Society), and the photographs by Hugh Palmer which were specially commissioned for this book: p.17, pp.18–19, pp.20–21, pp.22–23, pp.26–27, p.28, pp.30–31, p.32, pp.56–57, p.96 (below), p.97, p.104, pp.106–107, p.109, pp.114–115, p.116 (above right), p.117, pp.118–119, pp.120–121, p.124, p.125, (below left and right), p.126, p.155, p.159, pp.160–161, p.162 (left and right), p.170 (left and right), p.196.

Frontispiece
Geoffrey Jellicoe photographed at work in early 1989 on his proposed plan of a leisure park in Turin.

British Library Cataloguing-in-Publication Data

A catalogue record for this book is available from the British Library

ISBN 0-500-01596-1

Printed and bound in Singapore by C.S. Graphics

Contents

Foreword 7

Introduction 9

PART ONE THE EARLY WORKS 1927–1960 37

Bingham's Melcombe, Dorset 42
Cheddar Gorge, Somerset 44
Ditchley Park, Oxfordshire 48
Royal Lodge, Windsor 52
Mottisfont Abbey, Hampshire 54
St. Paul's Walden Bury, Hertfordshire 55
No. 19 Grove Terrace, Highgate 58
Hope Cement Works, Derbyshire 60
Church Hill Memorial Gardens, Walsall 66
Sandringham House, Norfolk 68
Hemel Hempstead, Hertfordshire 69
Cadbury Estate, Moreton 72
University of Nottingham 73
Harvey's Store, Guildford 75
Ruskin Park, St. Helens 78
Park Royal, Middlesex 79

PART TWO A PHILOSOPHY OF LANDSCAPE AND GARDEN DESIGN 1960–1980 81

Rutherford Laboratories, Harwell 86
Cliveden, Buckinghamshire 88
Christchurch Meadow, Oxford 90
Kennedy Memorial, Runnymede 92
Horsted Place, Sussex 99

Everton Park, Bedfordshire 102
Shute House, Wiltshire 105
Hartwell House, Aylesbury 124
University of California, Berkeley 131
Smaller Projects of the Period 132

PART THREE FULL FLOWERING: THE MASTER PERIOD
FROM 1980 153

Sutton Place, Surrey 158
Modena, Italy 175
Brescia, Italy 178
The Moody Gardens, Galveston, Texas 181
Atlanta Historical Gardens, Georgia 188
Smaller Projects of the Period 192

Conclusion 206

Notes to the Text 207

The Complete Works of Geoffrey Jellicoe 208

A Chronology 211

Select Bibliography 211

Index 212

A Note on the Text
The texts relating to the principal schemes described in this book are
generally divided into two parts: an introduction by the author,
followed by commentary by Geoffrey Jellicoe drawn from his
published and unpublished works and signified by the initials
'G. A. J.'.

Foreword

IN THE OPENING PARAGRAPH of my contribution to *Denatured Visions*, published by The Museum of Modern Art, New York, 1991, I wrote: 'You first prepare a design in the normal way, you find it uninspiring, you place the drawing at a distance and preferably upside down . . .'. At first reading this advice might seem whimsical. It is not. It is the introduction to abstract art, that vast field of the creative subconscious. Let us continue: '. . . you gradually become aware that it suggests a shape foreign but friendly to any idea of your own.'

We now have the two distinct and separate worlds of C.J. Jung, the conscious and the subconscious. When antagonistic there is chaos; when separate, they are ineffectual; but when harmonious, ah, there is art, and finally: 'Tell no one, if you can, for this is a message from one subconscious to another, and the intellect spoils such things.'

All art wells out of the subconscious. In this book the theory of an invented invisible world can be followed in its various forms from Ditchley Park in 1935 when there was none, to the same family's Shute House over thirty years later, where it is paramount.

My deepest thanks are due to the owners, whose understanding, encouragement and participation have been essential. My grateful thanks to Michael Spens for organizing this progress from the beginning to the climax in the landscape of the Atlanta Historical Society (1992); there 'the subconscious harmonises the conscious', as the Greek philosopher Heraclitus put it in the 5th century B.C.

The drawings are the contemporary presentation plans for the client. What happened afterwards? Those that never took off are described simply as 'uncompleted'. Those that have been executed present a saga such as exists in no other art. Architecture is static, but in landscape the materials are in movement; and so, too, are the tastes and requirements of owners who may succeed the original ones. Reader, the truth of my ideas is *only* in these drawings, so beautifully reproduced in this book.

GEOFFREY JELLICOE
Highpoint, December 1993

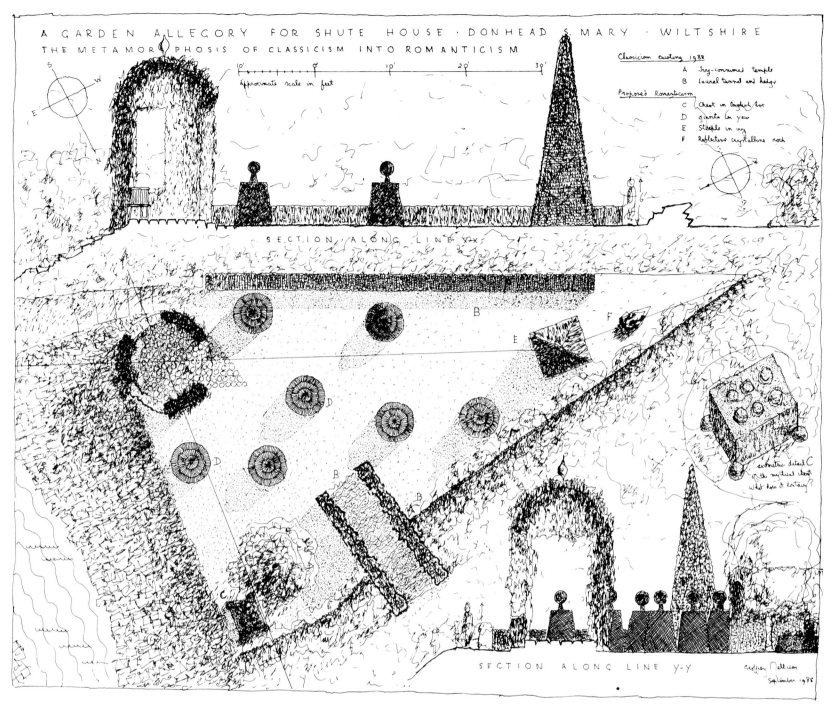

A GARDEN ALLEGORY FOR SHUTE HOUSE · DONHEAD S. MARY · WILTSHIRE
THE METAMORPHOSIS OF CLASSICISM INTO ROMANTICISM

Classicism existing 1988
A Ivy-consumed temple
B Laurel tunnel and hedge

Proposed Romanticism
C Chest in English box
D giants in yew
E Steeple in ivy
F Reflective crystalline rock

Approximate scale in feet

SECTION ALONG LINE X-X

SECTION ALONG LINE Y-Y

The plan for the allegorical garden at Shute House, drawn in 1988; it incorporates yew figures (D), an ivy steeple (E) and a mysterious chest (C), with a block of reflective crystalline rock (F) as the climax. The ivy temple (A) and the laurel tunnel (B) were already in existence.

T HE WORKING LIFE of Geoffrey Jellicoe spans nearly 'three score years and ten', to apply the biblical scale appropriate not just to his span of life, but in Jellicoe's case, to the creative evolution of a remarkable genius. From the time of the publication of his first book, *Italian Gardens of the Renaissance*, in 1925 (written jointly with J.C. Shepherd), to the planning of the Historical Gardens for the city of Atlanta in April 1992, he has completed schemes for over a hundred projects. Of these, about sixty are schemes either for landscape design or for individual gardens. The purpose of this book is to record, as far as documentary or physical evidence exists, these works for posterity. For the most part it has been possible to obtain adequate records; but garden design is, by its very nature, notoriously ephemeral, and it has been vital to have Geoffrey Jellicoe's own, direct contribution to the description of the works.

As the end of century approaches, it is important that we remind ourselves of the extent to which landscape architecture has moved, through a revision of global priorities in ecological and environmental terms, towards centre stage in importance. During Geoffrey Jellicoe's own lifetime, the design of gardens has become only a small part of the design of the environment at large. Both urban and rural life is now shaped by ecological considerations which even a decade ago were considered to be peripheral. The divisions that existed between architecture and the landscape, by which buildings were placed to dominate the landscape elements, have been removed. Indeed, the priorities have been reversed; landscape is now often the pre-eminent factor. Geoffrey Jellicoe has been a prime mover in this transformation, yet he himself is an architect, and trained and practised initially as such.

* * *

Born in Chelsea, London, in 1900, Geoffrey Jellicoe was moved at the age of two to the small coastal village of Rustington in Sussex. His earliest experience of architecture was the building of his parents' house at Rustington and his mother's frequent 'on-site' negotiations. On leaving boarding school with a classical education, some ability in mathematics and an all-rounder's skill at games, he was directed, following a fortunate encounter with the architect C.F.A. Voysey,

Introduction

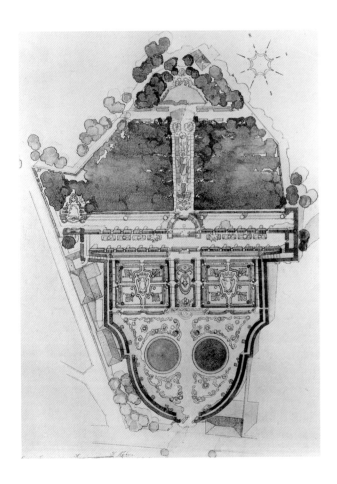

A plan of the Villa Garzoni (1652) (above), drawn by J. C. Shepherd after his and Jellicoe's journey to Italy, 1924.

A drawing of the Villa Garzoni and gardens by J. C. Shepherd (right).

towards architecture and the Architectural Association School in Bedford Square. There, Jellicoe became associated with a fellow-student, J.C. ('Jock') Shepherd, in the writing of a fifth-year thesis on Italian Renaissance gardens, on which very little authoritative literature existed at the time. Accordingly, Jellicoe and Shepherd had little prior information when they arrived in Italy in 1924. Renaissance buildings had been studiously documented almost to the exclusion of all else, especially of their immediate gardens, many of which were of course indivisibly related to the architecture. Hence, the publication in 1925 of the completed *Italian Gardens of the Renaissance* was both fortuitous and highly influential in the formation of Jellicoe's ultimate career. The influence, for example, of the gardens of the Villa Gamberaia, and even more so those of the Villa Lante, was instrumental in the development of Jellicoe's formal vocabulary.

This evolved initially through the method of measurement of the various gardens described in the book, which involved Jellicoe physically pacing out the dimensions (with remarkable accuracy as it turned out) on the ground. Shepherd drew up the surveys; supreme artist in ink and wash presentation, his virtuosity was invaluable for the book, but it had the long-term effect of causing Jellicoe to hold back his own particular talent in a very different mode of draughtsmanship – for decades, as it turned out. Looking today at the masterly plan drawings in ink and coloured crayon that revealed the great plans for the Moody Foundation's Historical Gardens at Galveston, Texas, it is hard to understand immediately why this should have happened. Not until the nineteen-seventies did Geoffrey Jellicoe evolve this highly personal yet appropriate technique; yet it had existed, in latent form, very much earlier.

This is a study of the work and not a biography, yet such issues are not resolved without recourse to some degree of biographical understanding. An examination of the drawings does not on its own explain this and other transitions that have occurred in the seven decades of

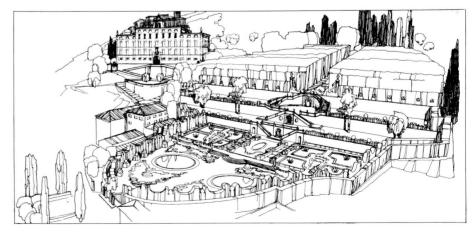

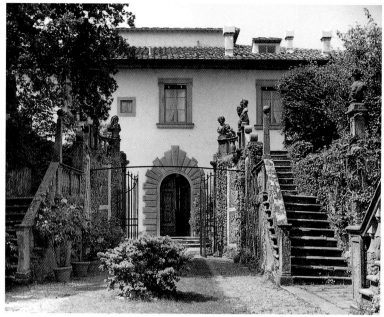

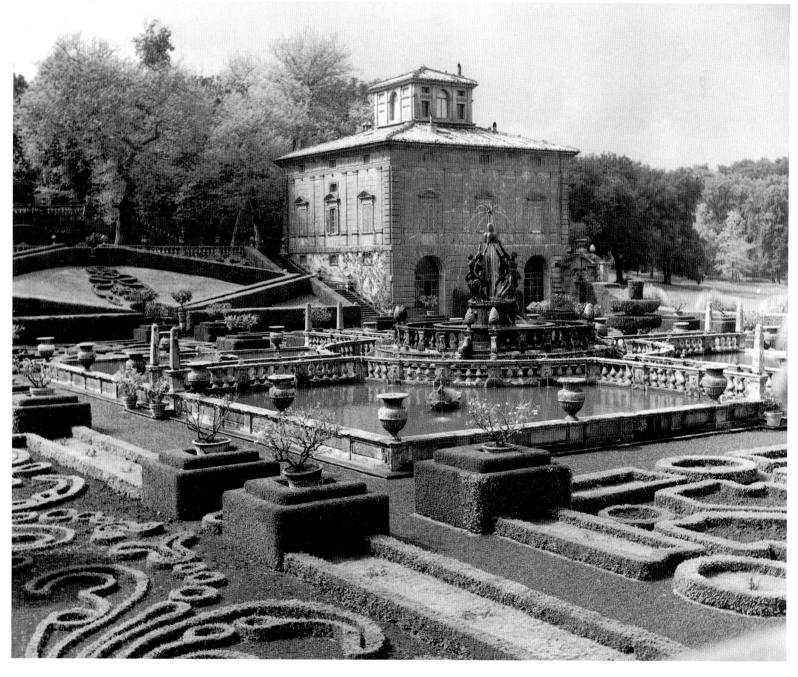

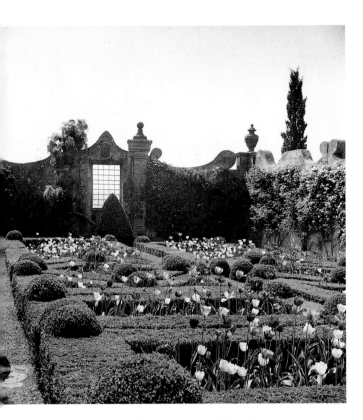

The upper closed garden at the Villa Capponi, Arcetri (c. 1572); it is interesting to compare this example of a 'windowed' garden with the enclosed memorial gardens designed by Jellicoe at Walsall in 1946; the window device was repeated at Sutton Place (1980).

Jellicoe's life as a designer. Of the many vicissitudes of such a career, true understanding requires a knowledge of motivation, preoccupations and interests beyond those of pure design. Certainly, again, it was the study of the Italian Renaissance which kindled in Jellicoe's mind a curiosity about the philosophical background to the gardens. Here, with a solid grounding in the classics, he was well equipped to extend his native curiosity to the humanist ethos of the Renaissance. A habit of linking design to philosophy, at first tentative, then sure, was to continue to enhance Jellicoe's work throughout his career.

* * *

There are three main periods in the working life of Geoffrey Jellicoe, and they correspondingly provide the main divisions within this book. The life is remarkable in that the first period effectively spans three decades, from his qualification as an architect in 1927. For most designers, this span would be the whole career, by the close of which most of the work upon which an evaluation can be based would have been finished. For Jellicoe, what had been achieved by the close of the nineteen-fifties was really just the beginning.

In this first period of work there were three main influences which enabled Jellicoe to develop an original direction to his career. Firstly, there came the chance diversion as a student, on the advice of an Architectural Association School teacher, into studying the Italian gardens of the Renaissance as a fifth-year thesis. The subject fitted with his classical education, and set him pondering the whole relationship of buildings and their surroundings, in ideal conditions. Secondly, at a somewhat later stage, his teaching experience with students at the same school, over five years, imbued him with their particular enthusiasm for the contemporary architecture of the time, and likewise for the work of Picasso, Le Corbusier, and Erich Mendelsohn.

These two strains of influence enabled him to satisfy an important client such as Ronald Tree, at Ditchley Park, in his quest for a Palladian garden, inserting with such skill the Long Terrace so admired by the Trees. At the same time he could embrace the Modern, to the extent of satisfying Henry-Russell Hitchcock's stringently critical eye, thus ensuring for his Cheddar Gorge project a prominent position in the English architectural canon of the nineteen-thirties.

Thirdly came the friendship and professional support, both in garden design and in architecture, of the furniture designer Gordon Russell.

It cannot therefore be claimed, at least in the first instance, that Geoffrey Jellicoe falls within the established tradition of English landscape design, as it was perceived in the early period of his career. The main influences were Italian and broadly European. The Le Nôtre

inspired garden at St. Paul's Walden Bury is a clear example of this. In 1936 Jellicoe was commissioned to carry out some minor changes to the garden. This remarkable place was much admired by him, and he has returned to it many times over the years. The English Picturesque tradition, by contrast, has not been a style with which Jellicoe ever felt particularly easy.

Here, indeed, lies a basic paradox: while his English fellow architect and contemporary, Christopher Tunnard, for all his Modernism and skill in designing the surroundings to new houses of the nineteen-thirties, accepted the Picturesque (the view from Bentley Wood, complete with Henry Moore sculpture, is entirely orthodox), Jellicoe talks in awe of Burle Marx's planted masterpieces in Rio de Janeiro, the counterpart of Cubism in the modern garden. The status of Tunnard, Gabriel Guevrekian (at Hyères, France) and Burle Marx he fully recognizes, though Jellicoe's quest is a different one in the end. If he cannot be easily accommodated either within the historic English tradition, or with the exemplars of the contemporary, how can he be properly categorized? The answer, as the second and third phases of his work will illustrate here, is that Jellicoe is essentially European in his cultural sources, but in the final analysis his message is universal, as the whole *oeuvre* will demonstrate. Ultimately he can be placed as the product of an English tradition, but he also escapes and surpasses all that went before, as did his contemporary and friend, Henry Moore.

A design by Roberto Burle Marx for a square at Recife, Pernambuco; Jellicoe particularly admired the combination of lush, tropical planting and a geometrical grid. He also admired the work of Christopher Tunnard (below), *which combines such Modernist elements as a Henry Moore sculpture with traditional English landscaping.*

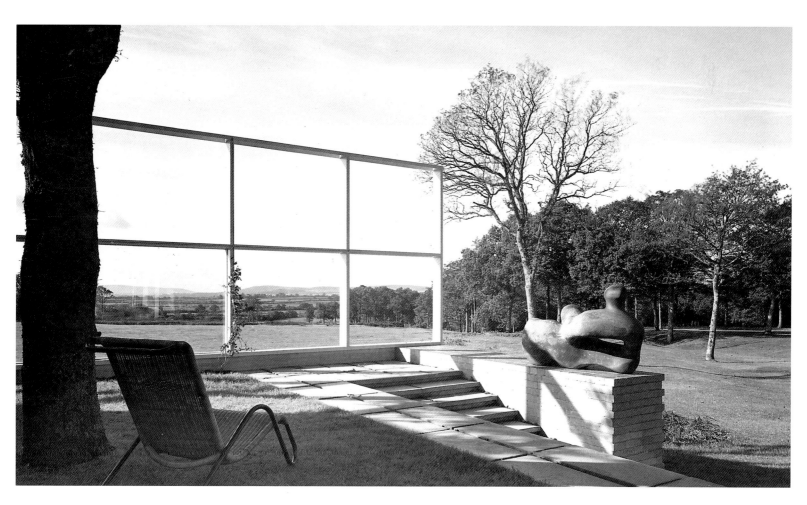

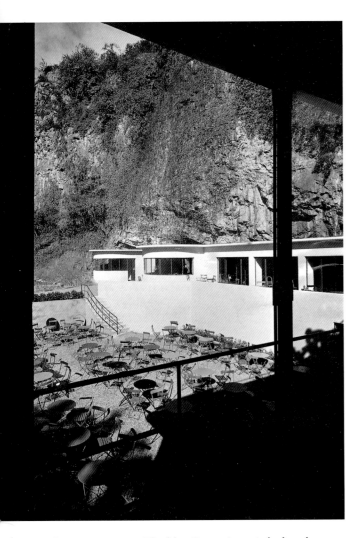

The restaurant at Cheddar Gorge (1934) declared Jellicoe's own commitment to Modernism in architecture and design. This was soon to be seen, however, as just one element in his very complex vocabulary.

The works fall into three main periods: 1927–1960, 1960–1980, and from 1980 to the present. In the first period, as we have seen, Jellicoe became an established figure and, by 1960, was distinguished enough to be serving on leading professional bodies; he was also well known through his publications. Between 1960 and 1980, however, his work entered into a period of major change. At first sight, this looks like the ready fulfilment of earlier promise. But on closer examination, it is obvious that what is really happening is more profound, less predictable than the previous period would suggest. During this period, too, Jellicoe exchanged the vicissitudes of fully-fledged practice partnership (in fact a succession of these) for a more singular application of his accumulated skills. This single shift in working method had a pronounced effect upon his drawing, which quite suddenly became much more distinctive and individual. Jellicoe's philosophy on landscape design was clearly deepening, and this was discernible from the drawn line, composition, and presentation of schemes.

This progression in Jellicoe's drawing becomes revealed to a fascinating degree as the work proceeds through these pages. Through the nineteen-seventies a series of ten private gardens helped enlarge Jellicoe's talent for communication and collaboration, person to person. Parallel to this were some notable public projects. His vocabulary of form was constantly evolving and being refined. His early classicism was re-charged by his sympathy for the Modern Movement, and this dualism stood him in good stead during the nineteen-seventies, when Post-modernist theory too readily confused the output of many outstanding designers. In the architectural world, especially, the new licence, the dismissal of established codes of acceptable references and the profusion of quotations from the past and present removed only the certainties. Jellicoe, pragmatic as well as *philosophe*, developed his skills. But he had always moved easily between the modern and classical worlds, and knew readily the necessity for both traditions.

The relevance of a design to its context has for Jellicoe always been of prime significance. Wherever in a project it can be identified clearly and without misrepresentation, Jellicoe seeks out the spirit of a place. From the earliest schemes, such as Cheddar Gorge or, by contrast, Ditchley Park, this has been the case. At Cheddar Gorge, the natural drama of the site is enhanced by the horizontally disposed building and this is further emphasized by the reflective pool; at Ditchley Park, the Long Terrace (given its historical function) likewise was wholly appropriate, setting off the whole building as apart from the ensuing landscape. At Runnymede, the Kennedy Memorial was set half way up the north slope of the meadow, to be reached through an allegorical 'pilgrim's way' through the natural woodlands; and at Horsted Place, the spatial context of floating circles appears to represent beds 'drifting'

in search of the existing 'ring'. At Guildford the roof garden for Harvey's store in the centre of the town seems to summon the very sky itself to perform - a sky garden here rather than a water garden. In the 'post-Sputnik' period of astral and planetary exploration, this made it wholly appropriate to the time. When planned it was in marked contrast to other roof gardens of the time, such as that at Derry and Toms in Kensington, London.

This condition of place, then, was central to Jellicoe's work. In the first instance the main building (in the case of those in gardens) would be placed in the landscape, and not simply in the immediate setting. The Long Terrace, or the Long Walk, occurs in approximately twenty of the schemes illustrated; here one must also include the smaller terraces created as much to concentrate spatial experience as to expand it. The Long Walk at Everton (1974), at Wexham Springs (1959) (where it becomes a 'philosophers walk'), appears as a lesser version at Stratfield Saye (1973), at Dewlish (1976), at Wilverley (1982), at Tidcombe (1989) and at Danemere (1991). At Runnymede it is designed as a link between the shrine and the seats for reflection: but, in essence, it remains a terrace. As the Long Way, it has been adapted to form a pedestrian route in an urban context, as at Gloucester (1961) or, on a smaller scale, at Walsall as early as 1949 (High Street to garden connection). At Modena (1980), it runs beside the Long Water; in the Moody Historical Gardens (1986), it becomes a water course, forming the main tourist route through the complex. What is *placement* in the private projects becomes main pedestrian route or axis in the public projects. At Sutton Place it provides the principal axial routing on the east side of the garden. Very

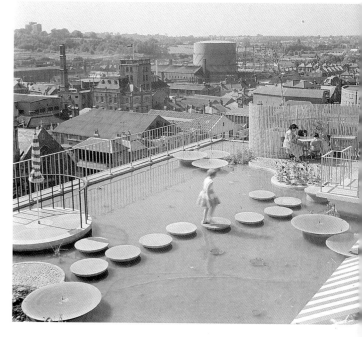

Water is rarely absent from Jellicoe's schemes; it is used in the roof garden at Harvey's store, Guildford (1956–57) to create effects of spaciousness by reflecting the passing clouds and forms of the sky.

The Long Walk or Long Terrace is a recurrent feature in Jellicoe's domestic projects; this example at Stratfield Saye, Berkshire (1973), shows the lateral disposition of hard and soft landscaping to create an interim stage between the house and garden.

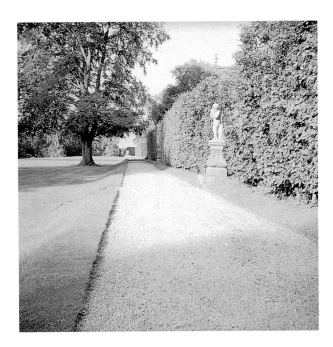

Paths or walks, here at Ditchley Park, are often used by Jellicoe as a means of opening up vistas towards some unexpected view or building.

At Ditchley Park (opposite) *the use of still water in a formal setting is perhaps derived from Jellicoe's interest in the French classical garden.*

much earlier, at Ditchley Park, the client himself noted: 'But it was the terrace that was Jellicoe's great achievement. Nearly three hundred yards in length, it ran north and south on the west side of the lake, overlooking the lake.'

Vista is the second major element in Jellicoe's vocabulary and logically complements *placement* wherever possible. Specific views were created (or re-created) by Jellicoe at Nottingham University (1955), at Hartwell (1979), at Brescia (1981), at St. Paul's Walden Bury (1983) and Shute (1987), as well as at numerous other projects. Buckenham Broad (1977), Barnwell Manor (1981) and Tidcombe (1989) are among the more prominent. Much skill is deployed at Everton in concealing the immediate view by distraction to either side via a Long Walk. Vistas are frequently unobtainable under contemporary conditions; if this is the case, Jellicoe then turns the project in on itself, as at Sutton Place, where the immediate surroundings are transformed with the inclusion of a new lake and compensating attractions. Existing 'ponds', as at Hartwell and Wilverley, which do not fit the scheme, are removed or ignored.

Water, of course, is a Jellicoe obsession. As a major element, it dominates the Nottingham University scheme (1955), Hemel Hempstead (1957), Villa Corner (1969), Shute (1970) and Modena (1980). It is prominent as an existing feature to be exploited at The Grange at Northington (1975), St. Paul's Walden Bury, Buckenham Broad (1977), Dewlish (1976), Sutton Place (1980) and of course the Moody Historical Gardens (1986). It is captured reflectively at Cheddar Gorge (1934) and at Harvey's, Guildford (1956). It cascades at Sutton Place (1980), while Shute boasts an audio-visual rill. Fountains were incorporated in the plans for Ditchley (1935), Hemel Hempstead (1957), the Villa Corner (1969), Wisley (1971), Modena (1980), the Villa Seeger (Asolo) (1988), and at Danemere (1991).

There are a number of secondary devices, used either together or individually to reinforce the elements described above. These range from arbours and seats, to trellis, sculptures and urns, to ornamental vases and baskets (such as the 'Repton' baskets at Horsted). These items are tactically deployed in many of the schemes to great effect. Many of them are established stock to the garden designer's trade. But Jellicoe always uses these sparingly, to greater effect.

Garden enthusiasts will be disappointed if they expect to find planting plans described here. In only three instances have these proved to be available: at Cliveden, Everton and Sutton Place. The former is in fact by Susan Jellicoe and the latter by Hilary Shrive, in consultation with Jellicoe. Indeed, he is the first to admit that he is not a plantsman. In fact, his expertise is more considerable in tree species, where he has tended to favour hardwoods. Ilex has been a more recently stated preference.

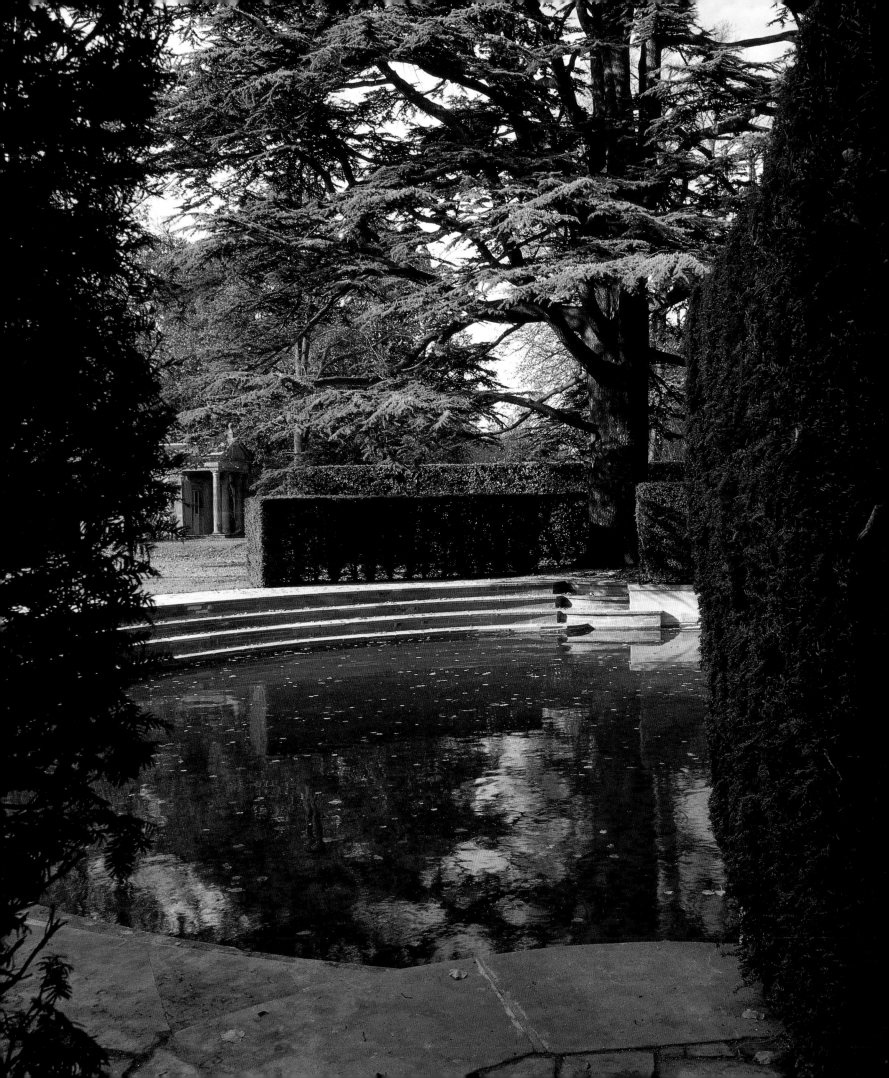

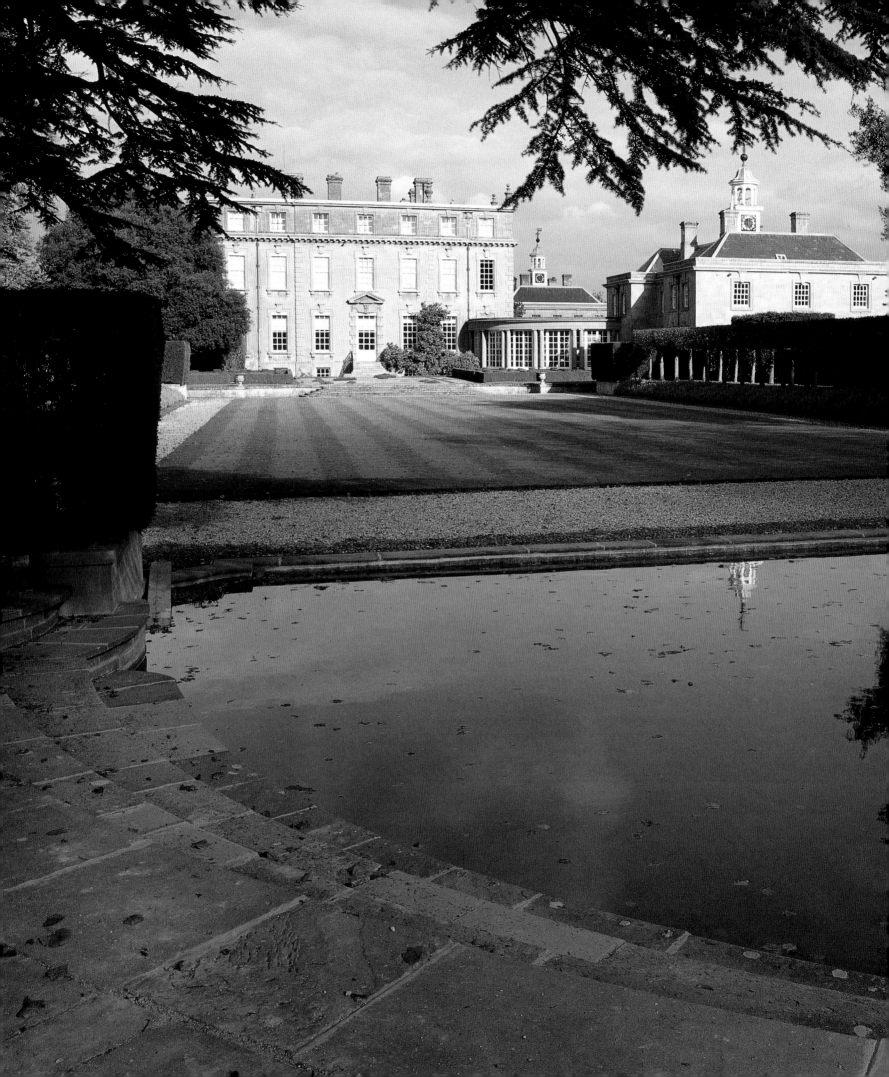

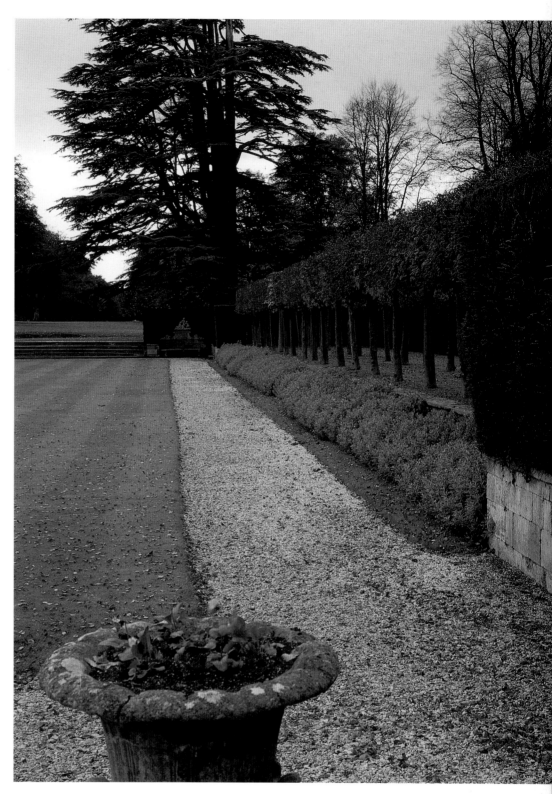

*Looking towards the house at Ditchley (left) from the pool; the Long
Terrace behind the house was added by Jellicoe as a spectacular
position from which to view the full sweep of the formal garden. The
view down the garden (above) towards the pools; note the formal tree
planting on the right. This is paralleled by a similar avenue on the left.*

The Kennedy Memorial, Runnymede (1964): a recurring motif in Jellicoe's design is the arduous way through the woods symbolizing the tribulations of the human condition. The reference here is direct: the concept is based on John Bunyan's The Pilgrim's Progress. *Such a path in Jellicoe's work often leads to a spectacular artefact, as the memorial stone here, which seems in the context to offer a sense of redemption for suffering humanity.*

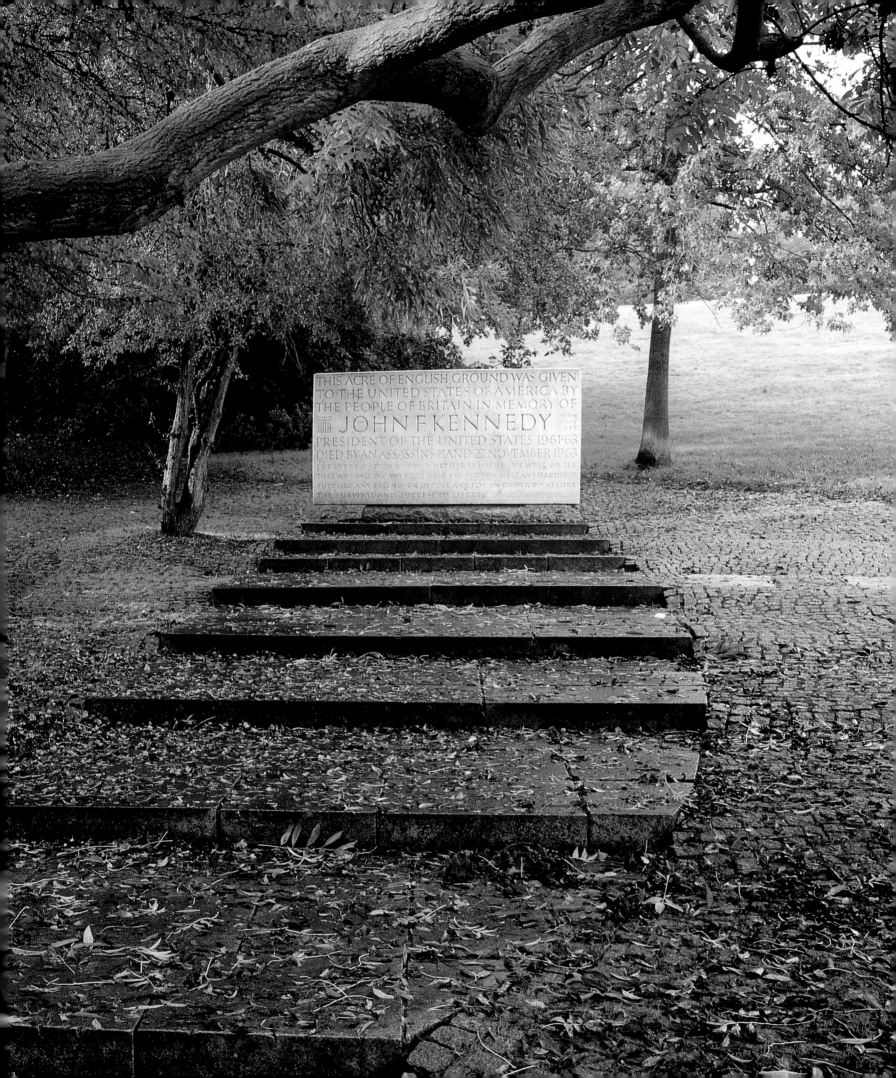

The garden at St. Paul's Walden Bury has been almost a permanent laboratory for Jellicoe since the 1930s. His work in the garden has been characterized by a re-emphasis of its underlying French characteristics, notably in the opening-up of the vistas in conjunction with statuary (below and opposite).

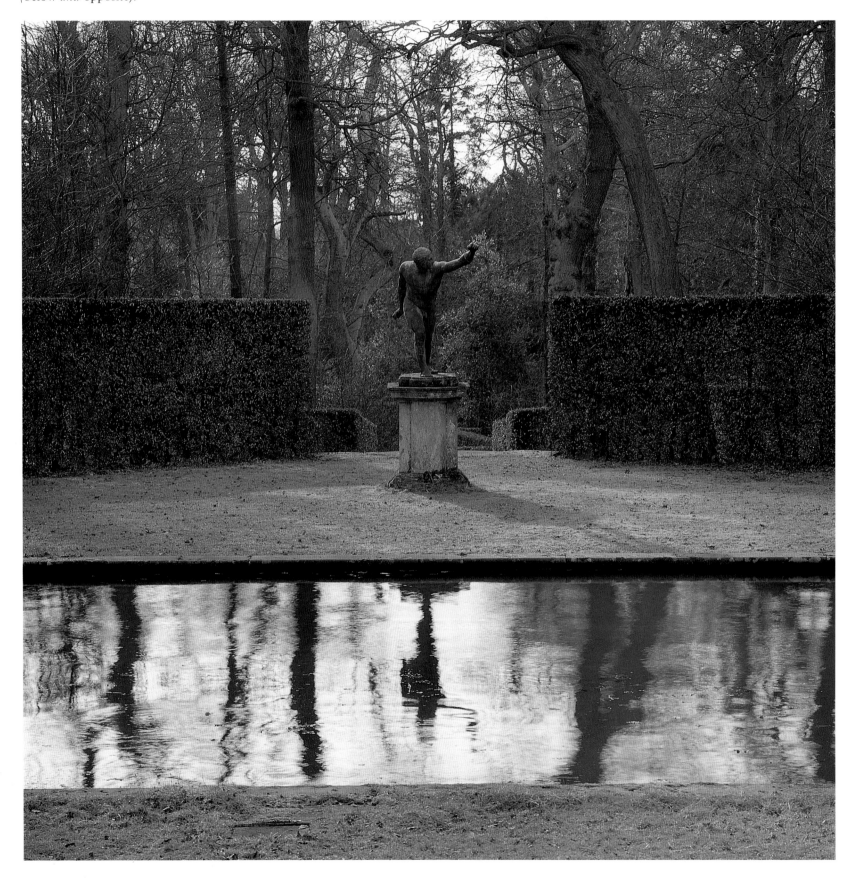

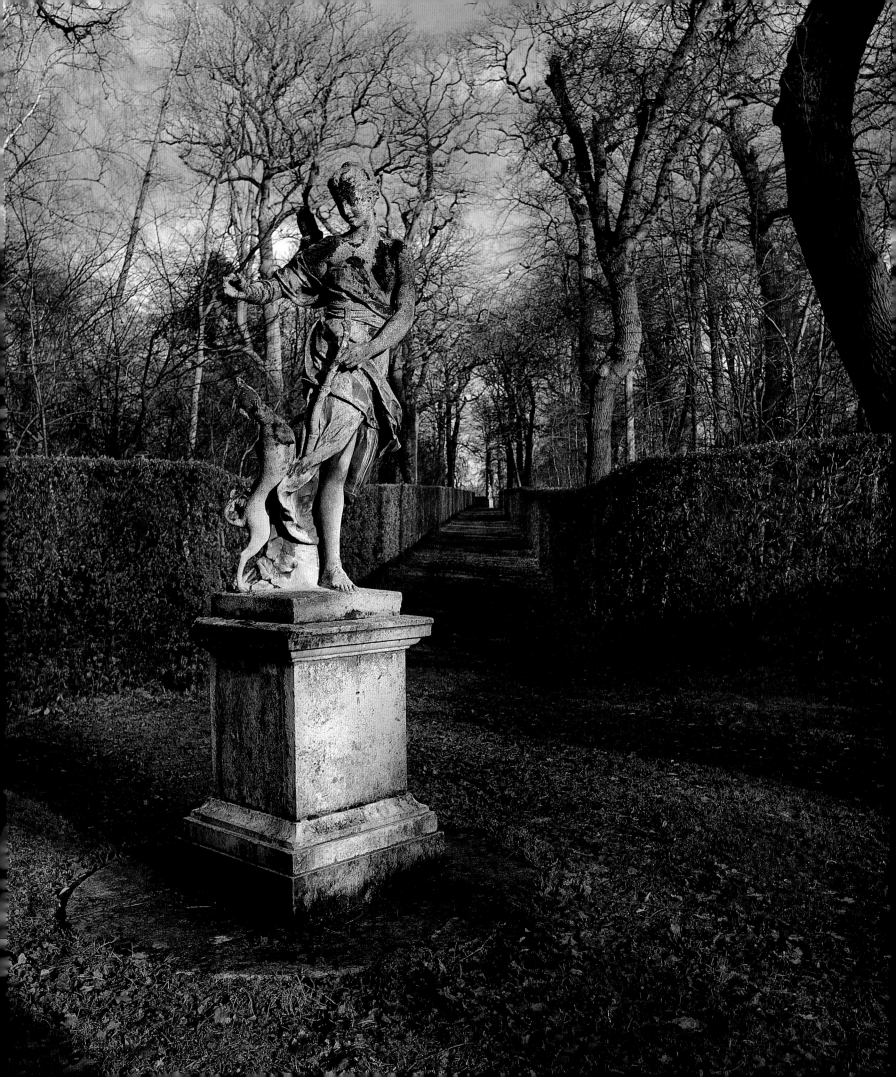

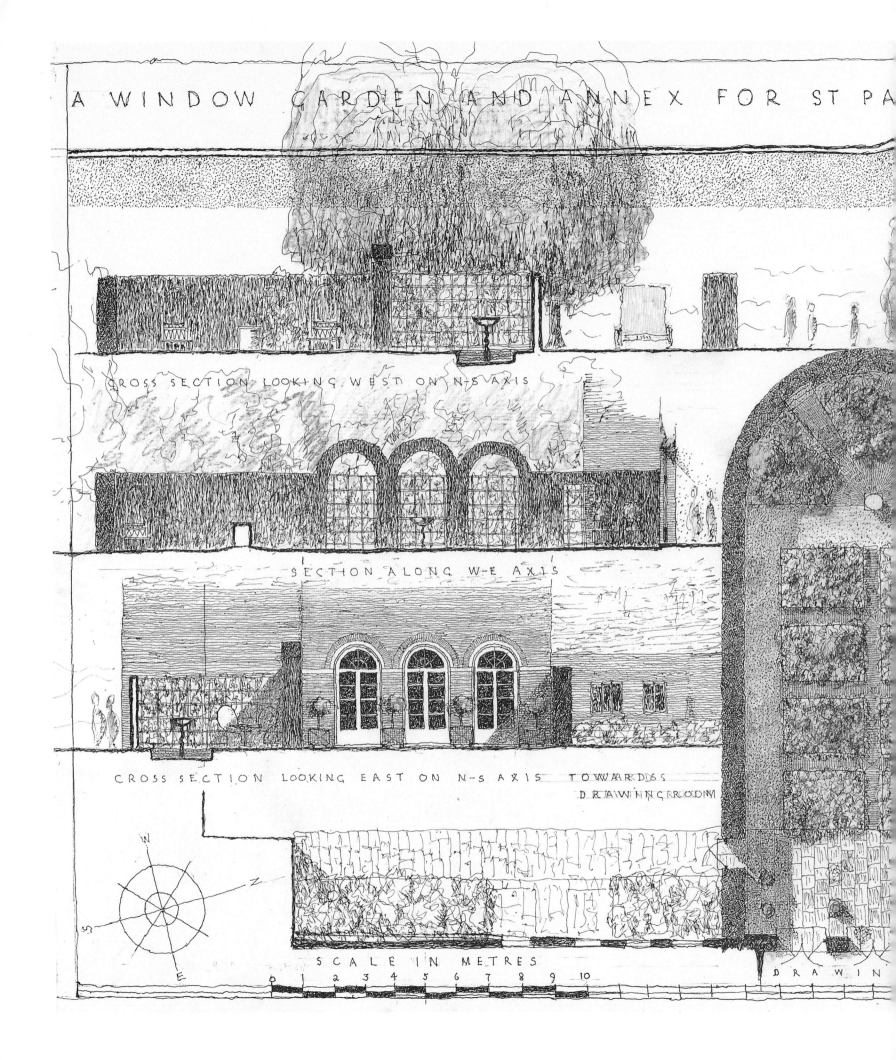

A WINDOW GARDEN AND ANNEX FOR ST PA

CROSS SECTION LOOKING WEST ON N-S AXIS

SECTION ALONG W-E AXIS

CROSS SECTION LOOKING EAST ON N-S AXIS TOWARDS
DRAWING ROOM

SCALE IN METRES

0 1 2 3 4 5 6 7 8 9 10

DRAWIN

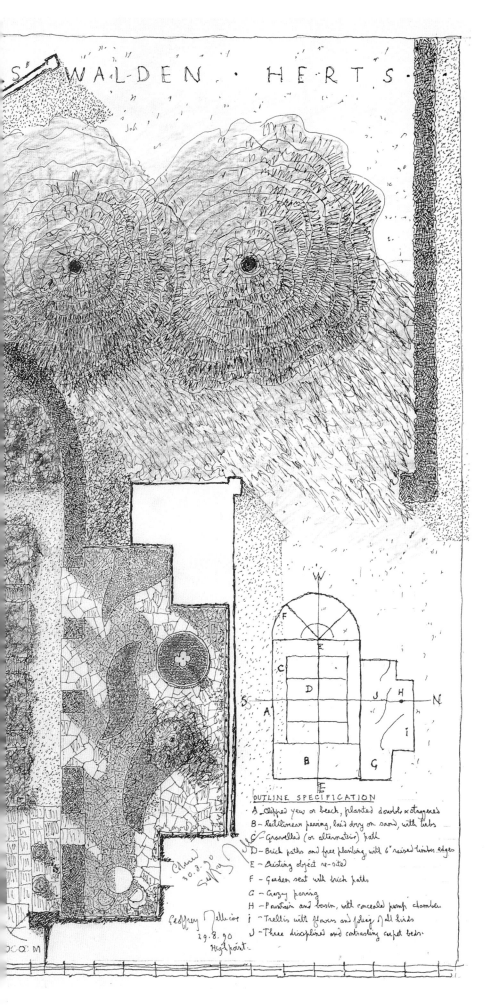

S' WALDEN · HERTS ·

W

F

C

D

E

J H

S A N

B G

I

E

OUTLINE SPECIFICATION

A – Clipped yew or beech, planted double & staggered's

B – Rectilinear paving, laid dry on sand, with turks

C – Gravelled (or alternative) path

D – Brick paths and free planting, with 6" raised timber edges

E – Existing object re-sited

F – Garden seat with brick paths

G – Crazy paving

H – Fountain and basin, with concealed pump chamber

I – Trellis with flowers and foliage of all kinds

J – Three disciplined and contrasting carpet beds.

Geoffrey Jellicoe
29.8.90
High Point.

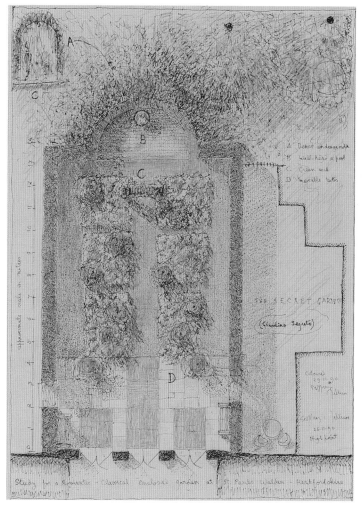

THE SECRET GARDEN
(Giardino Segreto)

In 1992 Jellicoe drew up two alternative plans (above and left) for a window garden at St. Paul's Walden Bury; his concern for the broader aspects of the garden at large was now concentrated in another dominant element of his vocabulary: the enclosed secret garden. In the version above, which was the one finally adopted, the three windows look out on the secret garden, which terminates, via an arch, in a fountain.

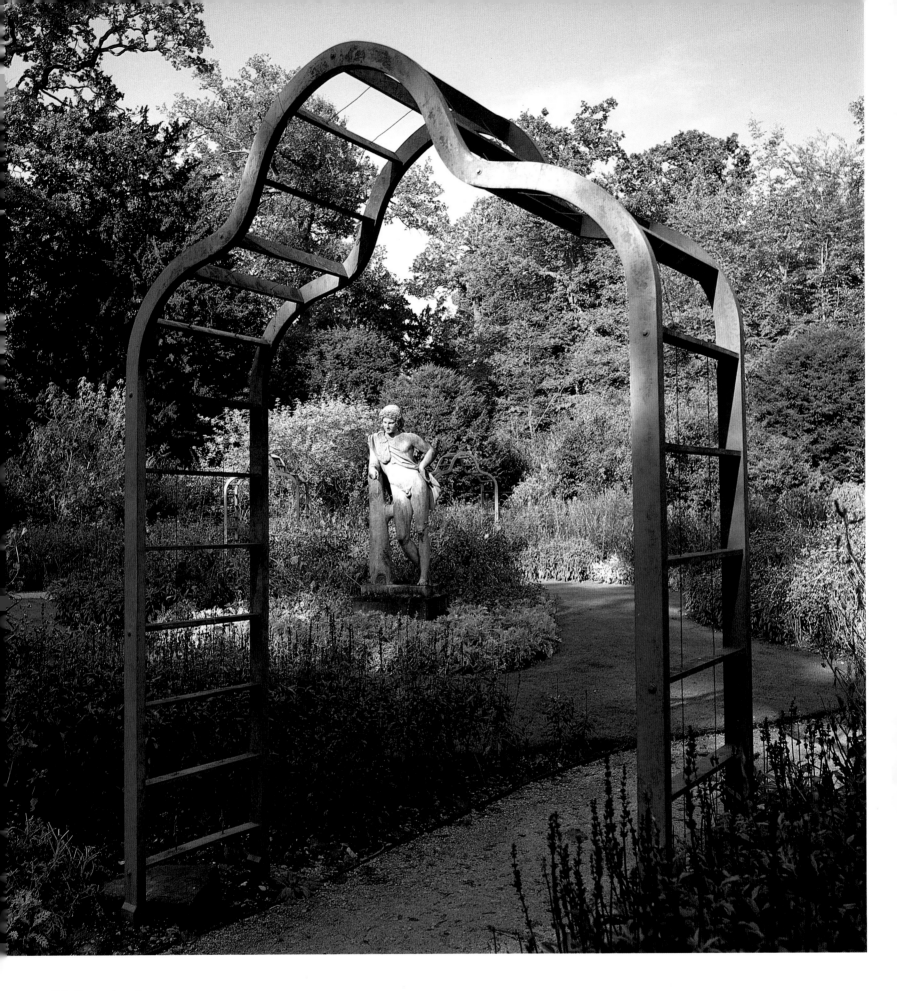

These two examples of enclosed areas in a large garden are both
characterized by architectural elements specially designed for the site by
Jellicoe, again reflecting his interest in the combination of rigid
structures and planting: the Rose Garden at Cliveden (1962) (opposite)
and the Paradise Garden at Sutton Place (1980) (above). The arches at
Cliveden are a semi-abstract representation of the human form.

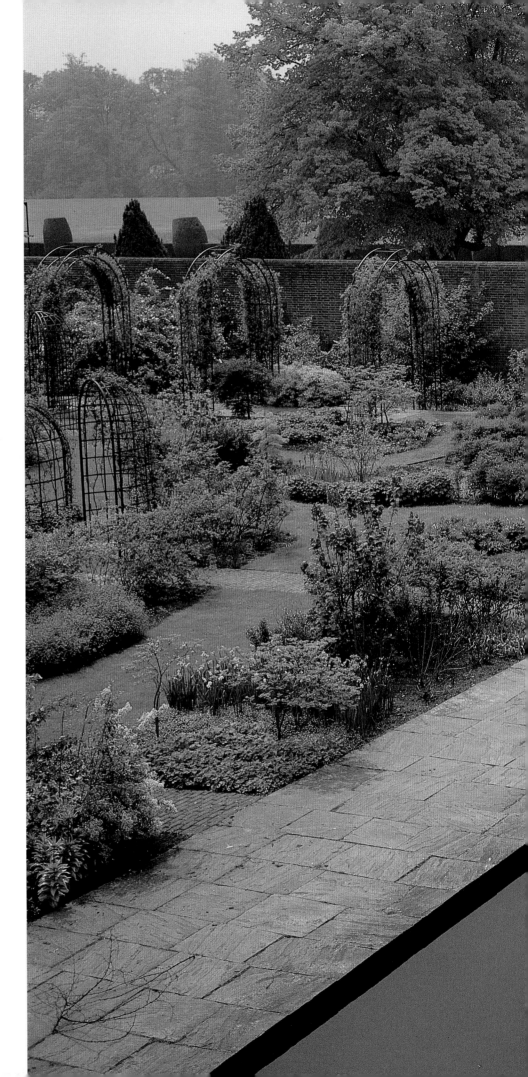

*The juxtaposition of order and disorder plays an
important part in Jellicoe's major works, especially at
Sutton Place (1980). The orderly elements can be seen
in meticulously designed and executed details as in the
window (top) and the wall spout (above) and in the
larger concept of the Paradise Garden (right) which acts
in this view as a perfect counterpoint to the park
beyond. The design of the rails of the balconies along
the moat is derived from a balustrade shown in* The
Allegory of the Progress of the Soul *by Giovanni Bellini
(1430–1516).*

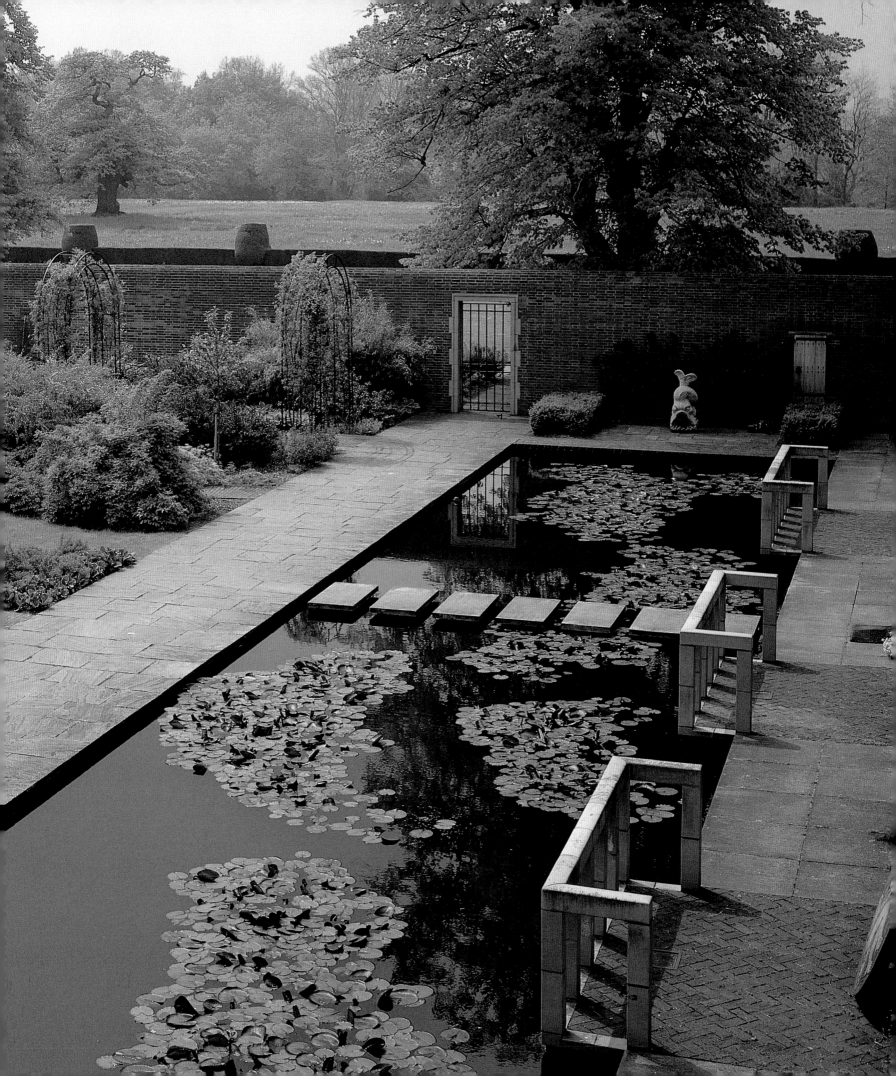

The gardens at Shute House, Wiltshire, are one of the greatest displays of Jellicoe's rich and complex landscape vocabulary. His use of water may be both formal, as in the canal overlooked by the two-way seat (above), or informal, as in this pool to the west of the formal garden and house, overlooked by an isolated statue (right).

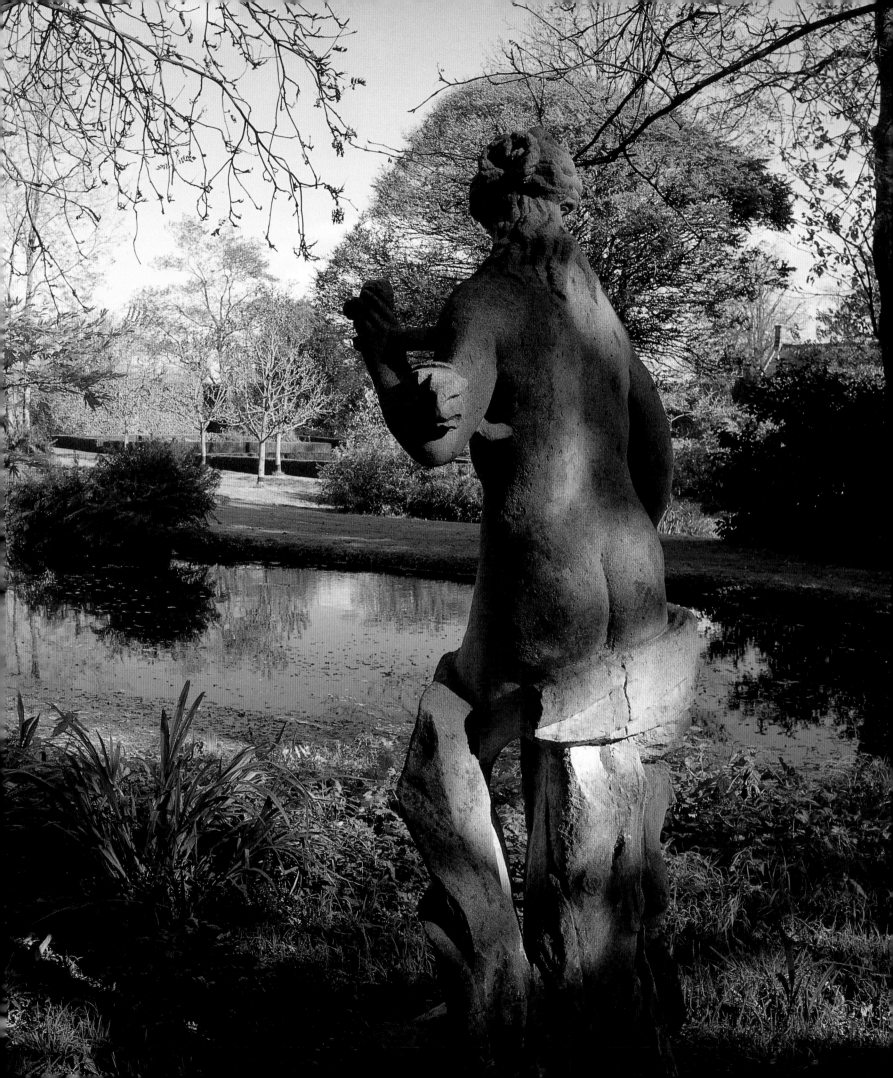

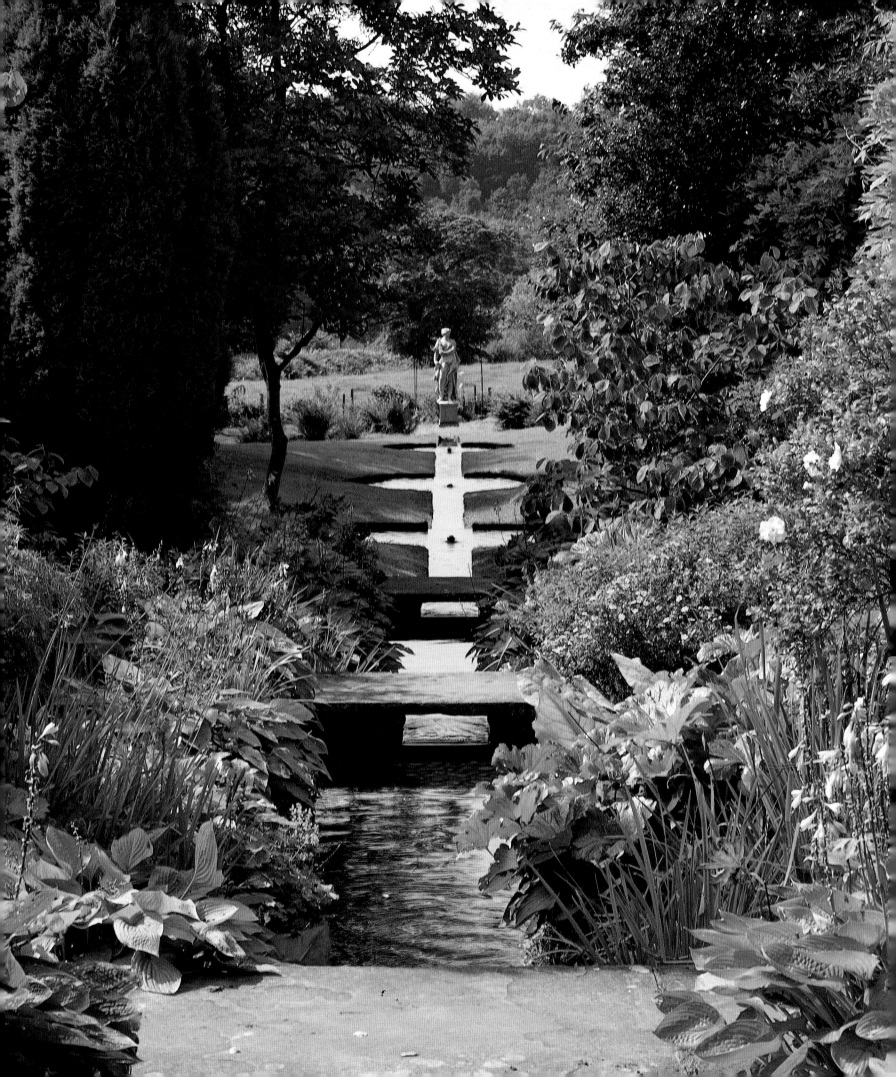

Viewing the sequence of work illustrated here, spanning some sixty or more years, one is confronted with a wide range in scale, from small urban gardens to massive leisure complexes. It is reasonable to ask what the common factor can be. Fundamentally, it is a human scale applied at every level. Even when Geoffrey Jellicoe was working on Ditchley Park, he would draw in the lower right-hand corner, to the same scale, the plan of his small urban garden at No. 19 Grove Terrace, as if to pin himself down to reality. Beyond this lies an open attitude of mind concerning human nature. This makes certain assumptions about the role of the subconscious mind in the act of perceiving landscape and moving through it. He views that subconscious in two ways, the individual and the collective human group. This is an attitude of great humility before the power of creation, yet one he has carefully and resolutely thought out over several decades now. And, of course, this basic attitude on human scale, both intellectual and physical, is also the product of great enlightenment, both by history and by experience. The classical grounding to Jellicoe's own thinking, like the physical experience, had been derived from pacing out the numerous Italian Renaissance gardens; this is so implanted that it is seldom entirely absent.

Yet Jellicoe would still be the first to claim that he is a Modernist. If so, his Modernism is of the timeless kind and, more specifically, he has an attitude to the new where he is continually prospecting. In his quest for inspiration on each project, Jellicoe casts far and wide. Since the nineteen-thirties, together with a great love of Renaissance art, he has been a committed enthusiast of modern painting and sculpture, notably of the work of Paul Klee, Malevich, Kandinsky and Picasso, of Henry Moore, his contemporary, and more latterly of Anthony Caro. More inspiration comes from a wide reading of literature, most especially of twentieth-century philosophy. He has also long been interested in ancient Chinese philosophy, which has also conditioned his concepts of landscape composition. The Latin Augustan poets, too, have proved an endless stimulus.

Today, Jellicoe believes that landscape architecture is well-poised to become a vital element in the survival of the environment, man's ultimate resource. The projects described in this book are evidence of his growing awareness of the vital and central responsibility to ensure the preservation of civilization by conservation of the entire global environment. The works of the nineteen-nineties have been affected by fresh insight, but the essential human predicament remains unchanged, despite its new planetary dimension. Jellicoe wrote in *The Landscape of Man* (1975): 'The greatest threat to man's existence may not be commercialism, or war, or pollution, or noise, or consumption of capital resources, or even the threat of extinction from without but

One of the most formal elements of the garden at Shute is the rill (opposite), a favourite Jellicoe device for establishing a strong central axis to a garden design. Characteristically, the view down the rill leads to a dramatic end-piece in the statue. Crossing points provide the opportunity for a variety of views along the length of the water, which is given a further dimension of interest by its harmonic cascades.

rather the blindness that follows sheer lack of appreciation and the consequent destruction of those values in history that together are symbolic of a single great idea.'

* * *

Inevitably, a major part of this book is devoted to the later years which, from 1980 onwards, must be considered the master period. It is also clear that the legacy Jellicoe leaves to posterity will primarily rest upon the five great projects of the post-1980 period: Sutton Place, Modena, Moody Gardens (first and second versions) and Shute House. To these can be added those for Hartwell and Brescia, but those first five are great schemes and they have accordingly been treated at considerable length in the present book. Each scheme of key importance is fully represented by substantial drawings. One might also add to this list the yet unfulfilled Turin Park (1989) proposal and that for Cairo (1992).

Of earlier projects, Horsted, Runnymede and the small scheme for Cliveden are clearly the most significant precursors of the prowess that was to emerge. Horsted already shows a growing preoccupation with graphic effect. At Runnymede there came the evidence of a surrealist tendency, which was deepened by the allegorical precision of the Kennedy Memorial. At Cliveden, Jellicoe made an unequivocal statement about Modernism in garden design. Hartwell has been a fascinating exercise in site analysis by Jellicoe, very thoroughly documented and something of a philosophical game of table-tennis; yet once again, despite new proposals invited in 1989, these remain as yet unexecuted. The two nineteen-thirties projects, for Cheddar Gorge (1934) and Ditchley Park (1935), tended both to be somewhat overlooked by post-war commentators. The former had been included in Henry-Russell Hitchcock's very tightly selected 1937 exhibition catalogue for the Museum of Modern Art, New York ('Modern Architecture in England'). Perhaps it was Jellicoe's eclecticism which confused historians at the time of the promotion of Modernism to the exclusion of almost everything else.

When considering the wide range of projects that are contained in this survey, the gradual development of presentation technique by Jellicoe needs particular attention. It is only from 1971 (Stratford-on-Avon), however, that the brilliance of the projects is fully realized, in their graphic presentation. At this point Jellicoe was in his early seventies. Clearly his working method had sharply altered. No longer was drawing delegated within the office which was, in any case, defunct by 1972. At the same time, he had more time to reflect on the deeper implications of his designs. This philosophical aspect clearly began to stimulate the act of drawing; and significantly for him, the process enriched his vision.

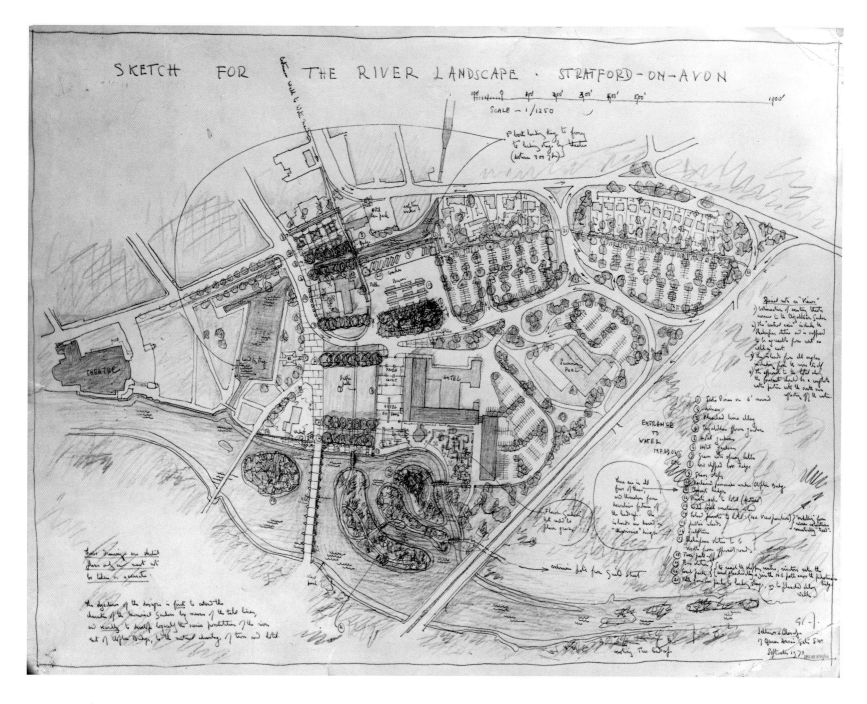

In the early seventies, Jellicoe's landscape plans began to undergo a major change. The drawings became much fuller in their presentation of his detailed planning. This plan (above) of the Stratford-upon-Avon riverside development (1972) has obviously been rapidly executed, but already shows the architect's eye for presenting the relationship of various complex areas in the fully detailed manner which was to characterize his mature style.

Thus, a major division of content is evident in this book. The projects up to 1971 are generally illustrated by a combination of photographs and site plans. Few if any of those projects are available as drawings. While the projects in this early period were considerable achievements in themselves and, indeed, culminated in the Kennedy Memorial at Runnymede, they lack (with this conspicuous exception) some of the fully evolved quality of the works from the final quarter-century or so.

It is evident that a full *catalogue raisonné*, in conventional terms, cannot be provided of Geoffrey Jellicoe's work. It is the nature of such designs that the physical end-product, when realized, is paramount; and the designer's drawings, from finished sketches for client presentation to

the subsequent working drawings, always remain a means to that end, not an end in themselves. Geoffrey Jellicoe was in his early seventies when he developed his remarkably personal style of graphic presentation, suitable for the detailed exposition of landscape elements – water, planting, hard and soft gradations in surface cover, pathways, and spatial differentiation of great subtlety. What therefore has been achieved in this survey, with Sir Geoffrey's full co-operation, has been the documentation of each project in sequence, together with the significant and relevant drawings still available in each case. Inevitably, over such a long career, many projects – mainly very minor – are incompletely documented and could not be the subject of complete entries in the main part of this book. However, a complete listing of works, including those which are predominantly architectural and therefore beyond the scope of the present work, is printed here as an appendix.

The outstanding quality of Jellicoe's work is always evident, the more so in retrospect. The project for Cheddar Gorge enabled him to enter the sunlit uplands of nineteen-thirties Modernism, yet still to devise a building utterly appropriate to its setting. Shortly after, Ditchley Park (1935) established his reputation as a practical designer of gardens in a historic context, and by this he was to become known in the uppermost echelons of thirties society. The plan for Broadway (1933), albeit a report, had already established his reputation as a designer-planner.

Although the Second World War made things extremely difficult for the Jellicoe practice, in 1943 he was still able to embark upon the fifty-year time scale of the Blue Circle Cement Company project in the Derbyshire Peak District National Park. After the Second World War, yet still in the formative stages of his career, he received royal patronage for a second time in a decade: Royal Lodge, Windsor, was followed by Sandringham from a grateful sovereign. So Jellicoe moved forward, too, in the ranks of his profession and through the Institute of Landscape Architects, to establish an overseas reputation, helping later to found the International Federation of Landscape Architects.

Wherever possible, throughout this book, Geoffrey Jellicoe's own writings, both published and unpublished, have been used to explain his thinking on each project. Such writings are unusually prolific, and I have drawn upon them generously but selectively. This volume, then, contains Jellicoe's major *oeuvre*, in most cases partly explained in his own texts or updated with relevant facts. The subject of gardens and landscape design is as universal as humanity itself, now entering the third millennium; Geoffrey Jellicoe has, for most of his international career, been the undisputed doyen of their conception and realization.

PART ONE · THE EARLY WORKS
1927-1960

The Early Works
1927–1960

GEOFFREY JELLICOE'S EDUCATION as an architect took place at the Architectural Association's School in Bedford Square, London. The influences there were mainly classical, thus in no way alien to a pupil reared on the Greek and Latin curriculum of a typical English public school of the time. As we have seen, a seminal influence of this period was his fifth-year thesis and subsequent publication on Italian gardens of the Renaissance. In the nineteen-twenties, though, on qualification as a member Associate of the Royal Institute of British Architects, Jellicoe found that there was a dearth of architectural work. Although nominally by then in partnership with 'Jock' Shepherd, his co-author of *The Italian Gardens of the Renaissance*, Jellicoe was best able to establish his name by lecturing and further writing. As joint author, again with Shepherd, Jellicoe published *Gardens and Design* in 1927, a useful and inspiring compendium of ideas and reflections on garden design, past and present. In the same year, the established furniture designer Gordon Russell contacted Jellicoe at his home-cum-office at No. 60 York Terrace, London NW1; this resulted in a project for the steps at Russell's house at Broadway in Worcestershire, although this was not fully realized until 1930.

Over this same period of five years (1928–33) Jellicoe acted as third-year master at the Architectural Association School in London. The importance of this is not to be underestimated: Jellicoe was quick to realize the intensity of student enthusiasm for the Modern Movement and its leading exponent, Le Corbusier. There, Modernist concerns eventually led to the planning and successful completion of a tourist information centre and restaurant at Cheddar Gorge in Somerset. It is important to note here that this project came to Jellicoe through the intervention of the garden designer Russell Page, already himself working not only for Gordon Russell, but also for the client owner of Cheddar Gorge, the landowner Viscount Weymouth (later Marquess of Bath).

Another significant milestone in the nineteen-thirties for Jellicoe was the commission to prepare an Advisory Plan and Report for the Parish of Broadway, Worcestershire. Russell was a prime mover here. Jellicoe accepted with alacrity, although this was not a design project but a plan. Indeed, it was the first of its kind under the newly enacted Town and Country Planning legislation of 1932, and became a model remembered

Geoffrey and Susan Jellicoe photographed in 1954 (opposite) in their garden at No. 19 Grove Terrace, Highgate; the structure and planting of this garden was a continuing project for the Jellicoes until the mid nineteenth-eighties. In 1974 Jellicoe designed another garden, similar in length and proportion to his own, at No. 27 Grove Terrace (p.194).

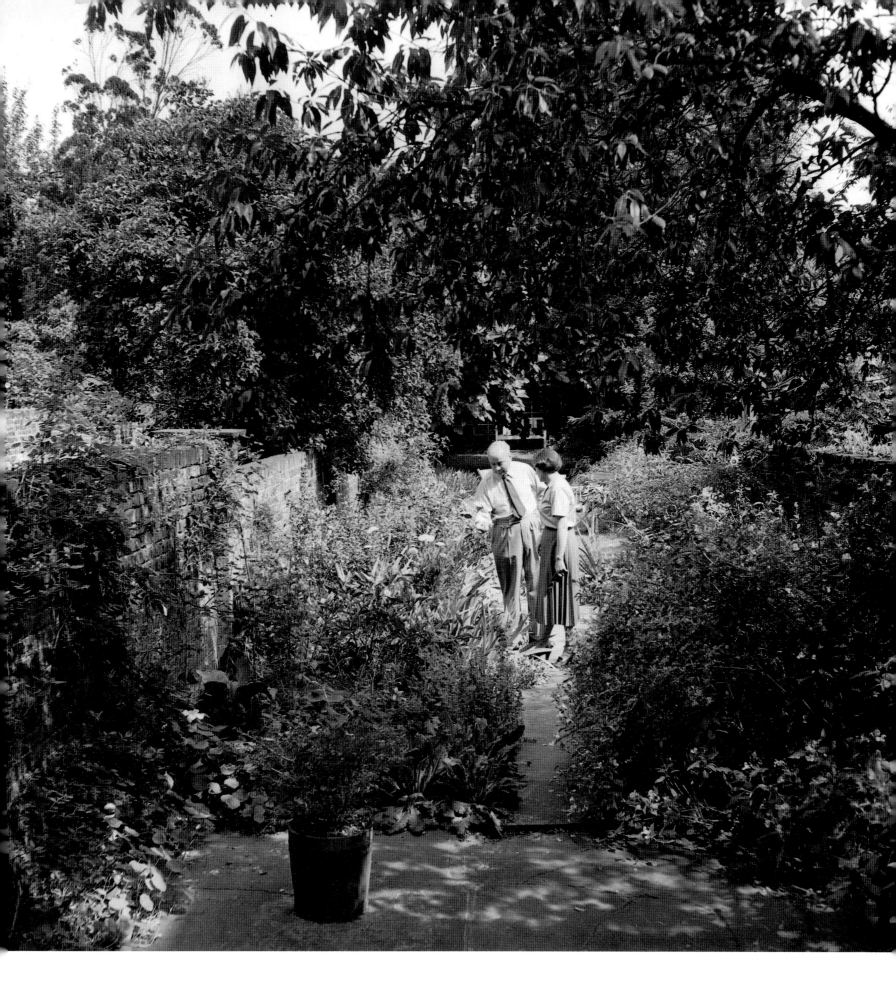

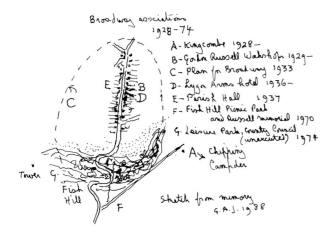

This *1988 sketch from memory recalls Jellicoe's involvement with plans for the village of Broadway in Worcestershire and his friendship with the furniture designer Gordon Russell.*

in the nineteen-forties when the Act truly began to be applied across the whole of England. Jellicoe became established in the letter of the Act as a professional planner, endowed with official status additional to that of a designer, a great advantage to him in the two following decades.

In the nineteen-thirties Jellicoe was thus able, in the most difficult conditions for obtaining work, to establish a name as a contemporary architect, as a designer of classical gardens, as a teacher in an outstanding school, as a professional planner, and as a co-founder and subsequently president (in 1939) of the new Institute of Landscape Architects. In the same year he was also appointed principal of the Architectural Association School. Equally important, he became known and appreciated by a small network of distinguished and influential clients. Through Russell Page he met the client of Cheddar Gorge, as well as the wealthy and influential American anglophile, Ronald Tree. Commissions came principally through Jellicoe's landscape and gardening reputation, established first by the publications. The partnership with Shepherd did not last beyond 1931, when Shepherd, with Elizabeth Scott, won the competition for the Shakespeare Memorial Theatre, Stratford-upon-Avon (1931). By now Jellicoe was self-sufficient and going his own way. In 1936 he had the good fortune to meet and marry Susan Pares, daughter of the distinguished historian, Sir Bernard Pares. Susan brought to Jellicoe's life a well-tried intellectual background and a personal determination – most relevantly, to become a leading plantswoman, eventually responsible for this important element in Jellicoe's own work.

As the decade advanced, Jellicoe found that he was in demand as a landscape designer on a larger scale. The scheme at Ditchley Park (1935) had been promptly followed by a commission from the Duke and Duchess of York; the designs for the areas immediately around the house at Royal Lodge, Windsor Great Park, proved highly acceptable to the future King and Queen.

Jellicoe by now had become a leading name in landscape architecture. Probably as a result of the Broadway Advisory Plan, there came in 1943, in the middle of the war, a commission to produce a plan to deal with the industrial spoil from the Hope Valley Works of the Earle Cement Company (later Blue Circle Cement) which lay within the boundaries of the Peak District National Park.

Although few drawings exist from this period, Geoffrey Jellicoe has himself kept written records of many of his works and experiences. Despite the fact that the period ran for three decades, and that he was sixty at its close, the work is today logically classifiable as forming only the initial period of his development. It has to be remembered that the environmental design professions were still evolving at that time. An architect first, Jellicoe relied upon this activity to keep his office going.

The fact that he gradually received garden and landscape commissions over the period had much to do with the fact that he already had an established practice. As the Town and Country Planning Acts had become increasingly all-embracing, he became identified primarily as an architect-planner. The loss of the Hemel Hempstead New Town brief as a whole, which he had previously had been awarded in 1947, and its reduction to responsibility for the Water Garden within the projected development, was very significant for his future direction. Likewise, the projects for Bingham's Melcombe (appraised in 1927, but only formally commissioned in 1949) and for St. Paul's Walden Bury (occasional consultation between 1936 and 1992) involved Jellicoe in considerable background research and thinking, but with little practical evidence of results. The work for Blue Circle Cement at the Hope works in Derbyshire is another commission over a protracted time scale – in this case half a century. Here, too, Jellicoe could take a longer perspective in the development of a way of thinking about landscape.

There were shorter-term, more intensive industrial commissions to be executed too (Pilkington, Cadbury and Guinness). Yet surprisingly little work materialized in the field of New Towns, landscape design, or other commercial projects. There were very few commissions from private clients for garden design, as the after-effects of the war continued for over a decade.

An essential characteristic of all Jellicoe's career has been his adaptability, and he survived these years with a broad-based portfolio of work. Much of this experience informed his seminal publication *Studies in Landscape Design* (vol. I, 1959; vol. II, 1966; vol. III, 1970). By the close of this period, Geoffrey Jellicoe had clearly achieved a leading position in the field of landscape architecture. The work for Nottingham University (1955) shows proficiency coupled with restraint. The project for Hemel Hempstead seems, however, to indicate more succinctly the future course of Jellicoe's thinking and here, unlike the much larger Nottingham project, the 'serpent' form predominates; at Nottingham there is no resource to allegory. It was at this point that there emerges the first sign of a concern with the subconscious mind as a factor in his designs.

The Festival of Britain (1951) brought this commission for the styling of a garden in an exhibition of low-cost housing at Poplar, London.

Bingham's Melcombe, Dorset

Geoffrey Jellicoe's 1960 sketch of the site of Bingham's Melcombe, showing the sight lines from the house in relation to the surrounding countryside (top): A Manor; B Fish ponds; C Mill pond; D Church; E Farm; F River; G Hanging woods; H Hillside.

This drawing of Bingham's Melcombe, by J. C. Shepherd (below), clearly shows the sweep of the lawn and the yew hedge, an influential example of the open and closed elements in garden design so important to Jellicoe.

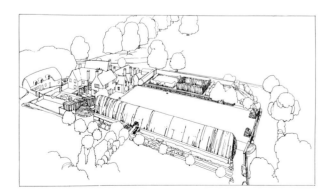

BINGHAM'S MELCOMBE remained an inspiration to Jellicoe from the time that he and 'Jock' Shepherd included it in *Gardens and Design* as an archetypal English form. Indeed, he likes to link it to the garden of the Capponi family at Arcetri, close to Florence, in its asymmetrical purity of form.

While Bingham's Melcombe only became a project in 1949, involving limited design and supervision of the existing garden, Jellicoe was eager to ensure appropriate restoration to a private garden that he had admired and studied since the mid nineteen-twenties. It is included here as relevant to his work of the twenties and thirties.

Geoffrey Jellicoe's own remarks in *Gardens and Design* are remarkably revealing, as well as prescient, about his own predilections in garden design. Bingham's Melcombe is particularly anticipatory of the design for the gardens at Shute, some forty-three years later, in its emphasis on approach paths or routes, the use of surprise, and specialized planting areas.

G.A.J. The site for this historic but little known manor was determined by river, protective hills and agriculture. Today it is still remote in the countryside. The earliest date of the buildings is unknown, but sometime, in the late middle ages, two enclosed wall gardens were made as open air rooms, extending from the great hall. These may have been known as the ladies' garden and the first plants may have been medicinal. The gardens were secretive and protected from a hostile environment, as it was then considered to be. Times changed, the environment was found after all to be friendly and inviting and when a Jacobean front was added to the west, the architecture was extended into a great grass bowling green that leads the eye into the distance. The age of reasoning had arrived, but not the foreign influences that were soon to become fashionable. Bingham's Melcombe is therefore an example of pure English landscape art, so well proportioned in fact as well as idea, that the ethos of place resisted any change except in detail, or where additions did not impinge on the historic composition.

It is perhaps the oldest garden example in England of a balance between open and closed, surely the eternal issue in the history of landscape design – an issue deriving from savannah and forest of pre-history.[1]

For here is an essentially English garden independent of foreign influence and fashion, yet composed of two basic elements that seem universal to domestic gardens of the western hemisphere: the enclosed and the open – the walled scented flower garden for the instincts of the lady and the open lawn for those of the gentlemen.

The garden at Bingham's Melcombe in Dorset was laid out for an older building. The crampedness of the Middle Ages has almost gone but the unconscious relation to its surroundings remained in the fine if unsophisticated lines of the gardens. The group is again situated remotely among hills, but the hills are farther away and lower, ringing themselves round the buildings in a partial amphitheatre. A wide valley leads in the opposite direction. The church is among trees out of sight of the garden. Though one of the earliest examples of a collection of gardens of more than one type, the real strength of the scheme lies in the breadth of the garden with its slender contrasting axis and its suitability to a haphazard house. The approach leads down the remains of a fine avenue, through a thirteenth-century ghost-haunted gate house and into a courtyard full of odd angles and shapes, one side open over a low parapet wall, and in their season hydrangeas on the little terrace throwing over all a glow of colour. Under the porch containing the powder closet one goes through the hall into what is known as the ladies' garden, a small-walled enclosure where flowers grow in quiet seclusion before the windows. From here a sunken path skirts the buildings to the west front, where the new garden passing from the gentle slope pauses before the house in the bowling green. To the right a bank supports a colossal yew hedge; in front there would have been a framed view up the valley and to the left, where the ground drops more steeply to a lower terrace containing the kitchen garden, a broad calm meadow continues up to trees and the hills beyond. Lawn and hedges slumber through the years. From this spaciousness a little path leads through the yew trees (so old that trunks and branches inside form a vast impenetrable network, so huge that it has encroached upon and enveloped a terrace that once ran along the bank parallel to the lawn), and thence into a flower and fruit garden shadowed and protected by the mighty hedge on one side, and partially enclosed by walls and hedges or fruit trees on the others. Near one end is that favourite device of the period, a circular dovecote and in those days the cooing of the doves was heard perpetually. Our little path, crossing the flower walk passes through the orchard into a great wooded avenue, from which the garden down the hill seems to have started. Along the avenue today leading from nowhere to nowhere in particular, one reaches, almost in the depth of a wood, a little fish pond, where the stream that feeds it comes fresh out of the trees.[2]

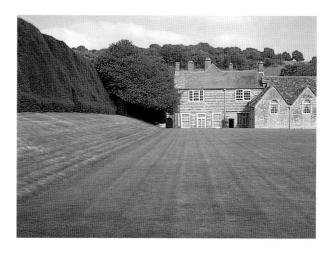

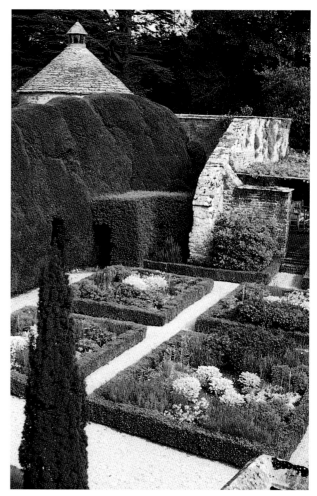

The open stretch of lawn (top) *at Bingham's Melcombe contrasts dramatically with the closed environment of the walled garden with dovecote* (above). *The box parterre is a reconstruction by Brenda Colvin.*

Cheddar Gorge, Somerset

VISITORS' CENTRE WITH RESTAURANT
1934
Viscount Weymouth

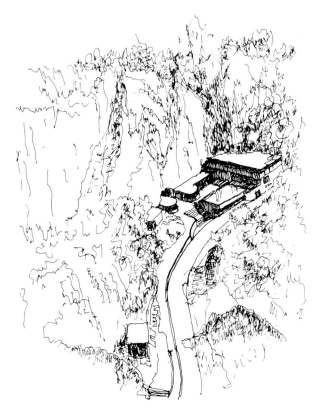

A perspective sketch by Geoffrey Jellicoe of the restaurant complex at Cheddar Gorge; its clean, Modernist outlines are perfectly set off by the rugged limestone crags.

CHEDDAR GORGE, if maintained in its original condition, would today rank as one of England's leading thirties buildings. Yet very few of its original features can now be recognized. Most surfaces had been re-clad or rendered with inferior materials by the nineteen-sixties; the glass roof over the restaurant, and its pool, had disappeared in the name of extra capacity.

Henry-Russell Hitchcock, Jr., the American architectural critic and historian, considered the scheme worthy of inclusion in his Museum of Modern Art (New York) exhibition. Yet it is curious that in Britain the project is nowadays largely overlooked. It completely escaped the notice, for example, of the curators of the substantial exhibition on the thirties at London's Hayward Gallery in 1979–80.

Jellicoe was exceptionally fortunate in his client for Cheddar Gorge. Henry Weymouth, later 5th Marquess of Bath, had inherited the management of the main parts of the Longleat estates, including the famous limestone caves located within one side of Cheddar Gorge. By 1930 the site was coming under intense pressure from tourists arriving by bus and by car. Weymouth first engaged Russell Page as landscape designer at the caves, since he had already been involved in works at Longleat itself. Initially, too, the plans for the site were rudimentary, but these were eventually extended to include a new restaurant, snack bar and museum. Page had originally intended to focus all visual attention on the mouth of the caves and to emphasize the surrounding verticality. To complete the scheme he brought in Geoffrey Jellicoe.

Jellicoe embarked immediately on an ambitious layout in a wholly contemporary style and, as he admitted, owing something to the influence of Erich Mendelsohn, the German architect whose De La Warr Pavilion had recently been completed at Bexhill (with Serge Chermayeff). Watching keenly, too, were Jellicoe's own students at the Architectural Association, who had just been set such a project by him at the same time. Jellicoe inserted two single-storey buildings at the cave's entrance with semi-circular glazed fronts. On the way in, the public would pass the administration block; on the way out, they were routed past an identical curved block housing the museum. The visitor then arrived at the restaurant and snack bar. The latter was designed with a long counter to facilitate speed of service.

At right angles to the snack bar the restaurant offered clear views up the gorge through plate glass folding windows. Russell Page and

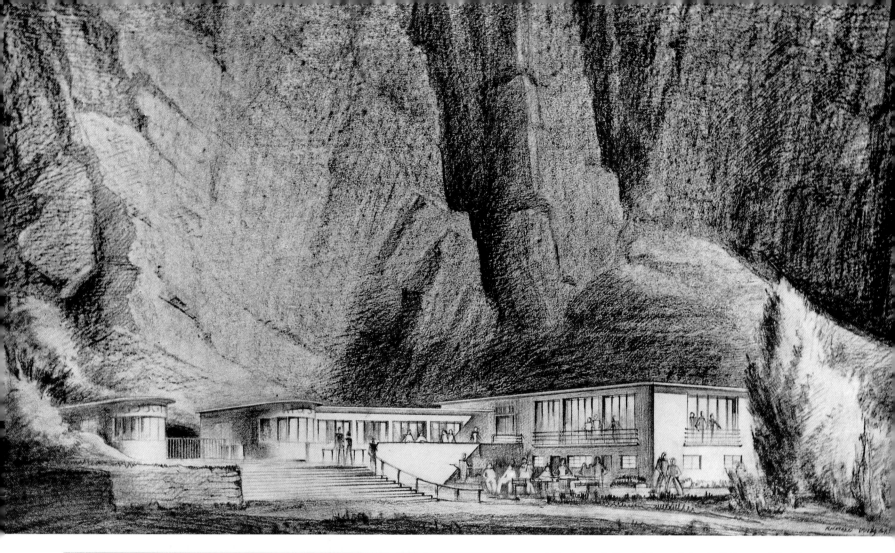

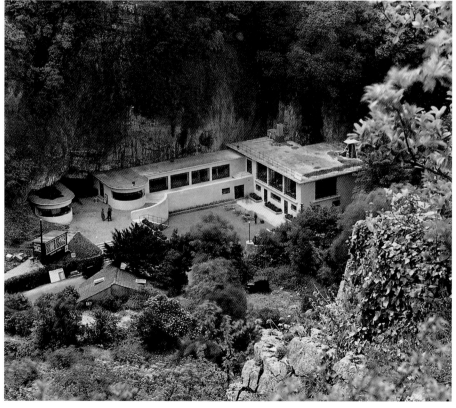

The lateral disposition of the building at Cheddar
Gorge (above and left) contrasts with the towering
verticality of the rock faces. These views show the first
phase of the building, without the supplementary dining
room and pool.

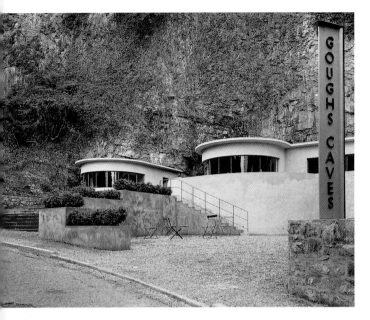

Geoffrey Jellicoe were both determined that no detail be left to chance. The project was thought through in every detail down to the furniture, waitress's uniforms and even cutlery and ashtrays. Gordon Russell Ltd., Jellicoe's old client, supplied high-quality furniture. Actual construction took barely fourteen weeks; so successful was the first season that a second dining room to seat 400 was added, set into the sunken space previously designated as a terrace. This additional building boasted a roof made of glazed pavement lights with a pool overhead, so that diners could literally eye the goldfish.

Such was to be the story of Cheddar Gorge, where the enterprise's very success led to further changes and adaptations in the face of growing visitor numbers, so that by the end of the nineteen-sixties it was barely recognizable as a pioneer construction of the modern period.

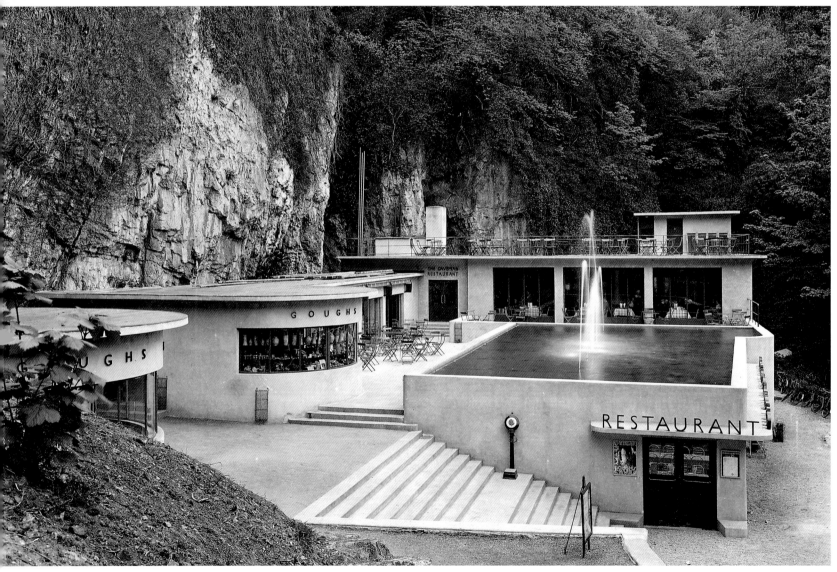

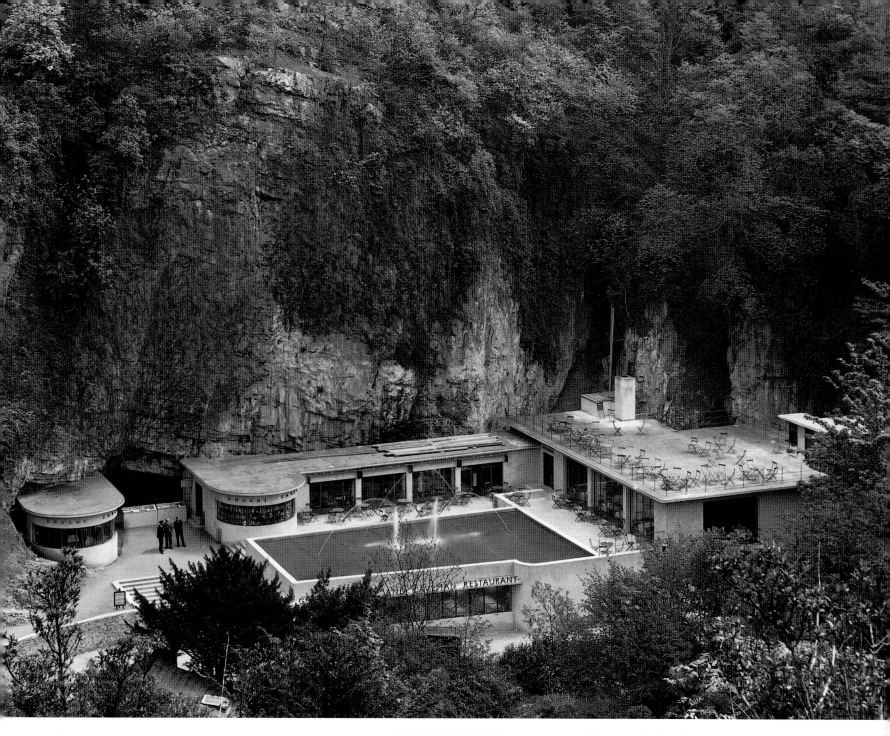

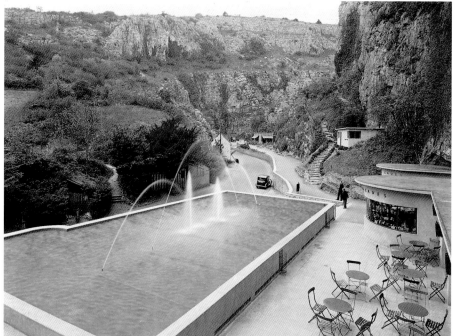

The final form of the building at Cheddar Gorge
(opposite, above *and* below) *shows a strong
commitment to the values and precepts of International
Modernism on the part of the architect. The ingenious
siting and dramatic visual relationship of the structure
to the surrounding rock faces almost make it an early
example of Jellicoe's 'hard' landscaping.*

The Early Works 1927–1960 · 47

Ditchley Park, Oxfordshire

GARDEN DESIGN
1935–39
Ronald and Nancy Tree

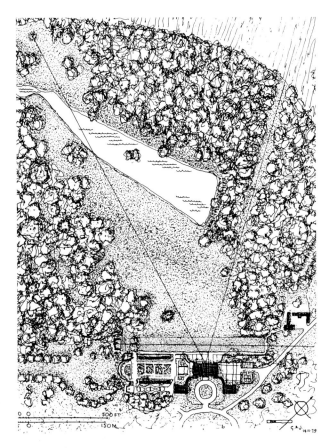

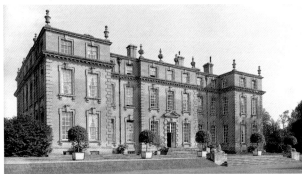

A retrospective drawing (1979) by Geoffrey Jellicoe shows the plan of the garden in relation to the house at Ditchley and marks the vistas which were a prime concern of its design. In the lower right-hand corner is an outline of the Jellicoes' own garden at Grove Terrace to indicate scale. Designed by James Gibbs (1722), the house was embellished by a long terrace and steps designed by Jellicoe.

SHORTLY after the Cheddar Gorge commission had commenced, and again through the good offices of *Country Life* (through Edward Hudson, the founder and editor), Jellicoe was recommended to Ronald and Nancy Tree, who had acquired Ditchley Park in north Oxfordshire in 1933 and had asked Hudson, their neighbour in Queen Anne's Gate, who could best design an Italian garden for Ditchley.

Ditchley is recognized as the domestic masterpiece of James Gibbs, the architect of St. Martin-in-the-Fields. Its condition, however, at the time of its acquisition by Ronald and Nancy Tree, was poor. As Ronald Tree recalled: 'There was virtually no garden when we first went to Ditchley only a few flower beds set higgledy-piggledy on a grass lawn unkept and uncared for . . . opposite to us in our London house in Queen Anne's Gate lived Mr Edward Hudson, the founder and editor of Country Life and a well known authority on garden layout. To him I went for advice as to whom he thought was the best young man to plan an Italian garden and a terrace. He strongly recommended Geoffrey Jellicoe, who had just published a distinguished book on the villas of the Brenta. We asked him to come and look at Ditchley, and so began a long and fruitful relationship that continues to this day.'[3]

G.A.J. The present house dates from 1722, replacing a Tudor Manor House on an adjoining site. With the welcoming arms of the two wings, it looks particularly well-sited as seen at any distance from the south-eastern approaches near or distant. But it stands on a point where the land skews and the relation of house to ground on the north-west is not happy. Presumably to counter-act this, Gibbs proposed an unusually long terrace, echoing Alberti's dictum that all buildings must stand upon a firm base (i.e. the garden). Between the completion of the house and the making of the garden, fashions in landscape changed. Alberti was *out* and the Burlington circle *in*. A Palladian mansion must now stand on its own as an element of pure man-made geometry in a setting that was not an extension of itself but the product of nature. The projected terrace and south-west garden as shown in the prints dated 1726 were abandoned. Some fifty years later the park took its present shape according to English Landscape rules, but the fundamental drawback of the land shape remained, aggravated by the ground surface between mansion and lake being convex rather than concave. The lake gave trouble and at some time later was cut in half, thereby emphasizing the lack of harmony between it and the house. In the nineteenth century the area between the house and lake was clouded with cedars of Lebanon.

Looking back after nearly half a century I cannot help admiring the gamble of my appointment. In architecture and landscape design the responsibility towards others for success or failure is

inconceivably heavy: while the designer pulls out after completion, his design is with the owners for ever. I had certainly studied the Italian garden in detail, but except for abortive designs for a new landscape at Claremont some years previously, my experience in the actual design and execution of the classics was nil. My aesthetic inclinations indeed, were wholly for the modern movement in art, fostered by teaching for five years at the Architectural Association's Schools of Architecture; but the architect's mind needs to be more adaptable than the artist's and I had no qualms about accepting this neo-historical commission. Nor, as it proved, was I overawed by the immense scale of Ditchley, and would set out confidently from a house (in which my wife and I still live) that could fit several times over into the entrance hall of Ditchley – which is proof, if proof is needed, that sheer size has little or nothing to do with the satisfaction of living.

Casting aside therefore, all thoughts of twentieth century art, or Picasso and Le Corbusier and Frank Lloyd Wright, I threw myself enthusiastically into a unique study of landscape history made real.

Ronald Tree's instructions were that I was to interpret but not copy the lines of the 1726 plan, provided these lines, in my judgement, were good. I found them brilliantly planned for the terrain and I must here confirm that the basic landscape at Ditchley emanates from Gibbs. But two new factors had changed the requirements: the enlargement of the park with its lake and temple, in idea if not size; and the exceptional love of entertainment of the Trees combined with the new mobility that enabled people to come

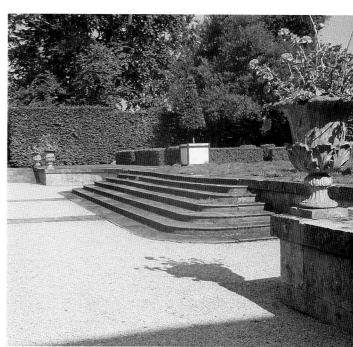

The Italian influence on Jellicoe's work can be seen in the architectural details he introduced to the garden at Ditchley: the steps from the terrace (above); this stone seat and sculpture group (left), finally put in position by Jellicoe in 1937.

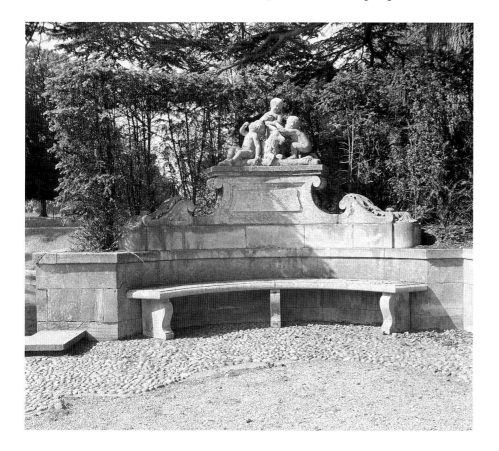

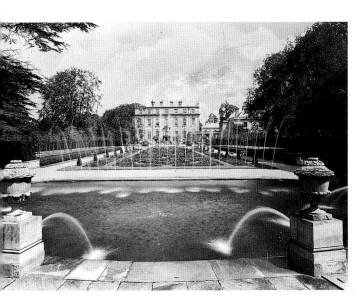

The main axis of the formal garden looking towards the house at Ditchley: the jets of water visible in the middle ground were in fact part of a water curtain which ran along the edge of the swimming pool to conceal bathers from the house.

from London for the day. Indeed, the spaces now required followed closely Paul Phipps's advice to double the normal provision. The modern plan shows how the enclosed garden has expanded and thrown the terrace further from the house, and how an extra garden has been added as an extension to the south wing.

In his autobiography Ronald Tree considered that I was influenced in the composition by the Villa Gamberaia near Florence; this may have been so subconsciously, for I considered Gamberaia, and still do, the greatest composition of its kind. But the only clear Italian precedents I can detect are the Villa Piccolomini at Frascati for the main enclosed sunk garden, and the lovely little parallel garden (specially designed for Nancy Tree and no longer existing) which may have been inspired by the *bosci* of the Villa Bernardini near Lucca. . . .

While the sunk garden was still in sketch form the question of furnishings arose. By good fortune for Ditchley, the classical garden at Wrest Park came under the hammer and a great deal of sculpture, together with a complete stone-edged parterre, was acquired and re-positioned. The four parts of the parterre at Wrest had formed a square, but at Ditchley they were placed in line to fit the space. The parterre was subsequently returned to Wrest, but the sculptures in their designed settings have remained. To suit my composition of open and enclosed, the end semi-circular pool with its lion heads spouting water was surrounded by a yew hedge sufficiently high to cut off the comparatively modern avenue beyond. You could bathe in the pool and if you were so disposed, you could throw up a twenty-foot curtain of water from secret jets to conceal you from the house.

From the sunk garden you passed to the terrace. Ronald Tree is really praising Gibbs when he writes: 'But it was the terrace that was Jellicoe's great achievement. Nearly three hundred yards in length, it ran north and south on the west side of the lake, overlooking the lake. At the south end, elevated to dominate the long terrace, was a temple we had found hidden away, overgrown, in what was known as the pleasure ground – an area of 100 acres enclosing the lake and surrounding by a ha-ha. The terrace was separated from the garden by a beech hedge which grew to a height of twelve feet. It was planted in such a way that at intervals along it were, so to speak, scallops, in each of which was one of a number of statues bought from Wrest Park. On either side of the door leading out from the stuccoed hall were a pair of large stone lions I had found in Venice.' Sunk garden and terrace are today beautifully maintained by the present owners, the Anglo-American Ditchley Foundation, and the temple to which Ronald Tree refers has been revitalized and dedicated to his memory.

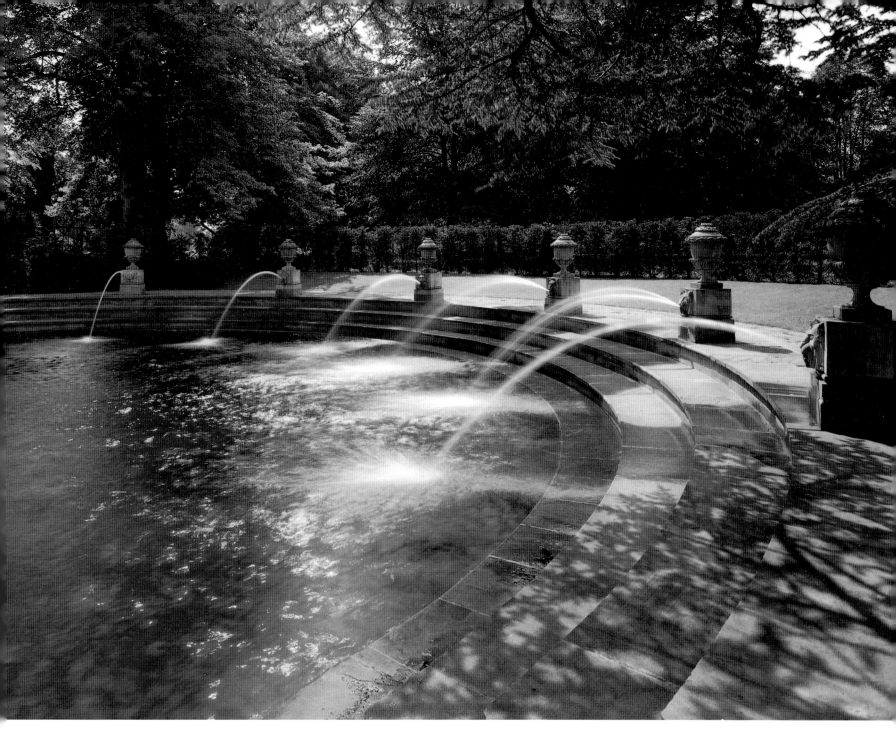

The gardens at Ditchley are an artificial projection of the eighteenth century into the present age. They recognize and respond to the overwhelming ethos of the mansion and are not, therefore, an anachronism. They are no more than the replacement of a limb (to paraphrase Alberti) which never materialized, modified by two and a half centuries of growth. If they lack the psyche for which the mind of modern man is searching, they can certainly remind him of some of the qualities of history he may be passing by.[4]

The semi-circular pool is the culminating feature of the enclosed garden at Ditchley. The ornamental fountains have now been removed.

Royal Lodge, Windsor Great Park

TERRACE AND GARDEN DESIGN
1936–39
T.R.H. The Duke and Duchess of York

IN 1936, Jellicoe was commissioned by T.R.H. The Duke and Duchess of York to design new gardens immediately adjoining the house. This design was completed in close consultation with H.R.H. The Duke (later H.M. King George VI).

G.A.J. In the early nineteenth century the two strands of classicism and romanticism ran parallel in their search to renew a golden past; while John Nash was conceiving Regent Street and the Roman palaces fronting Regent's Park, he was also designing the Royal Lodge in Windsor Great Park for the Prince Regent. The attraction was the dilapidated castle, later transformed by Sir Jeffrey Wyattville to outcastle all other pseudo-castles in its grandeur of composition. Since it was built Royal Lodge has undergone many alterations and additions. Set in a beautiful little park within a greater park it has still retained its peculiar classical-romantic charm, now pink and white like an iced cake. In 1936 new gardens immediately adjoining the house were commissioned, and these were designed within the ethos of history.[5]

At the Royal Lodge, Windsor, Jellicoe again concerned himself with the area between the house and the park. His aim was to establish an interesting viewing platform to open up vistas from the house through the planting (above and right). This terraced platform (seen in relation to the house in the inset sketch view and in the detailed photograph opposite) was embellished with a specially designed treillage *suitably crowned by heraldic beasts. The stepped paving, parapet and seats were designed to continue the architectural idiom of the Wyattville house.*

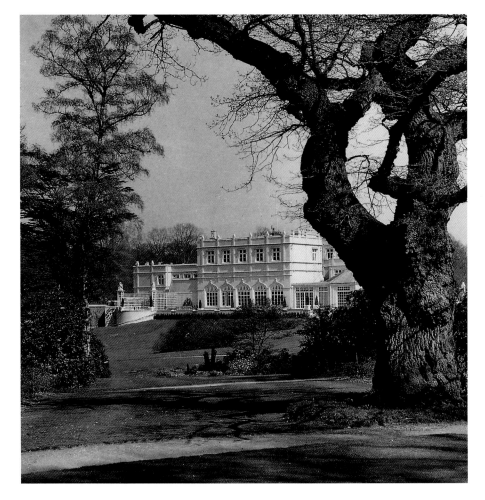

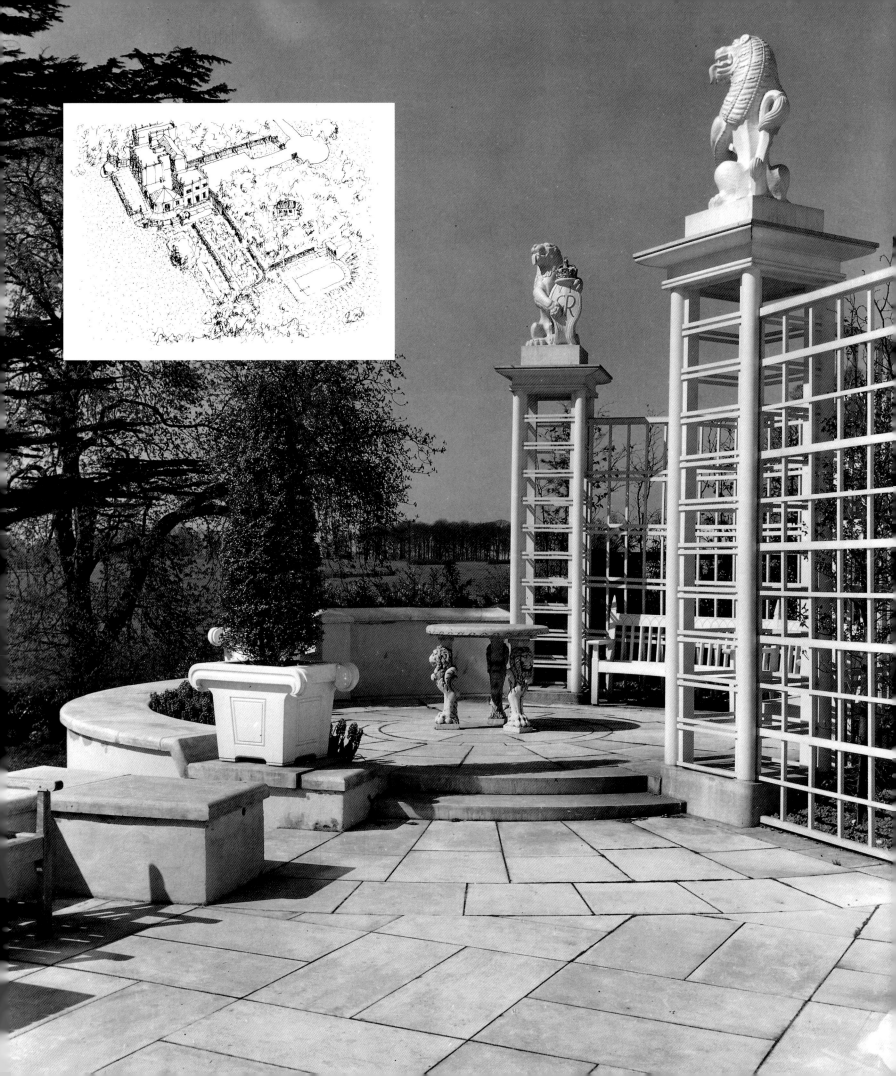

Mottisfont Abbey, Hampshire

GARDEN DESIGN AND REVISION ON APPRAISAL
1936–39

Sir Gilbert and Lady Russell

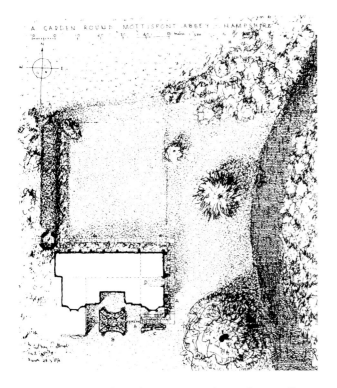

A retrospective plan (above) (1982) drawn by Geoffrey Jellicoe to show the revisions carried out to the garden at Mottisfont Abbey in 1936–39; a view towards the north façade of the house (below) shows the main lawn and the avenue of pleached limes.

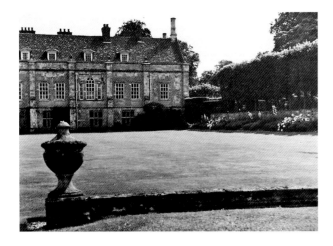

IN THE SAME YEAR as the Royal Lodge gardens, Geoffrey Jellicoe was commissioned to improve the gardens for Sir Gilbert and Lady Russell at Mottisfont Abbey, now owned by the National Trust.

G.A.J. The Priory of Holy Trinity at Mottisfont was founded in 1201 beside the river Test in a well watered valley, sheltered from what was a bleak countryside.

It reached its climax in the middle of the fourteenth century, when two gardens were recorded. Then came the Black Death and gradual decline until its dissolution in 1536. In exchange for the villages of Chelsea and Paddington, it was granted as a private mansion to Lord Sandys of the Vine, a statesman of Henry VIII who was present at the Field of the Cloth of Gold. The approach of Sandys to his new home can be contrasted with that of his contemporary, Sir Richard Weston at Sutton Place. Weston was an extrovert, Sandys an introvert who adapted the Priory buildings to his needs by truncating the tower, creating a 'piano nobile' within the nave (with cellars below) and demolishing the various monastic precincts.

Alterations and additions to the south front were made in the 18th century, but when the property was acquired by Mr and Mrs Gilbert Russell in 1934, the north and east façades – despite the windows – remained predominantly medieval. The whole was set beautifully in an English romantic style, whose trees include the largest plane in England.

In terms of art history, with lawns sweeping up to the cellared basement, the picturesque scene was complete. In terms of present day living, however, it lacked a flower garden close to the principal rooms. In addition, the early nineteenth-century stables were too close to the north façade. The design that evolved was linear, muted to leave the existing ethos of place undisturbed and clearly influenced by Bingham's Melcombe. The only access to the paved walk, from the south front, began with a sunny box parterre on the site of the cloister. This path then hugged the building until it entered the terrace of pleached limes. Continuously beside the walk were shade-loving herbaceous plants.[6]

As WORK PROCEEDED at Royal Lodge, Geoffrey Jellicoe was introduced to the Bowes-Lyon family of St. Paul's Walden Bury, Hertfordshire. Here was a remarkable garden in its existing form. His work here demonstrates the clear duality – Neoclassicism and Modernism – in his design philosophy which marked his work and teaching in the first decade of practice.

G.A.J. By the early seventeenth century Italian influence was being expressed in England in the formal geometry of architecture and the philosophy that the garden was a podium of, or extension to, the house. As the century proceeded Italian influence gave way to that of France, where Le Nôtre had changed the concept of space design from one in which the garden has been subsidiary to the house to one where it was to predominate. The Court of 'Le Roi Soleil' Louis XIV dictated European fashion in all things. Probably the most complete existing English domestic lay-out in the manner of Le Nôtre is St. Paul's Walden Bury in Hertfordshire . . . What is lost in monumentality and a naive design technique is compensated by a domestic charm that seems inherent in all English town and country planning. It can be detected from the plan that the original north front on which the lay-out centres is unusually small in scale. With its end pavilions it seems in fact to be almost a very large 'garden pavilion' in itself. When the gardens began to be restored before the last war an objective was not only to renovate what already existed, but to add others – pavilion, temples, sculptures – to terminate the vistas and to some extent recreate the flavour of the original relationship of house to richly humanised park. The structure of a Le Nôtre landscape, deriving from French hunting parks, is pure geometry, diverging only from the exact, when, like a spider's web, it must hitch on to an environment. The present endeavour is to reconstruct the web that had been mauled in the nineteenth century. The Victorians had rebuilt the main bulk of the house and in so doing had cut away the great avenue approach from the east to open up an angle view of the new lake, purposely ignoring any centering on the new façade. The 1978 planting is intended (a) to retain the angle view, but only as a subsidiary interest and (b) to focus the avenue on the octagonal corner pavilion by an imperceptible turn in the centre line of the avenue, concealed by illusion and (c) to prolong one of the existing avenues to cross the main avenue. The web is thus almost mended.[7]

The duality was to be reflected in my opposing soundings in design. One half of my time was spent as a master in the first year studies of

St. Paul's Walden Bury, Hertfordshire

APPRAISAL, REVISIONS TO LAYOUTS,
RESTORATION
1936–92
Bowes-Lyon Family

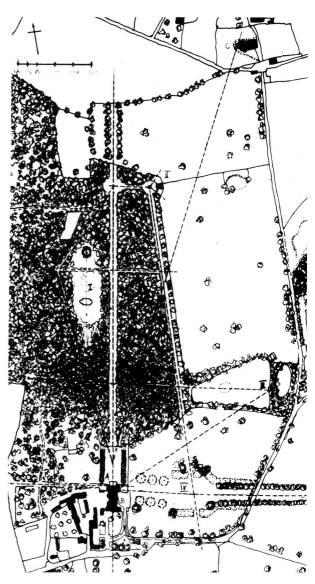

The influence of the great French parks is notable in Jellicoe's continuous work on the garden at St. Paul's Walden Bury; his main contribution to the planning of the present garden has been the opening up of vistas and foci through the heavy planting. This plan shows the development of the garden c. 1982.

the Architectural Association, and the other half in building up a solo practice through any chance commission that might float by and be caught. The one introduced me through questioning students to the concept of modern architecture, and the other to the creation of a highly accomplished neo-classical practice in garden design arising from *Italian Gardens of the Renaissance*. During the decade I practised both philosophies equally, keeping them apart.... At the time I was unconcerned about the oddity of my dual practice, but was undoubtedly feeling the way towards creating a status for landscape design.

The publication of *Circle* of 1937 is the most complete credo of the modern movement of the thirties. Although not specifically mentioned, the acknowledgement of Greek spiritual values rather than of the universally accepted Roman values is manifest. Environmentally the purity of the movement was damaged by the war and by subsequent dilution and exploitation. As an idea it is indestructible, progressing through the arts other than architecture and giving rise to the birth of a new art, that of collective landscape design.[8]

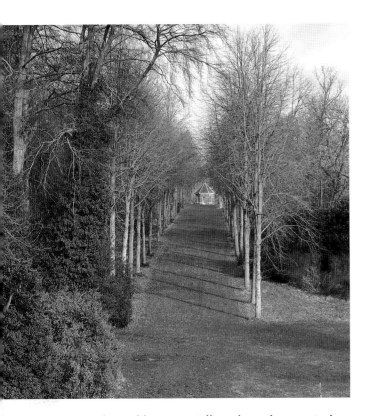

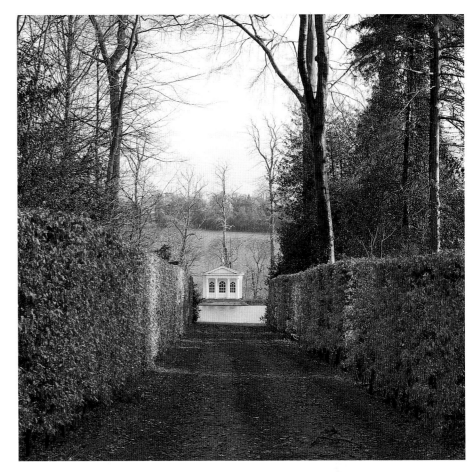

At St. Paul's Walden Bury, Jellicoe has taken particular care that the vistas and views in the garden should offer the onlooker a definite focus in the form of an interesting architectural feature. During the period of his early work at St Paul's, he was much concerned with the idea of revealing the pure form of the garden, of achieving its strongest expression in relation to the landscape. Here then (above, right and opposite) are three examples of his sense of large-scale structure; the east vista towards the music house (reconstructed by Jellicoe); the west-east vista across the lake to the temple; the view across the west lake towards the gazebo, named by Jellicoe 'the Running Footman Garden'.

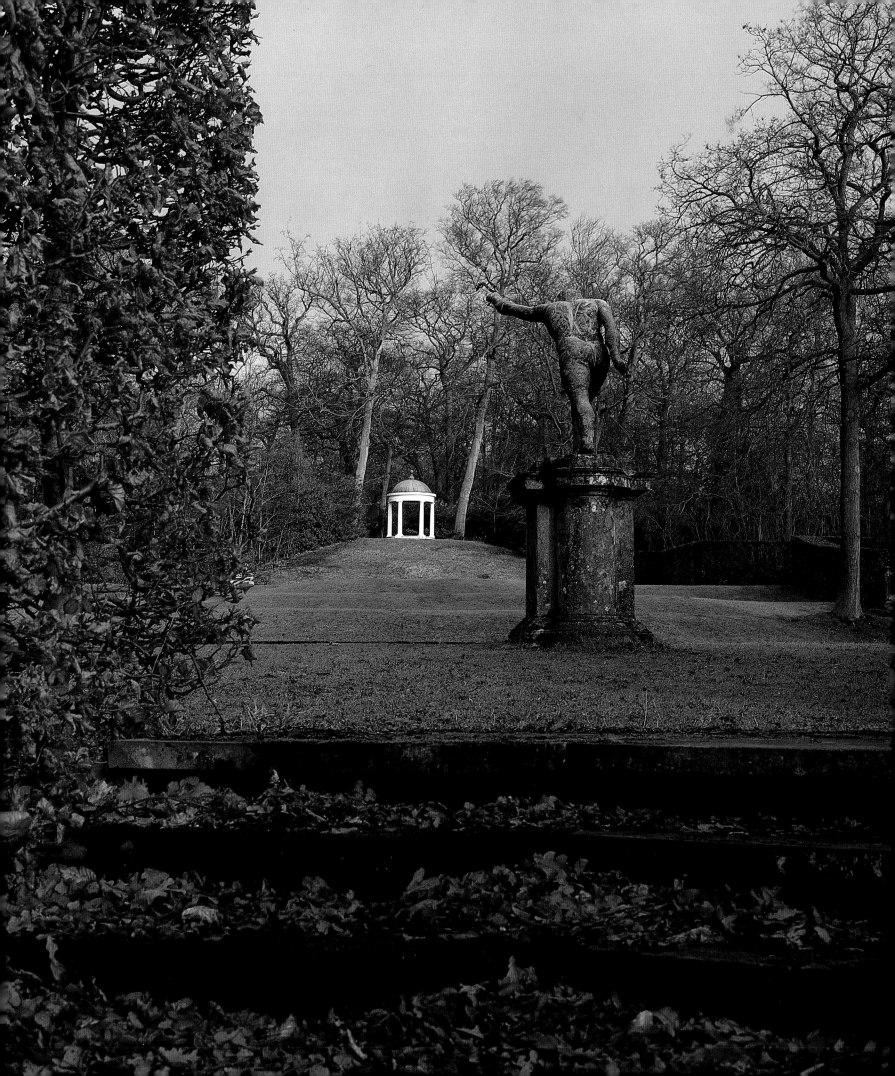

No. 19 Grove Terrace, Highgate, London

GARDEN DESIGN
1936–84
The Jellicoes' Own Garden

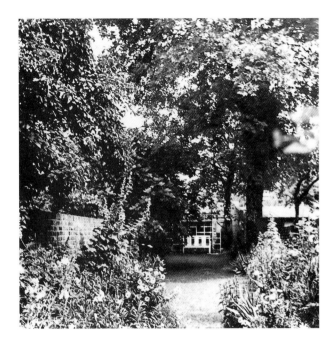

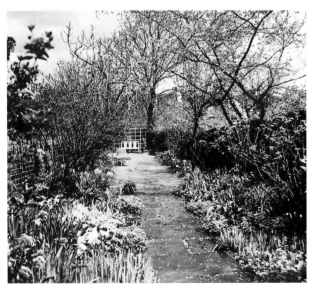

The Jellicoes' own garden photographed (top) *in 1938 and* (above) *in 1976, was a constantly changing extension to their professional interests. The structure and planting show a marked development over the decades* (right).

THE JELLICOES married in 1936 and moved into No. 19 Grove Terrace in the same year. They remained there until 1984, thus recording almost half a century of garden development.

G.A.J. While architecture remains static, every garden that is not an extension of architecture is in constant change. The obvious changes are seasonal but within the repetitive process there could quietly be taking place a further progressive change that is fundamental. Plants and humans are never static. They can grow up and mature in ways that are equally unpredictable. This town garden in Highgate is a record, experienced over more than forty years, of the way in which the mood of a garden can appear to have changed of its own accord, imposing its changes of idea imperceptibly upon its owners. In art historian terms the change is from the classical to the romantic; the space involved is no more than a rectangle five by fifty paces.

The first two plans show the site in 1936 before and after alterations. The existing impedimenta were removed and a long axial lawn passed under and between a mature ash and an old fig tree, to terminate architecturally on a white seat against a formal trellis. The view of 1938 shows the firmness of the enclosing walls and their underlying geometry, but suggests also an element of mystery in the far distance – a sense of mystery that was eventually to advance up

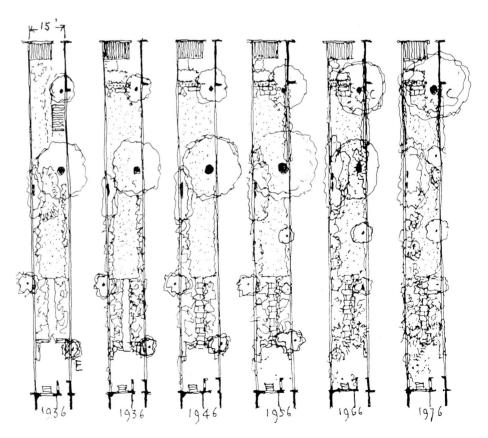

to the house itself. The exceptional length of the garden allowed forest trees to conceal the opposite houses; behind the ash is seen a young self-sown sycamore that would in time take place of the older tree in the composition.

(By 1976) the view shows the changed structure of the garden. The ash has gone and its place in the composition been taken by the sycamore. The fig tree will soon reach across the opposite wall. Shrubs have taken the place of herbaceous plants and the walls are planted out and will disappear in high summer.

The transformation from an open to an enclosed garden is complete. The garden end has become a *giardino segreto*. The illusion that carries humanism into the heart of nature lasts only a few months. Before the leaves fall and there is disillusionment, it is possible to lie on the ground and looking upwards to the sky through fig or sycamore leaves (or both) to imagine a return to forest origins and the processes of nature.[9]

The heavy planting of the garden at No. 19 Grove Terrace, seen here (above left and right) in 1965, leads the eye down the central vista of the garden to the ornamental seat and trellis. The structure of the garden has remained unchanged, although the planting has inevitably undergone some modification.

Blue Circle Hope Cement Works, Peak District National Park, Derbyshire

LANDSCAPE DESIGN AND CONSERVATION PLAN
1943–93

Earle Cement Works (now Blue Circle Industries PLC)

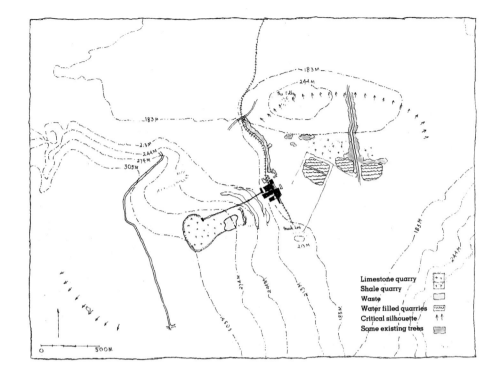

NINETEEN FORTY-THREE marked the transition in Jellicoe's work from domestic to public landscape design on a major scale. He was now able to achieve the clear resolution of the duality to which he had referred, in his work, between the historic garden and the Modernist ethos. As the nineteen-forties developed, public projects requiring Jellicoe's attention began to proliferate; it was in the Hope Cement Works that he resolved his dilemma and equipped himself with a vocabulary to deal with landscape problems on the largest scale.

The fifty-year plan, first of its kind in England, was commissioned in 1943. This was Jellicoe's first engagement by industry, whereby he was able to anticipate the ecological and environmental concerns of the nineteen-eighties and nineteen-nineties. Earle Cement Works (as they were then called) had been established in 1929 in the centre of what is now the Peak District National Park in Derbyshire. The site is equidistant from three villages of significance, and also opposite the famous Win Hill. Here for the first time (the plan for Broadway was very much smaller in scope), Jellicoe had been entrusted with designing landscape and conserving it against industrial chaos on a large scale. The 1943 plan was practical, adaptive, and above all visionary, reaching to the end of the century and beyond, and it respected the essential character of a National Park. Jellicoe was much influenced in this work by the painting of the contemporary American artist Jackson Pollock.

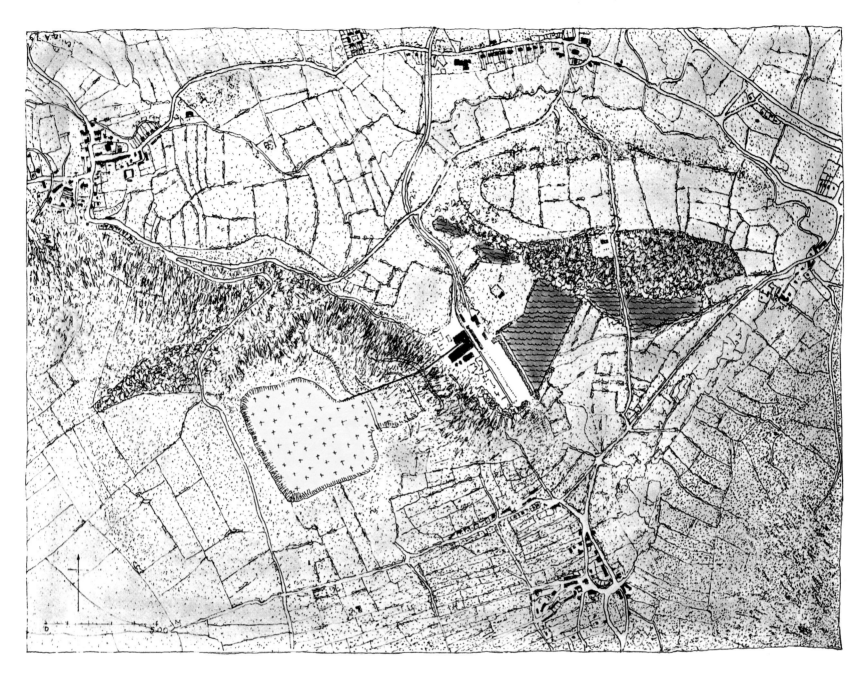

G.A.J. The translation of this vision into the realities of landscape itself is not easy. To study landscape as an expression of Jackson Pollock it is necessary to find a subject devoid of humanity, symbolism and all the countless associations of ideas that confuse the issue of pure art. It must clearly be very large in scale and should extend as an experience in time at least equal to the average span of a human life.

The works are splendid as complex geometry drawing upon the laws of the universe, but their design is inhuman and scientific rather than architectural. The breath-taking limestone quarry, governed by the unpredictable qualities of the stone and the legal restrictions of height that control the terrace, is an awe-inspiring void certainly not designed for aesthetics.[10]

A preliminary sketch (opposite above) *shows the terrain at Hope as Jellicoe found it in 1943. His first plan* (above) *shows an allowance for extensive planting around the works (in the centre of the plan), but the landscaping is sufficiently open for both the works and the quarrying area to grow. When the fifty-year plan was reviewed in 1979, it was found that the policy of constant planting and restoration of the landscape from spoil had contained the overall development of the site within the guidelines laid down 36 years before.*

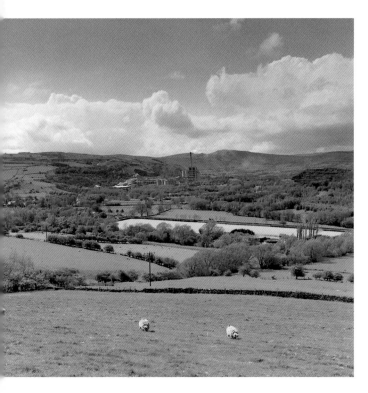

The Hope Cement Works as it is now (above and opposite) is a startling industrial artefact in Jellicoe's landscaping.

The landscape consists of bare hills and between them a fertile valley. The beauty of the scene lies in the contrast of the two, the timelessness of the one and the vitality and changefulness of the other. It is essential to retain in mind these two associations of ideas.

The works lie at the foot of the hills, the quarries above, and the exposed clay pits in the valley. The waste from the quarries has been used to form a platform on the hillside. The stone is carried down the slopes through a visible surface tunnel, but the clay is pumped underground through invisible pipes. The buildings themselves are well and compactly grouped, and, on the side towards the valley, lie beside green playing fields.

The conflict of ideas may be summarised as follows:
a. the quarries and the platform disturb the contours, denote change, and destroy the sense of loneliness
b. the clay excavations have created a derelict area in the midst of fertility
c. the buildings themselves denote a manufacturing rather than an agricultural industry.[11]

In 1979 the scene was very different from that envisaged. The works had more than trebled in size and output, criss-crossed with conveyors and marked by a chimney eighty feet higher than the cross of St Paul's. The quarries had increased proportionately and were edging towards the ultimate skylines, swallowing more surface lands. The water geometry had not materialized, for the valley shale had proved unusable as a material. Nevertheless, the original designer, called back after thirty-seven years, wrote in this report to the company: 'Despite these losses, the present scene is essentially in the tradition of containment within the hills and is remarkably impressive. Like some gigantic natural organism, it has metamorphosed itself into a landscape that is providing in grandeur what it may have lost in charm. It is a curiously unified three-fold composition of limestone quarry, buildings and shale quarries, whose magnitude (approximately one and a half miles by half a mile, with a vertical rise of five hundred feet) is of vastly greater scale than the humanized landscape in which it is set. That the overall scene is visually harmonious is clearly due to the extensive tree planting that screens or emphasises where advisable, intersperses tree scale with mechanical scale, and perhaps above all gives confidence in ecological regeneration in a landscape that is otherwise designed to be consumed, packaged and distributed to all parts of the Midlands. But the significance of the three-quarters of a square mile in a National Park is more than this, for within its frame is basically a gigantic piece of serendipic sculpture always in movement. The role of the

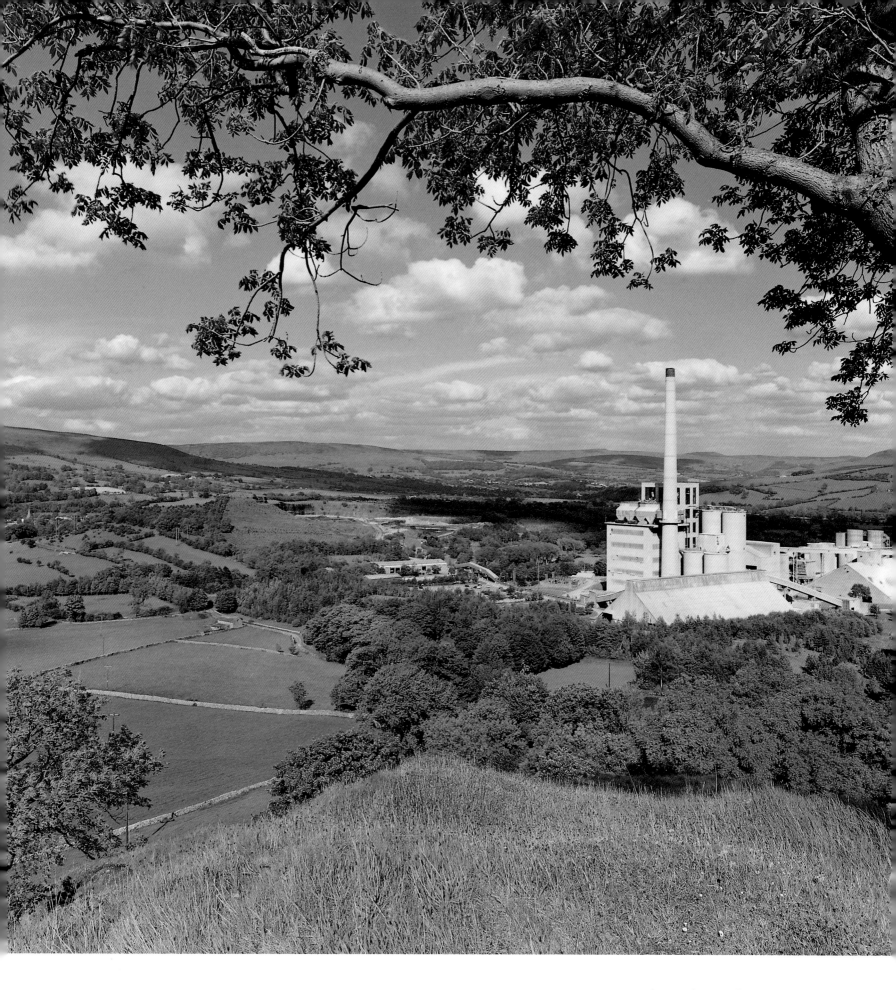

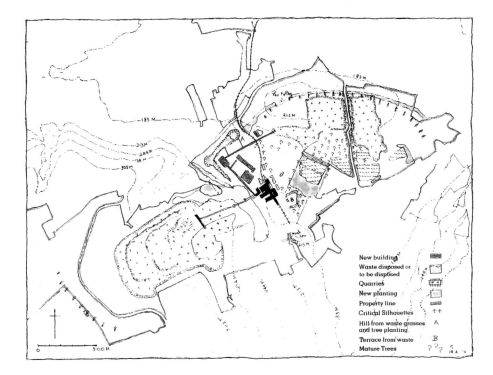

Jellicoe's sketch plan of the Hope site at the time of his review of progress in 1979, showing how far it had already developed from the original concept of 1943.

New building
Waste disposed or to be disposed
Quarries
New planting
Property line
Critical Silhouettes
Hill from waste grasses and tree planting
Terrace from waste
Mature Trees

landscape designer is primarily to recognize that such a sense of sculpture exists and thereafter, through judicious prompting, to act only as a guide, philosopher and friend.'[12]

The assumptions of future production and growth made in 1943 were too modest as regards both demand and methods of manufacture. The increased demand was reflected in a call on the quarries far beyond the original calculations. The effect on the buildings themselves of a change in technique from a wet to a dry process was more dramatic. . . .

The four main points of the original plan, however, remained as guide-lines. . . .

G.A.J. now quotes Sheila Haywood, his assistant.
'The planting of trees and shrubs at Hope has been a continuous programme since the inception of the original landscape plan. Linked with planting has gone careful ground shaping, and the constructive use of wastes, to provide screening where necessary, and to link with existing ground. Nowhere has this been more important than in the bankings leading up to the great limestone quarry. Early planting concentrated upon the works area, and today the approach to the work itself, the railway line, and the south-western margins of the playing fields are linked by belts of mature trees: Norway maple, poplar, ash and mountain ash, wild cherry and many others. These, underplanted by such shrubs as dogwood, snowberry, guelder rose and the wild privet for ground level screening, provided country character right up to the reception area itself. Here, by contrast an

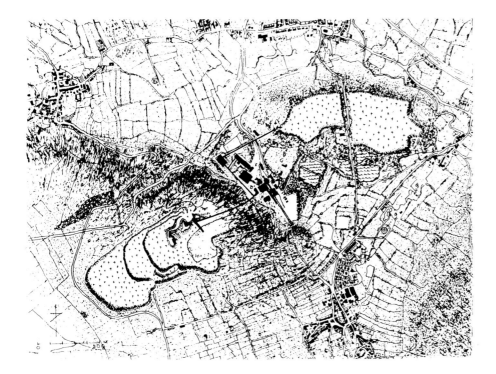

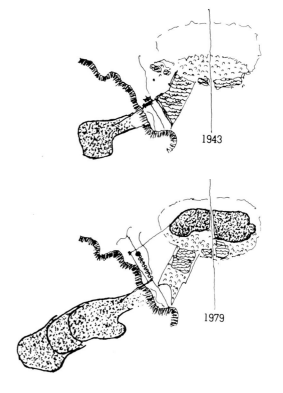

Jellicoe's projection in 1979 (left) for the future development of the Hope site. The contrast between the extent of quarrying in 1943 and in 1979 is shown in these two sketch plans (below) which also graphically convey Jellicoe's own excitement about the fundamental dynamism of the site.

1943

1979

older and more formal layout has been retained as a link with the earliest days of the works. A considerable achievement has been the retention, unharmed, of large established trees throughout major extensions to the works, in close proximity to the new buildings. The lakes today are fringed with birch and willow, their northern shores closely wooded, with natural regeneration taking over from man's handiwork, with a more open planting on the south-west. Meanwhile, as the designer envisaged, considerable bird life has come to the valley, and in particular to the lakes.'

To the overriding unpredictability of market forces and technical invention has been added that of the raw material. Thus its unsuitability as a shale quarry prevented the completion of the formal pleasure lake; vast extra shale quarries were opened on the adjoining hillside; and the limestone quarries far exceeded in size and fluidity of form any original calculation.

Nevertheless, despite the changes in both quarries and buildings the two essential points in the original plan had been retained; that the works should be contained within the silhouette of the hills and the escarpment preserved, and that there should be continuous tree planting.

An internal explosion from the original plan had been inevitable, and from it had emerged a conception of space that could be recognised as being far grander than the original. The only adjustment proposed for this dramatic self-creating landscape was the re-shaping of the southern platform now being made out of waste.

This would complete the geometry at the centre and relate it to the countryside.[13]

Church Hill Memorial Gardens, Walsall, Warwickshire

GARDEN DESIGN
1949–52
Local Authority

THE MEMORIAL GARDENS to Walsall's dead of the two World Wars offered Jellicoe a unique opportunity to design a fully funded public garden. Particular attention was paid to the planting to ensure that there was, within the walled and sheltered garden, a considerable variety of growth in an essentially contemplative environment.

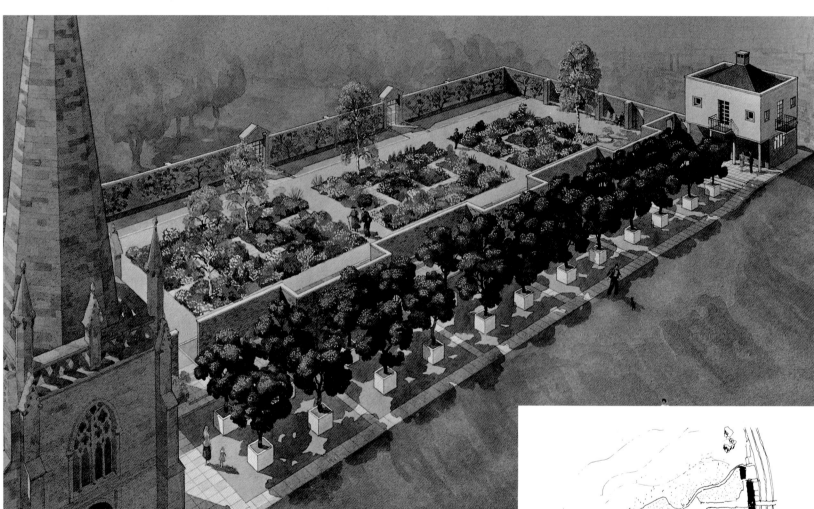

The plan (right) and (above) of the Memorial Gardens show again the influence of the Italian-style secret garden on Jellicoe. Such features as the 'open' gateways and profuse planting, however, almost declare him an early Post-modernist (opposite).

KEY
A St. Matthew's Church
B Memorial Gardens
 Digbeth Street pedestrian link to High Street
C Market
D Piazza
E Restaurant on pillars
F High Street

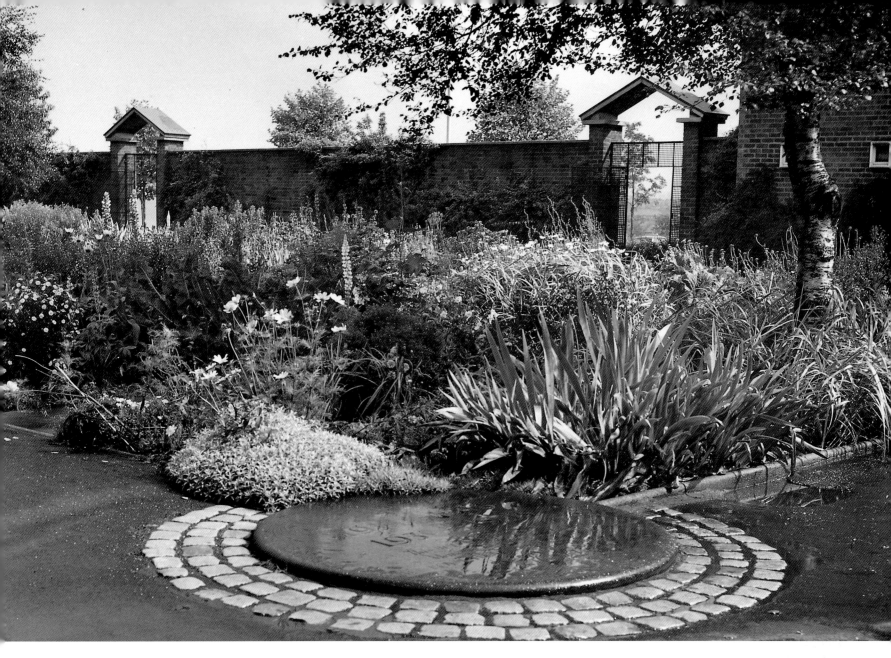

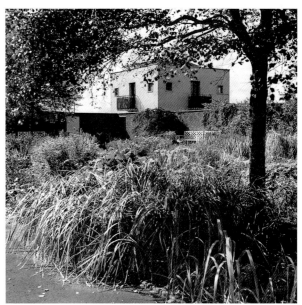

Sandringham House, Norfolk

GARDEN DESIGN
1947
H.M. King George VI

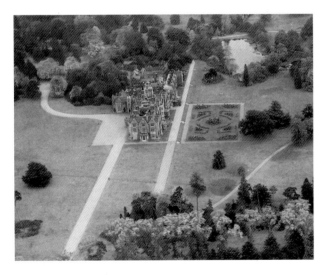

Prior to Jellicoe's introduction of an enclosed garden at Sandringham, the house enjoyed little immediate privacy. Jellicoe introduced a series of enclosed gardens, marked out by yew planting, to close up the area between the house and the woods.

THE COMMISSION for Geoffrey Jellicoe to undertake improvements to the gardens immediately surrounding Sandringham House came during the bleak early post-war period. The Royal family's private estate in Norfolk had always occupied a special place in their affections, and King George VI knew Jellicoe as a former client; as Duke and Duchess of York, he and Queen Elizabeth remembered the skills with which Jellicoe had translated their personal wishes for an improved setting for their first married home (Royal Lodge, Windsor Great Park) into reality. The relationship was one of mutual esteem over more than a decade. Now, in very different circumstances, the King wished Jellicoe to improve the urgently needed privacy in the gardens close to the house at Sandringham.

G.A.J. The house was built in 1905 as a country residence for Edward VII. It was reasonably far from London, relatively isolated and the shooting was good. In contrast to a Nash terrace in Regent's Park which united many houses to give the appearance of a palace, the house itself was a palace concealed within a domestic shell. Within the shell the monarch was allowed to live a private life like any of his citizens. Outside the shell the broad sweep of Edwardian gardens with their patterned bedding-out did not continue the privacy of the interior. In 1947 Edward VII's grandson, George VI, coming from the privacy of Royal Lodge to a now almost semi-public environment, determined upon the long enclosed garden that leads across the open lands (like the wall from Athens to the Piraeus) from his study to the woods. In this strictly private garden are still more private 'green rooms' of yew. Thus the need for garden secrecy, first demonstrated in the saga of the English home at Bingham's Melcombe, is answered here decisively in the Chinese conception of a box within a box within a box.[14]

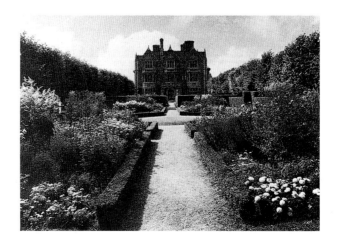

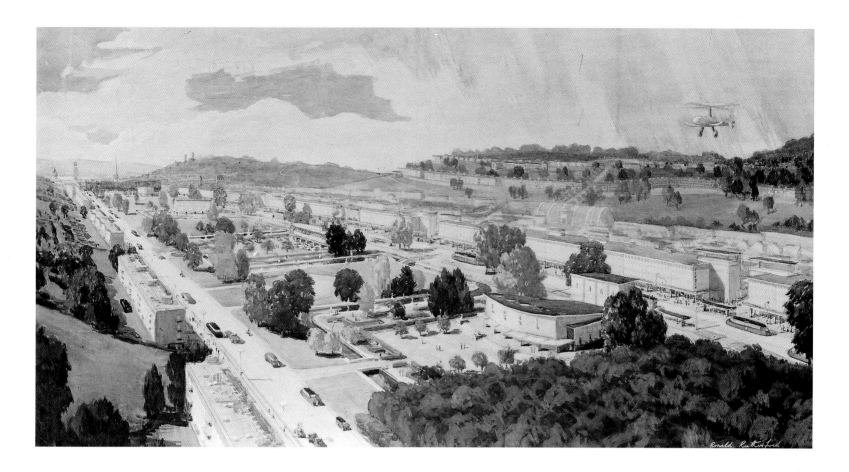

IN 1947 Geoffrey Jellicoe had been commissioned to plan the new town of Hemel Hempstead in the county of Hertfordshire, north of London. His vision for the new town was coloured by the ethos of the Modern Movement and incoporated natural landscape available for recreation and leisure pursuits. A large lake formed the central feature of the plan. Ultimately Jellicoe designed the water feature and its surroundings, but his plan for the whole town was not accepted.

G.A.J. (The site was) along a narrow green strip through which meandered the River Gade. On one side was the service road to the town high street and on the other, a series of car parks broken by a public flower garden. The strong lines of a straight canal seemed needed to organize the scattered environment: upstream the canal would emerge from the natural river and, downstream, would culminate in a lake. Pedestrian bridges would connect one side to the other.

The design was technically orthodox but stillborn. How to bring it to life and thus win the affection of the people? It was then, with Paul Klee as inspiration, that I first had the idea of concealing a ghost within the visible. As seen from the distance, the design suggested an abstract serpent. So if London had the Serpentine, could not Hemel Hempstead have one also? Smaller, certainly, but much more expressive. Thereafter, all detail was subordinated to this single idea:

Hemel Hempstead, Hertfordshire

LANDSCAPED TOWN PARK AND WATER GARDENS
1947 and 1957–59
Local Authority

A perspectival rendering (above) *of Jellicoe's original town plan for Hemel Hempstead.*

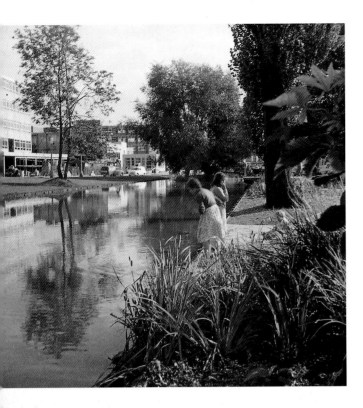

the tail flipping round the artificial hill; the soft underbelly with its subtle curve; the bridges that fasten the flower garden like a howdah on its back; the huge head with the single fountain eye and watery mouth.

The town loved the gardens from the start, unaware of the animal within. Then, recently (1990), came a proposal to impinge on the lake for road widening. To rational man the scale of the protest seemed unjustified, and only now have I revealed to a deputation what I conceived to be the root cause. Even rational man will pause before chipping at a much-loved civic monster and work of art, however deeply embedded in the subconscious.[15]

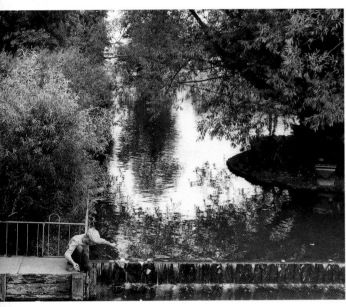

Eventually, only the water gardens at Hemel Hempstead (above, right and *opposite) were created according to Jellicoe's plan (above right), which also reveals the secret 'serpent' hidden in the scheme.*

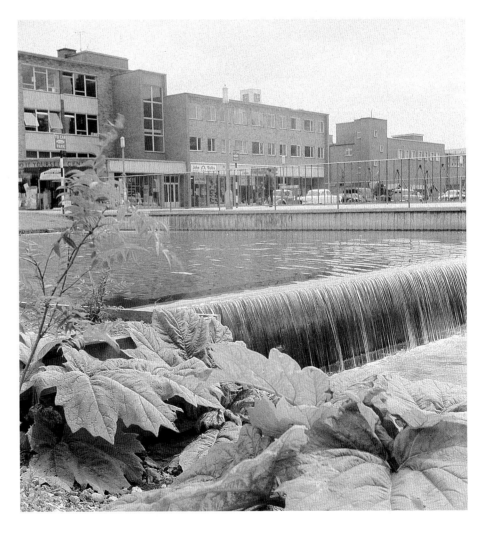

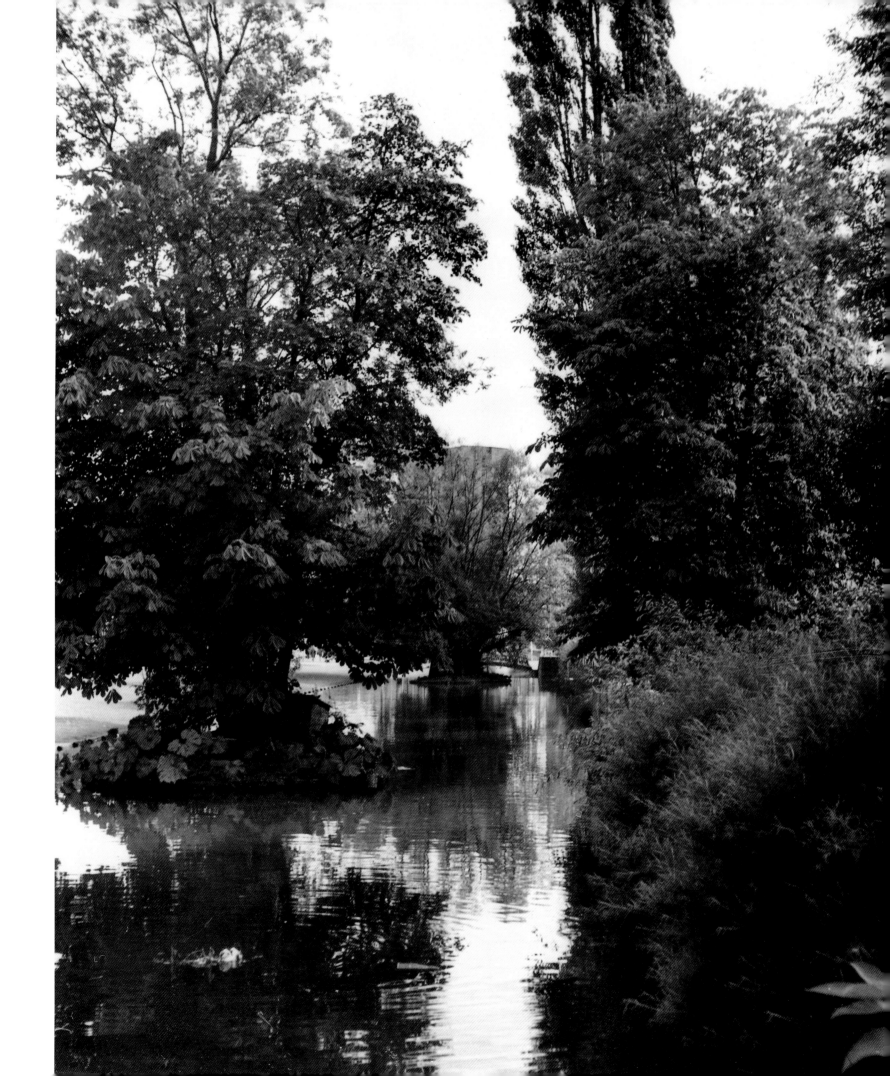

Cadbury Bros. Estate, Moreton, Cheshire

LANDSCAPE PLAN
1954
Cadbury Bros.

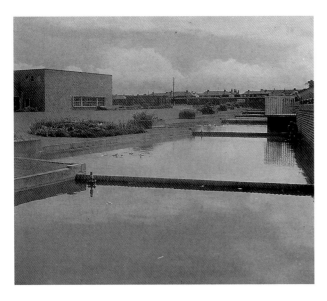

Described by Jellicoe as 'diabolical', the site at Moreton was cut in two by a wide canal.

GEOFFREY JELLICOE completed schemes in the nineteen-fifties for three major industrial concerns: Cadbury Brothers (1954) at Moreton, Pilkington Brothers (1957–58) at St. Helens, and Guinness (1959) at Park Royal. These developments indicate the extent to which the skills of the new landscape architectural profession were in demand by the end of the first postwar decade. Jellicoe found the requirements of the Cadbury Estate particularly demanding, as he notes below.

G.A.J. From the point of view of Landscape this is a diabolical site. It is bare and exposed to most violent winds. There is a major drain, now a canal, of great width and depth cutting the site in half. The silt from this had been thrown up on the farther side and lies at the moment in rough humps along the edge.

How does one begin to plan such a difficult area so that it may be humanized? The first thing is to break up the open flat land geometrically into different spaces and define these spaces by trees. These provide the first line of defence in wind screens and are in fact architectural extensions of the factory. Within those areas, now reduced to handlable size, you can in the future do what you like. They can be reserved for playing fields, housing, or factory extensions.

Although the trees will make good windbreaks, they will be insufficient to protect the factory itself and its immediate environment of gardens and of games such as tennis. But the answer lies to hand in the ugly heaps of spoil from the drain. With these and with further subsoil from future extensions of the factory. But we must also create an aesthetic idea. What shall this be?

The site at Moreton is not only dull and severe; it is intensely primitive. It is in fact that of a submerged forest, and you can imagine a million years ago it was infested with those prehistoric monsters we have seen illustrated. As heaps of slit changed to more agreeable slopes on the drainage, they took on the abstract shapes of two extended serpents. This will be a clue to their design in detail: that nature shall provide the aesthetic. They will take some twenty years to complete, but provided that this principle is not departed from, they may take many final forms. . . .[16]

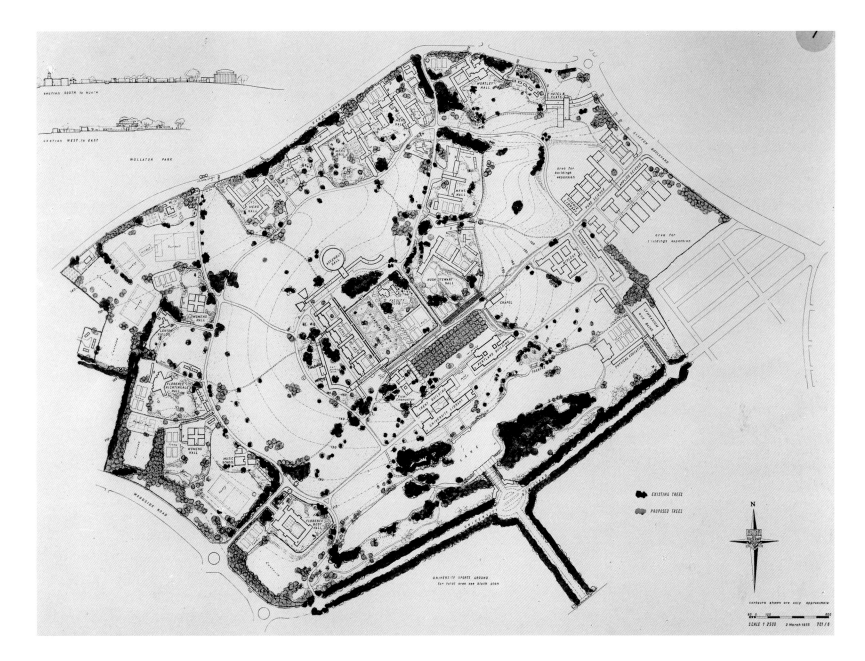

THE PROPOSALS for this plan were submitted in 1955, for a site of 257.58 acres, itself part of a total area of 436 acres, including adjoining land to be acquired. The whole project was based upon a plan of 1948.

Jellicoe placed considerable emphasis in his plan upon the park landscape, as surviving from nearby Wollaton Hall. The lake already existed, but the plan included a new bridge across the southernmost half, with gardens and carefully located 'groves' of trees; a plan for the creation of an arboretum was rejected.

Jellicoe provided a plan for co-ordinating existing and future buildings of the University to form a coherent landscape whole, based on the plan prepared by Sir Percy Thomas in 1948. The present University site has an area of 258 acres. This plan assumes the acquisition of adjoining land to

University of Nottingham

LANDSCAPE PLAN (uncompleted)
1955
University of Nottingham

Jellicoe's proposal of March 1955 (above) for the re-landscaping of the University campus at Nottingham; the main administration and residential buildings are in the centre of the plan.

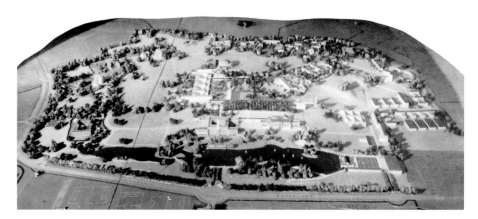

Models of the unexecuted Nottingham proposal: an overall view (above right) *and a detail of the central area* (above).

bring it to 436 acres. To the north lie the 700 acres of permanent parkland of Wollaton Hall, now a city museum. The general land formation gives the impression of a peninsula of high land extending into the level lowlands of the Trent Valley from the undulating and well-treed plateau that partly forms Wollaton Park. Part of the site is upon coal measures, and because of subsidence, any building programme must be related to the programme of mining. It is peculiarly rich in trees planted over a period of 200 years and more. The Vice-Chancellor's residence, Highfields, was built in 1760, and created at that time the essentially English park of tall trees, grassland and water, the identity of which survives. The main buildings date from 1928 onwards, but much building for expediency took place during and immediately after the war. The plan requires the removal of such temporary buildings; also of the present engineering buildings.

In this plan the University is entered by seven gates; three to the south, two to the north, and one each to the east and west. The axial gate from the south is for walkers only, who will cross the bridges and ascend the hill by a landscape stairway. It is, for the first time in a university, an 'open' plan based on access by car, motor-cycle or bicycle, but roads and car parks so far as possible have been segregated from the walks; occasionally, to prevent speed, the roads have been given sharp turns. Car parks are rendered as inconspicuous as possible and where possible have been designed to muffle sound. Because of the disadvantages of an 'open' plan in winter the buildings are grouped to give protection from wind, and covered ways connect the Portland Building to the assembly hall. It is suggested that use might be made of the heating service ducts similarly to connect the buildings of the science area. In order to retain the precinctual character of the central group, and at the same time not to interfere with cross-circulation of cars, the road cutting the space from east to west has been sunk and is crossed by three foot bridges.[17]

IN DESIGNING this garden above the busy shopping centre of Guildford, Jellicoe relied upon water and its reflective qualities – the sky being the element to be reflected.

G.A.J. The garden at Guildford is primarily a sky garden and the underlying idea has been to unite heaven and earth; the sensation is one of being poised between the two. The area, which is comparatively small is first flooded with the light of the sky by means of a water reflection, and carved out of this light are abstract island shapes reminiscent of earth forms as seen from the air.[18]

The site was some eighty feet above the pavement, with a central block rising higher to cover lift machinery, etc. Since the decision to make something unusual did not come until after the framed structure of the building itself was complete, anything exceeding the calculated live load must come above the stanchions. The idea of

Harvey's Department Store, Guildford, Surrey

ROOF GARDEN
1956–57
Army & Navy Stores

A view of the rooftop water garden at Harvey's store, Guildford; the openness of the plan ensures the maximum reflection of the sky in the pools, giving a constant sense of movement to the whole site.

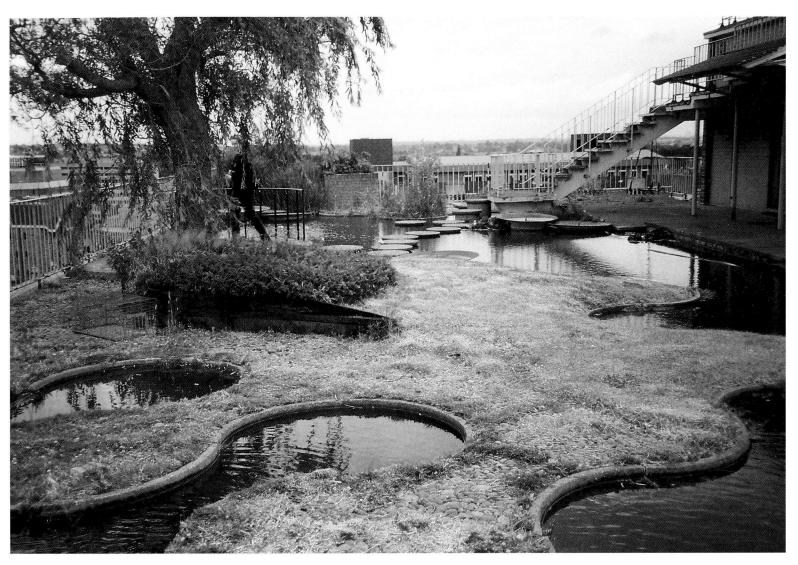

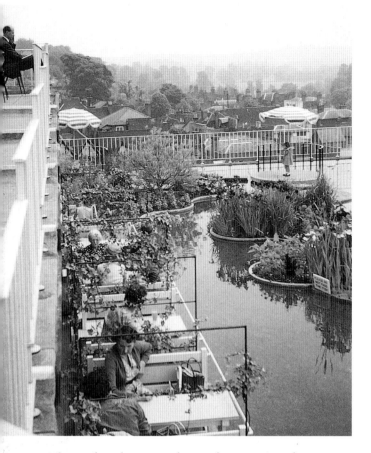

flooding the whole to a depth of 9 inches presented no problems. The floor was covered with one extra layer of asphalt, and the islands placed freely on top. The plan is based on standard quadrants, interlocked apparently by self-determination, but easily set out with open joints, on a squared grid. The plants were naturally water loving, the soil mounded above the stanchions to take small trees. The universal problem of evaporation being solved, that of wind called forth the semi-open screen that swept across the site like a cloud shadow. . . .

Here is the test of courage: a river that flows into the sky is crossed only by stepping stones that are unreal because they float on the water. Will they sink under your weight or carry you off over the edge to eternity?

It is the Chinese garden that gives us the most hints on that variety of sensations the experience of which the human curiously enjoys. At Harvey's there is the sensation of adventure and peril, of surprise and the unexpected, of pleasure in accomplishment, of the feel of wet and dry, and above all the modified excitement of being part of an environment that is removed from the everyday and is faintly heroic, like the abode of the gods.[19]

The roof gardens were designed to accommodate a number of seating areas (above) and areas of dry landscaping, combined with the water (right), with specially designed bamboo screening. The roof-level view of the pools (with inset plan, opposite) shows seating on the main terrace; there were also tilting fountains and a water-lily pool.

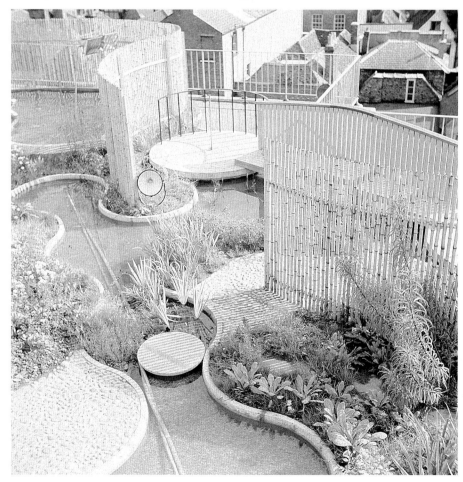

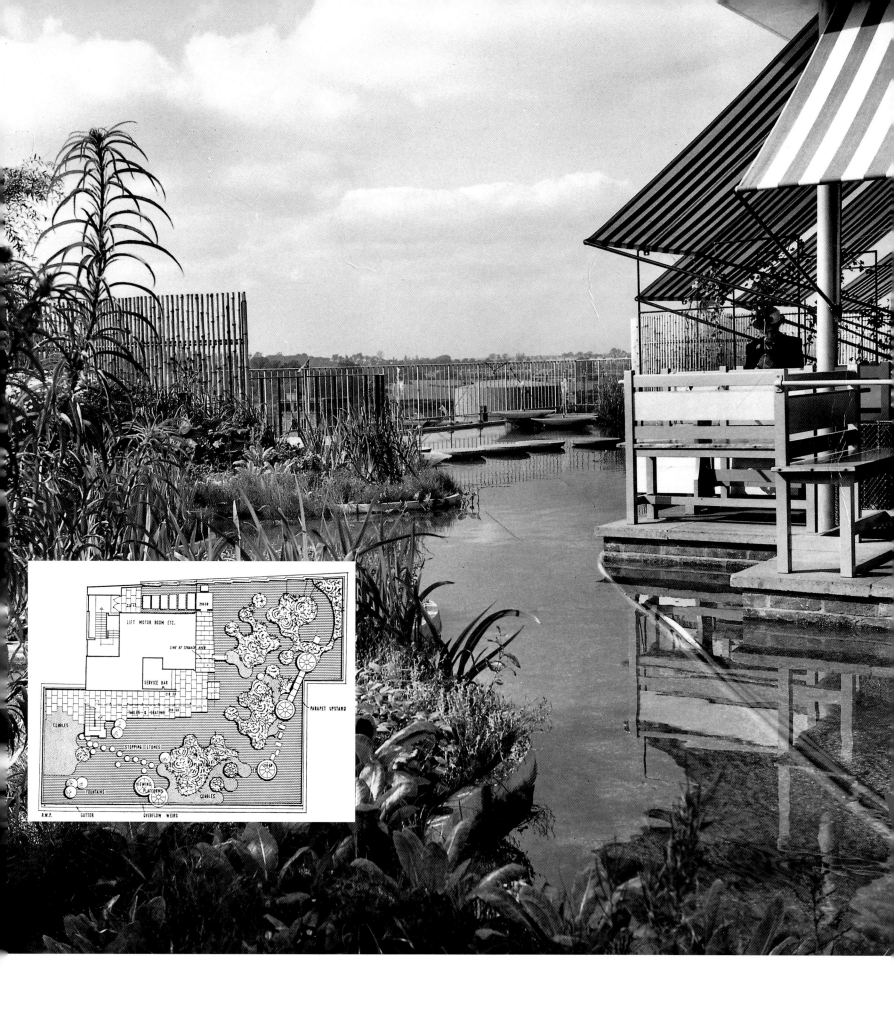

LIFT MOTOR ROOM ETC.

LINE OF TERRACE ROOF

SERVICE BAR

TABLES & SEATING

COBBLES

STEPPING STONES

PARAPET UPSTAND

STEPS

FOUNTAINS

VIEWING PLATFORMS

COBBLES

R.W.P. GUTTER OVERFLOW WEIRS

Ruskin Park Recreation Club, St. Helens, Lancashire (now Merseyside)

RECREATIONAL PARK
1957–58
Pilkington Bros.

The plan of the park (above) *emphasizes small, specialized areas. Facilities for children included the climbing sculpture* (below) *and an extensive area of special equipment* (below right).

JELLICOE here decided to depart from any conventional massing and grouping of recreational facilities and wherever possible to reduce the scale to that of the individual or small groups, in contrast to the large-scale industrial glass-making concern in which the members worked.

G.A.J. One might have expected, for the large sum of money involved, a majestically symmetrical building whose dignity would enhance the prestige of the employers; and playing fields whose specialized progress would dominate the ground pattern. Instead there is apparent confusion of such pavilions set among grass and trees which carry us to the ancient Chinese scenery where the buildings were always subsidiary to the landscape. In short, the scale is small and related to trees, the area is a landscape for all and not merely specialized physical exercise: and it is one where each member, however inactive, will find himself a person of consequence.[20]

The long embankment for spectators is modelled as a part of a designed landscape of shapes, of which the end is a pyramid of ground with a folly, and another is an artificial hill; all these elements introduced with the intent of breaking up the flatness throughout. Symbolic of this is the undulating surface of the miniature golf course, bringing unobtrusively the ideas of games into the precinct ... the colour on doors and corridors throughout is bright to catch the eye especially in winter, when the landscape is dreary; the incidents include a concrete climbing sculpture for children, as invented by the Swedes.[21]

Park Royal, Middlesex

LANDSCAPE PLAN
1959
Guinness & Co.

The artificial hills in the grounds of Guinness's Park Royal brewery were made from soil taken from the A40 underpass where it meets the North Circular Road.

THIS PROJECT had to relate to an existing brewery building designed by Sir Giles Gilbert Scott. Jellicoe turned to the creation of new vertical contours by moving spoil from existing roadworks on to the site.

G.A.J. The brewery designed by Sir Giles Gilbert Scott is (such) a feature in the scenery. The company were anxious to ensure that the view of the considerably widened road from the brewery and conversely the view of the brewery from the road, should not only be emphasized but if possible enhanced. With the company and all the authorities concerned with the road in general agreement on the landscape possibilities, it seemed an interesting example of what could arise from an identity of public and private interests. The preliminary study suggested that no variation from the standard treatment was possible, the road began on a massive embankment, it should be properly grassed, and softened here and there by groups of trees; and proper care was to be taken in regard to fencing, colour, lamp-posts, and all the paraphernalia of a modern road. This did not overcome the fundamental problem of the harsh parallelism of the road, and the consequent separation of road and environment. If soil were to hand to model and mould these shapes together, all would be well – and such subsoil was in fact to hand from the adjoining tunnel. Some twenty thousand tons will now be deposited within a short distance of the excavations instead of being carted five miles. With this soil it has been possible not only to model the land, but to create a hill some thirty feet high as part of a designed composition.[22]

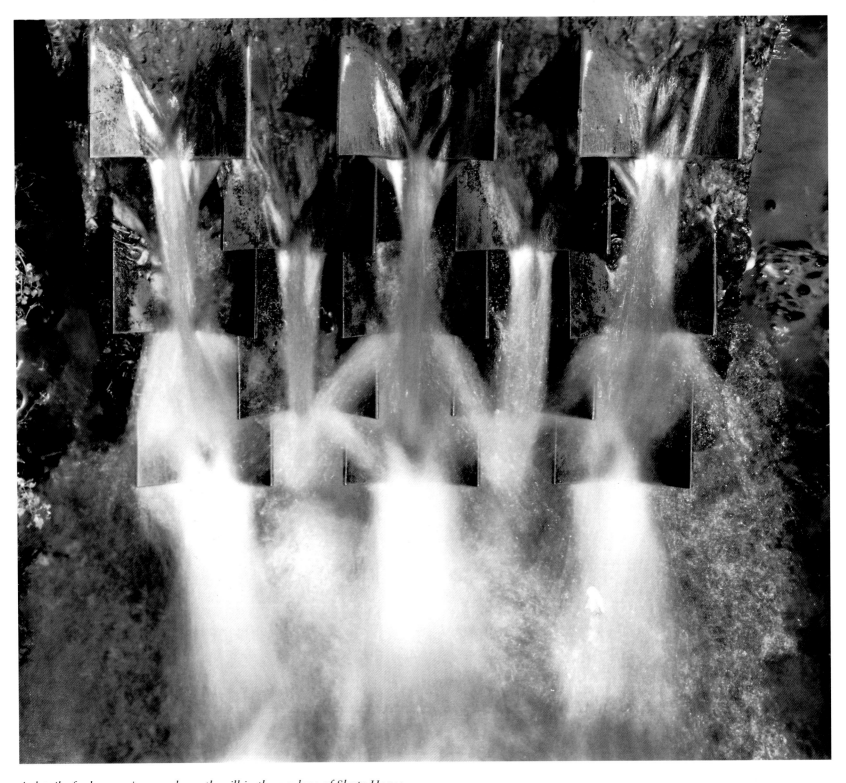

A detail of a harmonic cascade on the rill in the gardens of Shute House.

PART TWO · A PHILOSOPHY OF LANDSCAPE AND GARDEN DESIGN 1960–1980

A Philosophy of Landscape and Garden Design 1960–1980

By 1960 Geoffrey Jellicoe's status as an architect-planner as well as a landscape designer was well established. He had set up his practice at Queen Anne's Gate in London, near the offices of *The Architectural Review*; now sixty, he was right at the top of the profession of landscape architecture, which he had been largely instrumental in establishing as a distinct discipline. Jellicoe's reputation was derived in the first instance from his distinction as a designer of gardens. A chance sequence of patronage by wealthy and distinguished clients had allowed him the opportunity to create an outstanding modern building at Cheddar Gorge, though a building dominated by landscape. But public recognition of his skills as an architect-planner now led Jellicoe's practice further away from actual garden design. Such skills had to be contained within the garden walls of No. 19 Grove Terrace, where the Jellicoes had lived for almost twenty-five years. Prior to 1960, too, industrial and corporate patronage by three of Britain's leading companies (Guinness, Cadbury, and Pilkington) had provided further landscape projects. And the Royal family had, as early as 1947, returned to him for work at Sandringham House, their private home in Norfolk.

Within twelve months of the start of the new decade, the particular nature of two related commissions brought significant changes to the content of Jellicoe's work. The Rutherford High Energy Laboratories (as these nuclear research installations were mildly named) at Harwell introduced Jellicoe to the implications of nuclear fission. The impact of this upon Jellicoe's sensitivity to environmental questions was profound, and similar to that which affected the work of his friend Henry Moore at the time. A second project for a nuclear power station which Jellicoe was to relate harmoniously to the surrounding patchwork of fields remained unrealized. Following this awakening, Jellicoe became profoundly concerned about the future of mankind and of the planet. Much of this thinking conditioned the preparation of the book, *The Landscape of Man*, which was eventually published in 1975.

Shortly after the public commissions at Harwell and at the Oldbury power station, Jellicoe was asked to design the Kennedy Memorial at Runnymede. These were prestigious yet sobering commissions. By 1965, a year later, his design for the garden at Horsted Place, Sussex, was charged with a contemporary vitality which had little direct link with Italian Renaissance design. In 1962 his modernism had already

During this period Jellicoe addressed himself very much to the problems of combining architectural elements with landscape in its widest sense. His plan for the open spaces of the Great Square in Plymouth called for, as he put it, 'both dignity and frivolity'. In 1971–72 he was commissioned by the Royal Horticultural Society to design ornamental pools and fountains for its gardens at Wisley (below and below right).

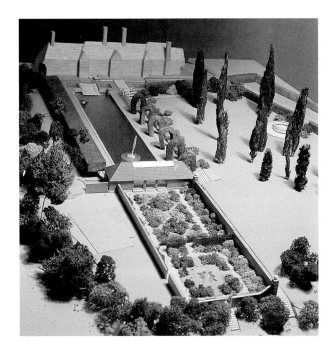

produced at Cliveden a superb transposition of abstract painting into landscape form, inspired by Paul Klee. Horsted was the extension of the thinking. At Armagh Cathedral, Jellicoe's interest in the meaning of all life was expressed in a different way to that of the Kennedy Memorial, but no less potently. The project for the Villa Corner at Treviso, nothern Italy, through unrealized, was a sudden expression of Jellicoe's patiently acquired expertise on Renaissance gardens: it too was a fantasy.

However, Jellicoe was already establishing a working method that, while classically based, was a synthesis of key elements ancient and modern. Firstly, the Long Walk or Terrace was an important feature of the gardens at Wexham Springs (1967–69); examples recurred at Framingham (1971) and in his great and dramatic work at Everton (1974). Water features appeared where feasible, again at Framingham, The Grange (1975), Dewlish (1976) and Buckenham Broad (1977). Such projects for private clients helped re-establish Jellicoe's primary skills as a landscape architect during the seventies. His talent for relating landscape design to fundamental human concerns and needs now began to blossom fully.

A series of designs for country house gardens followed the remarkable, strictly classical design for the Villa Corner (1969). The seventies saw a dozen or so such projects, in which especially well-tried devices in garden and landscape design recurred several times. The ultimate design of this particular line of development was the garden at Shute House, which became a kind of testing ground and workshop from 1969.

During the following decade the works at Shute proceeded apace, allowing Jellicoe to refine his philosophies and sharpen his command of the landscape designer's language. The possibility in 1972 of major work at Chequers, the Prime Minister's official residence, opened up especially exciting prospects, although the project ended by being a rather more prosaic exercise in conservation.

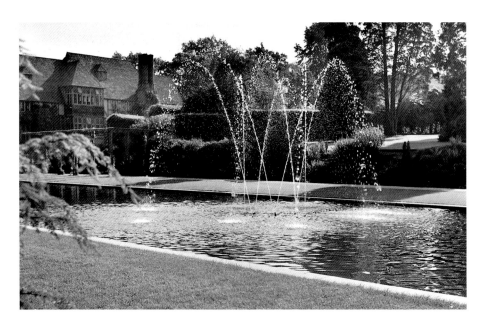

However, new gardens at Everton Park (for Lord and Lady Pym) were initiated in 1974 and, although on a modest scale at first, came to rank highly in Jellicoe's own estimation of his work during the seventies. This was a project in which Susan Jellicoe also collaborated extensively in drawing up the detailed planting plans. Under the careful stewardship of the Pym family Everton has developed to become one of the outstanding works in Jellicoe's total achievement.

The second part of this period saw another significant tendency emerge in Jellicoe's work and thought. This was his concern with the disposition of water in the landscape, first expounded in the book which he compiled jointly with his wife, *Water: the Uses of Water in Landscape Design*. The fruits of this thinking were to be fully harvested in his next period, that of the masterworks.

Jellicoe's vision of a Florentine Ponte Vecchio applied to twentieth-century London (above); this span of the Thames was to provide a crossing from Vauxhall to the Tate Gallery, incorporating a six-lane roadway with access ramp, hotels, shops and other facilities. Known as 'Crystal Span', it was a project of the Glass Age Development Committee set up by Pilkington Brothers in the nineteen-fifties. Dating from 1963, it demonstrates Jellicoe's concern with the landscape as a whole, including the articulation of urban spaces.

Rutherford High Energy Laboratories, Harwell, Berkshire

LANDSCAPE PLAN

1960

United Kingdom Atomic Energy Authority

Jellicoe's plan and profile of the three hills at Harwell (above and *above right): Zeus, Themis and Klotho.*

EARLY in 1960 Geoffrey Jellicoe completed designs for two artificial hills for the Rutherford High Energy Laboratories at Harwell. While working on this project Jellicoe increasingly realized the meaning of the massive yet contained energy for which his landscape was a form of concealment. He drew solace as well as foreboding from the work of other artists of the period, such as Henry Moore, who were also facing this reality, the presence of a new and immensely destructive tool which had been placed in the hand of humanity by scientists. In later years, such realization was to heighten Jellicoe's search for a compensating spiritual force that might assist humanity in making the choices involved.

G.A.J. In the subterranean laboratories at the foot of the hills the most advanced scientific studies as yet made by man are taking place. The scientist himself will tell you that the splitting of the atom leads to infinity or as one scientist put it, 'to God'. The mathematical sciences have far outstripped the biological sciences and this disequilibrium, as we all know, could lead to the eventual destruction of the human race. Opposed to this fearful intellectual development is the human body that is still the same as ever, and within this body, but very deep down under layers of civilization, are primitive instincts that have remained unchanged.[1]

The story of Harwell Hills is one of a light-hearted frolic into the expression of a deep-rooted and sinister idea. While evolving the design, I sat next to Henry Moore at meetings of the Royal Fine Art Commission in London, and I remember how he encouraged the concept of modeling the land as sculpture on a gigantic scale. Basically, the fun was to find out whether one could play upon the subconscious emotions through association of ideas.[2]

Harwell's subterranean laboratories are concerned with high-energy atomic research. Above them was a huge waste heap of excavated chalk which was to be remodelled to fit the existing landscape at the foot of the Berkshire Downs.... the project was named 'Nimrod', the mighty hunter and scourge of mankind. As if to act as guardians of this underground monster, three hills were placed upon it and

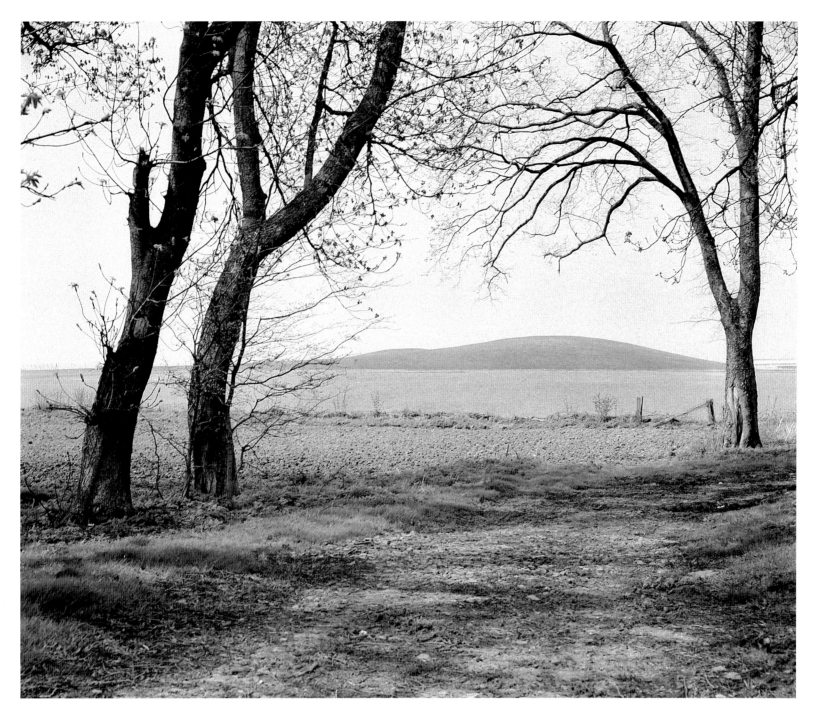

named: Zeus, father of gods and man; Themis, one of his wives, divine justice, daughter of heaven and earth, goddess of law, justice and order; and their daughter Klotho, one of the fates who determines the life and death of man. The assurance was that so long as Klotho remained constant, the future of man was safe. But this was not to be ... for shortly before the start of work a telephone call stated that the small hill, Klotho, would impede certain rays emanating from Nimrod and must be removed. So Klotho was returned to Themis' womb and only the two hills of Zeus and Themis were made. The fate of mankind therefore, still hangs in the balance.[3]

Only two of the hills, Zeus and Themis, were finally constructed at Harwell.

Cliveden, Buckinghamshire

ROSE GARDEN
1962
Lord Astor

The Fruit (1932) by Paul Klee (top) which Jellicoe claimed to be his inspiration for the designing of the Rose Garden at Cliveden; its influence can be clearly seen in the two plans (above) and the final planting scheme by June Harrison (right) in their suggestion of enclosure and fecundity.

In 1962, Jellicoe had the good fortune to return to the smallest scale, a small rose garden at Cliveden. After the pressures of the work for major private and public concerns in the late nineteen-fifties, Cliveden came as an unexpected relief. As at Ruskin Park, Jellicoe found that the work of Paul Klee could be his inspiration and the design was based on the latter's painting of 1932, *The Fruit*. Yew was established in four places; artemisia, lavender, Philadelphus (Sybilla) and old fashioned roses were to be interlaced with wallflowers and nicotiana, so creating a poetic symbiosis. The unique concept is to be restored by the National Trust, the present owners of Cliveden (1993).

G.A.J. The site is an open glade and is wholly surrounded by trees and foliage. The circle of the original garden is the conventional design of beginning of the century and is clearly a relic of Renaissance design. It is static and finite. The new design endeavours to create a different sense of space and by reason of its organic form generates a sense of movement and therefore a sense of time. It is a reflection, however of the design by Paul Klee.

Probably no artist is more rewarding to landscape than Klee, for his inventiveness is infinite and his explorations seem to have covered almost every field that could come within the province of the landscape architect.[4]

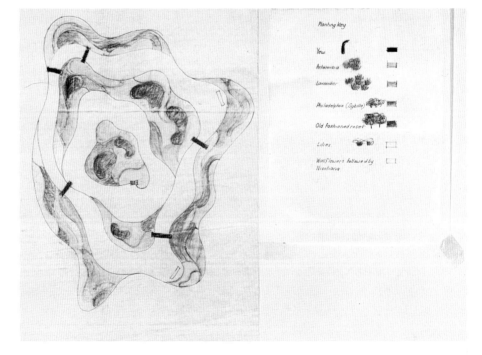

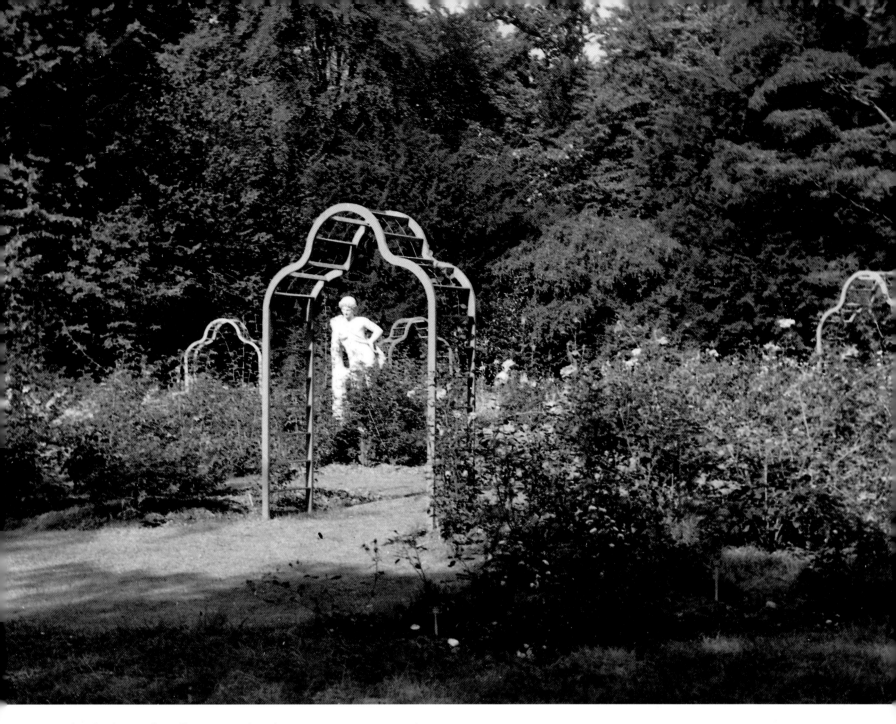

This little garden illustrates the change in man's attitude to environment that has taken place this century – from the nineteenth century's academic outlook to the ecological approach of the twentieth century. Set in the woods of the great classical mansion of 1851 and as if in deliberate contrast to its grandeur, the Edwardian rose garden was redesigned from its geometric circle to correspond with the sensitive feelings of the present owner. The design was inspired by the probings of Paul Klee into the vegetable world. Planted by its owner, it was never wholly completed, being maintained today by the National Trust.[5]

The Rose Garden at Cliveden incorporates Jellicoe's specially designed architectural elements with planting and the idea of the secret, enclosed garden (see p.26).

Christchurch Meadow, Oxford

LANDSCAPE PLAN (uncompleted)
1963
Local Authority

IN 1963 Jellicoe was deeply involved in a famous controversy over the proposal for a road over Christchurch Meadow, Oxford. He found there a profound dilemma, which he has commented on at length in *Studies in Landscape Design*.

G.A.J. Suppose the Minister of Health had ordered (not requested) that a long incision be made of necessity in some beautiful living body; supposing he was to request a leading surgeon to make this difficult incision; and supposing that the incision was unnecessary, what should the surgeon do? If he refuses, the operation might be carried out clumsily; if he accepts, his conscience may never forgive him. In this instance the surgeon accepted, made skilful preparation, recorded his philosophy, and breathed again, when the project was abandoned. Today, the High in Oxford remains more congested than ever, but the meadow remains empty.[6]

The Times of 8 October 1963 carried the following description of Geoffrey Jellicoe's proposals under the heading 'Illusion to hide road across Christ Church Meadow':

Plans showing Jellicoe's proposed siting of the new road over Christ Church Meadow and the diversion of the river Cherwell.

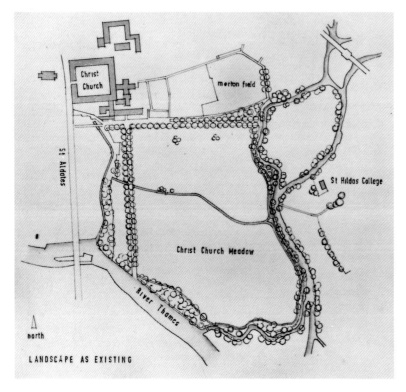

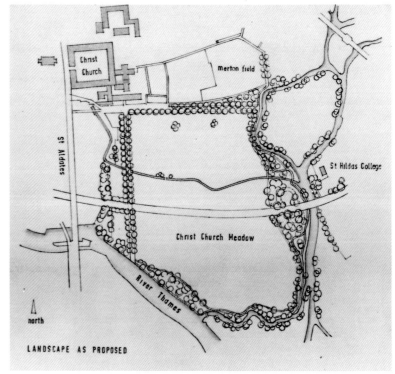

Mr Jellicoe said he believed that the meadow road project was 'one of the most important matters of landscape that this country has ever known'. It was natural for an architect to want to make his mark on Oxford. But I like to think, he said, that one's mark on Oxford will be that there is no mark at all. His aim had been 'to make the road disappear' and to do this he had called on the arts of illusion in landscape.

A major problem was that the river Cherwell – which had to be crossed by a bridge – was so close to the meadow that the road could not be brought below ground level in time. The simple answer was to move the river's course to the east and leave an island of land between the old and new beds of the river on which an artificial hill would be built.

Traffic on the road would be audible, but it would be a 'muffled sound, a continuous murmur', not much greater than St Aldgates, near by.

Mr Jellicoe said he intended to provide distraction for the eye to foster the illusion that no road was there. There was already running across the meadow a ditch which he believed might well follow the line of a historic river of former times, the Shire-lake, which was the county boundary with Berkshire. The sense of illusion would also be helped by the presence in the meadow of willow trees, the cattle bridge and, indeed, the cattle along this stream.

The trees, said Mr Jellicoe, were of paramount importance and a very careful study had been made of them with the help of the director of botanical gardens. Existing trees would be disturbed as little as possible, and it would also be necessary to plant 300 new trees – although some near the footpath bridge across the road would have to come down.

On the question of cost Mr Jellicoe, saying that the sunken road would cost approximately twice as much as a surface road, commented: 'I make no apology for this at all. I think the expenditure would be entirely justified. One has the feeling that this meadow is primitive and reaches right down to one's deepest feelings. This is something we must try to keep as far as possible.'

In a report accompanying his proposals Mr Jellicoe says that the theory of illusion in landscape is based on the premise that the mind is prepared to accept whatever the eye sees and create its own image is what lies behind. 'It is an art that should be developed more and more in modern England.'

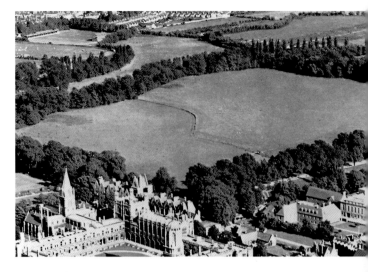

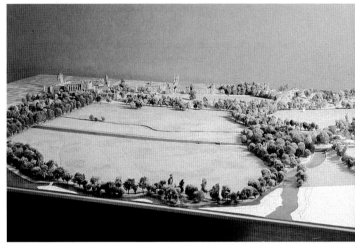

An aerial view of the site (top) *and a model* (above) *of the proposed re-landscaping.*

The Kennedy Memorial, Runnymede, Surrey

LANDSCAPE PLAN AND MEMORIAL
1964–65
H.M. Government

SOON AFTER the assassination of President Kennedy on 22 November 1963, the British Government set aside an acre of English soil on rising ground looking north over the river Thames, at the meadow of Runnymede. The land was given to the United States as a tribute to a President who had striven to secure world peace. Runnymede today has fulfilled all Jellicoe's aspirations, and it is now a complete landscape work; the woodlands stand replete with the product of natural regeneration. The 60,000 granite setts which make up the winding path have perhaps been marginally eroded by souvenir hunters, but if each single sett represents a pilgrim, a few gone amiss are scarcely an inappropriate comment on humanity. The monument stone itself stands benignly in its pastoral English setting, balanced by the stone seats to the west, designed by Jellicoe for contemplation. The American scarlet oak flames each year into November, as if to provide a salutary reminder of man's violent spirit. Jellicoe found his mind turning to analogy here, and likes to quote the saying of a Chinese painter-philosopher: 'Never paint a stone without spirit. If a great mountain is the most important part of your picture, the mountain must seem like a host and the other hills and trees like his guest.' He adds: 'I have found this analogy with human behaviour truly fascinating and have often based free grouping of trees so that they might resemble individual humans in casual conversation.' The arrangement of trees and the planting at Runnymede appears utterly natural through the skilful application of such concepts.

G.A.J. The Kennedy Memorial became my own adventure into a new field, of Allegory. The simplest of all devices with which to captivate the mind, and perhaps the most ancient. The outstanding eighteenth century English example of allegory in landscape is of course Stourhead, which historians feel represents the progress of heroic man from life to death and immortality, although there is no actual proof that the designer had this in mind. At Runnymede, which I completed in 1965, the eye of the visitor sees a wicket-gate, an informal path leading upwards through a self-regenerating wood to the memorial stone. Beyond along the contours and across open meadowland, a formal path leads to two secluded seats of contemplation overlooking the fields of Runnymede below. The eye of the visitor, I hope, is pleased. In his mind however he has been taken on a far grander journey, one closely resembling John Bunyan's in *The Pilgrim's Progress*. The journey is one of life, death and spirit. This concealed concept emerged of its own accord during sketch plan stage and once revealed controlled every detail.

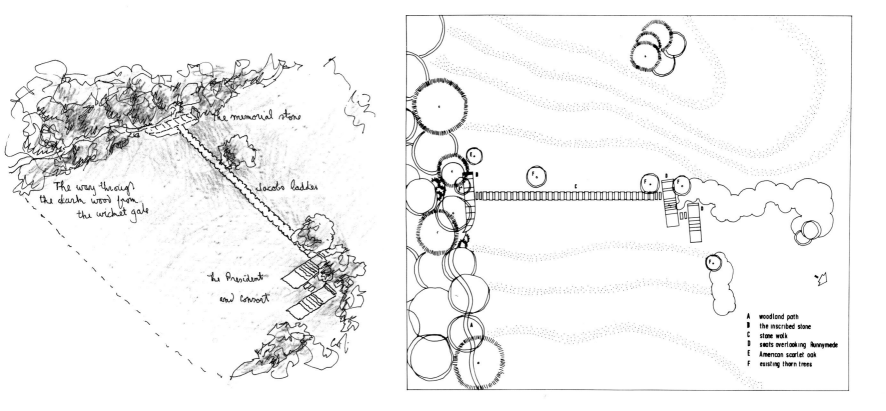

The wicket-gate, you will remember, began the Progress. The setts of the woodland path are the multitudes of mourners who jostle their way upwards. The Stone is a catafalque balanced on the shoulders of the populace. Beyond lies immortality. The path (like Jacob's ladder) leads to two thrones in family relationship. The form of seats, paths and threshold, like a Greek temple that brings the harmony of the heavens to earth is proportioned geometry. There is no clue given to the inner meaning of the design; and what I can only describe as the magic of the subconscious cannot operate with a visitor in a hurry.[7]

The wood through which the path gropes its way upwards is symbolic of the virility and mystery of nature as a life force. It is appropriate that it is not very good as forestry, and in fact in order to emphasize the cycle some trees have been retained beyond their reasonable maturity. It is a natural ecological system that is based on self-regeneration and, beyond a few repairs and encouragement to the ground cover, has been largely left undisturbed. Some thickening of the rhododendron edging was necessary, for ultimately it is essential that no open land be seen from the woodlands until the stone is reached. This is to encourage that sense of foreboding that woods that close in upon one can evoke: reminding us of the 'dark wood' of Dante.

Jellicoe's sketch plan (above left) *and finished treatment* (above) *for the approach to the Kennedy Memorial Stone: the way through the dark wood to the actual site of the memorial overlooking the Thames is intended as an allegory of man's journey through adversity to better things ahead, based on John Bunyan's* The Pilgrim's Progress.

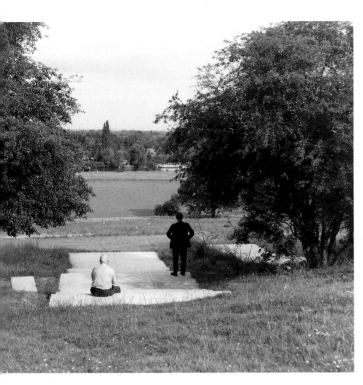

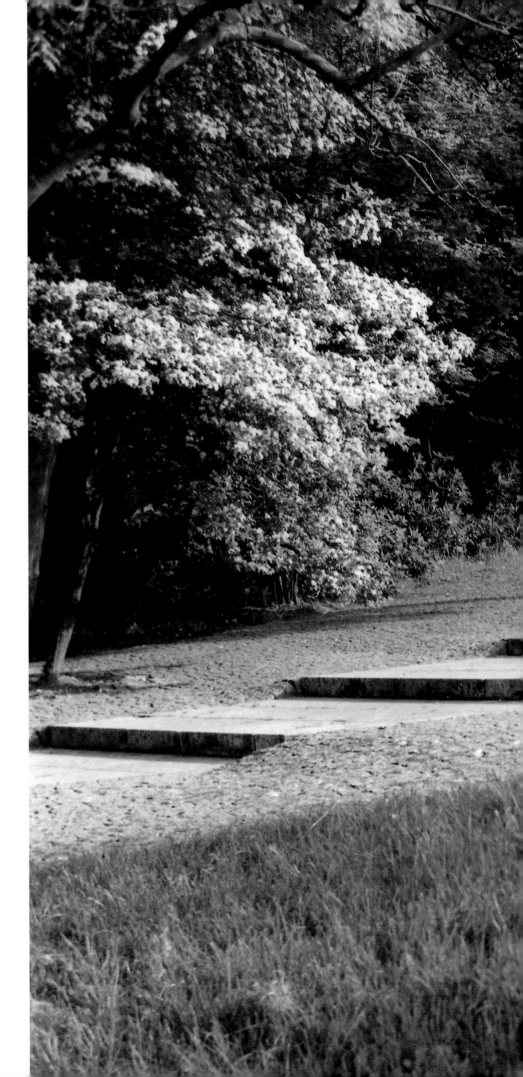

*The view across the river meadows to the Thames
(top)signifies the opening-up of the landscape of hope in
the allegory. The wicket gate (above) to the way
through the woods is suitably mysterious, contrasting
with the siting of the memorial stone (right).*

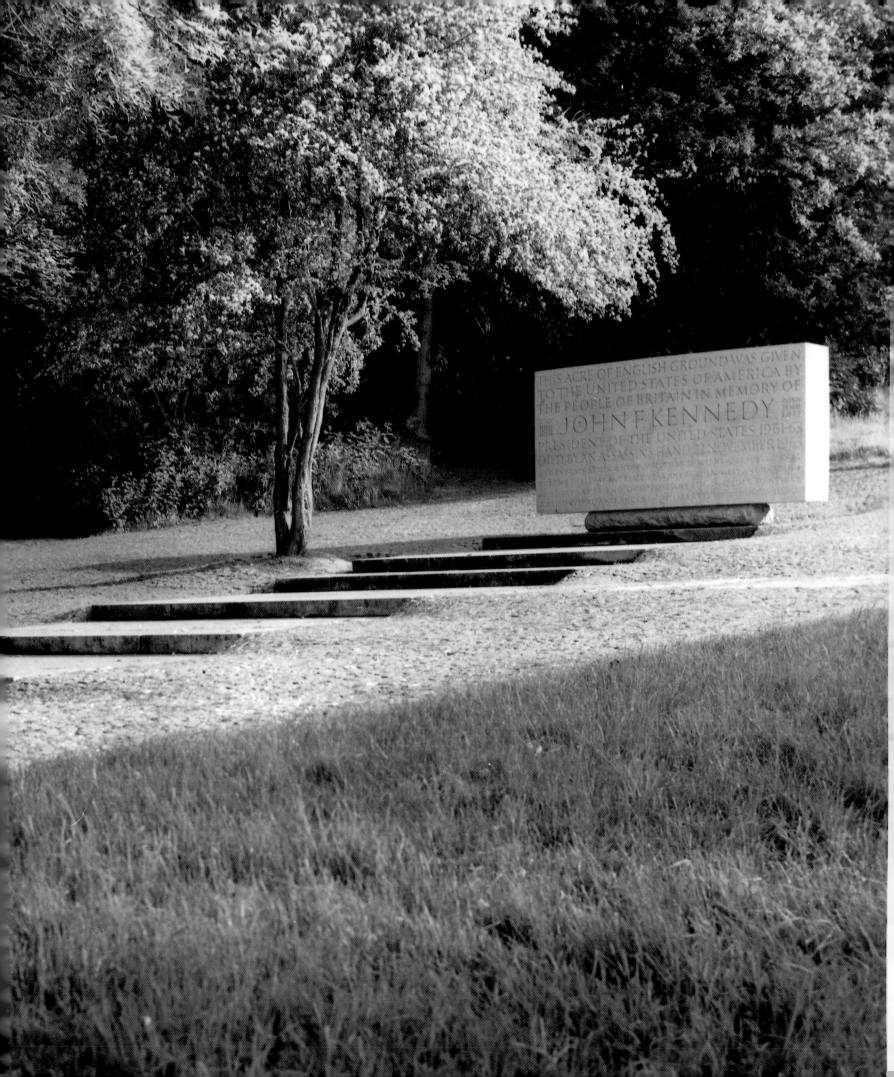

The seats of contemplation (above), combined with the stone, produce a feeling of tranquillity in stark contrast to the winding path (below) of the difficult journey upwards. The granite setts of the path may be seen as a representation of the multitudes who will pass along its way (opposite). The actual setts are laid dry, although the risers are fixed in concrete.

The stone is symbolic of a catafalque, borne on the shoulders of the multitude. I am sorry that this idea of the people actually supporting the stone did not materialize until it was too late to alter the design: the material is correct but the cushion curve runs counter to the allegory. The lettering on the stone covers the whole surface, so that it is not so much an inscription upon it as an expression of the stone itself; it is as it were the stone speaking. It is deeply cut because it is seen against the light. . . . To correct optical illusion the stone is imperceptibly curved in all directions. Even so I could have wished that it conveyed even in repose perhaps a more formidable sense of power. It weighs seven tons and was carved from a fourteen-ton block. The intention was to give an effect of great weight floating just above the ground. . . .

This highly sophisticated and precise design is fitted into a landscape that is very much the reverse. The intention is to convey the same impression as that of a Greek temple, whose presence lends meaning to a primitive scene. There is no compromise of neatly cut grass and trim flower-beds; technically the maintenance of the *status quo* of the existing landscape proved probably the most difficult of all. Much is known about the creation of a normal public park or garden, but little as yet about the re-creation of natural scenery in such a way that it survives the human element. . . .

During the summer of 1964 some quarter of a million people visited the memorial, and since then the flow has been continuous. It is of course a monument for quiet contemplation and one which could suffer from over-use (not so much the hard surface as the adjoining natural scenery). Each side of the woodland path has been worn, partly because the path itself is purposely not too wide and partly because the granite setts are hard on shoes with thin soles. The ardour of the climb is part of the design, for an objective is appreciated all the more for being difficult of access. You are, for a short while, a pilgrim in the historic sense. The lovely colour and texture of the granite setts is for the time being blurred by mud carried on the soles of countless shoes, and this must be accepted.[8]

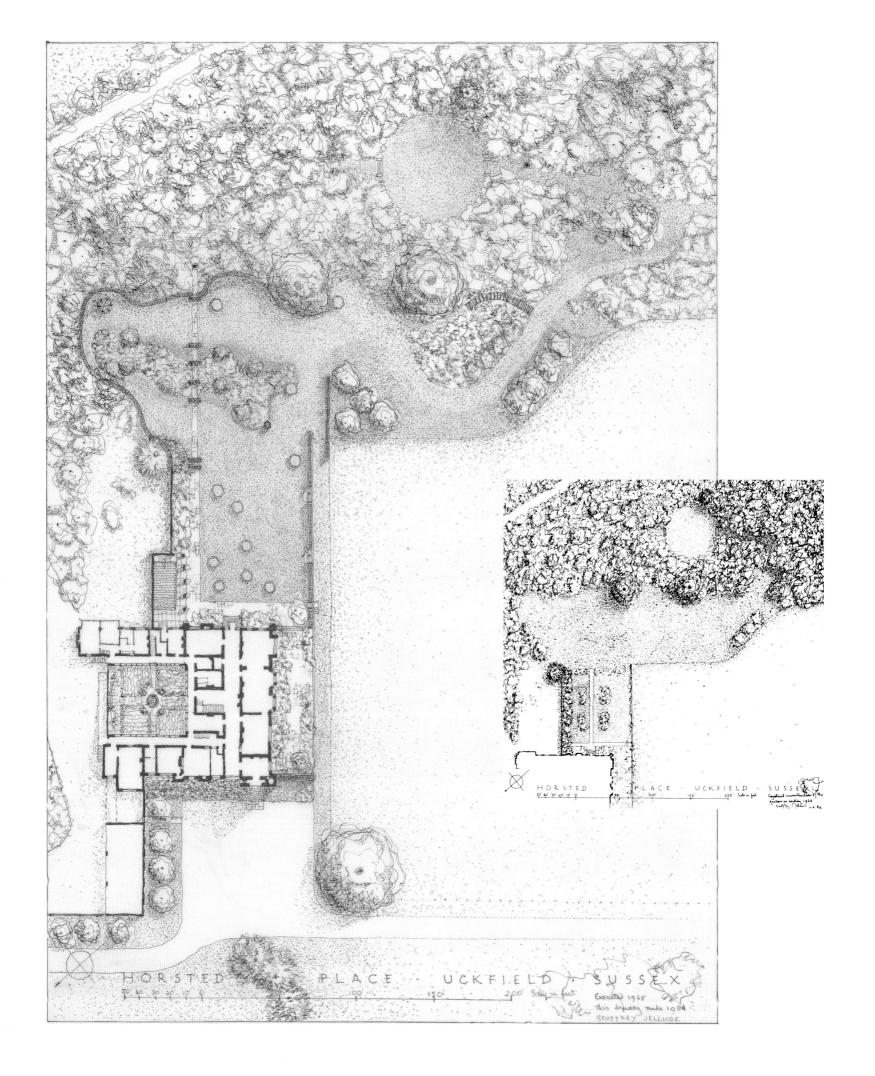

HORSTED · PLACE · UCKFIELD · SUSSEX
50 40 30 40 10 0 100' 150 200' Scale in feet
Conceptual reconstruction of the
garden as existing 1960
Geoffrey Jellicoe 11.6.82

HORSTED · PLACE · UCKFIELD · SUSSEX
50 40 30 20 10 0 100 150 200' Scale in feet
Executed 1965
This drawing made 1982
GEOFFREY JELLICOE

HORSTED is one of Jellicoe's most interesting exercises in garden design and it is fortunate that documentation of the garden before and after execution is so complete, for today it no longer exists in its originally intended form. Jellicoe strove to accommodate the most detailed requirements of his clients, Lord and Lady Rupert Nevill, including importing ten baskets, originally modelled on those designed by Humphry Repton for Brighton Pavilion, from another location.

G.A.J. The house lies on rising ground some two miles south of Uckfield. It is mid nineteenth-century medieval, with a romantic silhouette of chimneys. To the west of it is a formal forecourt, to the north an enclosed kitchen/flower garden, to the south a view over the weald to the South Downs, and to the east a 'pleasaunce' with baskets of flowers inconsequentially placed. Except for an existing terrace wall, forest trees and a grass circle in the woodlands, the pleasaunce was made from materials and semi-mature trees transported in many loads from the owner's previous home. Mythically speaking, it sprang out of the ground fully grown, as if by magic. This garden of instant landscape is baroque in its feeling for movement in space but not in time, being the antithesis of Dewey's conception of art as a continuum. It is a garden for the pleasures of the moment; its flowers are beautiful, its lawns and clipped hedges impeccable, its birds colourful, its perfume delicious.

Horsted Place, Sussex

GARDEN DESIGN
1965
Lord and Lady Rupert Nevill

The retrospective plan of 1980 (opposite) shows Jellicoe's 1965 design for the landscaping of the gardens at Horsted. The siting of the Repton baskets can be seen clearly to the side of the house – a progression of circles leading to the greater circle in the woodland, which is a focal point in Jellicoe's 1982 drawing of the gardens before planning (inset opposite) and which recalls the work of land artists such as Long and Serra.

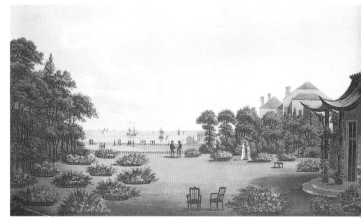

A mid nineteenth-century coloured lithograph of the original baskets designed by Humphry Repton in place in the grounds of Brighton Pavilion.

The house at Horsted (left), photographed c.1965, with the Repton baskets clearly visible close to the house.

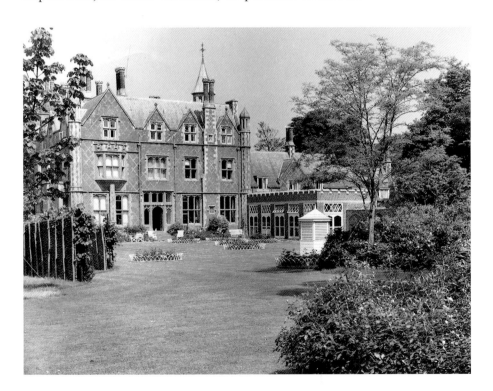

Among the imported objects were ten baskets based on an old print of those designed by Humphry Repton for Brighton Pavilion. Setting forth from the house, these baskets of fragrant roses drift towards the woods as though individually propelled by the eddies and currents of a river. The river disappears behind an island and into the woods beyond. The first basket has drifted out of sight, the second is just visible from the house. To what are these minor circles attracted if not to the plain big circle concealed in the woods? And how is it that the scene never seems to pall?[9]

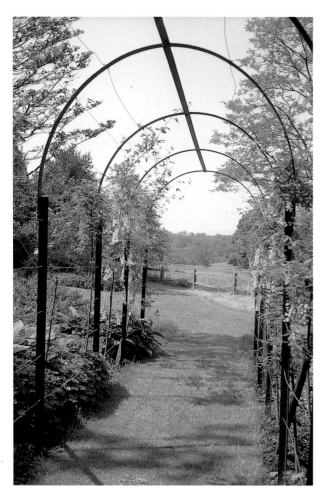

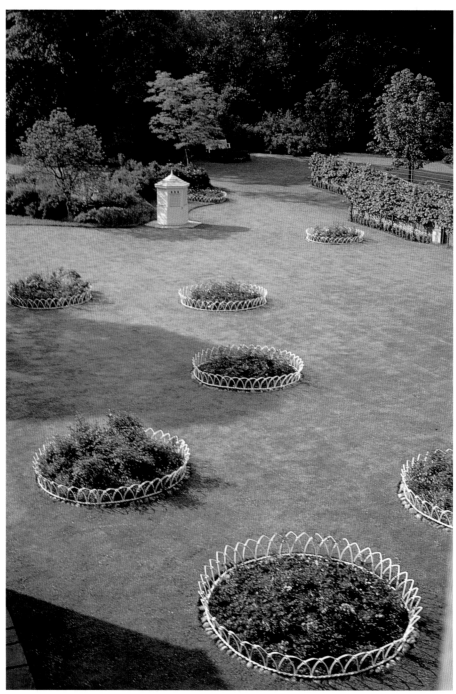

The development of the green tunnel at Horsted (above) looks towards the woods beyond. There is a strong sense of movement in the siting of the Repton baskets (right), producing a distinct impression of progress to the woods. The grass 'river' (opposite), looking northwards, where it passes the temple before looping round the island of planting on the left; the 'river' narrows (opposite below) before returning to the source. Many of the features shown here have been substantially changed or have disappeared altogether.

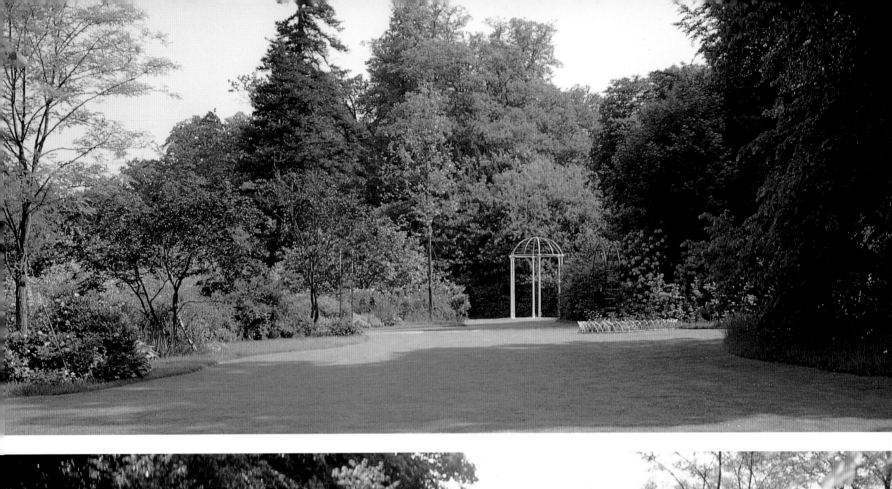
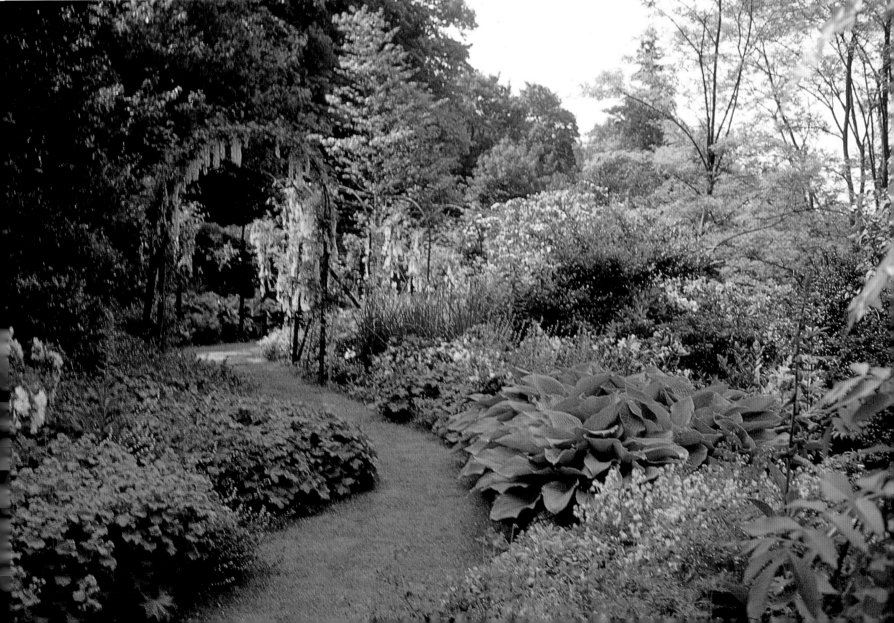

Everton Park, Sandy, Bedfordshire

LANDSCAPE DESIGN
1974
Lord and Lady Pym

A recurrent motif in Jellicoe's work is the Long Walk; the version for Everton was designed in 1975 and leads from the house to the south bosquet (right).

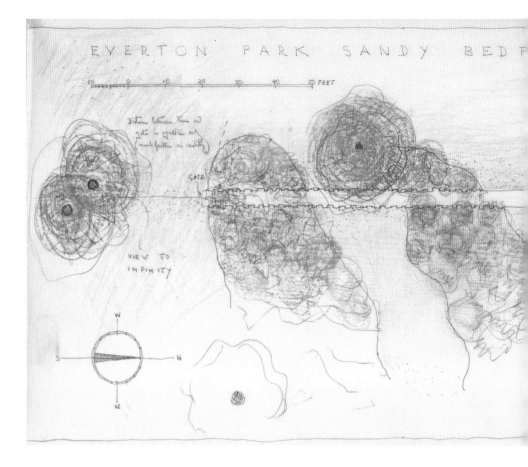

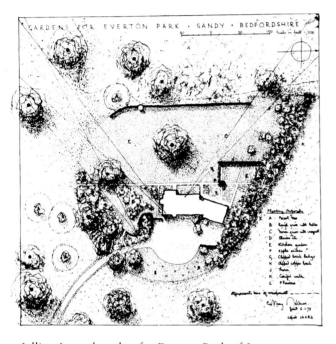

Jellicoe's garden plan for Everton Park of January 1975 shows his overall arrangement of the planting to provide two main vistas from the house through vegetation to the open countryside (above).

Susan Jellicoe's detailed planting plan for the south bosquet (opposite) created a profusion of colour to be viewed from the intersecting path of the Long Walk.

MR AND MRS FRANCIS PYM (now Lord and Lady Pym) had been long-term friends of Geoffrey Jellicoe. The project at Everton Park intrigued Jellicoe, since it was almost like following in Repton's footsteps. Indeed the Pyms still have the original 'Red Book' of designs by Repton. The scheme evolved over more than ten years; Susan Jellicoe drew up the overall planting plan.

The major feature of the proposal, now fully executed, is the Long Walk, as Jellicoe named it, which runs due north-south and defines the extent of the garden proper and emphasizes the westerly orientation of the principal rooms. (The drawing here was made some months after the commission.) The continuation of the Long Walk to the south bosquet (designed by Susan Jellicoe) has been highly rewarding. The Long Walk is enhanced by rose beds on the south elevation of the house, lavender borders on the west terrace, and to the north-west side by a herb garden. To the north, the Long Walk finally terminates in a bosquet and the end is to be marked by an ornamental urn, statue, or vase.

The planting proposals for the scheme exemplify Jellicoe's usage of distinct categories of planting and ground cover. The conifer wall is today fully realized. Two viewpoints have been created, but the recent expansion of the town of Sandy below is skilfully hidden. The Long Walk assists this effect by stretching the outlook westwards.

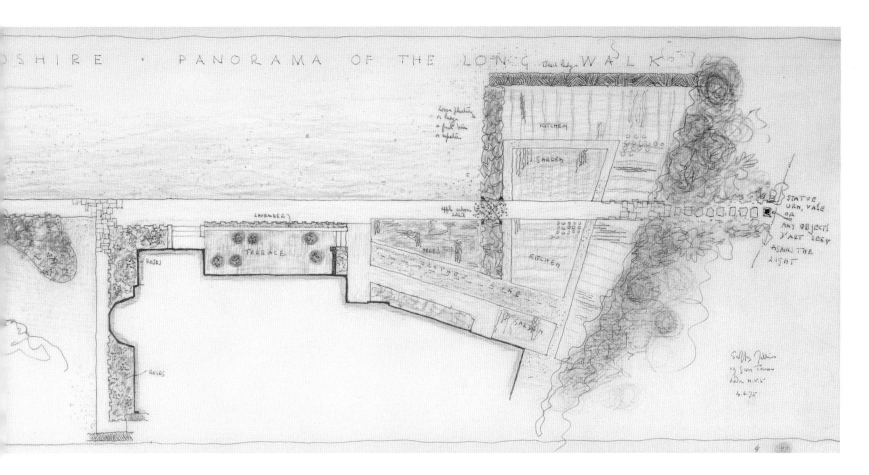

G.A.J. The new house was built modestly in neo-Georgian style to suit conditions of living after the second world war. It lies on the fringes of the Repton park along the escarpment a few hundred yards from the mansion. The approach from the east and the north is protected by the service quarters, the domestic views being towards the west and south. Climatically and physiologically the continual presence of the great view over the Bedfordshire plain (now partly industrialised) was overwhelming, and has been closed by clipped hedges, except for specially placed openings. Privacy being paramount, the east is also closed; and by further closing from the north the 'feel' of the gardens is directed towards the ruined mansion and its place in history. The design of the garden is intended to balance classical order with natural disorder.[10]

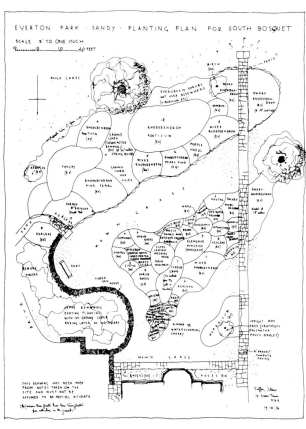

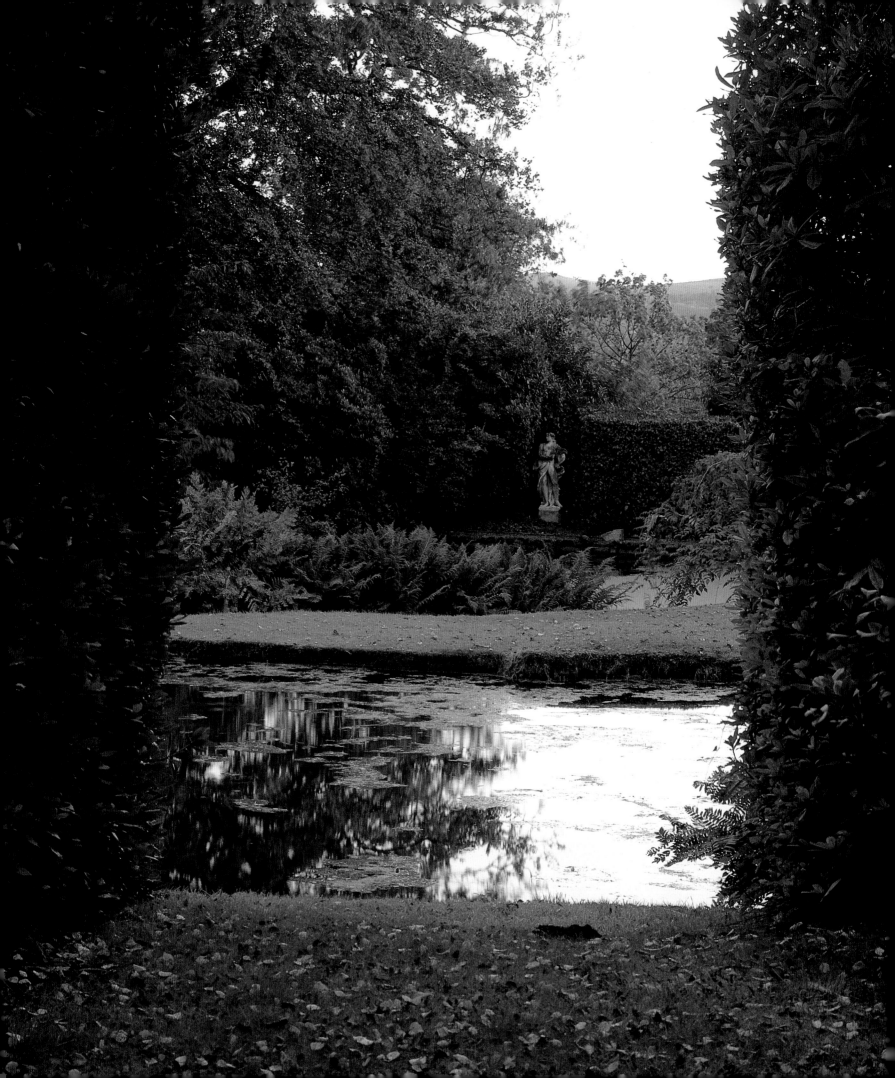

THE GARDEN DESIGN for Shute, near Shaftesbury, was commissioned from Geoffrey Jellicoe by Michael and Lady Anne Tree in 1970. Shute House occupies an ancient English site, set on a Wiltshire ridge with superb views southwards over rolling downland. The house itself stands between the open escarpment of the site to the south, and the village road which passes the house grounds immediately to the north. Aware of the ancient history of the site, the Trees were immediately fascinated by a mysterious spring, the source of the river Nader, at the head of the watercourses which run southwards through the grounds from the summit of the ridge to the boundary of the garden.

Over the following twenty years, Shute became a laboratory for the evolution of Jellicoe's ideas, developed in collaboration with Michael and Anne Tree at every stage.

The Shute waterscape, as Jellicoe describes it, incorporates a timespan of over two millennia in its evolution. The canal is a superb fantasy, crowned by three busts commemorating Virgil, Ovid and Lucretius. Jellicoe has inserted two ingenious balconies so that the visitor can pass across the head of the canal, below the Augustan poets and a miniature classical amphitheatre of cut box hedges; the whole area remains formalized and the green is only highlighted by the presence of some wisteria and numerous deeply implanted arums, resistant to winter frosts. At the point of departure here the visitor is forced to stoop to pass a discrete grove of ilex trees. This comprises the geometrical hinge that leads into a regular grouping of six square box beds. And audible to one side is the long rill which Jellicoe inserted as a dramatic focal point, incorporating a harmonic series of cascades. The rill descends via a series of bubble fountains to join the westward course.

Moving through the box beds, which display an overwhelmingly natural ensemble of mixed annual and perennial growth, the visitor is drawn along past a carefully located acacia (mop-headed) towards the latest experimental area: here, on the edge of the garden, a space is evolving that appeals directly to man's subconscious sense of mystery, where Jellicoe has mixed classicism and romanticism. Entry is through a green laurel tunnel leading to a temple garden in miniature. From inside the gazebo's bell-shaped structure, now wholly covered in ivy, new views appear to the east. On an adjacent, triangulated structure a large crystal stone is to be placed which will capture the evening sun. Here, too, is another place of contemplation, where the rational mind of man is abetted by the subconscious.

Shute House, Wiltshire

GARDEN DESIGN
1970–93 (commission 1970; major works 1975–80; revision 1993)
Michael and Lady Anne Tree
Mr and Mrs John Lewis (1993 revision only)

This view across the upper pool at Shute (opposite) *leads the eye quite deliberately to the downs beyond. In the middle ground, on the far side of the second pool, is a stone figure which enhances the sense of mystery and ambiguity in this part of the garden.*

The oddly shaped ilex grove at Shute (above) is situated between the canal and the parterre flower garden; it was named 'the Philosophers' Grove' by Jellicoe.

The point of entry to the box beds from the ilex grove (opposite), the mystery of the grove is left behind for the main formal part of the garden.

Shute's final development phase spans precisely the period in which Jellicoe's career has flourished through such major projects as Sutton Place, Brescia, Modena, and the Moody Gardens in Galveston, Texas. The first evidence of this great flowering is already there at Shute: the unique sequence of watercourses, emanating from the original spring, provides repeating views, contra-axes, greater and lesser foci, which are the prime features of this essentially philosophical garden.

G.A.J. Shute House lies deep in the Wiltshire countryside close to Shaftesbury. With a rich scenery of hills and undulations this area was one of the birthplaces of the English school of Landscape. Wardour Castle is across the valley; Fonthill, Stourhead, and Longleat are hard by. The house itself is a complex of history from the mediaeval to the Palladian. The estate lies on the south slope of a ridge with a highly fertile soil riddled with springlets. The parent spring lies at the top of the site and was undoubtedly the cause of settlements here since the Roman occupation. The garden existing in 1969 consisted of a grass terrace facing south, a ha-ha, two ancient pools that may have been fishponds, and obscured view towards distant downs. Adjoining the terrace was a brick wall at an angle behind which lay a kitchen garden, dense woodlands, and a curious dog-legged semi-formal canal which received water from a hidden spring-fed pool at the change of an angle. Into the romantic, watery, semi-wilderness behind the wall have been devised seven or more green compartments each informed with differing historic cultures, with different shapes and different moods.[11]

The landscape, before alteration, like the house, was a complex of romantic charm. Water from the spring flowed downward through dense woodlands, along the way feeding water shapes made at different dates for different purposes, and finally flowing into a partially obscured scene of distant downs, along which ran an ancient way across southern England. There was never any doubt that it was the thought, presence, action, and sound of water that was holding together the competing ideas that had been introduced into the woodlands – ideas remotely associated with Islam, Greece, the Middle Ages, the primeval, and other times and cultures. It was not until the summer of 1988, when the view was opened up and an abstract design of further pools introduced, that a unity of earth and sky became apparent.[12]

In *The Guelph Lectures* (1983), Geoffrey Jellicoe describes the key features of Shute.

The south elevation

The house lies directly on the south side of a lane that follows a ridge leading out of Donhead St. Mary. The front facing the village is eighteenth century Palladian; behind are buildings dating from the Middle Ages, when it is known to have been a pilgrims' rest. The site seems to have been occupied since Roman times, the attraction then as now being a perpetually flowing spring at the highest level, providing the head waters of two streams either side of the ridge. From the grass terrace before the house are seen, clockwise: a framed view of the church tower, the grand south panorama, and a curious brick wall at an odd angle. It is what lies behind the wall that has placed this garden so early in the saga of history.

The apple porch

This is the entrance to woodland gardens that are small and compartmented in space, but eclectic in time. With water, foliage and trees as building materials, the mind is invited to experience the complexities of classicism and romanticism, finding satisfaction in the unity of these two seeming opposites and traditional antagonists.

The rill

There is water in abundance, embarrassingly so when it emerges from countless subterranean streamlets, but nevertheless, the cause of abnormal fertility. The sound of water is everywhere, intensified altogether by eleven small falls or cascades. The first four of eight chutes of the rill itself are designed to form a harmonic chord of treble, alto, tenor, bass; but whether such an idea is unique is debatable, for any water sound would be pleasing in such a setting. In the distance is a sculpture, brought from Mereworth Castle, in Kent, the previous home of the owners.

The bubble fountains in the foreground are gravity worked, an idea derived from Kashmir. Behind the small view terrace at the summit of the cascades there was planned a conservatory inspired by that which once existed at Chatsworth, having an interior of moss or fern walls kept continuously damp. The realisation of this would have proved too costly in structure and maintenance, and its place as crucial to the composition has been taken by clipped yew and beech hedges, now high enough to disengage the rill gardens from the contrasting world of the grottos.

A view of the harmonic cascades on the Shute rill (opposite); successive viewing points are provided by stone slabs laid across the watercourse. The banks on either side of the rill are now covered with abundant growth from earlier plantings by Lady Anne Tree.

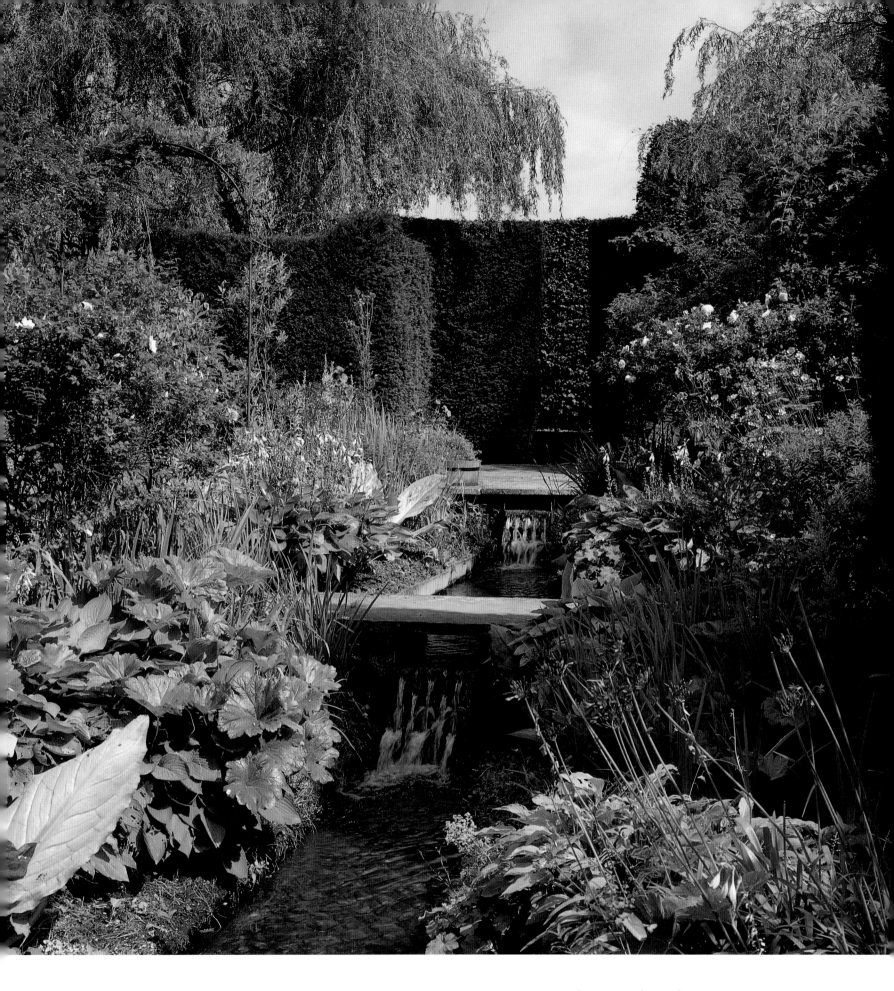

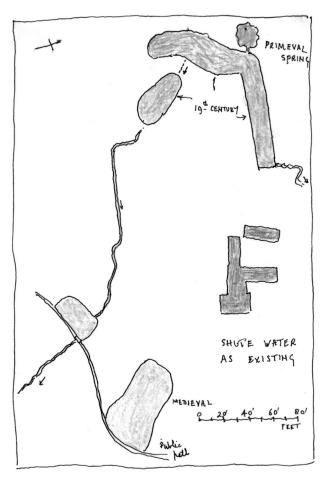

PRIMEVAL SPRING

19ᵗʰ CENTURY

SHUTE WATER
AS EXISTING

MEDIEVAL

0 20' 40' 60' 80'
FEET

Public
Path

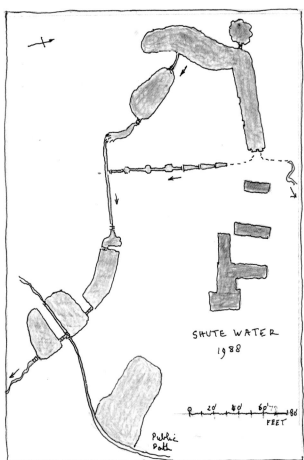

SHUTE WATER
1988

0 20' 40' 60' 80'
FEET

Public
Path

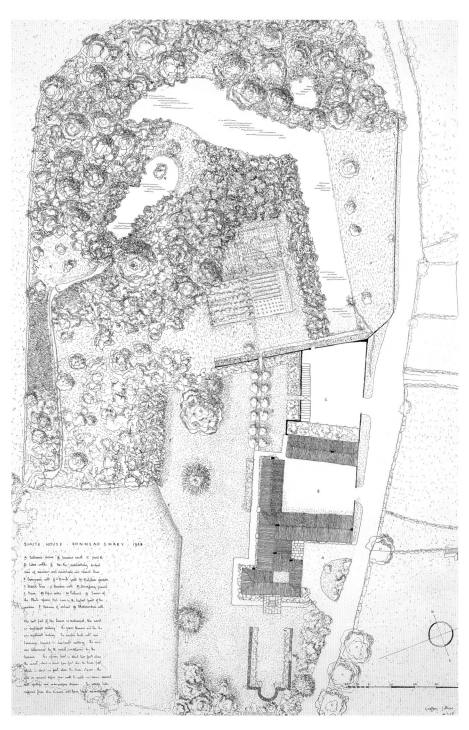

SHUTE HOUSE · DONHEAD S.MARY · 1968

The changes in the water régime at Shute House are clearly shown in these two sketches of 1988 (left above and below). The plan of the gardens (above) shows the original water areas.

A very late colour drawing (1993) by Geoffrey Jellicoe (opposite) shows the gardens at Shute in their most complete form according to his original plan. The original plan for Shute (right) shows clearly how water was to be used as the main linking element in the design, by connecting the pools, the canal and the rill, all derived from the same source.

Fold out ▶

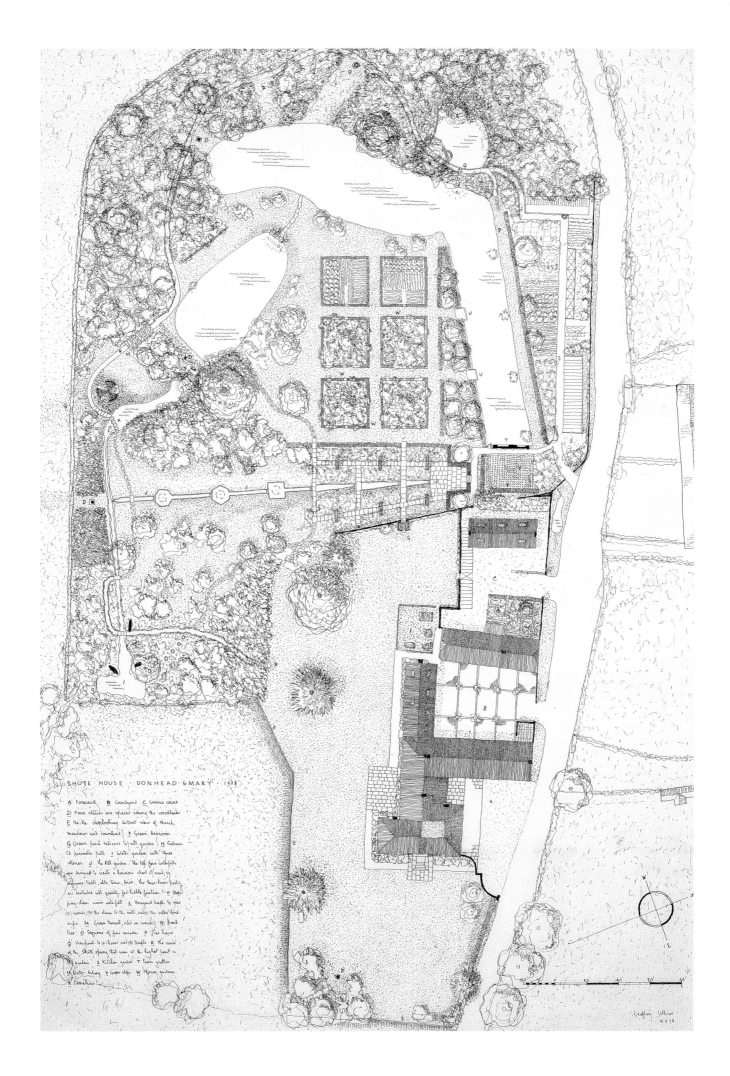

SHUTE HOUSE · DONHEAD S.MARY · 1978

A Forecourt B Courtyard C Service court
D Four statues one placed among the woodlands
E Ha-ha overlooking distant view of church,
meadows and woodland F Green bedroom
G Green porch entrance to rill garden H Entrance
to perimeter path I Water garden with three
stones J The rill garden : the top four waterfalls
are designed to create a harmonic chord of sound, in
sequence : treble, alto, tenor, bass. The three lower/pools
are distributed with gravity-fed bubble fountains K Steps
pass stone across waterfall L Hexagonal temple to view
(a) cascade, (b) the stream to the south, and (c) the outer land-
scape M Green tunnel, vista on cascade N Beech
hive O Sequence of four cascades P Tree house
Q Viewpoint to (a) house and (b) temple R The source
of the Shute spring that rises at the highest point in
garden S Kitchen garden T Lawn grotto
U Water tablery V Green slope W Mexpens gardens
X Camellias

 Geoffrey Jellicoe
 15.3.78

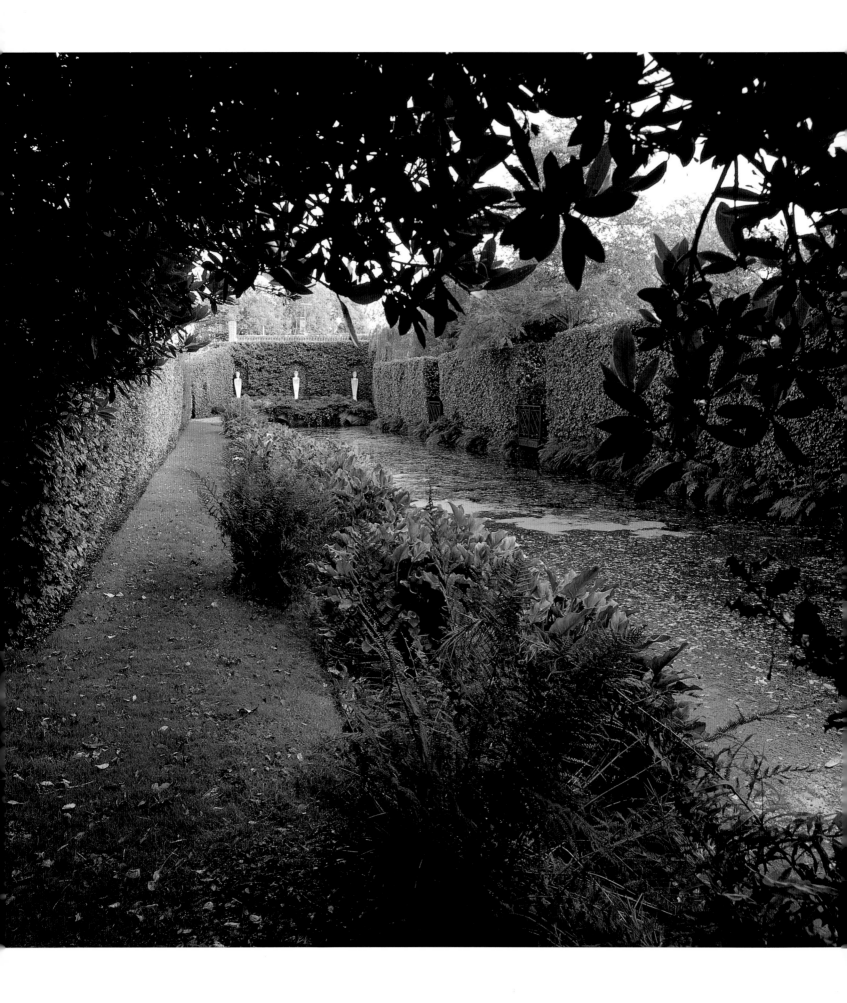

The silhouette of the twin grottos brings the sequence of red-tiled roofs down to the water. The grottos illustrate an element essential to landscape art. With their black background giving an illusion of depth, they symbolise the divided flow of water either side of the hill. Our intellect knows that in fact the water itself leaves the canal ignominiously through concealed man-holes, but our imagination lifts the *idea* of the flow of water into the heroic. The grottos themselves, influenced by William Kent, are the first backward step in time as we proceed along the perimeter path.

The grottos

The view westwards along the canal at Shute from its north side (opposite); *at its far end can be seen the busts of Virgil, Ovid and Lucretius above the grottos.*

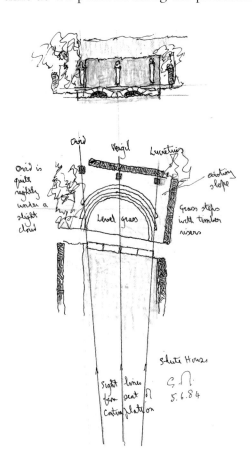

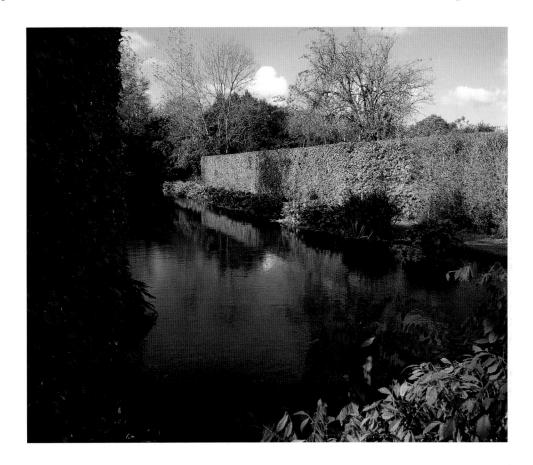

Anti-clockwise the perimeter path leads through clipped hedges to the straight canal. In the distance is the cascade from the hidden pool, the source of the water. The path passes behind the grottos and along the canal, giving glimpses of the inner garden through the water balconies. The canal turns and the scene changes from the classical to the romantic, another sculpture from Mereworth being seen beyond the water against dark trees and foliage. The path plunges into the woodlands and arrives at the two-way seat of contemplation, one part looking outwards towards the house and the other inwards to what the Greeks would undoubtedly have designated the 'sacred' spring.

The canal

A sketch plan (above left) *of the end of the canal illustrates the principles of perspective in relation to the figures of the Latin poets.*

A view of the north side of the canal (above) *shows the thick box hedge which screens the kitchen gardens.*

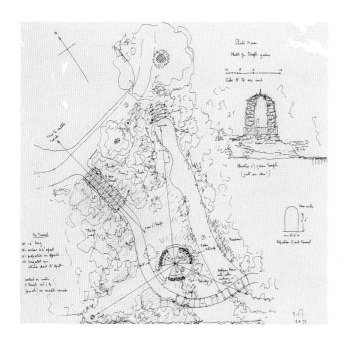

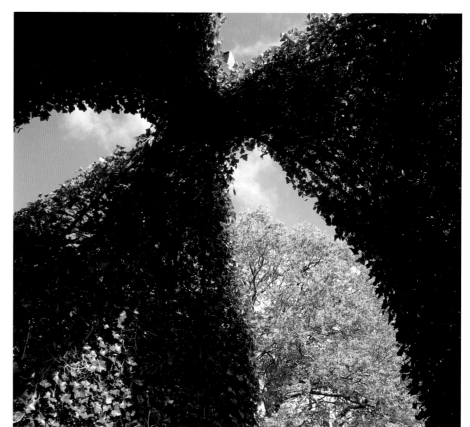

The temple

The path continues through woodlands with two accidental glimpses of the garden across water. You emerge beside a lower lake and plunge immediately into a green tunnel. Beyond, in a small exclusive enclave in the woods and open to the agricultural landscape beyond, is a hexagonal ivy temple.

This is the second step backward in time. One balcony overlooks the dark recesses of the largest of the cascades and the rivulet below, another looks towards the outer landscape, and the third (in due course) to the present-day equivalent of a mythological urn. You leave this temple by hazardous stepping stones across a lower cascade – hazardous because no eclectic landscape can be complete without an element of peril, real or imaginary.[13]

(In 1990 Geoffrey Jellicoe made an addition to the temple garden.)

G.A.J. 'Lady Anne bought a rock crystal to catch the rays of the setting sun and she wanted to put it somewhere remote and mysterious to be a "magic" stone. I had previously designed a temple garden with a quasi-gazebo made of unclipped ivy, approached through a green tunnel. Lady Anne and I evolved the idea of mystical shapes made of clipped yews. It should be a place where a child might be slightly frightened.' Already the iron skeletons which will form the base for topiary are on site – abstract chessmen, perhaps, or still figures from another planet.[14]

A plan and outline of the temple in the allegorical garden (above); the temple 'roof' allows views of the changing sky and foliage (above right).

Jellicoe designed individual cast-iron frames in anthropomorphic forms at Shute for the growth of individual shrubs in the allegorical garden (opposite).

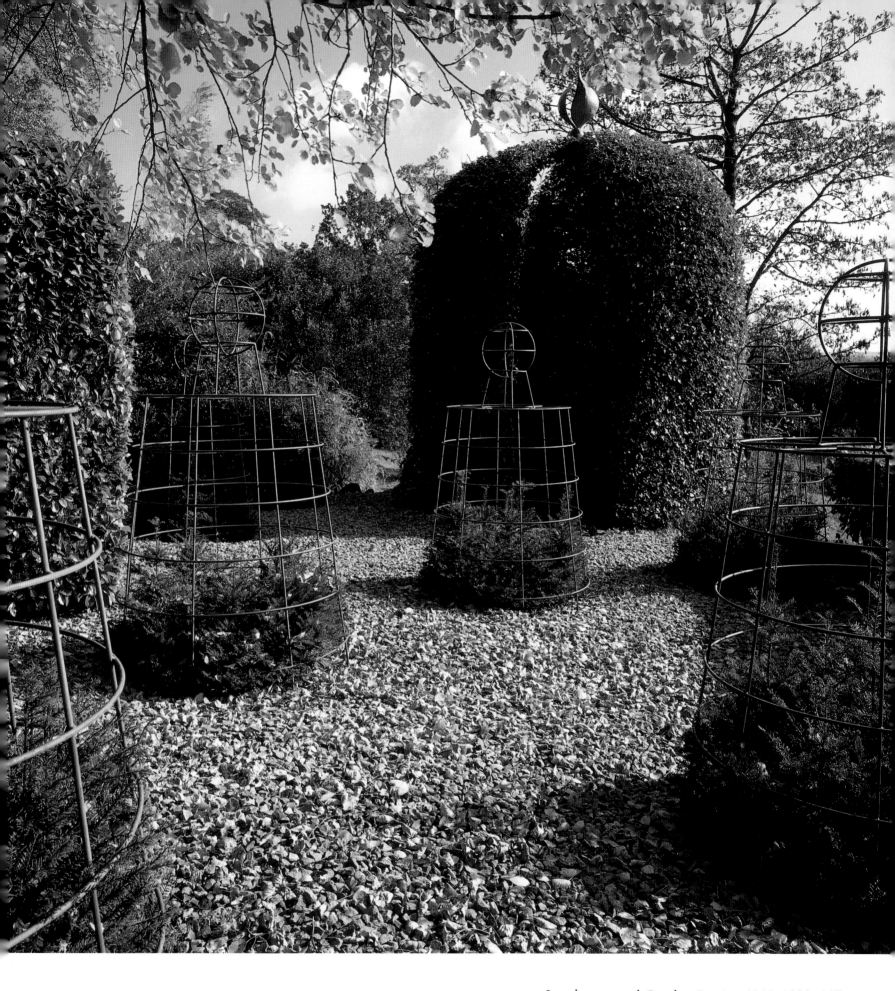

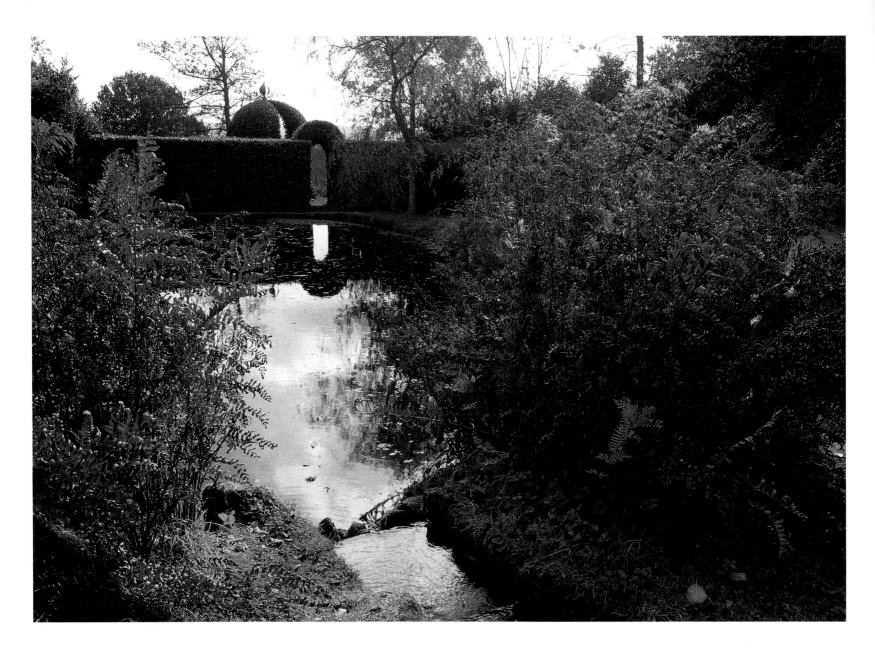

The view southwards at Shute (above) *across the pool to the point of entry to the allegorical garden through the laurel arch; the upper part of the temple is visible above the hedge (see p.8).*

This proposal for the main features of the allegorical temple garden was subsequently replaced by the design for a glass equilateral triangle upon which the rock crystal could be placed, but this has never been completed.

The stone-bog garden

Stepping stones (opposite) *lead from the allegorical garden to the bog garden.*

After threading your way through foliage and crossing the lower end of the rill, you enter the bog garden in which three great stones are set. The long journey in time ends with one of the oldest ideas in the relation of man to environment – the Chinese philosophy of an analogy between man and the rock from which he emerged, and the human significance of the stone itself. Three stones were chosen, for their personality, from a near-by disused quarry, and after discussion, were disposed on the site in a relationship that was unaccountably agreeable.

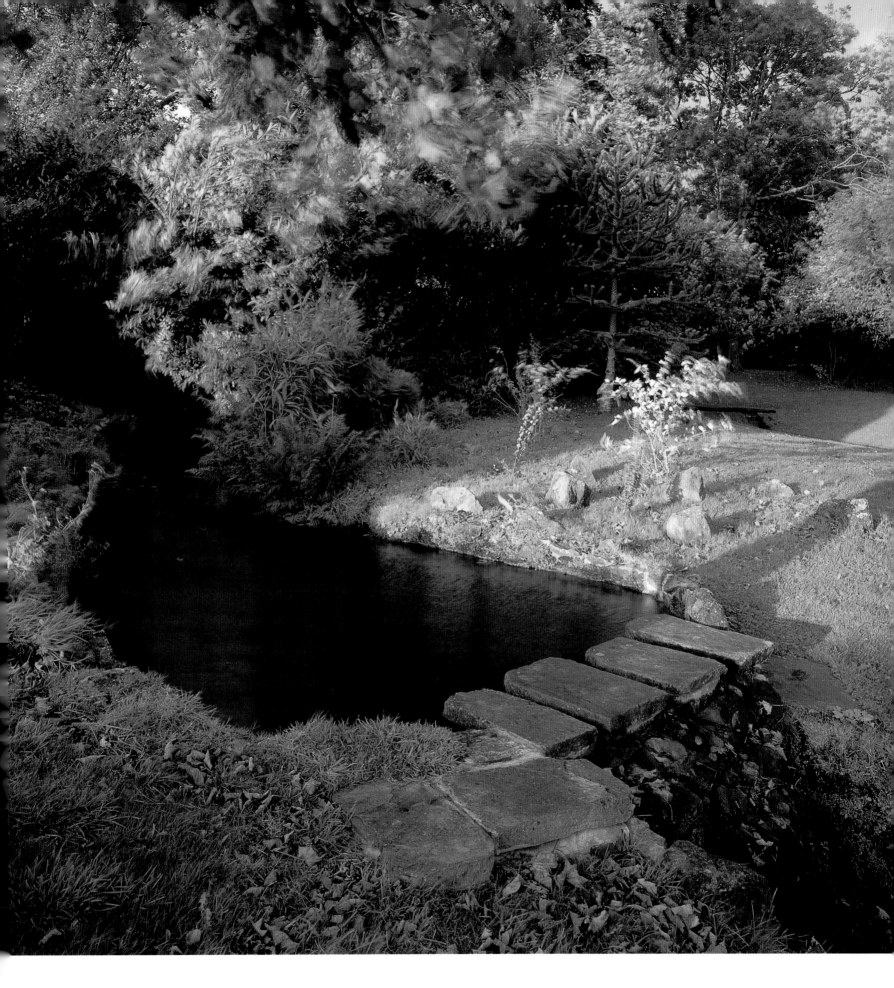

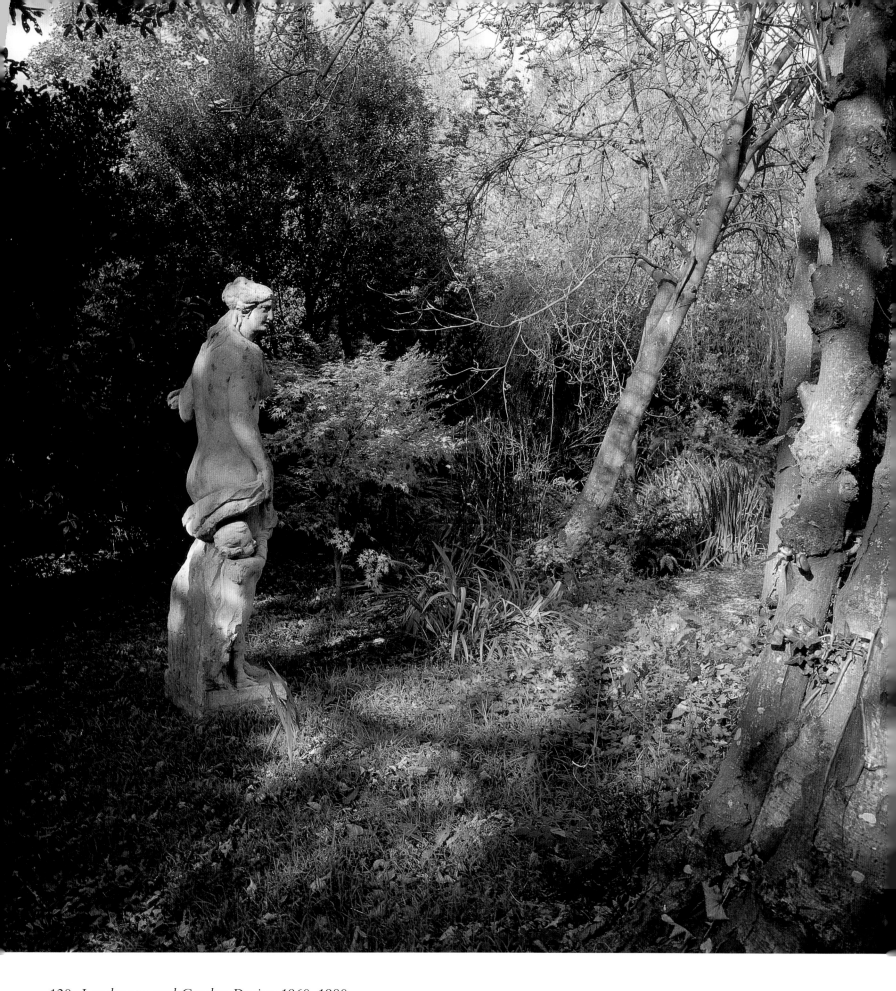

It is theoretically possible to create a true harmonic water chord from four cascades, but scientifically speaking it will require as much research as any musical instrument. The Shute cascades are a happy affair of hit or miss, made simply of copper Vs set in concrete. The greater the number of Vs, the more fragmented is the water and therefore the lighter the tone as it falls on the calm water below. This at least is the reasoning, the Vs growing less in number as they move downstream through trebles, altos, tenors and bass.

The water from its source in the highest pool finds its way southwards by two routes, one classical (canal and rill) and the other romantic (lower pool and temple) the two re-uniting before entering the bog garden. The three cascades of the romantic route are formed from stones selected from the adjoining quarry. The stones of the upper cascade were chosen for their horizontality and the specification for positioning was so simple that they were constructed by a local stonemason with an instinctive understanding of what was required.[15]

The 'alto' cascade: a note on detail

The 'romantic' movement of water through the garden, as opposed to the 'classical' features of canal, rill and cascade, is especially exemplified by the middle pool, its southern tip defined by a lone statue (opposite). Viewed from the trees to the north-west (left) it takes on a special air of mysterious tranquillity.

The stepped cascade in detail

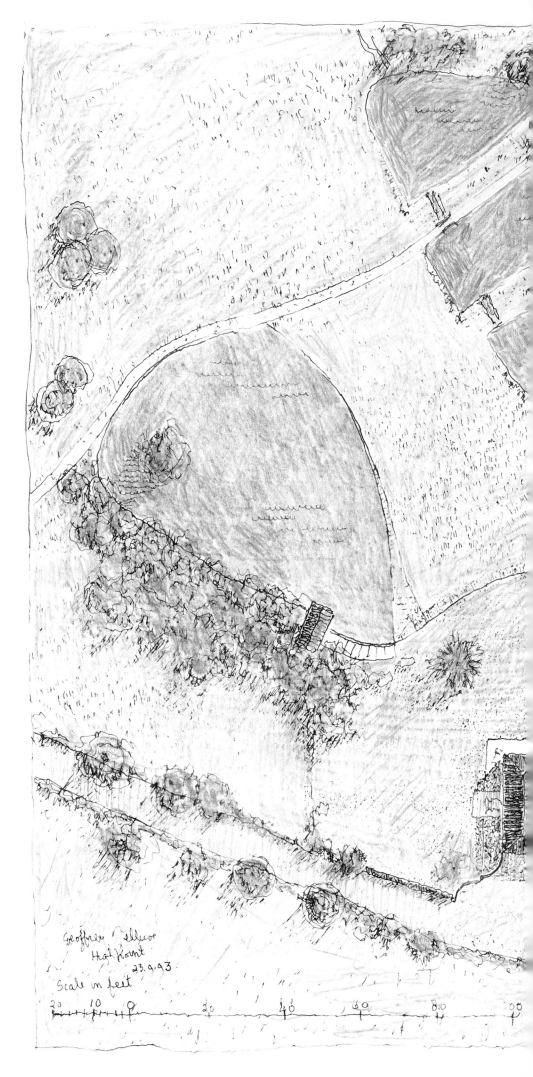

In 1993 Shute House and its gardens changed hands and Geoffrey Jellicoe was requested by the new owners to make certain modifications to the design. In his own words these were, '... a swimming pool inserted into the existing landscape as a water square of contemplation; and a lake extension for boating united to the existing pools by counter curves ...'. The pool can be seen clearly positioned in the detail and in the main plan on the site of the box beds, giving it a direct relationship with the main axis of the rill.

Geoffrey Jellicoe
Highpoint
23.9.93

Scale in feet

20 10 0 20 40 60 80 100

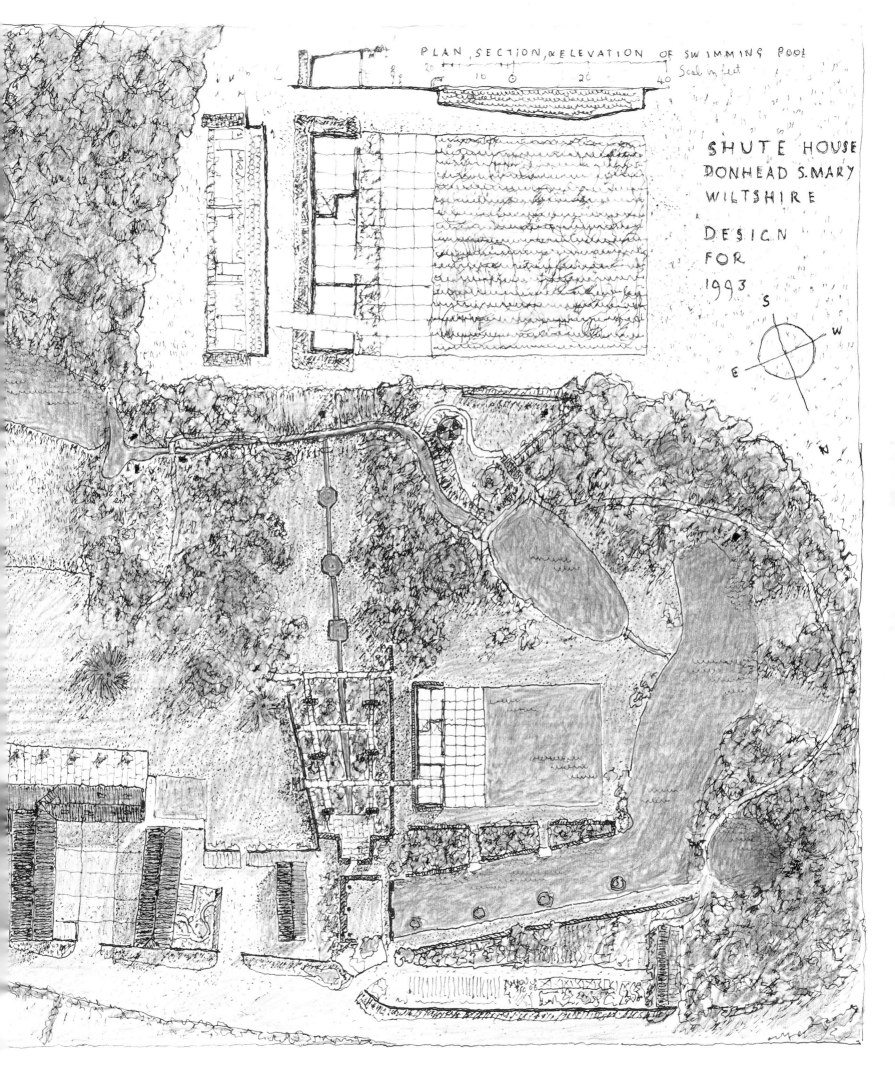

PLAN, SECTION, & ELEVATION OF SWIMMING POOL
20 10 0 20 40 Scale in feet

SHUTE HOUSE
DONHEAD S. MARY
WILTSHIRE

DESIGN
FOR
1993

S
W
E
N

PLAN, SECTION, & ELEVATION OF SWIMMING POOL
Scale in feet

Hartwell House, Aylesbury, Buckinghamshire

GARDEN DESIGN AND RESTORATION
1979–89 (later design uncompleted)
Cook Trust et al.

The equestrian statue in the entry forecourt of Hartwell House was retained in all of Jellicoe's landscape plans.

A view (c. 1738) by the Spanish painter, Balthasar Nebot, towards the Gibbs pavilion, complete with ornamental canal (opposite above)*; this latter feature was in fact never constructed. The south façade, designed by Henry Keene in 1759* (opposite below left)*; Jellicoe has proposed building an extensive terrace here to link the house to the walk through the 'fish' garden and so on to the Gibbs pavilion* (opposite below right)*. The hedges around it have been restored and the classical busts re-erected in Jellicoe's scheme.*

THE COMMISSION for Hartwell House was important for Geoffrey Jellicoe in that it stretched his talents at a time when he was in search of a project that would provide intellectual stimulus and challenge. As the following comments indicate, he found the complexity of the house and its relationship with the surrounding park intriguing; he was also pleased to be following in the footsteps of James Gibbs and others. There was an inherent riddle about the site of the Gibbs pavilion: had it been aligned or intended to be aligned, as the contemporary Spanish painter Balthasar Nebot suggested, on the axis of a long canal? Should this feature, then, be restored? This and other uncertainties seemed to Jellicoe to permeate the landscape park.

Subsequently, a decade later, Jellicoe was invited by the Cook Trust and the operators of the new hotel at Hartwell House to submit further plans for the park. He proposed new works linking the house and the stable block, with a cascade on one side; opposite this, across a restored terrace, a superb garden in the shape of a fish was to lead guests to the Gibbs pavilion.

G.A.J. Hartwell House is about two miles to the west of Aylesbury. The present landscape, with its grey old buildings, mature trees and grass, is beautiful enough, but it is confused. The mansion is half Jacobean and half eighteenth-century classical, aligned on a central axis marked by a grand avenue. The Jacobean half looks out on a Gothic revival church splendidly placed on rising ground – the temporal and the spiritual in dialogue, as it were – across a sea of parked cars and undergrowth. At the back, in front of the eighteenth-century façade, is a haphazard inner garden enclosed by a sinuous ha-ha, beyond which is an isolated classical pavilion lost in trees. The pavilion faces a distant and partly concealed bridge with a lake beyond, the bridge, in turn, facing towards the church. Various bric-à-brac enrich the scenery: a castellated tower, a standing column, an obelisk, and a superb but discreetly placed equestrian statue of Frederick, Prince of Wales. It is not at first easy to appreciate that within this extraordinary scene lies a conception of space, and of objects in space, that is unique to England.

Although the settler was on the site before Domesday, the earliest record is of an Elizabethan house within a formal garden, beyond which were a church, approach road and stable. Nothing remains of these buildings, but a print shows conclusively that the present ethos of the place had been established. Thereafter, evolution followed the normal course of the settler.

James Gibbs, designer of the classical pavilion, appears on the scene in the first half of the eighteenth century, fresh from Ditchley Park in north Oxfordshire and with two years' experience of

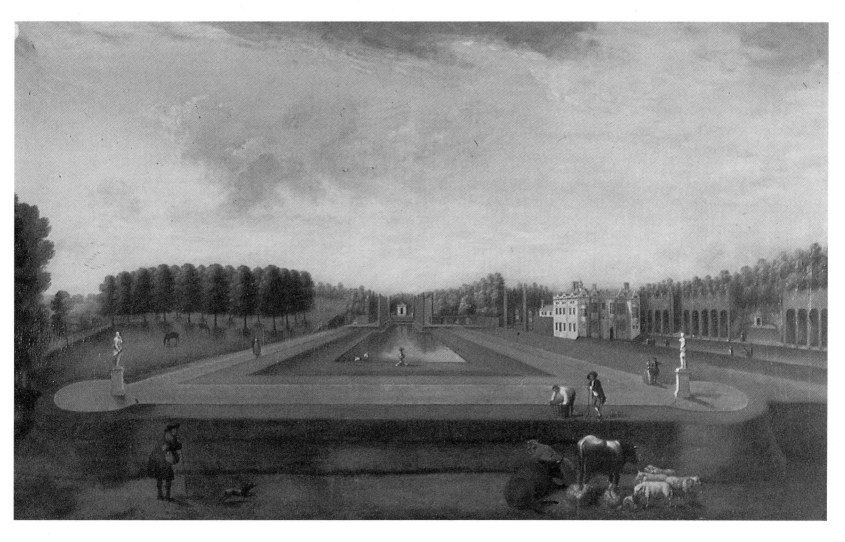

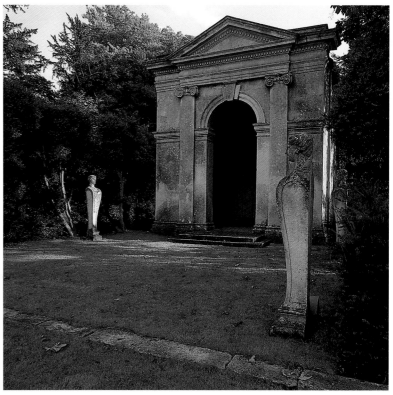

Baroque space in Italy. It seems probable that Gibbs inspired a remarkable series of paintings of a classical garden at Hartwell by the Spanish painter Balthasar Nebot, now in the Aylesbury Museum, but there is no evidence that this ever existed. Instead (as at Ditchley), fashion in landscape changed, classicism was out and romanticism in. Only the pavilion was executed by Gibbs, who also placed various objects in the park; the present composition was carried out by his sympathetic successor Henry Keene.

But the heroic age at Hartwell was not to last. It was incomplete. Although it resolved the conflict between the settler and the hunter instincts so agreeably, it did not take note of the instinct for flowers and personal flower gardens that is inherent in women. At the end of the century, therefore, the poet William Mason, enshrouding the house in flowering shrubs and wavy paths (and possibly replacing a geometric forecourt with the present shapeless one), deliberately began the disintegration of the heroic. This movement, the Picturesque, led to Victorian sentimentality and gives warning of what may happen when one of the primary instincts is repressed. The result at Hartwell was confusion, which was increased in the next century by such a Victorian addition as a circular pool, and other delightful miscellanea.

The mansion is now a hotel (1989). The interior is entirely changed, but the landscape, beneath the apparent confusion of phase upon phase, is constant. The plan of 1979 is not intended to change the course of history but to reveal it as a continuum that is by no means finished. The plan is intended to reveal the essence of landscape history and adapt it to modern needs. It is in this respect, therefore, a *re*creation rather than an original design. The inessential in history has been eliminated. The essential is the classical geometry (from Jacobean to Renaissance) which dominates; the heroic romantic landscape that interweaves with it; and the tender 'gardenesque' (if the wavy paths can be so-called) that complete the

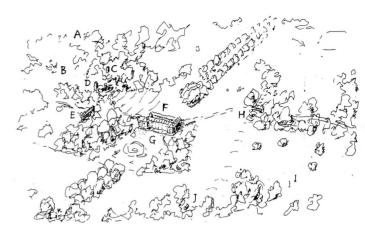

This sketch (above) *emphasizes Jellicoe's tree planting concept for Hartwell; it still indicates the site of the round Victorian pool which formerly dominated the rear garden, seen clearly in this aerial photographic view (*below left*).*

KEY. **A.** The Hartwell, **B.** Village, **C.** Battlemented folly tower, **D.** Gothic revival Parish church, **E.** Classical stable, **F.** Tudor mansion, **G.** Classical mansion, **H.** Bridge, **I.** Column of George II, **J.** Gibbs pavilion, **K.** Gibbs statue, **L.** Equestrian statue of Frederick Prince of Wales.

The path through the shrubbery (opposite), *leading from the Gibbs pavilion in the direction of the house; in the 1989 proposal this section of the garden is emphatically laid out in the form of a fish.*

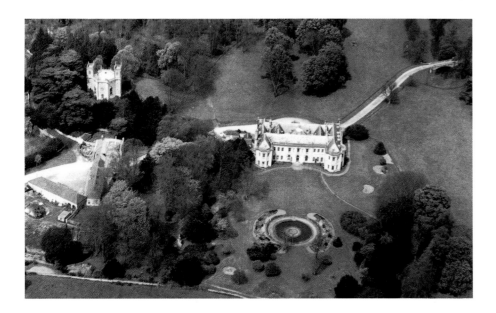

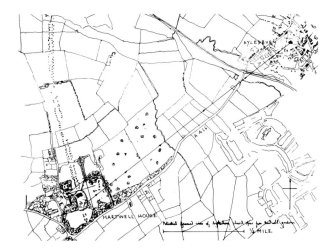

Sketch plan by Geoffrey Jellicoe (above) of the Hartwell estate in its immediate setting; he has noted the potential vista towards the spire of Aylesbury church.

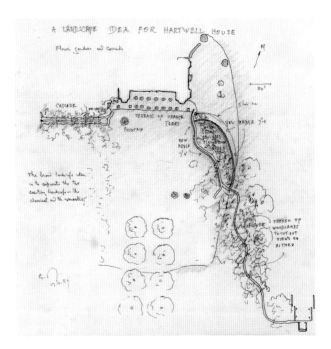

A preliminary sketch (above) for Jellicoe's proposal of 1989 (opposite); the development of the 'fish' garden at the head of the winding way to the Gibbs pavilion is clearly shown in both plans. The 1989 proposal has not been implemented and the gardens remain roughly half way between the original design of 1979 (right) and the new design; the circular form of the entrance drive, for instance, has been introduced.

composition. To adapt itself to the car, the forecourt has been extended to add dignity to what is still a noble façade and to allow parking only on exceptional occasions. A new car park for daily use is an extended 'after'-court to the eighteenth-century stables. A sun terrace has been formed south of the house. The equestrian statue of Frederick has been opened to view from the stables entrance (as apparently shown in the 1777 plan); the Gibbs pavilion has been dignified by clipped hedges to frame a potentially beautiful picture of bridge and lake beyond; a view of Aylesbury church spire opened up, in sympathy with the Nebot paintings; and clear views within the triangulation restored.

This plan is intended to be like a tapestry woven of once antagonistic threads, now reconciled and each part of unified whole, whose 'time' is the present.[16]

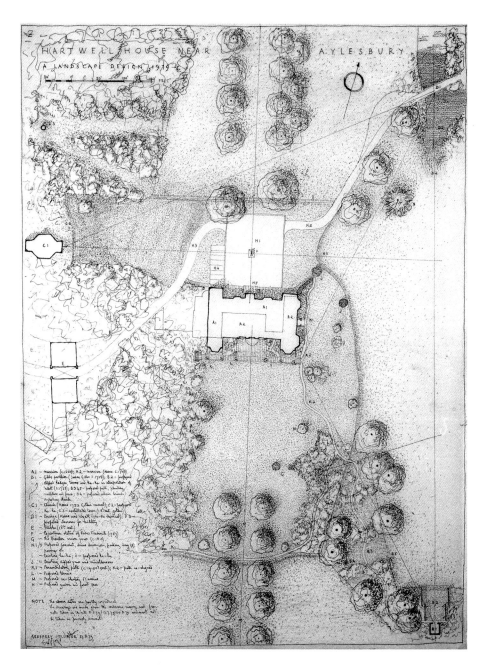

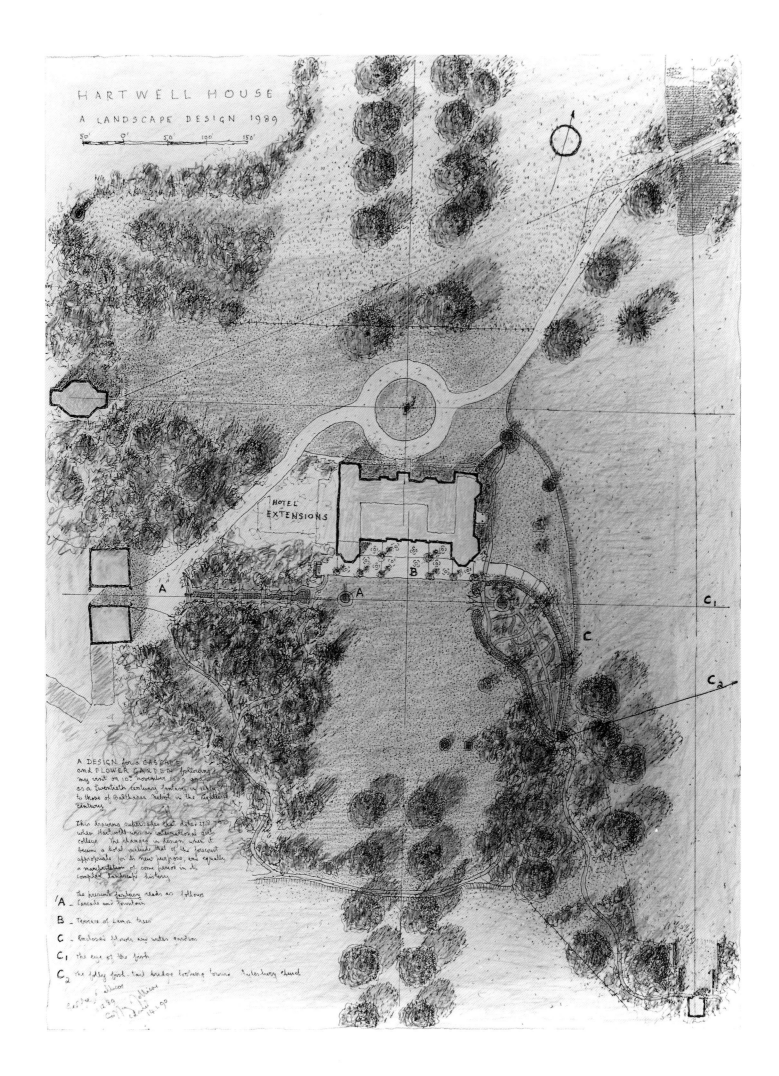

HARTWELL HOUSE

A LANDSCAPE DESIGN 1989

50' 0' 50' 100' 150'

HOTEL
EXTENSIONS

'A

A

B

C₁

C

C₂

A DESIGN for a CASCADE
and FLOWER GARDEN following
my visit on 10ᵗʰ November 1989 and
as a twentieth century fantasy in relation
to those of Balthasar Nebot in the eighteenth
century.

This drawing supersedes that dated 28.7.90
when Hartwell was an international girls'
college. The changes in design when it
became a hotel include that of the forecourt
appropriate for its new purpose, and equally
a manifestation of some period in its
complex landscape history.

the present fantasy reads as follows

'A Cascade and fountain

B Terrace of Lemon trees

C Enclosed flower and water garden

C₁ the eye of the fish

C₂ the ogley fish-tail bridge looking towards Aylesbury church

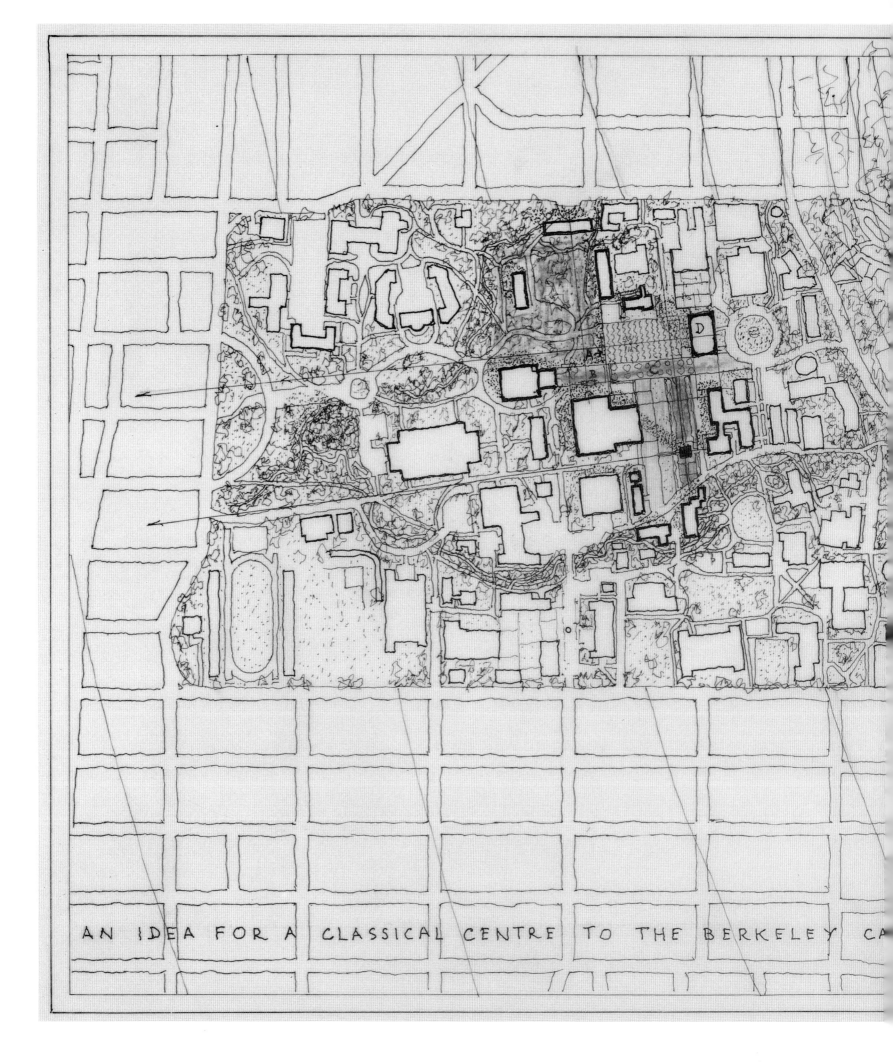

AN IDEA FOR A CLASSICAL CENTRE TO THE BERKELEY CA

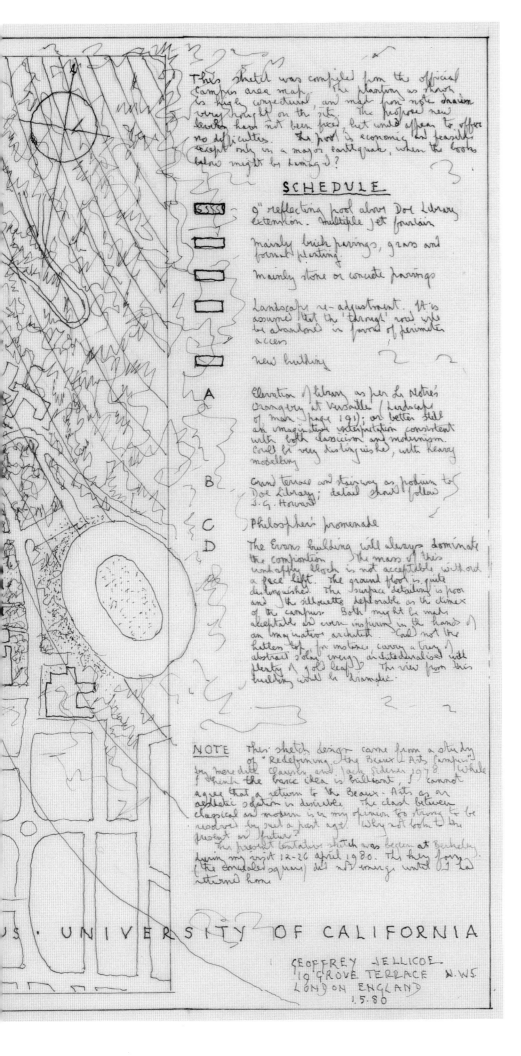

LANDSCAPE SUGGESTION (uncompleted)
1980
Personal

Geoffrey Jellicoe's planned revision of the layout of the central campus at Berkeley was inspired by the work of the Russian Suprematist painter, Kasimir Malevich. It foresaw the imposition of a distinctly Modernist plan on the original Beaux-Arts layout. This was more a visionary exercise than a concrete proposal and no part of it was executed.

ON A VISIT to Berkeley Geoffrey Jellicoe dicided to submit some ideas for the landscaping of the central campus; he proposed a departure from the formal Beaux-Arts scheme that already existed. Jellicoe sought to unify the disparate architecture in a more liberal, Modernist context. Jellicoe had been inspired towards abstraction through the work of the Russian painter Kasimir Malevich, and it is evident that these principles served him well when he came to view the complexities of the Berkeley project.

G.A.J. A development of abstract geometry in relation to environment can be seen in the history of the campus of the University of California at Berkeley. The modest first design, a 'mall', or *tapis vert*, sloping down the hill and shooting at the sunset beyond the Golden Gate. This proved inadequate and in 1893 E. Bernard won a competition for a great outlay based on the neo-classical principles of the École des Beaux-Arts, Paris. This was developed by J.G. Howard. The symmetrical layout is dominated by a Rotonda, with independent units balanced about a central axis. A number of these classically proportioned buildings had been built when the monumental conception was itself abandoned and deliberately obliterated by a later age groping through functionalism for a more liberal expression of society. Seek out the abstract geometry from either style, however, and there emerges a unifying common denominator in space design of square, rectangle and plane upon plane. Abstract art is universal.[17]

Smaller Projects of the Period

Armagh Cathedral, Northern Ireland

GARDEN DESIGN (uncompleted)
1967
Diocese of Armagh

Though dating only from 1843, Armagh Cathedral stands on an ancient ecclesiastical site. Geoffrey Jellicoe's preliminary sketches for a garden of contemplation on the cathedral hill (opposite above) shows the effects of the time of day on the light and shade derived from the planting.

There have been only two ecclesiastical commissions during Geoffrey Jellicoe's career, both relating to cathedral approaches. The plan for Exeter Cathedral (1974) was executed as proposed, but sadly that for Armagh never came to fruition.

Already at Armagh, Jellicoe was profoundly interested in the role of the subconscious and the value of orientation as an ordering system, in this case ordained by the sun itself. The scheme proposed would clearly have enhanced the ancient meaning of the site, linking Christianity with the earlier traditions which it absorbed from the Celtic past.

G.A.J. The site for the gardens of contemplation lies immediately south of the cathedral itself and on the steep slopes beyond the massive retaining wall to the upper terrace. At the lower end, and defining what may be called the cathedral precincts, is a low, mainly eighteenth-century terrace of small houses. These face a narrow road

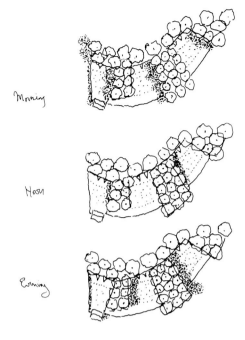

which also served buildings, now demolished, whose garden walls led upwards to meet the great retaining wall. The ruined walls divided the land into compartments facing south, and provided protection from the winds that sweep the upper terrace and make it uncongenial to plant and man alike. Because of the curvature of the hill, there is a slight variation in the orientation of each compartment.

Normally it is wise in landscape design to develop any existing features, rather than to demolish and start again. This has two advantages: it is generally more economical because the features become an asset rather than a liability; and it protects and develops the existing 'ethos'. It can often be said of landscape design that the design already exists and the designer's work is only to reveal this design and make it practicable. The physical nature of the work at Armagh has been to reconstruct the garden walls, and alternate them with open gardens and closed groves of sycamores. In the gardens are seats against the wall, set between raised stone beds of sweet-smelling plants.[18]

THE CEMENT and Concrete Association had acquired two adjoining estates, Wexham Springs and Fulmer Grange, comprising some 70 acres, in 1946 and 1961 respectively. Jellicoe was invited to prepare designs for a south-facing terrace at Wexham. Susan Jellicoe prepared the planting plan. The work was executed in 1967. The Jellicoes' work was confined to the improvements at Wexham, while Sylvia Crowe created a 'town garden' in a separate area nearby. The architects Alex Gordon and Partners were responsible for Fulmer Grange. Jellicoe also designed a characteristic long walk ('the Philosophers' Walk') linking the two estates.

G.A.J. Transformed from a sedate country house in the centre of the experimental headquarters of the Cement and Concrete Association, the demesne now comprises two nineteenth-century estates blended into a single landscape plan.

Wexham Springs and Fulmer Grange, Buckinghamshire

GARDEN DESIGN
1967–69
Cement and Concrete Association

A plan for the front terrace of the headquarters of the Cement and Concrete Association (left) *demonstrates Jellicoe's handling of planting and hard landscaping (photograph overleaf above left).*

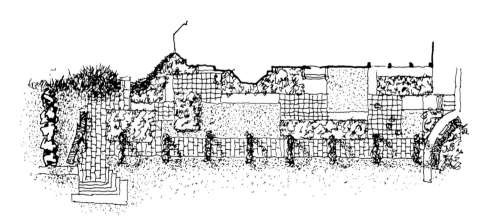

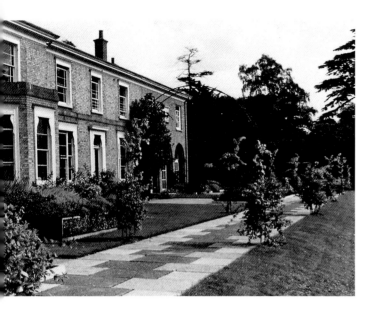

An unusually imaginative approach to landscape by a commercial company was encouraged by two factors: (a) the recognition that good landscape was good business and that those seeming opposites, plant and concrete, could in fact be happily married; and (b) that only a properly conceived design would be acceptable to the planning authorities. The challenge of design was two-fold: to reconcile technically the tenderness of the flower (the human element) with the concrete (mass-production) and more indirectly to unite the abstract idea of the domestic with that of the superhuman or gigantic – for behind the scenery lay an immense complex of offices, research laboratories and the like, not desiring to loom but equally not be ignored. The little front terrace to the house, now reception offices, was designed to resolve these differences.[19]

Sports Centre and Park, Cheltenham, Gloucestershire

LANDSCAPE PLAN AND BUILDING DESIGNS
(partially completed)
1968–71
Local Authority

THIS MAJOR design at Cheltenham for a new sports centre and surrounding landscape park, like so many other projects, was never fully realized, but it did involve Jellicoe in a re-definition of the role of classicism in modern landscape design. Cheltenham itself provided the classical context, an eighteenth-century spa town reflecting the graceful town planning of the period in its squares and terraces. Pittville was to be the centre for the new scheme, to be laid out beyond the nineteenth-century extension of Pittville Lake, close to Bristol University College of Physical Education. Jellicoe found that there was a need to reinforce the idyllic impression made by the surroundings of the lake.

Jellicoe employed familiar devices from his landscape vocabulary: the 'way' (this time modelled on the Sacred Way at Delphi); the 'vista'; water courses; and an amphitheatre, felt to be especially suitable to the context. It is interesting to note here Jellicoe's aversion to solutions of 'instant landscape', and his emphasis on the twenty-five years of good husbandry needed to ensure success.

A model of the planting and artificial hills, designed to offset the strong forms of the main sports complex at Cheltenham.

G.A.J. We have only two courses open, those same two courses that basically confront all concerned with the design of environment: whether to create a classical-romantic landscape where the building dominates skyline and scenery, or a romantic-classical landscape, in which the buildings become subsidiary. The former is the easier and the more obvious, the latter requires considerable upheaval but is the more promising. All landscape architects at this point of decision should take courage from, for instance, Picasso, who would not hesitate to turn topsy-turvy into topsy-topsy-turvy if this must be done. The valley which has become a plateau shall become a hill, which for good measure we will call Mount Kronos. The waters of the spring shall flow backwards.

It is now comparatively easy to design a total change in the existing scenery. There is a thick screen of trees at the end of the lake. This enables us to swing the landscape away from the building and along what is left of the original valley. The relation of this scenery to the building is not unlike that of the Grecian valley to the mansion at Stowe, beside which it passes. The path itself similarly continues independently of the building in the manner of the Sacred Way at Delphi. *En route* it passes the pool of the inward flowing waters, past the open air theatre scooped out of the hillside, and so upwards to Mount Kronos. From this tree-clad view-point, which breaks and dominates the skyline, and below which and 'leaning up against it' is the stadium, it will be possible to have a panorama of the enfolding Cotswold hills and the distant Malverns. To the north the railway has disappeared, the banks lowered and converted into a tree-lined road, and over this the eye will continue to another far-off rounded hill, this time real, and already designated Mount Olympus. The full length of this Grecian landscape running from the lower slopes of the Cotswolds into the centre of Cheltenham is about two miles.

The soil movements in the baths and stadium have been designed to be in balance, i.e. 'cut' equals 'fill'; but surplus soil from the town will continue to be dumped to create Kronos and the lesser hills. Thereafter tree-planting (hardwood in the valley, conifers on the summits) takes place, and since this is as vital to the scheme as are the trees at Olympia, it may be twenty-five years before the scene is completed as it was imagined. This time factor is far beyond that of architect, sculptor, or painter, and indicated the difficulty of trial-and-error experiments in landscape architecture. But the art would assuredly lack something if it were governed only by the need for 'instant landscape'.[20]

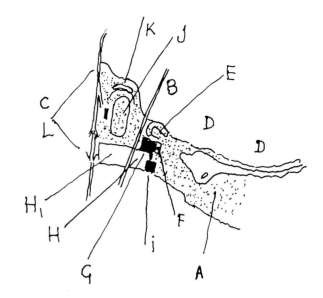

A summary sketch of Cheltenham in 1990:

KEY. **Existing Landscape. A.** Pittville park and lake, **B.** Road, **C.** Railway on embankment, **D.** Golf course. **Executed works. E.** Open-air theatre, **F.** Sculpture garden, **G.** Swimming pool complex, **F.** Car park. **Projected works. H.** Car park, **I.** Sports pavilion, **J.** Stadium, **K.** Mount Kronos, **L.** Road replacing railway.

A model of the amphitheatre at Cheltenham, with related planting.

Villa Corner, Treviso, Italy

GARDEN DESIGN (uncompleted)
1969
Anonymous Client

THIS DRAWING, dated November 1969, is a remarkable scheme and of great significance in Jellicoe's development. Although intended to be a fully worked scheme, there are elements of fantasy which in retrospect are of great interest. For Jellicoe, still occupied in a large practice, the drawing represented an outpouring of the author's deep knowledge and understanding of the Italian Renaissance garden. In his seventieth year, the significance of this was critical. The client never pursued the project – but that may have been largely irrelevant; Jellicoe was here re-orientating himself. The drawing was executed at speed, yet has considerable detail; it is perhaps best considered as a visual taxonomy of Renaissance garden design.

The commission encompassed the entire grounds. From the top of the area, where the ground rose sharply, Jellicoe planned a substantial rill, exploiting the fall in the land; this ends in an ornamental pool to the west of the villa. The shallow water-course that extends from the central portico of the villa, however, continued in the same direction, supposedly (says Jellicoe) to infinity in the flatlands beyond.

There were several sources for this display of post-Renaissance landscape drama. The various shades of green planting, with no floral diversity to speak of, derives from the archetype, the Villa Gamberaia; the extensive plantings of box, yew and ilex, with avenues of cypresses for shade, also echo the garden at the Villa Gori, Siena. The vast *bosco* is possibly derived from that at the Villa Torlonia. Other interest is provided by sculptured figures, single-jet fountains and the lemon pots. The low elevation does not provide much terrace viewing of the numerous geometrical parterres drawn in from memory, but these would be more readily viewable from the house itself. A maze is hinted at in the south-west corner, but this is unfinished.

The Villa Corner project is significant precisely because it reveals Jellicoe's deep nostalgia at this time for his early experiences in evaluating the design of the most notable Italian gardens. It must have provided some relief from the more mundane pressures of running a professional practice.

The design for the Villa Corner gardens (opposite) gave Jellicoe a unique opportunity to draw on the original design vocabulary he had derived from his early work on Italian gardens. Unfortunately, the design was never carried out, due to the death of the client, but this project may well be seen as the beginning of Jellicoe's mature style. Note the compartmentalized, enclosed sub-gardens in the Italian style and the strong axis of the rill.

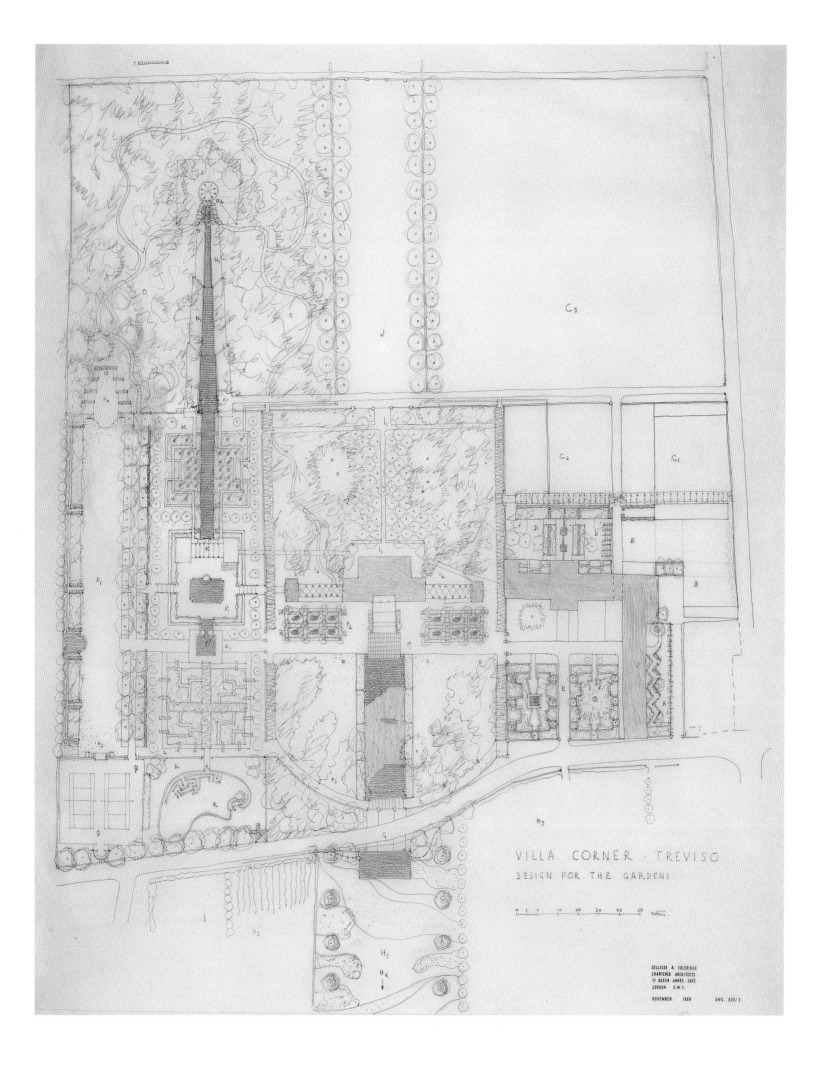

VILLA CORNER · TREVISO
DESIGN FOR THE GARDENS

JELLICOE & COLERIDGE
CHARTERED ARCHITECTS
17 QUEEN ANNES GATE
LONDON S.W.1.

NOVEMBER 1969 DWG. 829/2.

Chequers, Buckinghamshire

LANDSCAPE CONSERVATION
1972
H.M. Government

Jellicoe's proposed avenue restoration at the Prime Minister's country residence avoids complicated detail and concentrates closely on tree husbandry. At the north end of the avenue, two distinct tree rings were foreseen. Indeed, the avenue plan does not in fact depend on lines of trees, but represents a sequence of rings linked by intermediary lines.

JELLICOE'S avenue restoration (Victory Avenue) eschewed complicated detail yet concentrated closely on wise tree husbandry. At the north end of the avenue, two distinct tree rings were separately established. Indeed the avenue is not in fact composed of lines of trees, but represents a sequence of rings of trees linked by intermediate lines.

G.A.J. The grand concept of landscape design as a tranquilliser and restorative in an overburdened modern world was formally recognised when Chequers was presented to the nation by Lord Lee of Fareham as a country residence for the prime minister of the time – a place far from Whitehall to which diplomats of all nationalities could be invited for conference and where the Cabinet itself could meet in peace. The house itself is basically Elizabethan and additions, like the rose garden of 1905 and the post-war Churchill avenue, are subordinated to this style. The accompanying plan for this whole estate made in 1972, separates the geometrical man-made inner landscape from the romantic landscape of the Chilterns in which it is set – symbolising man's endeavours to create his own ordered, stable world in one that is in constant flux and beyond human comprehension.[21]

The Hussey Memorial, Scotney Castle, Kent

MEMORIAL DESIGN (uncompleted)
1970–72
Mrs Christopher Hussey

This sketch by Geoffrey Jellicoe of July 1970 for a memorial stone to Christopher Hussey looks backwards to his most famous work in this category, the Kennedy Memorial at Runnymede.

THIS DESIGN for a memorial stone to Christopher Hussey, the architectural author and critic, was prepared by Geoffrey Jellicoe for a site at Scotney Castle at the request of the family. Although the scheme was never carried out, it represented Jellicoe's standpoint on the matter of commemoration and extended a repertoire that already included both the Walsall Memorial Gardens and the Kennedy Memorial at Runnymede. In this tribute to a long-standing friend and supporter, Jellicoe preferred the simplest of designs, in a natural location and carved in stone.

Framingham Hall, Norfolk

LANDSCAPE PLAN
1971
The Coleman Family

THIS PROPOSAL was drawn up in June 1971 and, like some previous schemes (Villa Corner, Treviso), is a very early example of the change in Geoffrey Jellicoe's drawing technique at this time. The scheme, however, was not executed as originally proposed.

Water gardens, incorporating no less than seven pools, form the principal axis running north-east; a long walk runs south to east from the existing house. Numerous secondary elements are inserted, incorporating new planting of woodland varieties. The church spire, as at Hartwell and Buckenham Broad, is again brought into focus via a specific 'tunnel' feature here. Already perceptible are many landscape elements which were to become distinct items in Jellicoe's vocabulary. At the same time, the drawing technique was changing, although it still lacks the finesse and resolution of later years.

This landscape plan in ink and crayon is an early example of Jellicoe's mature style of representing the salient features of his vocabulary: water along the dominant axis; the Long Walk running south to east; purposefully grouped planting.

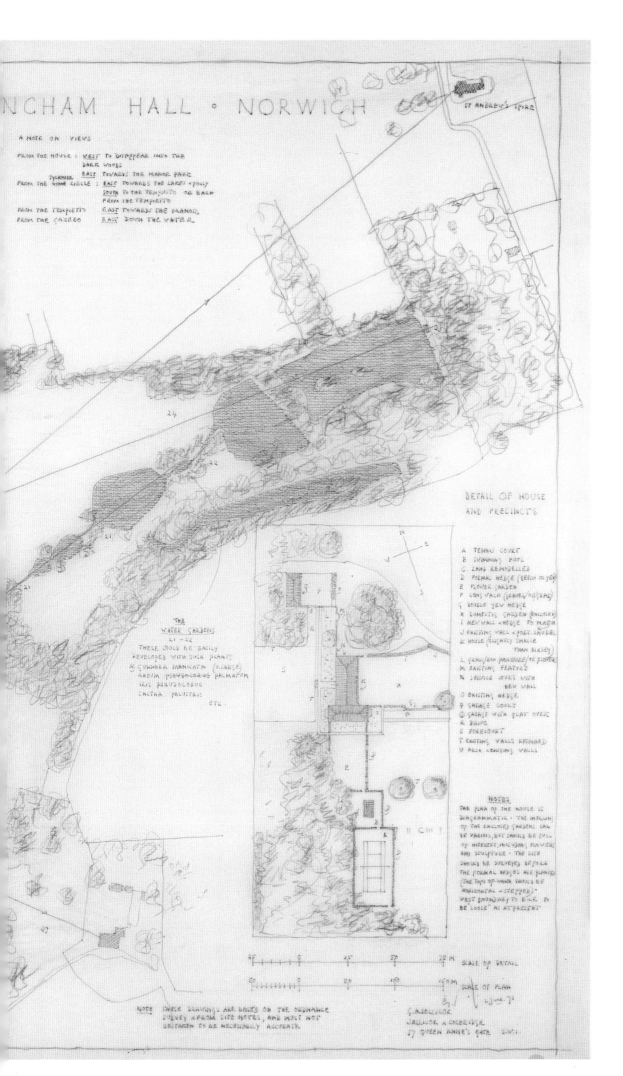

NCHAM HALL ○ NORWICH

A NOTE ON VIEWS

FROM THE HOUSE : WEST TO DISAPPEAR INTO THE
 DARK WOODS
 SYCAMORE EAST TOWARDS THE MANOR PARK
FROM THE RIME CIRCLE : EAST TOWARDS THE LAKES & FOLLY
 SOUTH TO THE TEMPIETTO OR BACK
 FROM THE TEMPIETTO
FROM THE TEMPIETTO EAST TOWARDS THE MANOR
FROM THE GAZEBO EAST DOWN THE WATER

THE
WATER GARDENS
21 - 22
THESE COULD BE EASILY
DEVELOPED WITH SUCH PLANTS
A GUNNERA MANICATA (V. LARGE)
RHEUM (PSEUDOACORUS PALMATUM
IRIS PSEUDOACORUS
CALTHA PALUSTRIS
 ETC.

DETAIL OF HOUSE
AND PRECINCTS

A TENNIS COURT
B SWIMMING POOL
C LAND REMODELLED
D FORMAL HEDGE (BEECH OR YEW)
E FLOWER GARDEN
F LONG WALK (GRAVEL / OR GRASS)
G DOUBLE YEW HEDGE
H DOMESTIC GARDEN (ENCLOSED)
I NEW WALL & HEDGE TO MARCH
J EXISTING WALL & PORT. LAUREL
K HOUSE (SLIGHTLY SMALLER
 THAN BIXLEY)
L GRASS/BOX PARTERRE/OR FLOWER
M EXISTING FEATURE
N SERVICE COURT WITH
 NEW WALL
O EXISTING HEDGE
P GARAGE COURT
Q GARAGE WITH FLAT OVER
R DRIVE
S FORECOURT
T EXISTING WALLS RETAINED
U NEW EXISTING WALLS

NOTES
THE PLAN OF THE HOUSE IS
DIAGRAMMATIC · THE INFILLING
OF THE ENCLOSED GARDENS CAN
BE VARIOUS, BUT SHOULD BE FULL
OF INTEREST, INCLUDING FLOWERS
AND SCULPTURE · THE SITE
SHOULD BE SURVEYED BEFORE
THE FORMAL HEDGES ARE PLANTED
(THE TOPS OF WHICH SHOULD BE
HORIZONTAL & STEPPED) ·
WEST BOUNDARY TO BE 'TO
BE LOOSE' AS AT PRESENT

RF |·····|·····| 25 50 75 M SCALE OF DETAIL

 |·····|·····| 50 100 450 M SCALE OF PLAN

NOTE THESE DRAWINGS ARE BASED ON THE ORDNANCE
SURVEY & FROM SITE NOTES, AND MUST NOT
BE TAKEN TO BE NECESSARILY ACCURATE.

G. A. JELLICOE
JELLICOE & COLERIDGE
17 QUEEN ANNE'S GATE S.W.1.

Bridgefoot Area, Stratford-upon-Avon, Warwickshire

LANDSCAPE DESIGN FOR RIVERSIDE
1971–75
Local Authority

Jellicoe's original plan for the Stratford development; it is interesting to compare this more finished version with the sketch plan (p.35). The stretch of water around the island was never completed.

IN 1971 Geoffrey Jellicoe was commissioned to review the landscape close to the Memorial Theatre and around the site of the new Hilton Hotel. The plan illustrates the degree to which his deployment of key elements was already part of an established method. He proposes here an island linked by bridges, a tree-topped mound and terraces with yew green arches. As at Hemel Hempstead, the grass banks are permitted to run down to water level. The graphic technique, while showing signs of 'sketchiness' and pressure of time, is already advancing towards the precision of the large drawings of the nineteen-eighties.

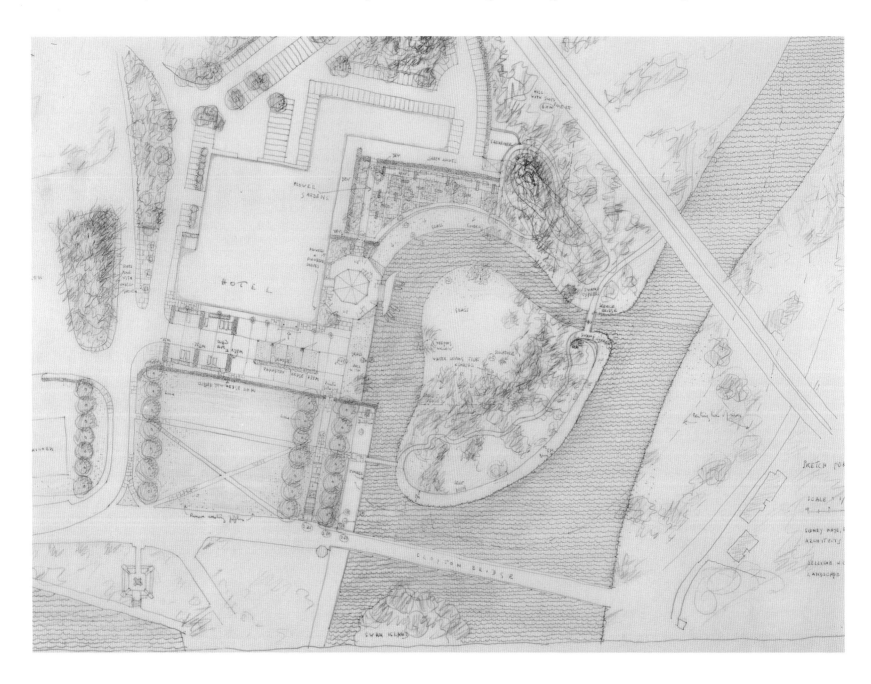

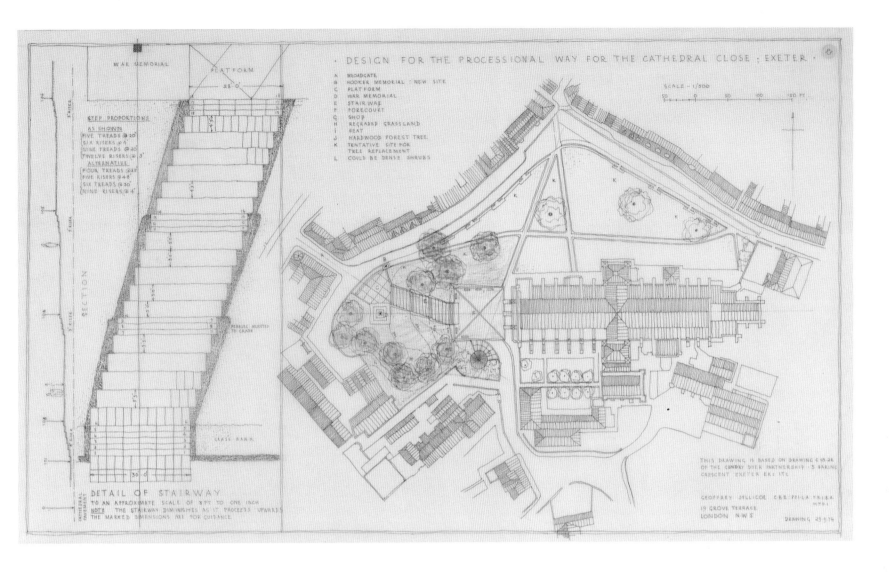

THIS COMMISSION, to design the surroundings and immediate approach to the west end of the cathedral, was an unusual one for Jellicoe, but was eventually executed more or less in line with his original proposals. An initial stairway of stone steps with three-inch risers at varying rather than regular intervals creates a rhythm in the movement down to the entrance forecourt. A final flight of six steps has risers of four inches on what has become a forty-foot wide span. At its commencement, the flight of steps is only twenty-eight feet wide, and subtle adjustments are made by grouping steps and varying the height of the riser. The step widths also vary, from four feet nine inches at the top, to five feet in the middle of the flight, to five feet three inches close to the base. There are eighteen steps in all.

Exeter Cathedral

PROCESSIONAL WAY
1974
Diocese of Exeter

The design for the Processional Way for Exeter Cathedral, dated 29 September 1974, shows the detailed design of its most important feature, the flight of steps.

The Grange, Northington, Hampshire

GARDEN DESIGN
1975
Sir John Baring (now Lord Ashburton)

BY 1975 the Baring family had moved out of The Grange, their ancestral home, into a new house close to the walled garden of the estate, still overlooking the lake but from a different viewpoint to that of the original home. That year Geoffrey Jellicoe was commissioned to prepare plans to improve the outlook.

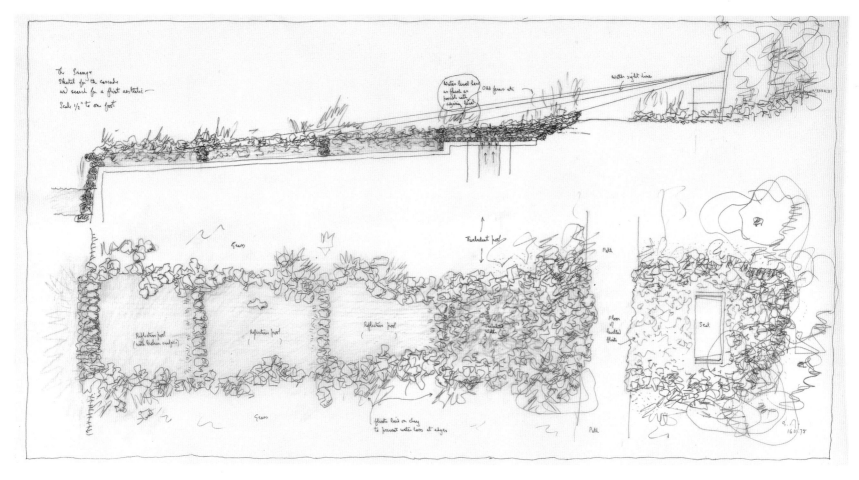

Jellicoe's detailed design of 16 July 1975 for a cascade to run down to the lake.

The drawing of 23 July 1975 (opposite above) shows the architect's concern with opening up the vistas from the house to the surrounding landscape. The island in the lake offers the opportunity of return views to the original Palladian mansion.

The drawing dated 23 July 1975 incorporates plans for a cascade, a Chinese bridge leading to the island in the lake, and a seat there offering views to the original site of The Grange itself. In addition, larger and more extensive views were opened up to the west.

The drawing dated 16 July 1975 is a sketch for the proposed cascade, which Jellicoe designed using flint stones over which the water would run.

In the following years a number of mature trees were lost in gales, substantially changing the views, and the cascade was never built. However, the various other aspects came together well to sustain a vision which both designer and client shared, and one which echoed the seventeenth-century tapestry on a wall of the dining room which has an arcadian view of the lake.

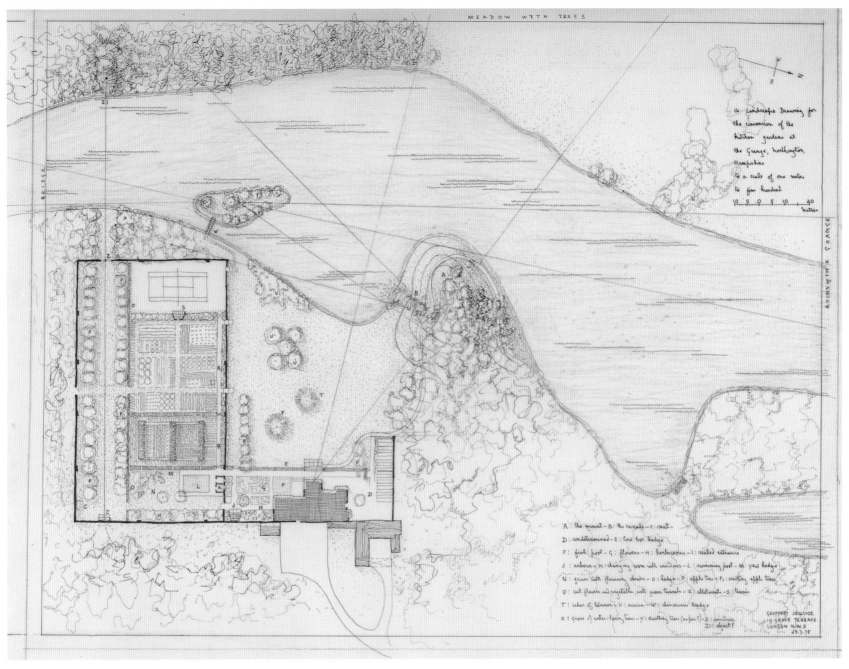

MEADOW WITH TREES

a Landscape Drawing for
the conversion of the
kitchen gardens at
the Grange, Northington,
Hampshire
to a scale of one metre
to five hundred
10 5 0 5 10 30
 metres

A : the mount — B : the cascade — C : seat —
D : undetermined — E : low box hedge
F : fish pool — G : flowers — H : herbaceous — I : sealed entrance
J : arbour — K : changing room with windows — L : swimming pool — M : yew hedge
N : grass walk (flowering shrubs) — O : ledge — P : apple tree — P₁ : existing apple tree
Q : cut flowers and vegetables, with green tunnels — R : allotments — S : tennis
T : cedar of lebanon — U : acacia — W : chinoiserie bridges
X : grove of water-loving trees — Y : existing trees (aspen?) — Z : windows,
Z₁ : object?

GEOFFREY JELLICOE
19 GROVE TERRACE
LONDON N.W.5
23.7.75

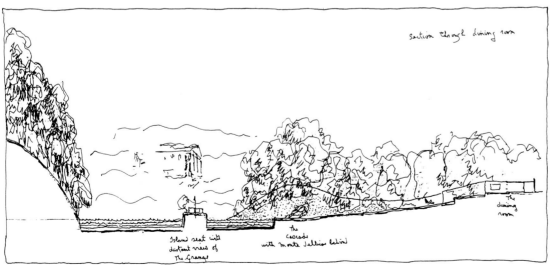

section through dining room

Island seat with
distant views of
The Grange

the
Cascade
with Monte Jellico below

the
dining
room

*A sketch section of the cascade,
with a glimpse of the house in the
background* (left).

Landscape and Garden Design 1960–1980 · 145

The 1976 plan for the formal garden at Dewlish (right) with designs for the trellis arbours reminiscent of those at Sutton Place.

Dewlish House, Dorset

GARDEN DESIGN

1976

Mr and Mrs Boyden

THIS SMALL GARDEN is a compact example in the sequence of garden schemes which Geoffrey Jellicoe began designing in 1965. It is made up essentially of a substantial trellis arbour with an extended balcony or elevated walk along a flint wall, together with two seats, a sculpture, and loosely arranged shrubs and lawn. From the balcony, a formal axis leads to a swimming pool via steps, stepping stones, and stone pavings.

Dewlish House lies close to the remains of a Roman villa, with which it is aligned by way of a formal lawn, pool and fountain. Hidden from the main lawn by a jasmine arbour and 'tunnel' are a swimming pool and a summer house. The lake has two artificial islands and a temple site is planned for the opposite bank.

An overall plan of the garden of Dewlish House executed during the summer of 1977 in ink and crayon, showing the relationship of the enclosed garden to the lake and of the whole scheme to the Roman villa site.

THE COMMISSION for Buckenham Broad House was important for Jellicoe. Here he was confronted by the direct relationship of a landscaped garden to 'primaeval wild'. There are also indications on the site of extremely early settlement, as well as the presence of two ancient parish churches in opposite directions from the house. The house itself, as indicated on the coloured plan, is a long building with ancillary structures and an existing formal garden. After making a detailed survey of levels, Jellicoe proposed two raised islands in the re-entrant corner where the long rivulet approaches the house to the immediate south west. Thus the view from the main drawing room of the house through the window on the south-west gable end extends far across the wild landscape. To the south-east, in constrast, Jellicoe proposed a secret seat giving a formal vista towards the distant Norman flint round tower of St. Mary's church in the distance and, in the opposite direction, towards a footpath leading through the woods to the similar church of Buckenham village.

SURROUNDING an Edwardian house, this is one of the transitional projects in terms of Jellicoe's technique. He was already evolving such methods of graphic presentation as marking grassed areas with ink dots which, though time-consuming, became a characteristic of his style. The sketchiness of the 'practice' years disappear: trees become clearly marked by position and the overall shape of the design is made more emphatic in the drawing.

Close to the house, a terrace lawn has been created on the line of an existing ha-ha. A statue is positioned to the south, establishing a vista emphasized by two rows of poplars on either side. The lawn is composed of rougher grass around the house, quite distinct from the cut lawn of the rest of the terrace. The area close to the house is also distinguished by ilex and chestnut. Two 'tunnels' in metal extend from the terrace on either side, creating a sense of enclosure but also giving access outwards.

Five cubes, approximately 7ft.6ins. for each dimension, to be clad with ivy or else wisteria, are specified. In contrast, the area round the pool court is planted with roses and sweet smelling shrubs, with pavings cut back on the south-west side for privacy. The terrace of the house is to be adorned with ornamental vases. To the east of the site a seat is placed some way from the house to look over a clear expanse, backed by forest trees. The existing copper beech is to be moved to a new position, thus clearing up a misplaced avenue remnant.

Buckenham Broad House, Norfolk

LANDSCAPE PLAN
1977
Mr Bruce Giololy

Aberford Court, Yorkshire

GARDEN DESIGN
1978
Anonymous Client

BUCKENHAM BROAD HOUSE

It was discovered in November 1993 that the original crayon drawing of the Buckenham Broad plan had faded to such a degree that it could not be effectively reproduced. Geoffrey Jellicoe therefore prepared a re-coloured plan (reproduced here) which shows his mature style of representing landscape elements at its finest. It contains all the details present in the original (ghosts of previous elevations and the approaches to the house can still be seen) but displays the full range of Jellicoe's mature technique in the combination of fine ink line with colour crayon. Most of the landscape features have now been realized, but the plan for the house remains to be completed. As befitting a site on the Norfolk Broads, Jellicoe's favourite element, water, delineates the overall form of the design.

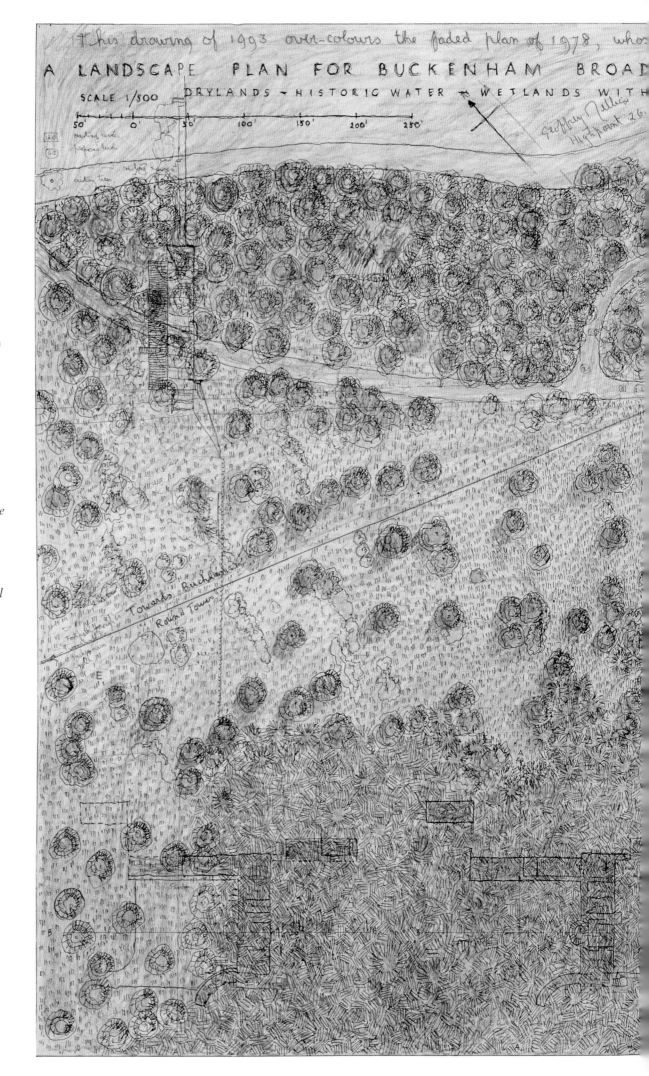

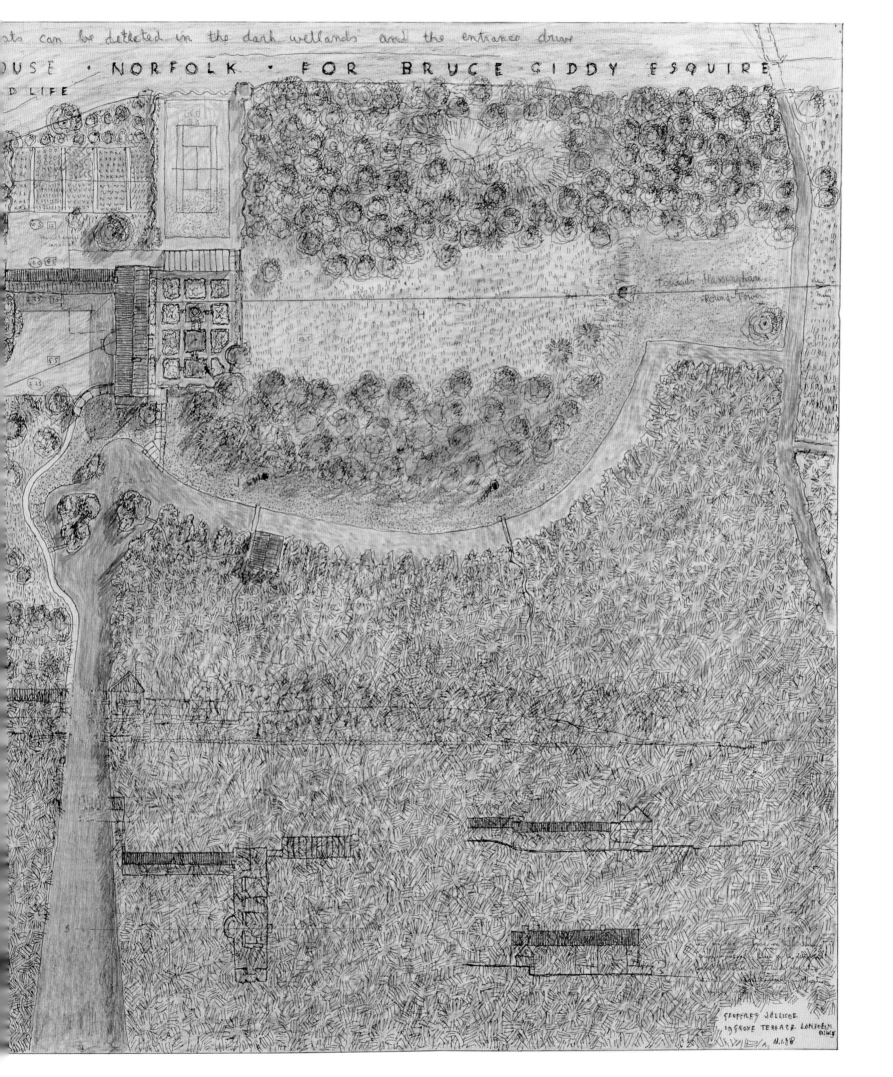

GEOFFREY JELLICOE
19 GROVE TERRACE LONDON NW5

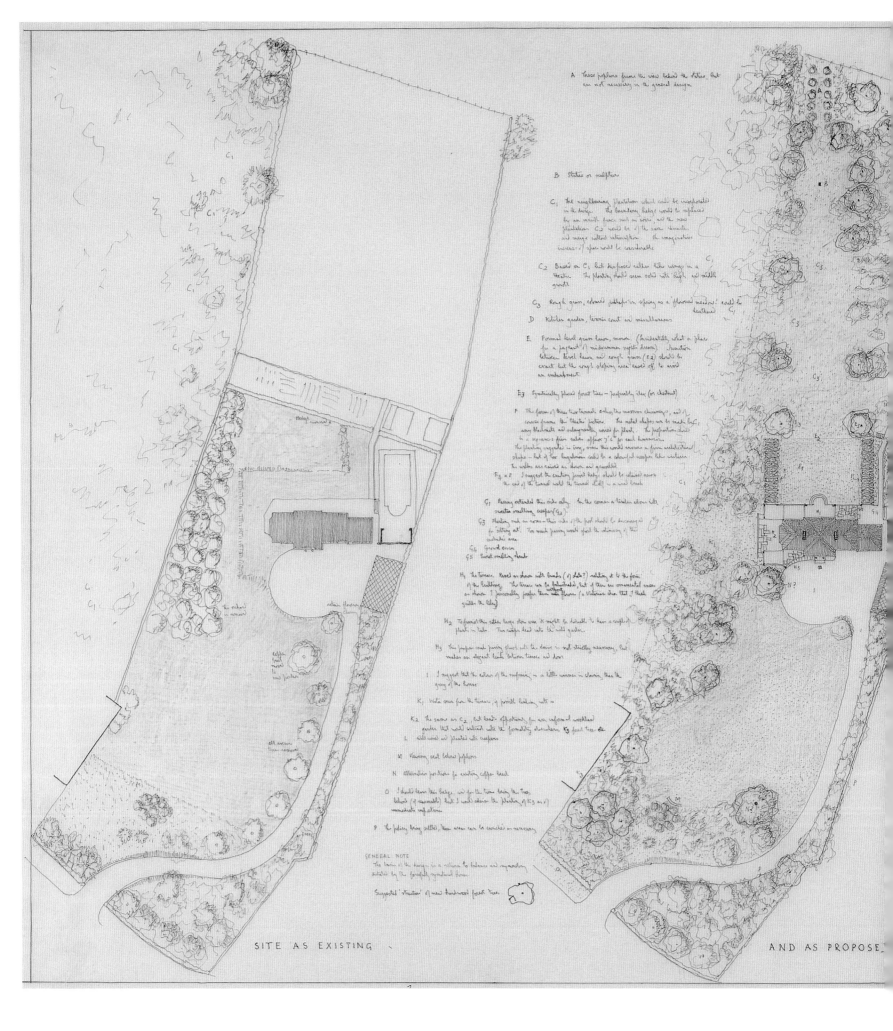

SITE AS EXISTING

AND AS PROPOSED

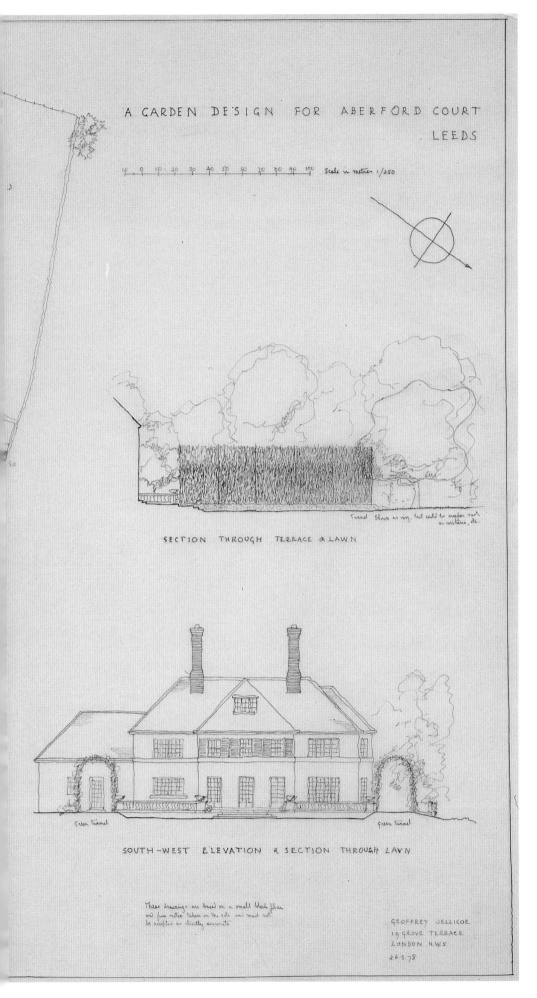

A GARDEN DESIGN FOR ABERFORD COURT
. LEEDS

Scale in metres 1/250

SECTION THROUGH TERRACE & LAWN

SOUTH-WEST ELEVATION & SECTION THROUGH LAWN

GEOFFREY JELLICOE
19 GROVE TERRACE
LONDON N.W.5
26.5.78

ABERFORD COURT

This is an especially interesting example of Jellicoe's work on the gardens of important houses, which formed a substantial part of his portfolio during this period. This drawing is deeply significant in that it shows, within a single composition, the immediate effects of his plan, briefly summarized below:

A. These poplars frame the view behind the statue, but are not necessary in the general design.

B. Statue or sculpture.

C1. The neighbouring plantations which could be incorporated in the design.

C2. Based on C1 but disposed rather like wings in a theatre.

C3. Rough grass.

D. Kitchen garden, tennis court and miscellaneous.

E. Formal level grass lawn, mown.

E2. Junction between level lawn and rough grass.

E3. Symmetrically placed forest trees – preferably ilex (or chestnut).

F. The form of these two tunnels echoes the massive chimneys, and of course frames the 'theatre' picture.

E4. I suggest the existing privet hedge should be retained across the end of the tunnel until the tunnel itself is a wind break.

G1. Paving extended this side only.

G2. Sweet smelling creeper.

G3. Planting such as roses.

G4. Ground cover.

G5. Sweet smelling shrub.

H1. The terrace.

H2. To furnish this rather larger stone area it might be advisable to have a couple of plants in tubs.

H3. This ... paving flush into the drive is not strictly necessary, but makes an elegant link between tarmac and door.

I. I suggest that the colour of the surfacing is a little warmer in colouring than the grey of the house.

K1. Vista seen from the terrace.

K2. Same as C2, but lends opportunity for an informal woodland garden that would contrast with the formality elsewhere.

K3. Forest trees etc.

L. Planted with creepers.

M. Viewing seat below poplars.

N. Alternative positions for existing copper beech.

O. I would advise the planting of K3.

P. The policy being settled, these areas can be enriched as necessary.

General Note: The basis of the design is a return to balance and symmetry dictated by the forcefully symmetrical house.

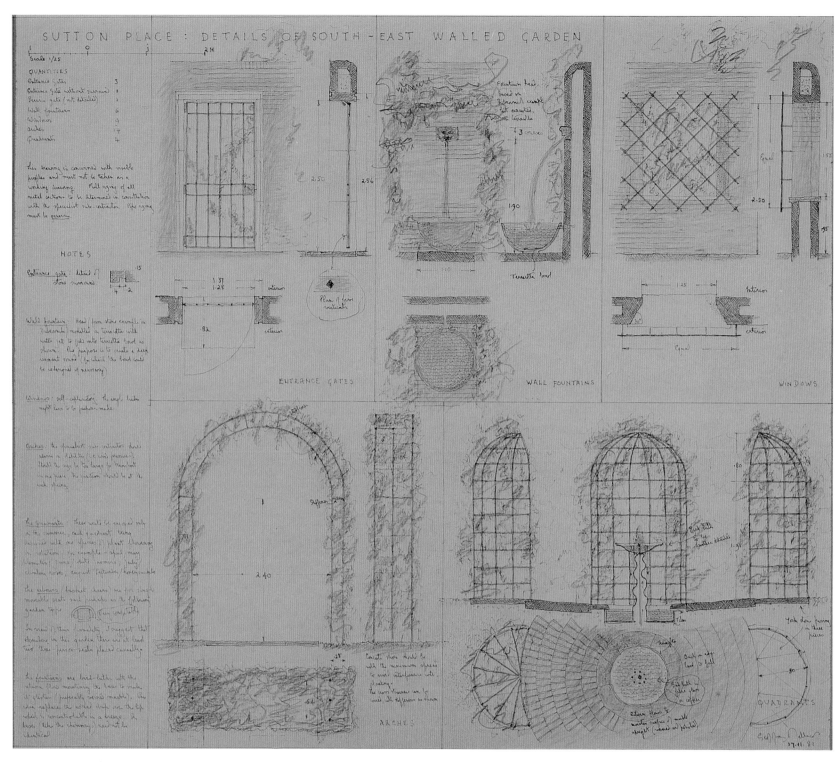

Jellicoe's mature period is marked by the planting and realization of a number of major projects. These are notable both for their breadth of scale and conception and for their detailed planning. A supreme example of Jellicoe's ability to put the finishing touches to his plans is this chart of the garden furniture of the south-east formal garden at Sutton Place, otherwise known as the Paradise Garden. The trellis arbours and arches were specially designed by Jellicoe for the garden, while the features detailed in the upper part of the drawing show his continuing interest in the ornamental features of the Italian gardens. Photographs of the complete garden, with the wall spouts, are on pp.28/29.

152

PART THREE · FULL FLOWERING: THE MASTER PERIOD FROM 1980

Full Flowering: the Master Period from 1980

THE BEGINNING of the nineteen-eighties saw Jellicoe developing further ideas for the new gardens at Shute, which had been commissioned in 1970. The designs of the past fifteen years could now be seen as the precursors of the late masterworks. During the nineteen-sixties and seventies Jellicoe had refined his skills in landscape design more fruitfully than at any other time since the thirties. In 1979 he had been honoured with a knighthood and seemed to be looking forward to a peaceful retirement in Highgate with his wife Susan. But within twelve months came the commission for Sutton Place from Stanley Seeger and, shortly afterwards, an invitation from the Italian city of Modena to prepare plans for an urban park. The following year, at the request of Professor Leonardo Benevolo, he was asked to design an urban agrarian park at Brescia.

However, these commissions were insignificant compared to the brief for the Moody Foundation (1984–87). This richly-endowed Texan body had decided to fund the design of a series of historical gardens in Galveston, which were to occupy Jellicoe for the next three years. By 1988 he had published a fully detailed book on the gardens, although work was not scheduled to start before 1993. Jellicoe intended that the Moody Historical Gardens should be a visual paradigm of his seminal work, *The Landscape of Man (1975)*.

The schemes mentioned above were the projects of the decade, but they were not the only ones. As Jellicoe's name became better known through media attention and his own writings, he was offered a number of smaller commissions. In three instances former clients returned to him, as at Hartwell (1979), Tidcombe Manor (1989) and Danemere Park (1991). In the small town garden in London for Lady Rupert Nevill he produced a paradigm of Horsted, *in memoriam* as it were for a disappearing garden. There have been other international initiatives: notably, the Turin Leisure Park (1989–90), an important garden design in Cairo (1992) and the historical gardens for Atlanta (1992–93). Like his predecessor Humphry Repton, Geoffrey Jellicoe has learned, above all, to believe in the value of proper graphic presentation and these latter projects are especially notable for the detailed and complex quality of the drawing.

During these years, Geoffrey Jellicoe's drawing technique and style developed considerably. Increasingly, he has finished project drawings

The architectural and ornamental designs, illustrated on p.152, are seen here realized in this pathway leading through the Paradise Garden at Sutton Place in the direction of the house (opposite).

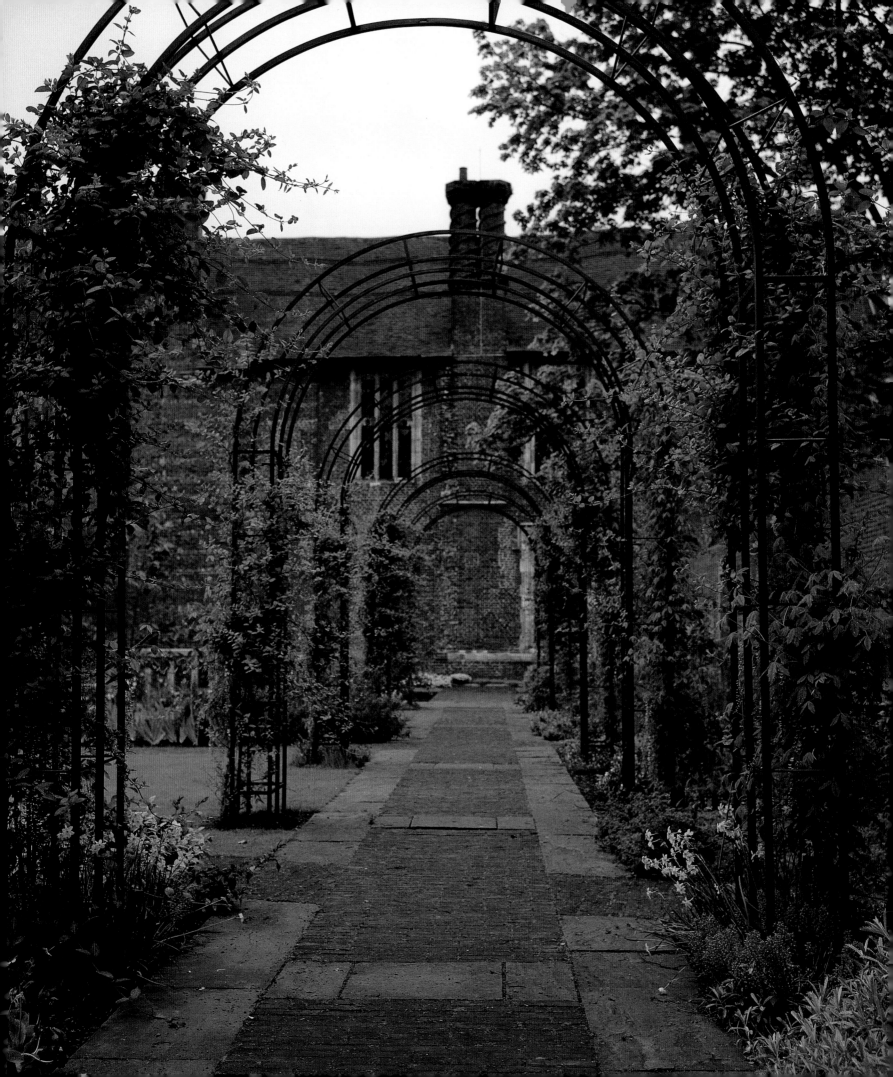

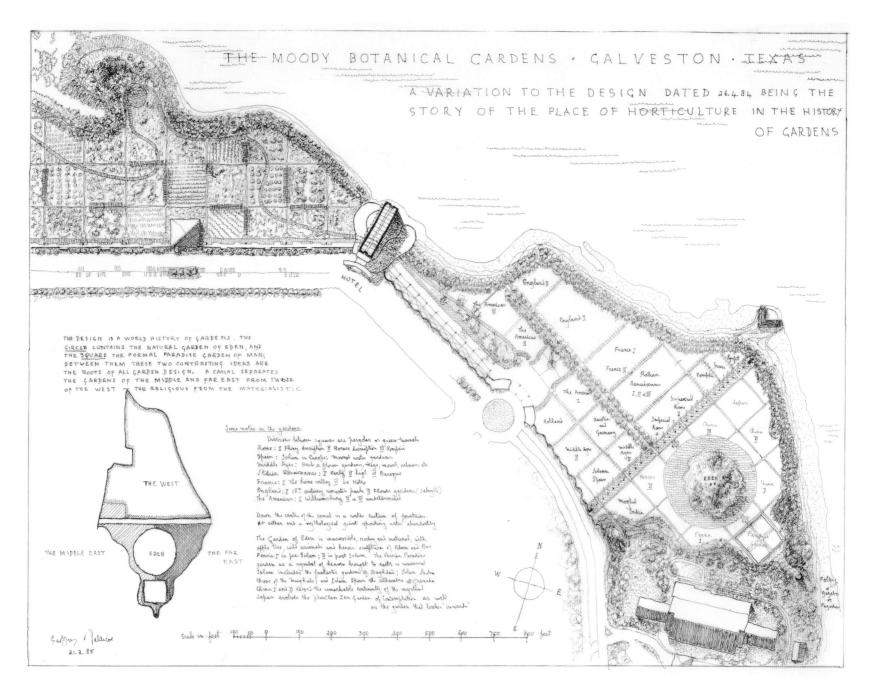

The design within the drawing reads:

THE MOODY BOTANICAL GARDENS · GALVESTON · TEXAS

"A VARIATION TO THE DESIGN DATED 26.4.84 BEING THE STORY OF THE PLACE OF HORTICULTURE IN THE HISTORY OF GARDENS

THE DESIGN IS A WORLD HISTORY OF GARDENS. THE CIRCLE CONTAINS THE NATURAL GARDEN OF EDEN, AND THE SQUARE THE FORMAL PARADISE GARDEN OF MAN; BETWEEN THEM THESE TWO CONTRASTING IDEAS ARE THE ROOTS OF ALL GARDEN DESIGN. A CANAL SEPARATES THE GARDENS OF THE MIDDLE AND FAR EAST FROM THOSE OF THE WEST — THE RELIGIOUS FROM THE MATERIALISTIC.

A first scheme for the Moody Gardens, Galveston, Texas; this proposal was principally horticultural, with categorization of various planting schemes by geographical areas; it precedes the later schemes for historical gardens, which formed the final design.

in coloured crayon, painstakingly applied in range and depth. This has given these later works a degree of accomplishment in their own right, as master drawings in landscape and garden design. They represent a remarkable advance from the hurried and less than accomplished sketching technique still evident in the earlier drawing for the Villa Corner project (1969), and the Stratford-on-Avon proposals (1971–75). The use of pen and ink, wash, and a method of representing lawn by fine *pointilliste* dotting has been augmented by layers of coloured crayon. This is especially useful in representing water elements, such as cascades (Shute, Sutton Place), and it has also been deployed with great skill in the later designs to represent elaborate planting arrangements.

Geoffrey Jellicoe has worked steadily from home during the past decade. The drawings for the major projects have taken shape almost ceaselessly. For example, in 1986 the entire folio of drawings for the Moody Historical Gardens, complete with enlarged detail drawings (to ensure its survival for posterity, as Jellicoe would wryly assert) were produced in total isolation during a period of six months continuous work. The accuracy and the quality is never at variance.

After the death of his wife Susan in 1986, Geoffrey Jellicoe became absorbed in two major projects, in rapid succession. The first project for the Moody Foundation had been for a Botanical Garden. Subsequently this was deemed less than viable in terms of public drawing power and commercial return, compared to the second scheme which was then developed, for the Historical Gardens. Jellicoe had now become something of a celebrity, but once the Moody Gardens were both fully designed, and documented by publication, he decided to take on only those commissions which had a strong personal appeal for him.

The Historical Gardens destined to open in Atlanta in 1996 to coincide with the Olympic Games represent a grand climax to Geoffrey Jellicoe's work. All the features of his late period are represented: the rill, the cascade, the grotto with its allegorical significance, and finally the grove or place of contemplation. Here, too, is a sequence of paths and routes designed to take the visitor through a variety of moods and experiences. References and allusions to landscape history in general and to the history of this particular site in Atlanta abound. The finale is a grove dedicated to the Greek philosopher Heraclitus, from whose work Jellicoe drew his inspiration for this project, especially from the philosopher's emphasis on the instability of the world.

Atlanta has emerged as the ultimate consummation of ideas developed at both Sutton Place and Galveston, though the first testing of many features came at Shute, a decade or so earlier. Perhaps the most important aspect of the Atlanta project was the virtual certainty from its inception that it would be realized. This positive fact enabled Jellicoe to adjust and adapt to the characteristics of the site and work on detailed drawings almost ceaselessly through 1993. These are notable for their liveliness and, thematically, their timelessness, as they look towards the new millennium, by which time the scheme will have come fully to fruition.

Sutton Place, Guildford, Surrey

GARDEN DESIGN
1980–86
Mr Stanley Seeger

This sketch of 1980 shows the lake located to the north of the house and formal gardens. The mound indicated to the east of the lake was to have been the site for the largest Henry Moore sculpture ever cast, but this was never put in place. Another significant three-dimensional work of art, this time realized, is the Ben Nicholson wall of 1981 (opposite), located at the head of the oblong stretch of water to the west of the Magritte Walk.

SUTTON PLACE occupies a key position in Geoffrey Jellicoe's work as a whole; even when it was first proposed in 1980 it was clearly a project of the first importance. The project came 'out of the blue' as Jellicoe has said; ten years later it seemed in danger of disappearing 'into the blue', but any such possibility has now been averted by the intervention of the present owner, Henry Koch, and the establishment of the Sutton Place Heritage Trust. While it might be regretted that certain major features planned originally, such as the east-facing cascade and the lakeside sculpture by Henry Moore, will not be executed, the existing house and its surrounding works of landscape and garden design have been maintained and restored. The Moss Garden, too, has gone, but more for practical reasons than for any failure of design.

Jellicoe's initial visit to Sutton Place was in July 1980 and came as a result of a recommendation by Sir Hugh Casson, himself already engaged in work there on the house. Clearly, Jellicoe and Stanley Seeger found early common interests, both in seeking to establish Sutton Place as a consummation of all that had passed in the history of English garden design, and also in showing a genuine recognition of the nature of contemporary art expressed in landscaping.

The plan conceived by Jellicoe was remarkable in its simplicity: he incorporated the orthogonal nature of the existing garden, recognizing the importance of its axes to the north and east, and created a new walled garden to balance the one already sited to the west of the house. The Renaissance was to be celebrated by a twentieth-century infusion of talent, applied on a scale of which the original founder, Sir Richard Weston, would have approved. Both Ben Nicholson and Henry Moore were to be included in a grand and allegorical extension from the original garden. The allegory refers to the act of creation, the continuity of life, and the aspirations of man for the future of this planet. Jellicoe, in words that follow, acknowledges Seeger's recognition of such intentions: indeed he returned the compliment by allowing Seeger's identity to pervade the whole concept. As a model, Jellicoe kept the Villa Gamberaia very much in mind.

Looking back now at the great achievement of Sutton Place, admiration for what was done far outweighs any regrets for any designs unrealized. Given that Geoffrey Jellicoe had effectively retired in 1979, his career established and reputation secure yet seemingly closed with the final accolade of a knighthood, he could have bowed out honourably from the profession of landscape architect.

This was not, however, his way. When Stanley Seeger suddenly entered life at Grove Terrace a whole new world was opened up. It remains a superlative reaffirmation of Jellicoe's inherent talent; it also opened the way to further projects, being immediately followed by Modena at the instigation of Leonardo Benevolo, the leading Italian

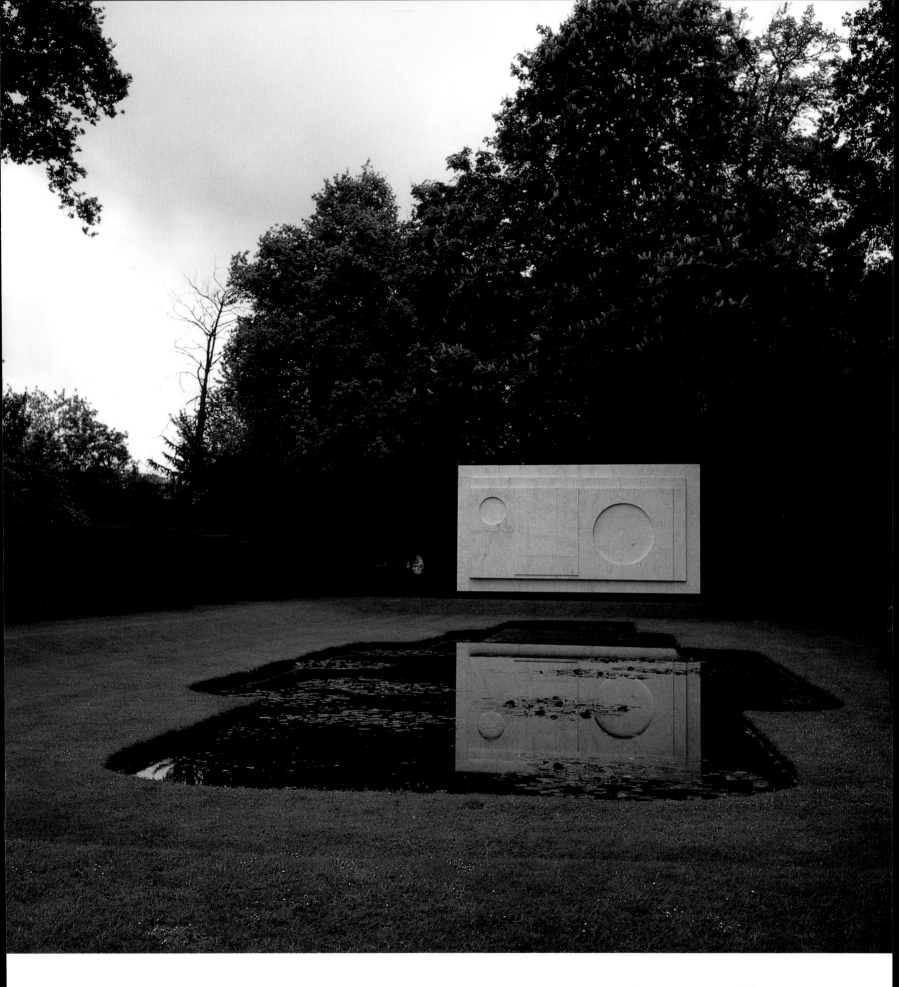

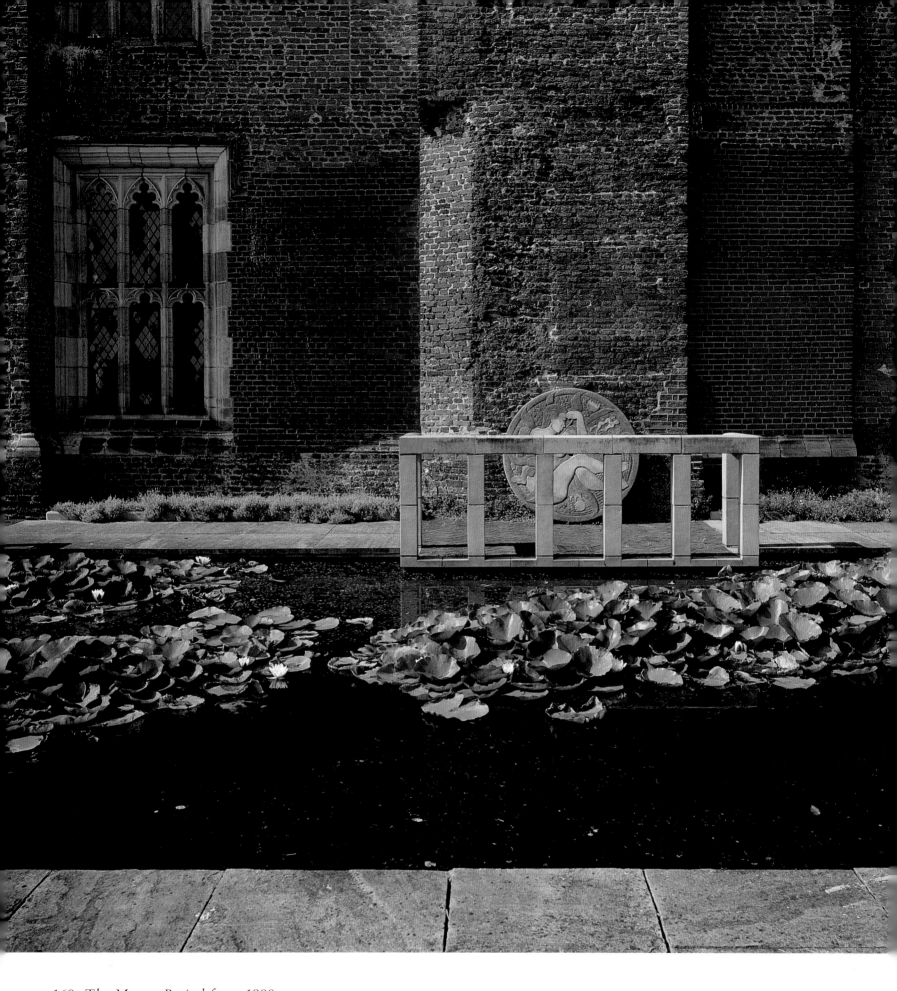

town planner and architectural historian. And when Peter Atkins, Director of the Moody Botanical Gardens, visited Sutton Place in 1983, like Stanley Seeger he realized that Geoffrey Jellicoe possessed a quite unique talent.

G.A.J. My first visit was on 22nd July 1980. I remember nearly stumbling over a Henry Moore sculpture on the floor and observing a Ben Nicholson over the mantelpiece, with a huge Monet close by and a Graham Sutherland in the offing. I realised within a few minutes that Stanley Seeger and I were on the same wave-length in thinking that landscape art should be a continuum of past, present and future, and should contain within it the seeds of abstract ideas as well as having figurative meaning. Following four days of rumination and one at my drawing-board, a diagrammatic plan of my proposals was approved by Mr Seeger (I am told) in ten minutes. Except for the lake, whose present position I had found unrealistic, in terms of costs, the realisation is identical with the diagram. The plan is simple: the continuation of what already existed in axial design, and the reconciliation of the mansion with the vastly increased landscape about it. It is primarily a reaffirmation of classical values, enriched and not disrupted by romanticism (as the intangibles are still classified). There was no thought at this stage as to what those intangibles might be.

Soon afterwards Stanley Seeger made two momentous decisions: that the 'Moore' lake landscape, repositioned by him, and the 'Nicholson' wall chosen by him, should be gigantic in scale, far beyond that of the house with its essentially English domestic character. Thus, unsuspected at the time, the idea of a grand allegory of *creation*, *life* and *aspiration* was now in being.

The composition having acquired a sense of completeness in the mind in a way impossible for the eye at any one moment to comprehend, there now remained the infilling. Behind each part with its seductive delights lurks an idea that reflects, or is intended to reflect, either a lighter or a darker mood of the subconscious. Some of these ideas may seem self-revealing. Thus Pluto's grotto is recognizably a return to Greek myth, yet the subconscious appeal is not the myth itself, but the direct analogy with man's place in the cosmos. Similarly, all can see that the lake is in the shape of a fish, but few that the hills around are composed as the man, woman, child

At Sutton Place, Jellicoe skilfully retained many traditional details, such as this bench (below), within a highly eclectic overall composition.

At Sutton Place, Jellicoe skilfully retained many traditional details, such as this bench (below), within a highly eclectic overall composition.

Allegory

Analogy

The viewing platforms over the shallow moat (opposite) are protected by balustrades made to a design derived from a painting by Giovanni Bellini (p.29). This stretch of water serves as a transitional element between the enclosed garden and the east wing of the house.

complex immemorial in art; and that the whole concept – water into hills into sculpture – is an analogy of the emergence of civilisation.

The east walled garden is a concentration of ideas emanating from Stanley Seeger and processed by myself. You must fathom how it is that hazardous stepping stones across the moat are more satisfying than a sensible bridge; why the pleasure garden with its conversation arbours, flowers and the sound of water is now called the Paradise garden; why the secret garden beyond contains two hidden circles, one of grass and the other of moss; outside the east wall garden, why on earth surrealism should be a fitting end to the sensible long south walk; and, on beyond this, not on earth, cogitate upon the Nicholson wall and its two circles.

Sutton Place is the portrait in landscape of an individual. The challenge in the modern world is that of the collective. Yet the same principles apply; the organisation of both conscious and subconscious to release instincts and aspirations that cannot otherwise be satisfied. Because it is young and immature, the potentialities of collective landscape design as the most comprehensive of the arts in space and mind have scarcely begun to be realised. Allegory and analogy will have their own invisible part to play in this saga, for in essence they subconsciously relate a design to something that has already been accepted in the abstract as a work of art; and if not an art, landscape design is nothing.[1]

A constant theme of the garden at Sutton Place is the movement from enclosed, formal areas to open, less regimented ones, yielding to unexpected and exciting vistas (above).

To the west of the house lies the Miró Mirror (right), which is the swimming pool with a sun raft reached by circular stepping stones. It was originally intended that the raft should carry a number of ornamental pots with planting, but neither this plan, nor that for a vine-covered walk around the pool were ever completed.

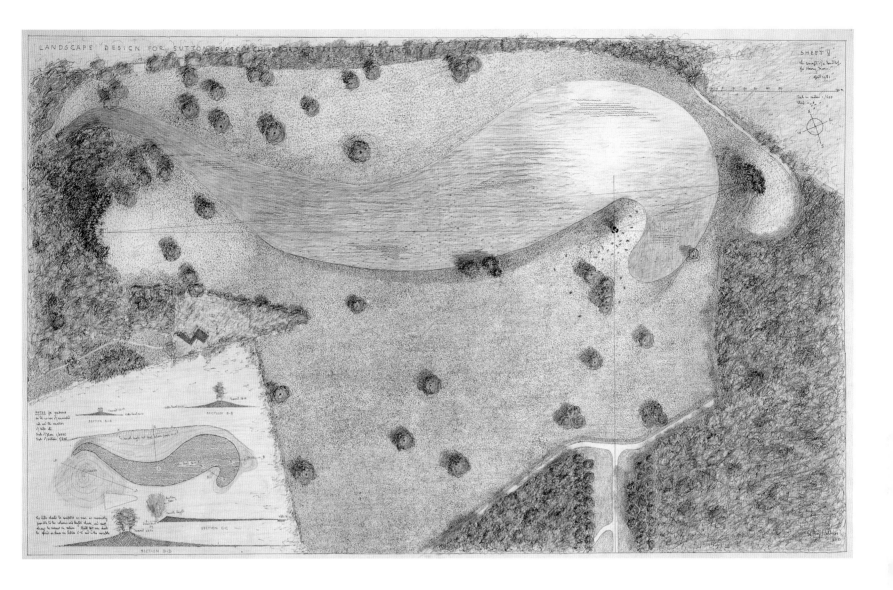

The lake was not included in the preliminary concept since the land form was such that no water at river level would be visible from the house. A few miles west at Painshill, however, Charles Hamilton in the eighteenth century had raised the waters of the River Wey several feet to form a lake of somewhat similar size. A raised twentieth century lake under the same circumstances and with modern mechanical equipment did not seem impossible and accordingly is now being made. The pure form of the concept did not allow for wild life of all kinds and the design has subsequently been enriched with three islands and sanctuaries along the coast.

The lake is the beginning of the allegory. From its primeval depths had emerged two natural hills: that to the west is the father figure, that to the east is maternal. Between them and particularly under the eye of the mother figure, will be an abstract sculpture, 'Divided Oval', by Henry Moore, now being cast in Hamburg (1983), the largest Moore sculpture in the world.

The lake (as designed in 1981)

The lake (above), located to the north of the house, was planned to take up 4.6 hectares of former sheep pasture. It is Jellicoe's gesture of homage to the eighteenth-century English Picturesque style. Its form suggests a fish and therefore links it in the overall allegory of the garden to the origins of human life and creativity. The mound to the east of the lake was designated as the site for the interlocking sculpture by Henry Moore.

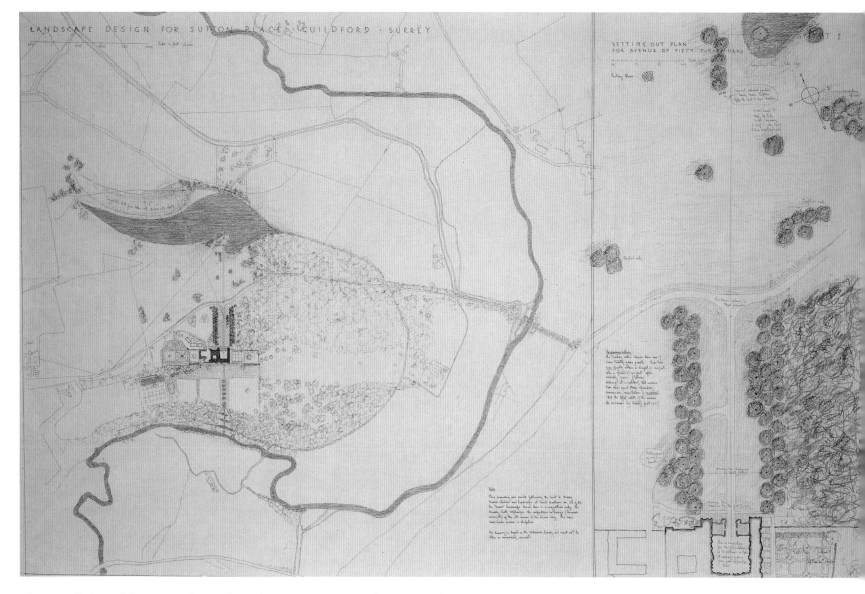

The overall plan of the estate (above) *shows how it is enclosed by the river, a landscape feature whose significance cannot have escaped whoever chose the site originally. Jellicoe has been much concerned in his design at Sutton Place to take account of the larger environment, hence his emphatic planting of the oak avenue* (above right) *to establish the main axis across the garden and park. The master plan of 1980* (fold out) *shows Jellicoe's grand design for the features immediately in the vicinity of the house. To the east are the Paradise Garden and the Moss Garden; to the south the proposed cascade and Music Room; to the west lie the formal pool with the Nicholson Wall, the Magritte Walk, the walled kitchen garden and the swimming pool.*

Jellicoe's 1981 proposal for a garden music theatre (opposite), *never executed, shows a typical joke or conceit. The central rectangle with the paved areas C and D, is intended to represent Henry VIII, a monarch who was also a composer.*

The garden music room

Due to the unpredictable English weather the theatre was designed to accommodate the same number of audience as could be fitted into the long gallery. Even in Italy, where it originated, the garden theatre was regarded first as an ornament and folly, setting fire to the imagination even when empty. The drawing carries with it the following enigmatic note: 'Very keen observers of the land shape will appreciate how Henry VIII broods over the whole'. The king was himself a composer.

The gardens are balanced about the house in time as well as space. The house represents a past whose humanistic values will prevail and whose authority over all is reinforced by the architectural pleached limes. The gardens to the west are surrealist, those to the east are of the present or near-present.

Fold out ▶

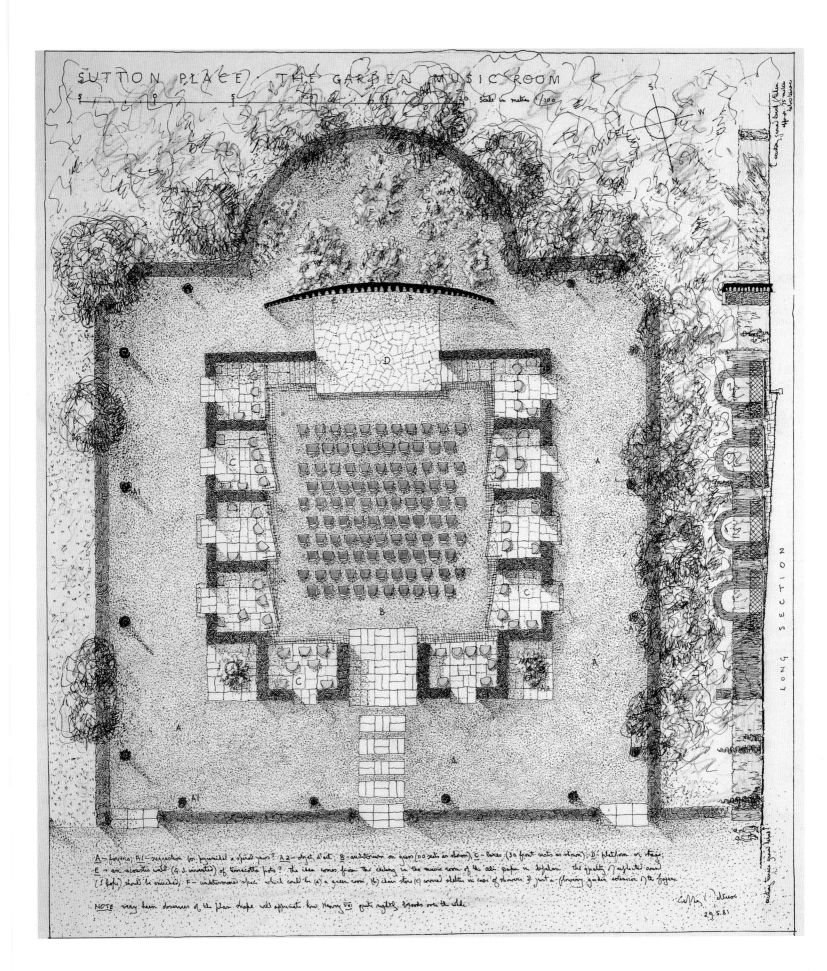

SUTTON PLACE · THE GARDEN MUSIC ROOM
Scale in metres 1/100

LONG SECTION

A – foyers; A1 – suggestion for pyramidal or spiral yews? A2 – objet d'art; B – auditorium on grass (110 seats as shown); C – boxes (30 front seats as shown); D – platform or stage;
E – an acoustic wall (G.J. inverted) of terracotta pots? the idea comes from the ceiling in the music room of the Ali-Qapu in Ispahan. the quality of asphalte and
(I hope) should be invited; F – undetermined space which could be (a) a green room, (b) dressing room (c) covered shelter in case of showers, d) just a flowing garden extension of the foyers.

NOTE: very keen observers of the plan shape will appreciate how Henry VIII quite rightly broods over the whole.

29.5.81

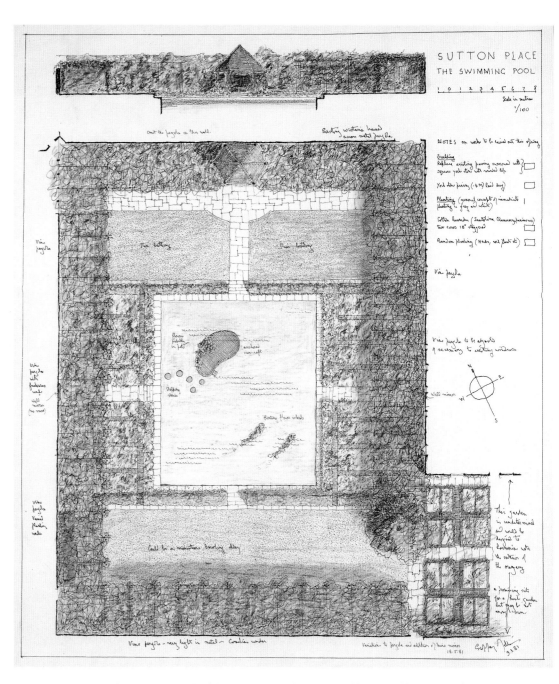

The swimming pool, or Miró Mirror, showing the asymmetrical siting of the sun raft; the vine-covered walk, clearly marked on the plan, was never executed.

The pool is surrounded by a covered vine walk, recalling (to the art historian) the cool garden arcades that Weston must have seen in the Touraine. On the light reflecting surface of the water are stepping stones to an anchored and flowered sun raft. Two smaller rafts float by promiscuously. The water picture was originally inspired by Miró and is known as 'the Miró Mirror'.

The two main squares of the kitchen gardens are defined by apple and pear espaliers. Within each square is a further subdivision into four squares. Within all eight of these subsidiary squares lie everchanging patterns of vegetables. To look down upon this restless continuum are two observation towers, known as 'Espalier Escalier towers' and crowned respectively with a gold apple and pear.

The landscape design is a continuation of historical phases I and II. It is possible to think of the gardens in terms of a model, and over this a further model is to be placed, fitted in such a way that no parts of the lower model were damaged.

The areas, from east to west, are as follows:

a. The east walled garden, balancing the existing west walled gardens. Divided into two by an existing yew hedge, this informal garden is in two parts, echoing Francis Bacon's description of the civilised adjoining the wild. The sculpture garden later became the secretive moss garden.

b. The long south walk leading from the east pavilion (later an octagon) through pleached limes that emphasise the basic classical symmetry, to a surrealistic terminus (later the Magritte garden).

c. The avenue of fountains, Persephone fountain, the grotto and the great cascade, modified later to retain all existing forest trees.

d. The Music theatre, remaining undetermined on grounds of external noise interference. Later a green theatre.

e. The walled swimming pool.

f. The walled kitchen garden.

g. The sculptured wall by Ben Nicholson, sited and made in close association with the artist. Note the change during the making of this drawing from one water design to another, both of which dissatisfied the artist and has been left as existing (at his special request). Nicholson did not live to see the completion of this great 'project for a wall'. The scale, like that of the lake, is heroic as befits the end of allegory.

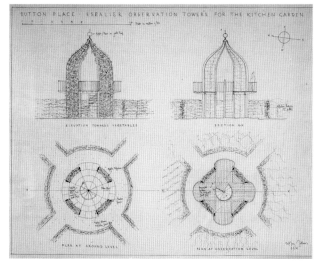

This detailed plan of the kitchen garden and pool to the west of the house is another example of Jellicoe's Italianate approach to confined spaces. The enclosure is bordered to the south by the Magritte Walk with its magnificent, oversized urns. An espalier observation tower was to have been located at the centre of each of the kitchen garden enclosures (above).

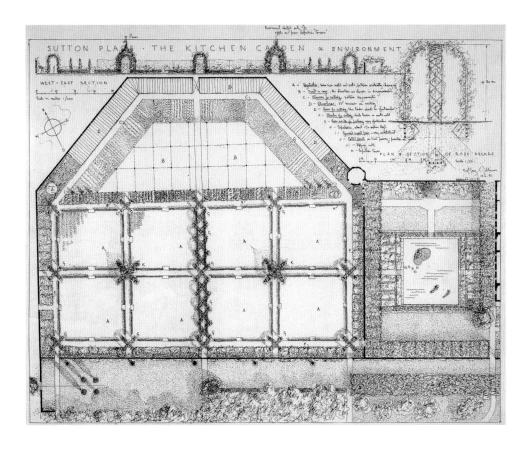

The long south walk

There are two long walks at Sutton Place which counterbalance each other: the Magritte Walk (below), to the west, and the Long Walk to the east which terminates in this belvedere (right), designed by Geoffrey Jellicoe.

The long walk terminates on the east in a pavilion (now an octagon) whose domed and painted interior looks out upon the four pleasurable elements in the landscape that have fashioned civilised man. The window towards the moss garden overlooks the landscape of dreams and imagination; the second window sees the forest from which as *Homo erectus* he emerged with all faculties complete; the third window looks upon the savannah country in which he hunted for survival and which inspired the English eighteenth century school of landscape; and the fourth upon the work of the settler and classical man.

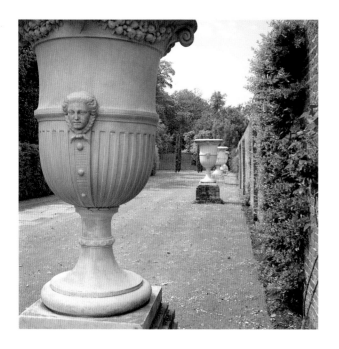

The avenue of fountains

The avenue of fountains is interwoven with the existing clipped yews that continue the axiality of the historic composition. They lead to the Persephone fountain, whose source lies underground beneath the waters. To reach the grotto you must pass under the waterfall and thence along a dank dark passage. In the centre of the fern clad circle, illuminated through the water above, is the Persephone rock. Beyond is a sinister inner grotto, where the giant head of Pluto sucks in water. . . .

The form of the cascade is a change from that in the original concept, where it derived from Italianesque geometry. The practical factor of impeding the view from the house of distant industrial Guildford, combined with the ecological nature of the whole estate, caused the powerful baroque form to give way before the existing trees on their steep embankment. The water breaks into four chattering rills.

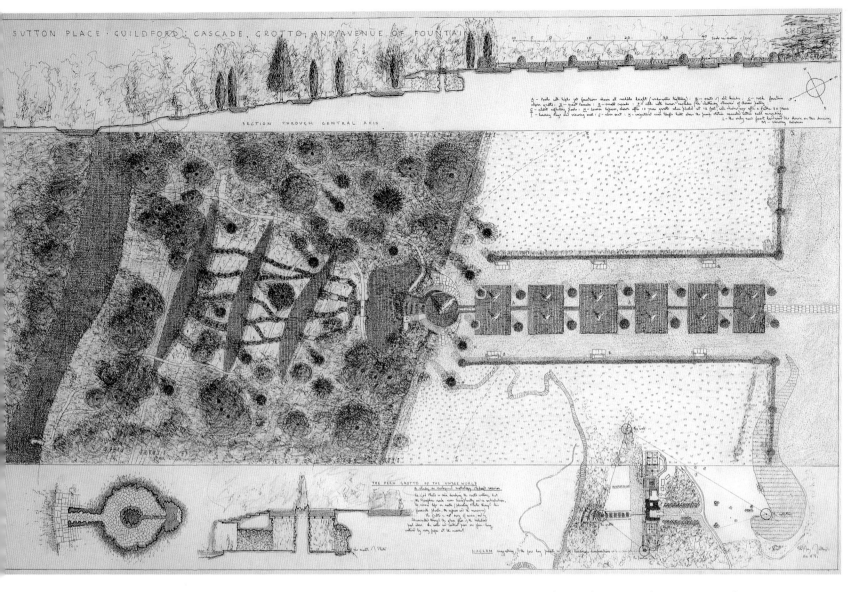

SUTTON PLACE · GUILDFORD: CASCADE, GROTTO, AND AVENUE OF FOUNTAINS

SECTION THROUGH CENTRAL AXIS

THE FERN GROTTO OF THE UNSEEN WORLD

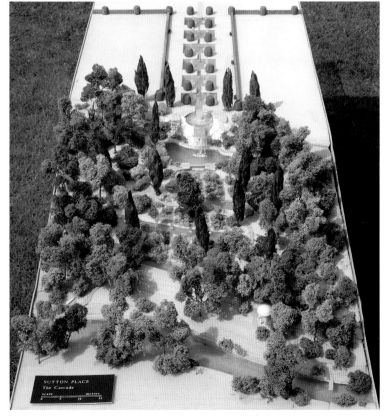

SUTTON PLACE
The Cascade
scale metres

The southern cascade, or Avenue of Fountains, was never actually built. It was to have run north to south along the main axis of the garden, passing from stylized formality to a more naturalistic design as it flowed away among the tree planting. The plan (above) and the model (left) show that Jellicoe's design had reached a very finished stage.

The Master Period from 1980 · 171

The east walled garden

The Paradise Garden and the Moss Garden at Sutton Place were designed to form an enclosed block to the east of the house. Unfortunately, it was found that the varieties of moss (the contrasting areas shown in the plan opposite) required an unacceptable level of maintenance to ensure the necessary balance of moisture and freedom from destruction by bird and animal life.

Since this drawing was made (December 1980) the enclosure has been divided into three rather than two parts, as follows:

a. The space between house and cross path, dominated by the chimney breasts, is now a moat overlooked by lily observation balconies and crossed by stepping stones. The allegory is that you must have a hazardous journey if you are to reach . . .

b. The paradise garden on the further side of the moat. This is a pleasure garden rich with flowers, arbours and fountains for the sensual enjoyment of the moment. The paths took their earth-worm shapes from the curlings of the Tudor chimneys. The arbours are for conversation, the grass glades for contemplation and the pleasaunce generally for music of water, bees and birds. Beyond the pleasaunce is the . . .

c. Wild garden with its one great plane and two smaller. Designed in this plan as a green exhibition gallery for modern sculpture, it subsequently changed into the moss or secret garden.

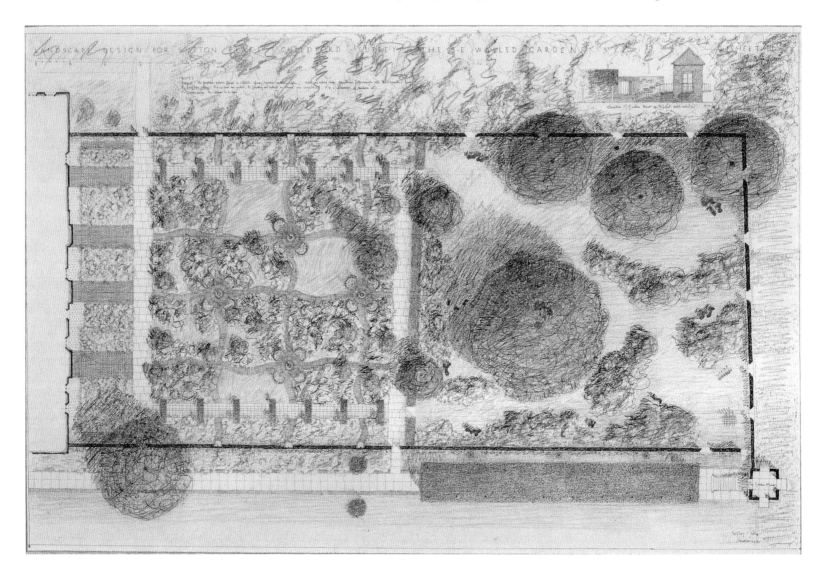

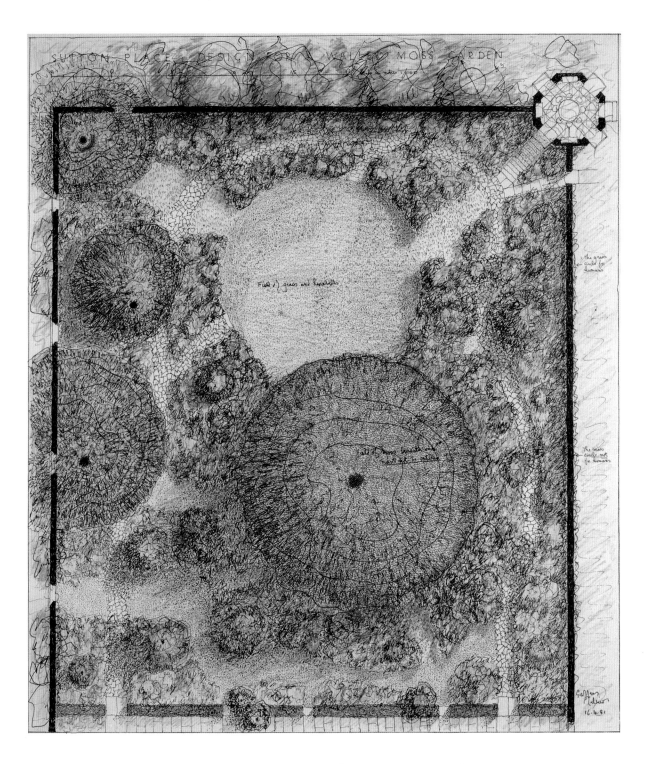

The moss garden

The moss or secret garden lies beyond the paradise garden and is the heart of the grand allegory. Within us lurk associations of the ideas of childhood, some of which indeed are a sub-conscious, pre-natal inheritance. The child's imagination is not confined to what it sees, for it creates pictures beyond the power of the adult educated in the rational.

The two interlocking circles hidden in the centre can be interpreted as each of us pleases, with this proviso only: that you can enter the grass circle, but not the moss under the plane tree.[2]

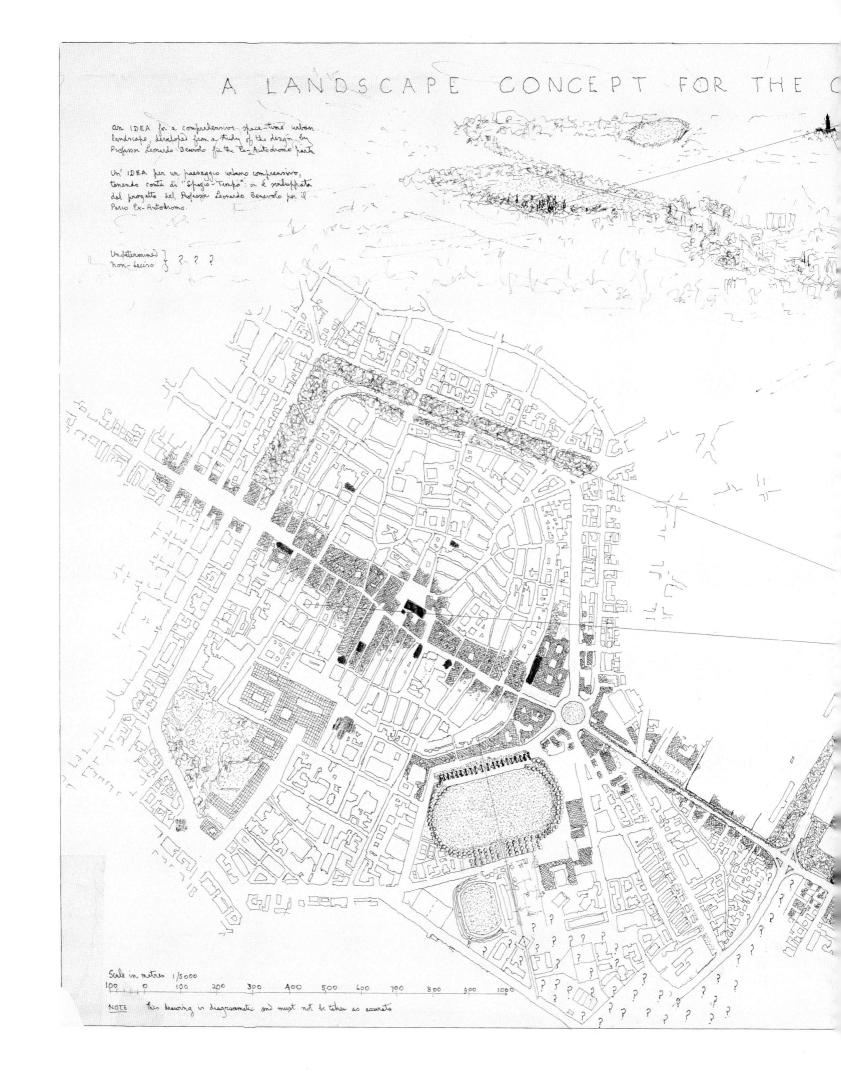

A LANDSCAPE CONCEPT FOR THE C

an IDEA for a comprehensive space-time urban
landscape, developed from a study of the design by
Professor Leonardo Benevolo for the Ex-Autodromo Park

Un' IDEA per un paesaggio urbano comprensivo,
tenendo conto di "Spazio-Tempo": si è sviluppata
dal progetto del Professor Leonardo Benevolo per il
Parco Ex-Autodromo.

Undetermined } ? ? ?
Non-deciso }

Scale in metres 1/5000
100 0 100 200 300 400 500 600 700 800 900 1000

NOTE This drawing is diagrammatic and must not be taken as accurate

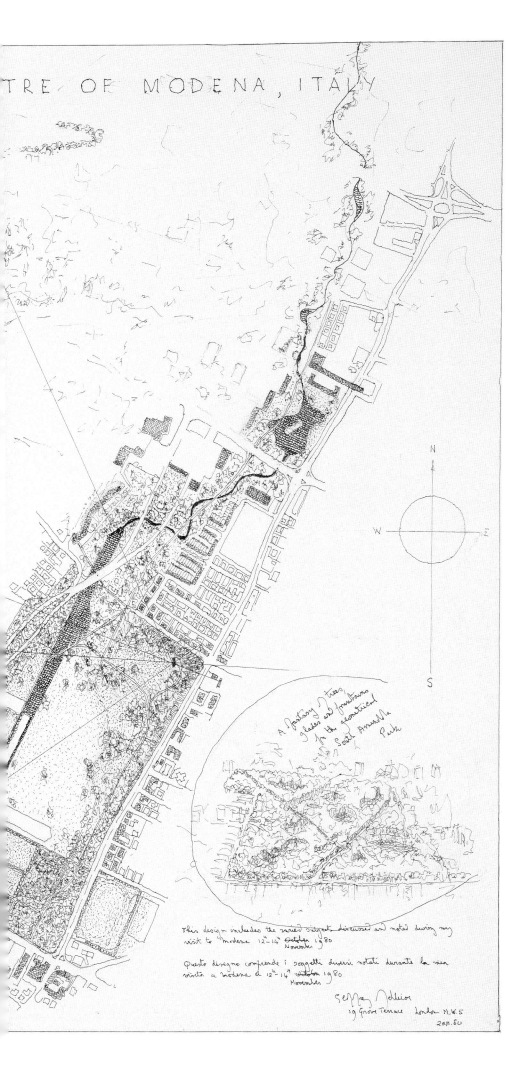

TRE OF MODENA, ITALY

A fantasy of trees,
glades and fountains
for the geometrical
South Amenable
Park

This design includes the varied subjects discussed and noted during my
visit to Modena 12ª–14ª October 1980
 November

Questo disegno comprende i soggetti diversi notati durante la mia
visita a modena el 12ª–14ª October 1980
 November

Geoffrey Jellicoe
19 Grove Terrace London N.W.5
2011.80

Modena, Italy

CIVIC PARK PLAN (uncompleted)
1980
Local Authority

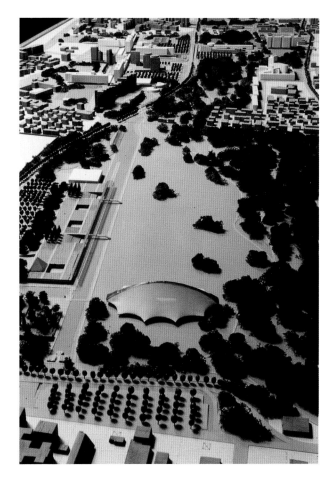

Geoffrey Jellicoe's original concept for Modena, 1980, marked the beginning of his large-scale works of the following decade, during which he was to address himself to specifically urban projects. The model (above) shows certain variations to the plan, but does emphasize the importance of the tree planting and water axis.

The Master Period from 1980 · 175

THE COMMISSION for Modena arrived shortly after that for Sutton Place. The two schemes represent a unique milestone in Geoffrey Jellicoe's development, embodying at the start of the ninth decade of his life remarkable advances in his vision. With these two projects, furthermore, his highly individual technique in drawing landscape attained a greater maturity, showing a marked advance on his designs of the previous decade. The two sets of drawings for Sutton Place and for Modena accordingly have much in common; most notable is a new and lyrical colouring in painstakingly applied crayon. Jellicoe layers the colour, gradually but consistently, thus building increasing depth and texture into the plan image, but always adhering to the conventions of sciagraphy. So the landscape plan displays technical accuracy, while at the same time the scheme is set out in all its natural botanical diversity.

At Modena Jellicoe was introduced to the city authorities by the Italian urban designer Leonardo Benevolo. His proposals were developed with the architect Vittorio Gregotti, but have not yet been executed.

G.A.J. These two landscape commissions (Sutton Place and Modena) arrived almost simultaneously in the late summer of 1980, just prior to my 80th birthday. Both were far larger than any I had had previously, and the basic design of both was completed and accepted after one visit. Both clients responded to the theory of landscape that

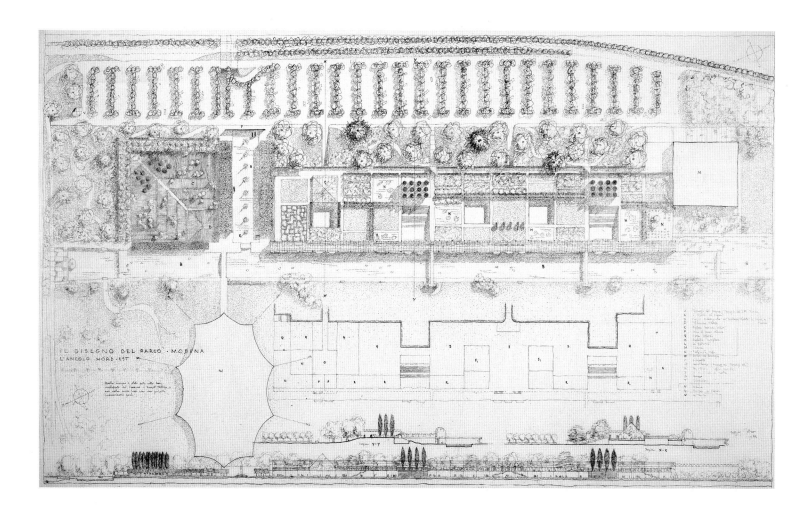

IL DISEGNO DEL PARCO · MODENA
L'ANGOLO NORD-EST

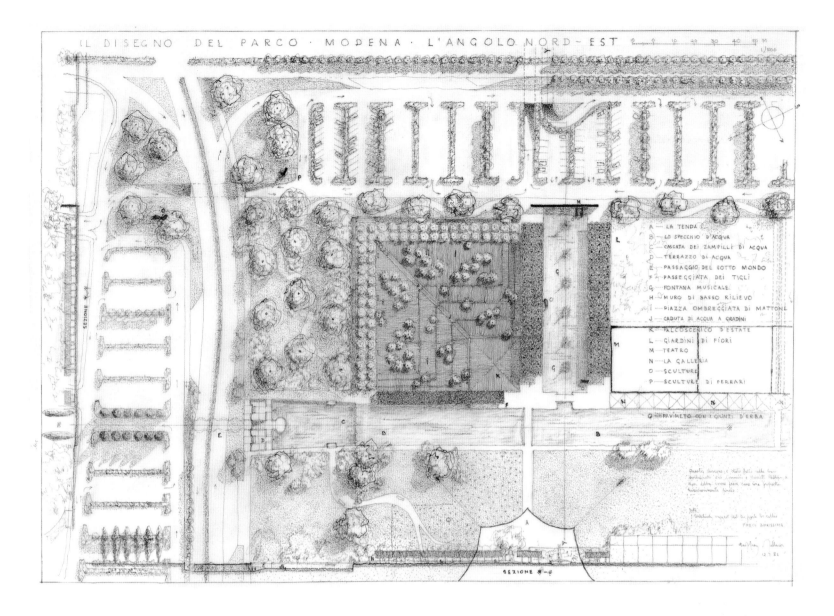

A — LA TENDA
B — LO SPECCHIO D'ACQUA
C — CASCATA DEI ZAMPILLI DI ACQUA
D — TERRAZZO DI ACQUA
E — PASSAGGIO DEL SOTTO MONDO
F — PASSEGGIATA DEI TIGLI
G — FONTANA MUSICALE
H — MURO DI BASSO RILIEVO
I — PIAZZA OMBREGGIATA DI MATTONE
J — CADUTA DI ACQUA A GRADINI
K — PALCOSCENICO D'ESTATE
L — GIARDINI DI FIORI
M — TEATRO
N — LA GALLERIA
O — SCULTURE
P — SCULTURE DI FERRARI

Q — PAVIMENTO CON I GIUNTI D'ERBA

SEZIONE A–A

I had experimented with over the past 30 years. This theory is that all man-made environment is a projection of our psyche, whether individual or collective, and when this is not so (i.e. a projection of our brain only) then there is disruption and unhappiness that is mainly due to the dislocation or repression of subconscious instincts. I don't mean only gardens, but towns and regions as well. These two commissions provided me with the opportunity of testing out these intangible ideas; but after that they were totally different, for Sutton Place is a study of the individual subconscious, with the assumption that most of the individual's expression in landscape will be universal in its appeal (or it may not, as with the Ben Nicholson wall); while that for Modena is collective, with the intention that different individuals can find expression in the different inbuilt instincts (such as forester, hunter, settler, etc). All these richly varied expressions come under the same umbrella of the art, rather than the science, of comprehensive landscape design.[3]

In 1982 Jellicoe drew up detailed plans for the south-west corner of the Modena site (opposite). One of the main features was a canal which became known as the Long Water. Jellicoe was particularly concerned that the general public should be able to leave the car park to the north and, passing under the access road, come upon the southwards vista down the canal. To the east, a galleria, theatre and flower gardens bordered a small canal feeding into the Long Water (above).

An analogy for the park at Modena can be made with Virgilian poetry considered as an entity, itself springing from the Greek ideas upon which western civilization is based (and, in particular, the source of ideas for our own landscape movement).

The prosperity of Modena (population 175,000) has historically depended on agriculture and, more recently, on industry (it is, for instance, the home of Ferrari cars). It lies in the flat valley of the Po, beside the Apennines. The Roman Via Emilia passes through Modena and the city was originally connected to the sea by canals, essential for irrigation as well as navigation in a fertile landscape with a high water table. Surrounded by indifferent modern developments, the lovingly preserved city centre is medieval in plan with a great Romanesque cathedral tower of white stone rising far above the red pantile roofs to dominate the cityscape. The architecture is generally Renaissance, the busy streets lined with lofty arcades changing perspectives. Access for cars is by permit.

The site for the park lies close to the centre, in undistinguished surroundings on land recently vacated by the military. The design could be considered an idealisation of the total landscape of the region: progressing from the city itself, the flat patterned landscape on which it stands and the neighbouring foothills leading up to the Apennines – except that the values are in reverse order to the reality, for in the microcosm of the park the country expands into the city rather than the city into the country. This replicates Virgil's own reversed conception of the values of the world about him as presented in the heroic verse of the Augustans.[4]

Visibly it (the Civic Park for Modena) is to provide recreation and relief like any town park, for a collective urban society. *Invisibly* it is intended to reinforce the values of the old city centre by opening the windows of the subconscious upon the dignity and relevance today of the classical world'.[5]

Brescia, Italy

PUBLIC PARK (uncompleted)
1981
Local Authority

As a result of the excellent relationship which had developed between Jellicoe and Benevolo (and also Gregotti) over Modena, Jellicoe was invited shortly after to design a park in the northern Italian city of Brescia, close to the Alps.

Jellicoe was this time much inspired by *The Metamorphoses* of Ovid, whose humour and pragmatism seemed appropriate here in contrast to Virgil's profundity. However, the Brescia authorities have not pursued the proposals further.

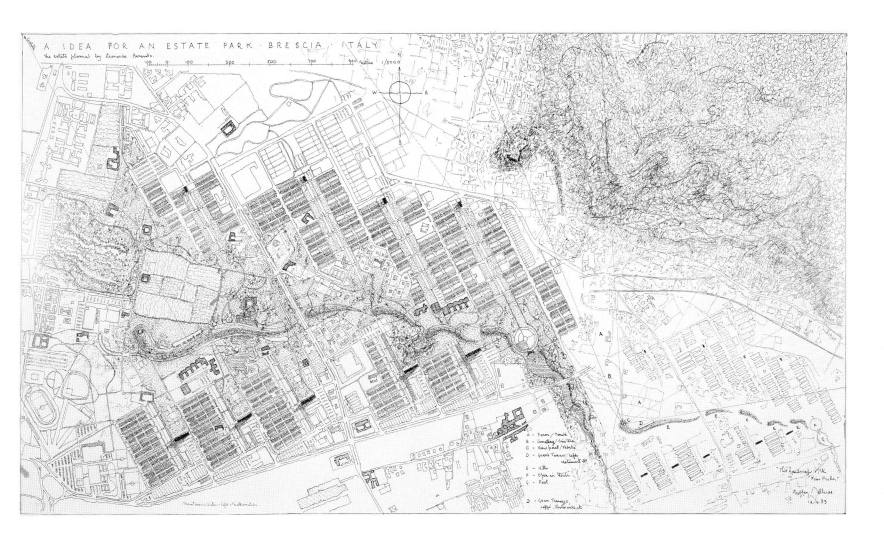

A IDEA FOR AN ESTATE PARK · BRESCIA · ITALY

G.A.J. The potential field for creative design is an infinitive as its sources are unpredictable and sometimes grotesque. It was a chance supper of five different kinds of fresh fish from Lake Iseo, one after another, that inspired the 'infilling' landscape project for the estate at Brescia, besides the foothills of the Alps. To combat the rigidity of the architecture, fishes drawn from the adjoining water landscape, now metamorphosed into artificial hills, split the two parts of the estate, linking en route not only the usual pleasures of parkland, but a live farm and a cemetery to complete the cycle of life.[6]

The association (at Modena) with Virgil suggests that the philosophy of the two streams of water landscape art can be traced to the single fountainhead of the Augustan poets. If Virgil with his breadth of vision and love of humanity inspired the civic park at Modena, it was Ovid who was to do so in the metamorphosing of fish into hills at Brescia, and Lucretius, in *De Rerum Natura*, in the significance of the act of creation, and the fragility of civilization itself, at Galveston.[7]

The plan for the landscape surrounding an important housing project in Brescia was another extended play on fish imagery, with its implications of a return to origins. The metaphysical references are most potently expressed in the hill forms. The estate itself was designed by Leonardo Benevolo, who had recognized the importance of complementing the high density grids of the new dwellings with a softer and more lyrical landscape around surround.

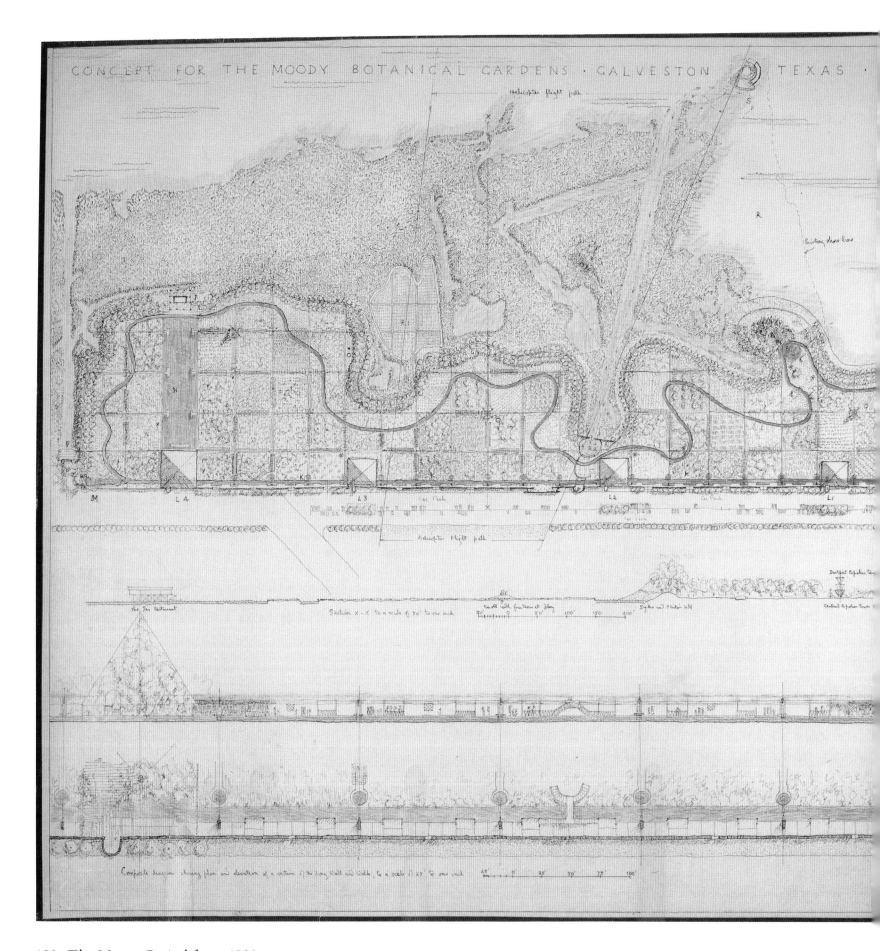

CONCEPT FOR THE MOODY BOTANICAL GARDENS · GALVESTON · TEXAS ·

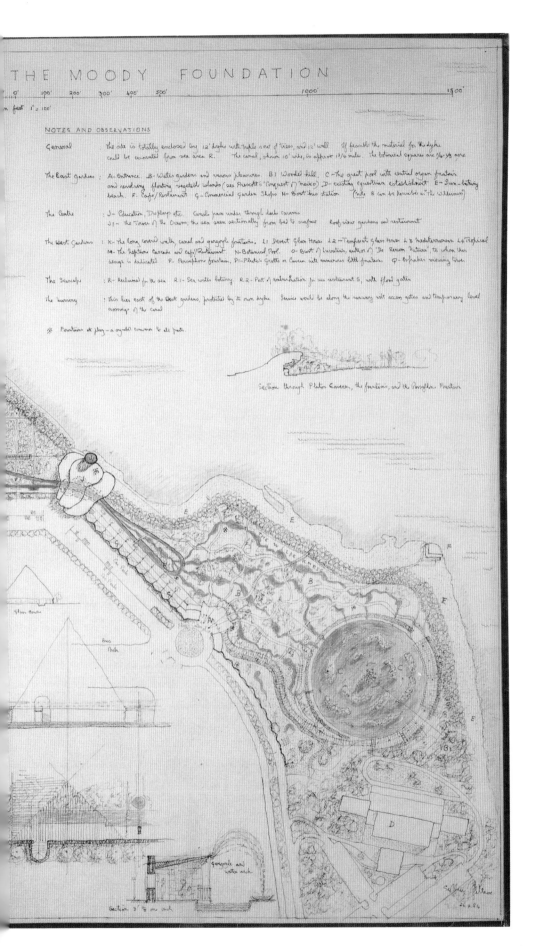

The Moody Gardens, Galveston, Texas

BOTANICAL AND HISTORICAL GARDENS
1984–the Present
The Moody Foundation

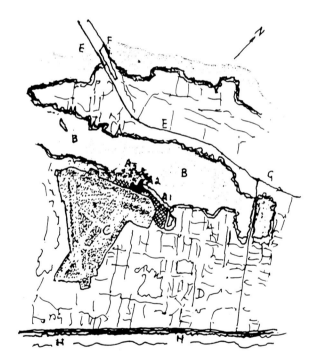

The original concept for the siting of the Moody Gardens (left) *can be seen in its overall context* (above):

KEY
A. Moody Gardens, **B.** Offatts Bayou, **C.** Airfield, **D.** Suburbs, **E.** Houston Approach, **F.** Railway Bridge, **G.** Broadway, **H.** Sea Wall.

THE MAIN COMMISSION for the Galveston project came to Jellicoe from the Moody Foundation in 1984. During the following years he devoted a major part of his time to its development through three major stages of revision. The original concept (1984) was primarily botanical. In many respects, it would have been, as Jellicoe himself notes, '... the grandest landscape in the modern world, having majesty, drama and singleness of purpose'. The project design formed part of the sequence of works in his 'Augustan poets' series. Believing that all Western landscape art can be traced back to the writings of the Roman poets of the Augustan age, Jellicoe first found Virgil to be an ample source of inspiration for this urban park for the Italian city of Modena; Ovid has a bearing upon the proposals for Brescia which followed immediately; finally, Lucretius seemed to provide highly appropriate inspiration for the Botanical Gardens at Galveston.

In Lucretius' great poem, *De Rerum Natura*, is described the whole nature and origin of the universe and so of humanity. This Epicurean philosophy, whereby man can break free of the chains of bigotry and religious superstition, has always appealed strongly to Jellicoe. He is particularly fond of the following passage, 'So irresistibly is human power ground to dust by some unseen force which seems to mock at the majestic rods and ruthless axes of authority and trample on them for its sport.'

The site was wholly enclosed by a dyke, twelve feet high, and excavated soil surmounted by a triple row of trees. A canal, some ten feet wide, can be seen in the drawing to wind through the grid layout of the various botanic species; it starts and terminates at the education centre. Other notable examples of garden architecture, evidently the product of improved technology, include here a glass house, a second 'temperate species' glass house, and a prominent viewing tower,

KEY
A. Preserved wild-life marshes
B. Nursery as located
C. Undetermined, with helicopter flight path over (later returned to marshes)
D1. Western Civilizations as located
D2. Eastern Civilizations as located
E. Proposed glasshouses and educational campus
F. Car park
G. Partially disused airport

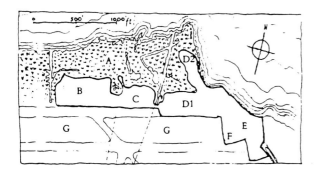

A model of the Moody Gardens (right); in the background are the gardens representing the civilization of the West; in the foreground are those of the East (see plan on pp.184/185).

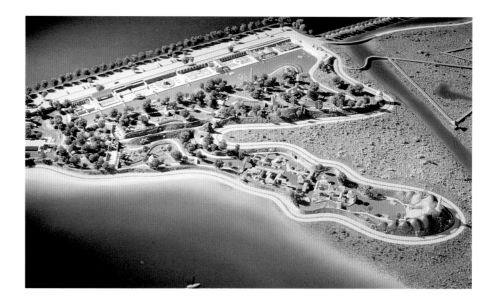

together with garden sculptures; these include gargoyle fountains, a Pluto's grotto and a bust of Lucretius himself.

Jellicoe allowed the wetlands to yield some territory to the sea, by a symbolic erosion of the existing shoreline. The Sea Restaurant is poised dramatically to the north, where the cosmic forces of nature can be most evident to visitors.

Unfortunately this great project was not taken further by the Moody Foundation, largely for commercial reasons. The emphasis on the purely botanical was replaced by a more historical theme, describing the history of human civilization through the evolution of landscape and garden history. Jellicoe's most comprehensive book, *The Landscape of Man*, was to be interpreted here on the Gulf of Mexico, on a scale unsurpassed in grandeur. Site work has already commenced (1992) and major works are being carried out.

The project is first described in the drawing of 30 June 1985. The botanical *tour de force* originally inspired by Lucretius is still partly evident in the nursery to the west of the site in the first plan. In virtually all other respects, however, the Moody Historical Gardens represent a completely fresh start for Jellicoe. The full scheme, as described in Jellicoe's own publication, has been publicised since. Yet is is rather less impressive in its reduced scale than its predecessor, in spite of its greater complexity. As Jellicoe has said, 'It is technically amusing, but it will never be as grand as the first. It's just not in the same class.'

While it is clear that the project is broader today in its historical appeal, and so economically more autonomous and viable, the two drawings of the respective versions reveal the differing preoccupations respectively of creation and of civilization. But the Moody Historical Gardens now reveal that other aspect of Jellicoe's work, the ability to draw upon a massive reservoir of historical detail in landscape history, thus illustrating the interaction of social evolution with garden design. Whatever the loss, the Historical Gardens will, when completed, represent a unique *tour de force* in the history of landscape and gardens. Jellicoe was conscious of the fact that, while at Modena, he was dealing with the *collective* subconscious (in Jungian terms), while at Sutton Place he was concerned with reaching for the *individual* subconscious. Now at Galveston he found it possible to link the two Jungian concepts together in striving to express the ultimate unity of man's existence. In the Historical Gardens (as opposed to the purely botanical first scheme) man is directed to address deep psychological space – in marked contrast, it seemed to Jellicoe, to the nearby Houston Space Centre, which reached outwards to the planets, to the essence of time itself.

In the final plan for the Historical Gardens, Geoffrey Jellicoe carefully differentiated between Western and Eastern cultures in dividing up the space on site.

The plans of 1985 for the Historical Gardens (overleaf); the details in the lower part of the main plan are of the development of the Western garden, to be sited along the straightened section of shoreline.

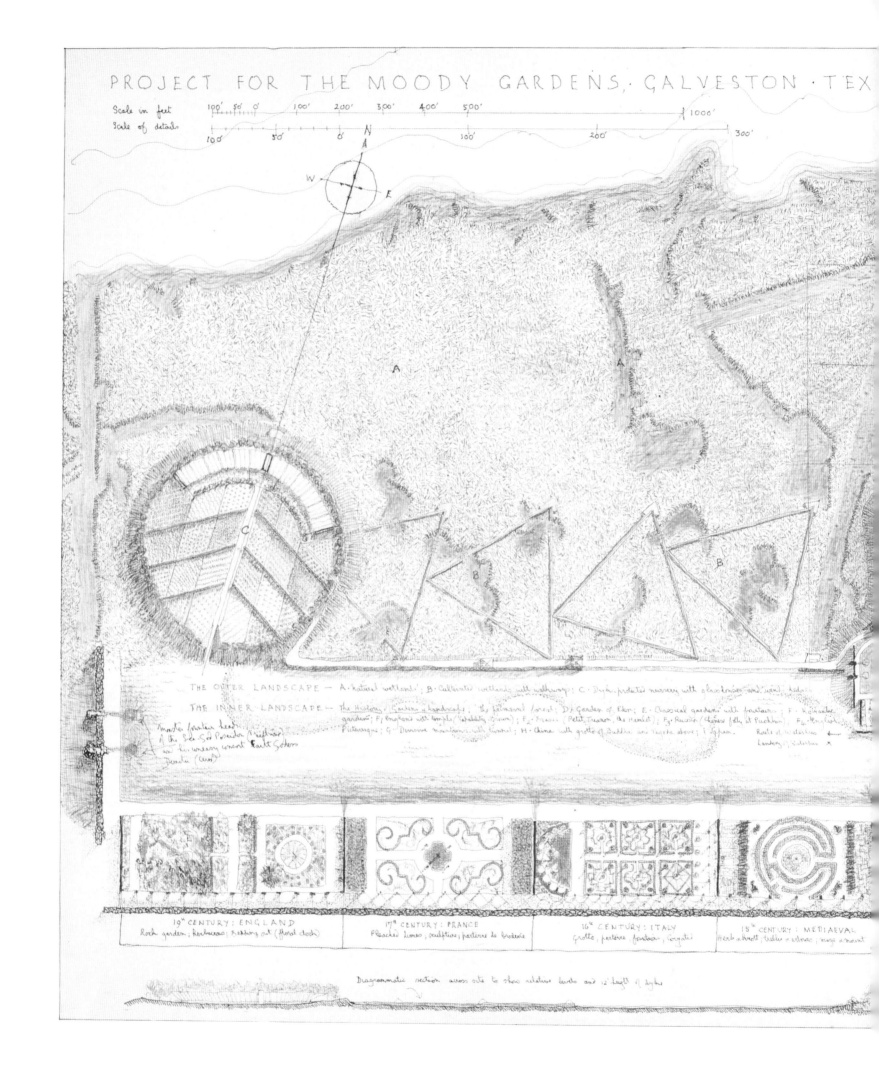

PROJECT FOR THE MOODY GARDENS, GALVESTON · TEX

THE OUTER LANDSCAPE — A. natural wetlands; B. Cultivated wetlands with walkways; C. Dyke-protected nursery with glasshouses and wind-breaks

THE INNER LANDSCAPE — The History of Gardens & landscapes; the perennial forest; D. Garden of Eden; E. Classical gardens with fountains; F. hydraulic gardens; F. Erotonic with temple (establishing a time); F₂ France (Petit Trianon, the hamlet); F₃ Russia (Chinese folly at Pushkin); F₄ English Picturesque; G. Deserve mountains with hermit; H. China with grotto of Buddha and temple above; I Japan.

19ᵗʰ CENTURY: ENGLAND
Rock garden; herbaceous; bedding out (floral clock)

17ᵗʰ CENTURY: FRANCE
Pleached limes, sculpture, parterres de broderie

16ᵗʰ CENTURY: ITALY
Grotto, parterres, fountains, pergola

15ᵗʰ CENTURY: MEDIAEVAL
Herb & knot, treillis & arbour, maze & mount

Diagrammatic section across site to show relative levels and to length of styles

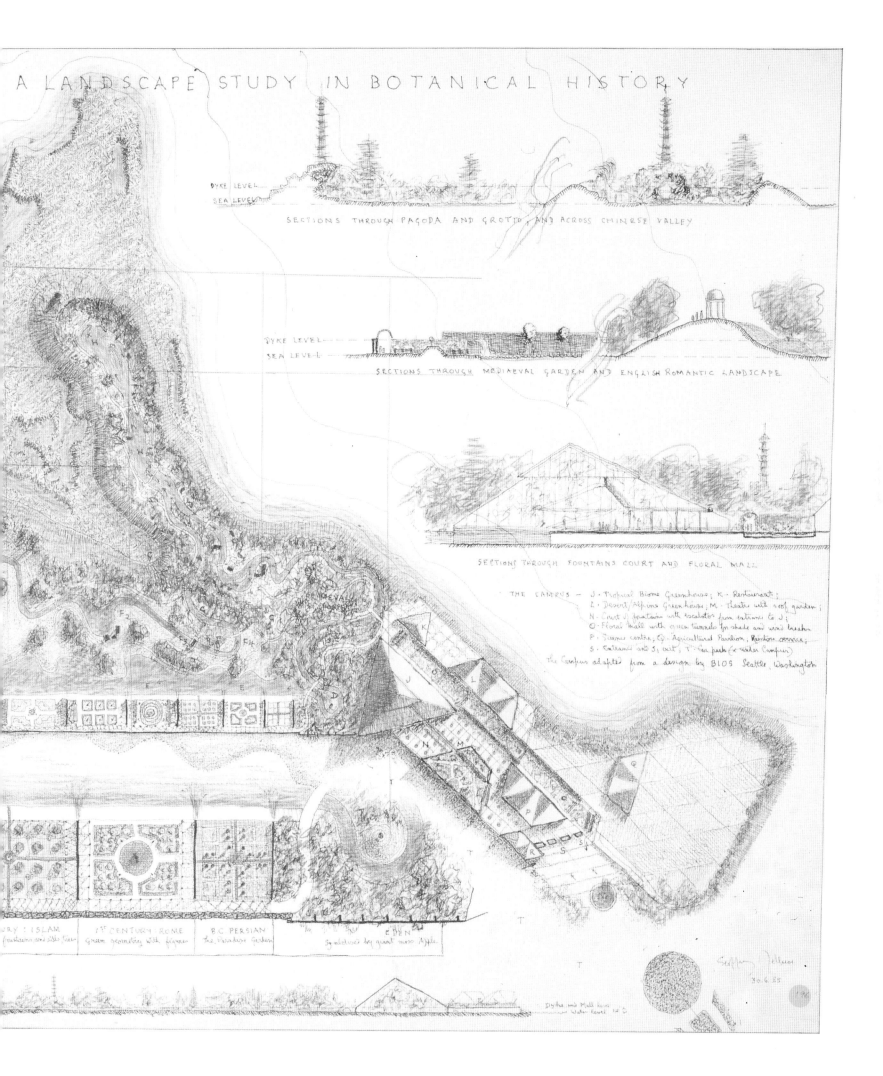

A LANDSCAPE STUDY IN BOTANICAL HISTORY

DYKE LEVEL
SEA LEVEL

SECTIONS THROUGH PAGODA AND GROTTO AND ACROSS CHINESE VALLEY

DYKE LEVEL
SEA LEVEL

SECTIONS THROUGH MEDIAEVAL GARDEN AND ENGLISH ROMANTIC LANDSCAPE

SECTIONS THROUGH FOUNTAINS COURT AND FLORAL MALL

THE CAMPUS — J · Tropical Biome Greenhouse; K · Restaurant;
L · Desert/Alpine Greenhouse; M · theatre with roof garden;
N · Court & fountain with escalators from entrance to J;
O · Floral Mall with green tunnels for shade and wind breaks
P · Science centre; Q · Agricultural Pavilion; Reinforce service;
S · Entrance and S; exit; T · Car park (or under Campus)
the Campus adapted from a design by BIOS Seattle, Washington

...URY: ISLAM 1st CENTURY · ROME B.C. PERSIAN EDEN
(fountains and still lakes) Green geometry with figures The Paradise Garden Symbolised by giant moss Apple

Dyke and Mall level
Water level 14'0

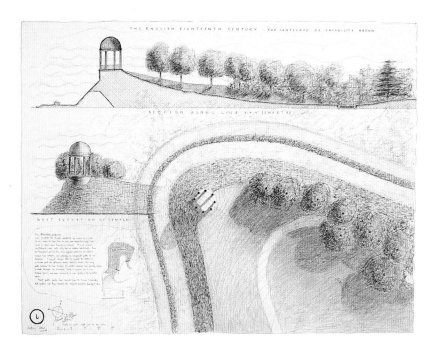

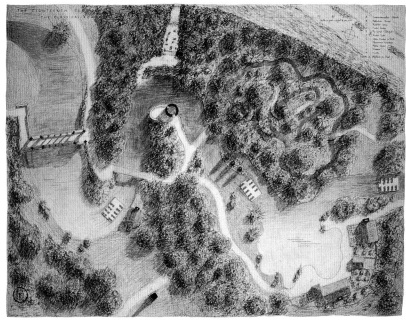

Details of the final plan for the Moody Historical Gardens: the English eighteenth-century landscape ('Capability' Brown) (above left), European eighteenth-century (Classical Romantic) (above right); English nineteenth-century (revised version), English eighteenth-century (below left); French seventeenth-century, Italian sixteenth-century (below right).

G.A.J. The SITE is slightly above sea level. The approach is from the campus to the east. On the south it is bounded by the straight line of the airfield. The irregular shape to north and west was governed by wildlife restrictions of the wet-lands. The whole is surrounded by a twelve foot dyke or wall as protection against inundation. The area falls naturally into three parts: the WESTERN and EASTERN cultures separated, as they are on the planet, by the PRIMAEVAL....

The PLAN is composed of the 'essence' of historic gardens and landscapes. Each 'essence' is not so much the copy of an actual example as the abstract idea, academically executed, that seems best to represent the age. The WESTERN CULTURES, predominantly *secular*, fall into two categories: classical and romantic. The classical

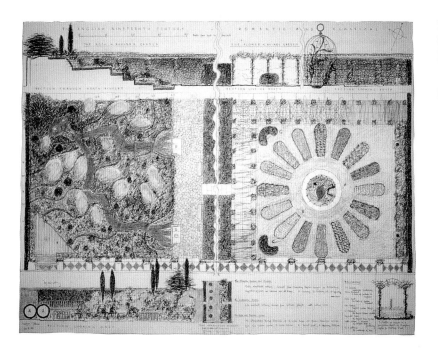

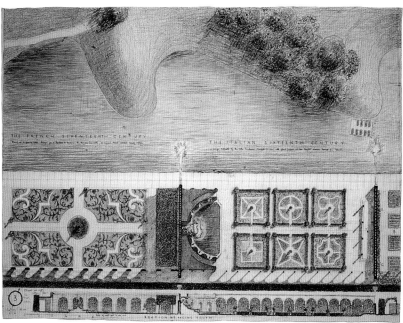

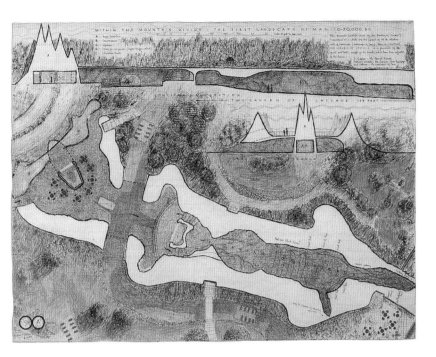

sequence, expressive of the geometry and rhythms of the heavens, represents stability and rational thought in a world of turmoil; it is accepted that a great and tranquil idea through mathematical proportion can be contained in a finite box. In contrast, the romanticism of eighteenth century Europe, the basis of the future public park, derives from the irrational in man and his urge to return to uninhibited nature: thus the boundless spaces which create further spaces beyond the eye. The EASTERN CULTURES are basically *metaphysical* and philosophically static. Some two thousand years of Chinese culture is dominated by the Buddha; the Japanese Zen garden is the deepest visual expression ever made of man's struggle to *feel* his relation to infinity.[8]

The Mountain Divide between East and West (above left); China: the Gardens of the Dragon Temple (above right); Medieval Europe, Islam/Mughal India, Classical Rome (left to right) (below left); Egypt of the Pharaohs, Primaeval Forest (left to right) (below right).

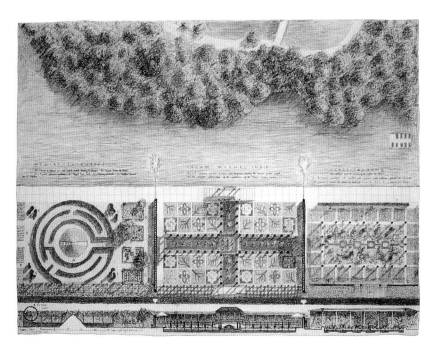

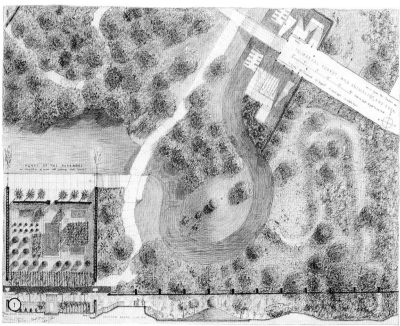

The Master Period from 1980 · 187

Atlanta Historical Gardens, Atlanta, Georgia

HISTORICAL PARK
1992–93
Atlanta Historical Society

Geoffrey Jellicoe drew his master plan for a sequential garden in Atlanta which would also take account of existing architectural and landscape features. Due to open in 1996 to coincide with the holding of the Olympic Games, the gardens are still very much a comprehensive statement of Jellicoe's art. Note the long axis, emphasized by water to the south-west and the winding path through woodland. Existing architectural features are denoted by the pink, cross-hatched areas (opposite).

IN APRIL 1992 Geoffrey Jellicoe was invited to prepare a landscape plan for an expansion of existing facilities consisting of some seven gardens spread over 32 acres in the middle of the city. One of the city's two major public parks, the area is distinctive for demonstrating man's relationship with plants and with whole environments at key periods throughout the history of Atlanta.

Sir Geoffrey found the quarry garden already in use; it covered three acres on the site of a former building quarry and contained a range of over 300 plant species, including azalea, fern and carex. Separately, the Tullie-Smith Gardens were developed to represent accurately the mid nineteenth century in Atlanta over six acres, evoking farm life on a large plantation. Likewise, the Swan Woods Trail illustrates ecological succession in the Georgian Piedmont, and contains remnants of century-old terraced cotton fields, symbolic of the post-Civil War period.

The core of the area is the 23-acre Buckhead estate around Swan House, with gardens designed in the Italian manner (loosely modelled on those of the Palazzo Corsini, Rome) and the work of the architect Philip T. Schutze. In addition to these, the Cherry Simms Asian American Garden, begun in 1988, incorporates examples of Asian species. The Frank A. Smith Memorial Rhododendron Garden focuses on the importance of the *Ericaceae* species within the overall horticulture of Atlanta.

The New Museum is surrounded by a garden, incorporating a beech plantation, perennial borders, where an American Indian garden had already been planned for the near future prior to Jellicoe's first visit.

Geoffrey Jellicoe found on his arrival that large tracts of car parking were already located centrally within the 32-acre complex and he soon decided to move this to a less dominant position. He planned a new entry focus, the Grotto, to be approached from the south-east, linking with the main pedestrian path from Tullie-Smith House and the New Museum further east. This was, then, a zone already loaded with existing attractions, including a restaurant on the southern periphery of the site. From here, moving in a clockwise direction, Jellicoe skilfully set about implementing a series of amendments and insertions within the existing fabric.

Close to the Grotto, en route for pedestrians moving further west, he took up the cue offered by the very charming nineteenth-century 'Victorian' Playhouse, created to the scale of children: the brief had indicated that funding would not be available to develop a completely historically accurate landscape, so the garden's link with that era remained tenuous. Jellicoe seized the opportunity to present here a group of three small separate but linked reserves. Contained within trellis walls, these incorporate in strict sequence an early nineteenth-century kitchen garden, a mid nineteenth-century flower garden and, as

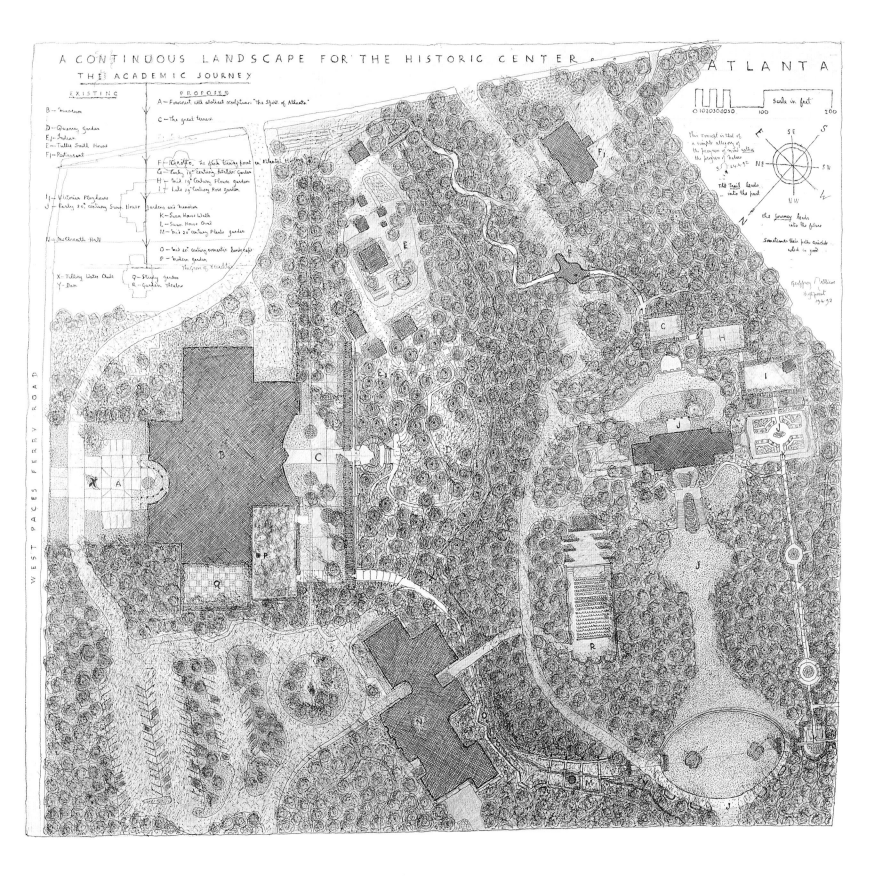

A CONTINUOUS LANDSCAPE FOR THE HISTORIC CENTER of ATLANTA
THE ACADEMIC JOURNEY

a climax, a late nineteenth-century rose garden. These were initially designed as perfect squares, but after consultation with the trellis designer, Jamie Garnock, it was finally decided to arrange them as parallel linked rectangles. The Playhouse was established at an angle in the southern corner of the rose garden, some way in from the boundary.

Moving further into the existing Swan House Gardens and mansion precincts, we come to Swan House Walk. Jellicoe here proposes reshaping the existing path into first a closed route, then an open one. This leads to a new semicircular pool; and from there at right angles, we move on north-east, circumventing the existing oval, via a new mid twentieth-century plants garden, through orthogonal green arches. The oval, with its peripheral seats, is treated as an historic climax, reminiscent of the Italian High Renaissance.

Via a new mid twentieth-century garden, Jellicoe guides the visitor along past the 'landscape of light' to reach in due course the climacteric grove of Heraclitus, symbolic of the twenty-first century.

Jellicoe had recently reached the conclusion that the ancient Greek philosopher Heraclitus could offer insight into the resolution of conflicting ideas. Heraclitus had advanced a theory of the universe in which all is in flux, in which opposites combine to produce harmony.

Jellicoe has retained this existing vista from Swan House to the north-west.

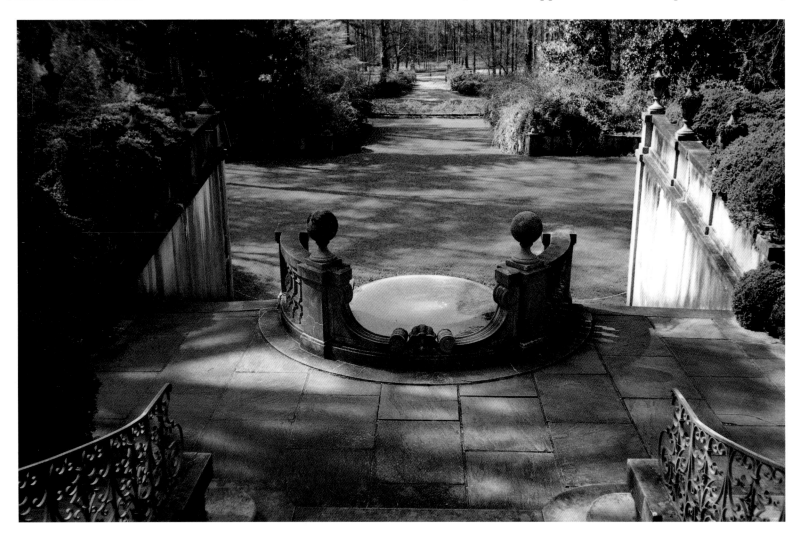

Jellicoe at Atlanta was now developing what he referred to as a theory of 'space-time design'. As the drawing indicates, he addresses most specifically, as always, the brief. The terms of reference were for an all-over landscape design which would both unify the whole disparate estate, visually, while at the same time (without resorting to 'theme park' ideas) ensure as easy a passage as possible for the traveller through the 'historical' stages of the garden.

G.A.J. As I worked on this shadow drawing of the original I found the essence of what the plan was – in trying to convey this it all became more clear. This revealed the real problem: how to incorporate the greatest feature of all, Swan House and environment – that is three centuries out of the context of history, both as to time and place. Yet I hope that it takes its place as a gracious exception that proves the rule that progress in the civilized arts is inevitable. The history pursued is materialistic and for this reason I hope that the 21st century 'quiet' garden of contemplation may stir the thoughts to ponder on the past *not as the past but as a pointer to the future.*[9]

The site is first treated to the 'Classical' approach – which is found wanting. The existing buildings are subjected to an axial harmonization. Perhaps a focus is created in the centre – the result is little more than sterile in this context. Furthermore the existing buildings are in any event three centuries out of context in historical time and place. The axis between the two dominant buildings might be supported by a monumental pool, a bridge or monument, in the valley between, with sculpture and fountains – like Washington Mall, on a smaller scale. The mind can be stabilized by such a heroic, man-made composition.

Then we have what may be called the 'Romantic' approach. Until recently the ethos of this remarkable site was greater than the buildings placed upon it: now there is uncertainty. In the manner of the eighteenth-century English Landscape School, its dominance might be restored if the present little stream were turned into a river of magnitude and personality, without either beginning or end: the sequence of dams would create the pleasing sound of falling water.[10] (The third and most appropriate concept may be called the 'cosmic' approach.)
Neither the 'Classical' nor the 'Romantic' approach respond to what is now the sole purpose of the estate, to provide for the one-day visitor a lasting academic experience and impression of the history of Atlanta. Can the scheme do so in its uneven and exotic journey through time and space? Can the mind, ultimately, unify matter?[11]

1. The 'classical' design.

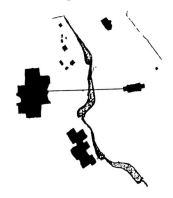

2. The 'romantic' design.

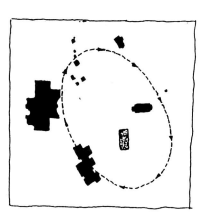

3. The 'cosmic' design.

Smaller Projects of the Period

Barnwell Manor, Northamptonshire

LANDSCAPE AND GARDEN DESIGN
1981
H.R.H. The Duke of Gloucester

Jellicoe's proposals for the re-landscaping at Barnwell Manor were principally concerned with the redefinition of vistas through clearing and planting.

In July 1981, Geoffrey Jellicoe was invited by H.R.H. The Duke of Gloucester to plan improvements to his home at Barnwell in Northamptonshire. He proposed the intersection of a new, protected terrace garden between the two main blocks to draw the looser elements of the existing garden together, with the addition of a summer house with pavings and a formally aligned yew hedge. From the main northward aspect of the house a small amount of tree clearing was needed to open up the view, which involved relatively minor changes: fence lines were removed and new hedgerows inserted, emphasizing the alternative aspect to the east, while providing enclosure to the west. Jellicoe attempted to enhance the 'romantic' aspects of the landscape visible from the house. Additional planting of forest trees helped to emphasize this effect. Indigenous trees were added to the new and existing hedgerows.

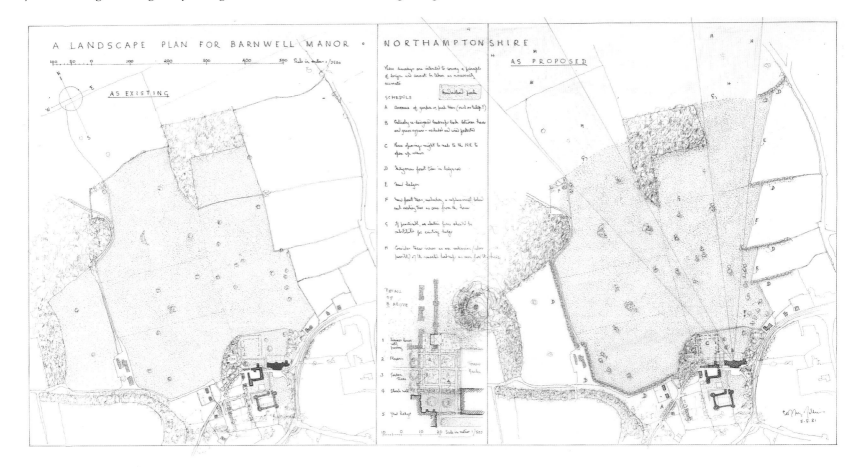

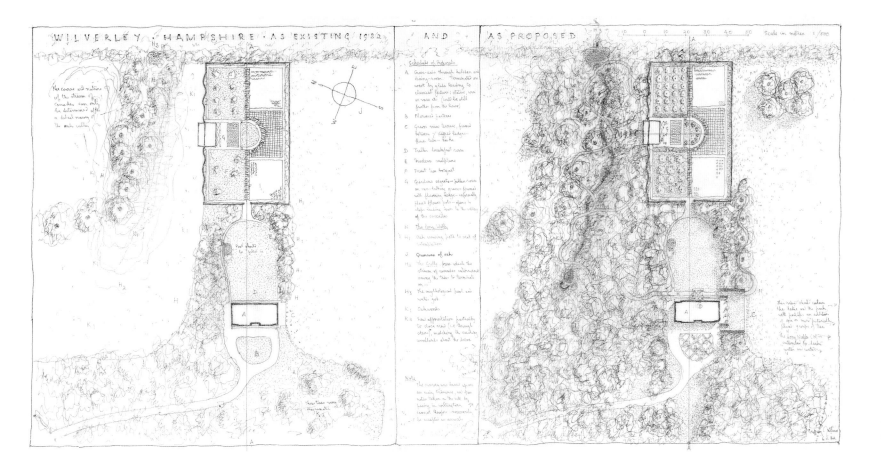

This scheme beforehand offered little to inspire the landscape architect. The copse of oak trees to the north of the house, bisected by a small stream, had little visual connection with the house and the existing formal gardens and approach. Immediately east of the house, Jellicoe added a long walk, a characteristic of many of his later garden designs. This was extended at both north and south ends into newly planted oak woods. A new path was laid out from the house to cross the stream to the north, opposite a new grotto from which, to quote Geoffrey Jellicoe, 'a stream of cascades interweave among the trees to terminate at the mythological pool and attendant water god to the East'. A quincunx of oak was then planted due east of the house, and new afforestation to the south-west. The project was sealed, so to speak, by a flowered parterre at the entrance point to the house. The previous cross axis was left on its asymmetrical alignment, but embellished with an enclosed garden, a *giardino segreto*.

Jellicoe has here skilfully incorporated existing elements into a grand gesture of homage to the ancient oak, embellished by water features. He has cleverly avoided the problem of the existing, arbitrarily placed pond to the east of the house by simply ignoring its presence.

Wilverley, Hampshire

GARDEN DESIGN
1982
Anonymous Client

An important before-and-after plan by Jellicoe; the tree planting proposals at Wilverley show him once again achieving strong contrast between a formal garden and parkland beyond.

No. 27 Grove Terrace, Highgate, London

GARDEN DESIGN
1974

Mrs. A. Smith

Town gardens are rare in Jellicoe's work. This example (right) is an earlier plan (1974) for a neighbour in Grove Terrace. It should be compared with the Jellicoe's own garden (p.58).

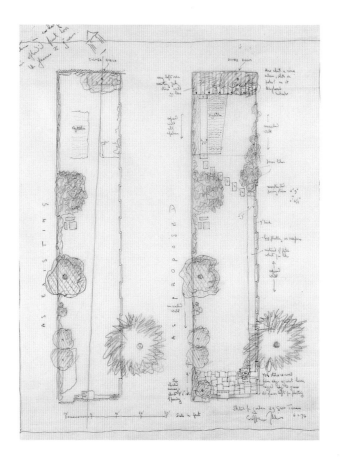

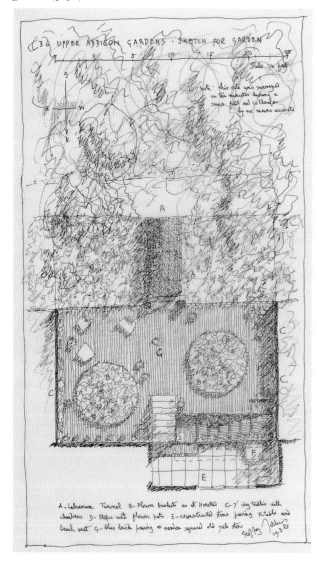

Two alternative schemes for a London town garden (above and right); note the plans for trellis arbours in the style of those at Sutton Place.

IN 1974 Geoffrey Jellicoe was approached by neighbours in Grove Terrace to re-design their garden, similar in length and proportion to his own. The drawing, dated 6 January 1974, indicates a new vine arbour (reminiscent of Jellicoe's childhood home, the Vinery, Rustington), perhaps intended too to 'drip with grapes' as he had put it on revisiting Rustington in 1988 with the present author. Skilful additional planting suggests Susan Jellicoe's involvement here.

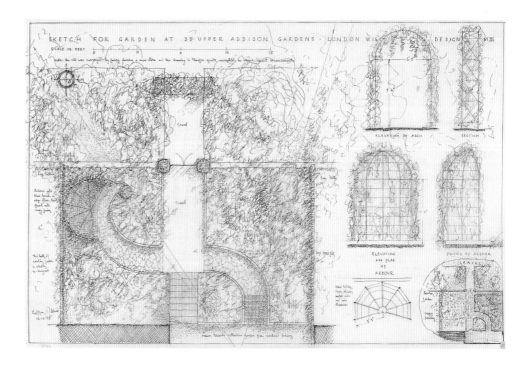

THE SUCCESSFUL collaboration with Lady Rupert Nevill at Horsted (see p.99) was extended in October 1985 to include a small garden scheme at her London residence. In March 1985 Jellicoe produced a first proposal that repeated the Horsted flower baskets, a circular design originally by Humphry Repton. In the London scheme these rest on blue brick paving suggestive again of water, leading this time to a small tunnel of laburnum. Jellicoe also designed an arbour on the east side of the garden constructed in metal trellis similar to that employed at Sutton Place. Beyond, an ivy trellis growth completed a double square. Such a private space was to emphasize this garden's relationship to the adjacent square, itself a communal garden and visible from the overhead balcony of the house.

No. 35 Upper Addison Gardens, London W4

GARDEN DESIGN
1985
Lady Rupert Nevill

THIS PROJECT for Stanley Seeger, the original client of Sutton Place incorporated, notably, a terrace on two levels overlooking the garden to north. To the south, a combined herbal and flower garden was planned, leading to a pergola on the west side. An arbour with a glass fountain was proposed close to the boundary wall. A tank fountain is the central element in the main garden area at ground level to the north, feeding a flattening rill with tilting pans designed to force water over the pebbles. On the lower terrace, the client requested a Pluto's grotto, incorporating a moss wall. Adjacent to it is a marble floor with water vases, a cool place for refuge during the midday heat.

Villa Seeger, Asolo, Italy

GARDEN DESIGN (uncompleted)
1988
Stanley Seeger

The formal elements in this plan show Jellicoe interpreting again the Italianate style which was one of his earliest and deepest influences, appropriately enough in an Italian garden.

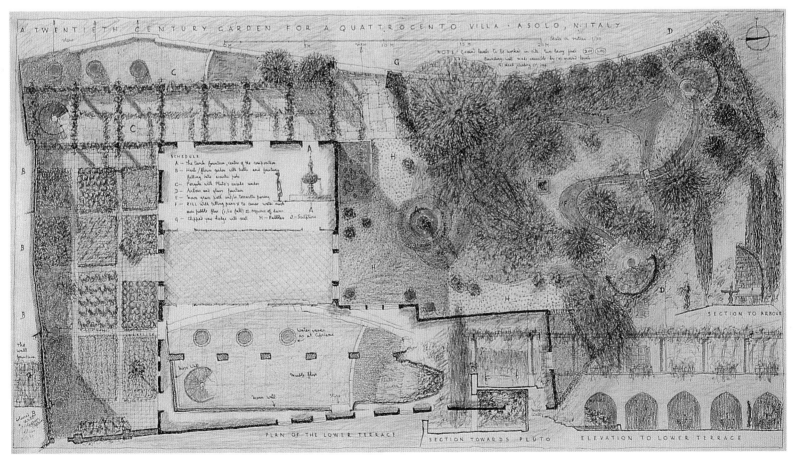

Tidcombe Manor, Wiltshire

GARDEN DESIGN
1989
Earl and Countess Jellicoe

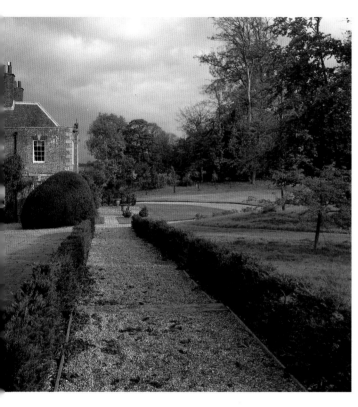

The long path towards the house at Tidcombe (above) was introduced by Jellicoe to link the main entry drive to the gardens.

This plan of the Tidcombe garden (right) shows the planting configuration before the great gale of 1987. In his completed scheme (opposite) the tree loss has been converted into an advantage by opening up the southerly vista. Jellicoe amusingly described the gale as the 'Capability' Brown of the twentieth century.

TIDCOMBE MANOR occupies a fine site within a historic landscape. In 1969 Geoffrey Jellicoe had been invited to prepare drawings for a new terrace, but this was not executed. It was only in 1989 when, following the great gale of 1987 which destroyed several mature trees at Tidcombe, that Jellicoe was invited to make a new and more comprehensive plan for the whole garden. Interestingly enough, he was able to make positive use of the loss of the trees, since they had partly obscured the view of the Downs.

The gardens at Tidcombe had originally been designed in the early twentieth century; Jellicoe now added a compartmentalized plan which included a spring flower garden with a second and third for summer and autumn – all to be linked by a long walk on the east side through green arches, running north to south. Adjacent to this was placed an arbour directed towards the house. Beyond this a peaceful green square was created with a range of cypresses aligned with a small plateau. A new kitchen garden was proposed further to the west. A double stairway of steps gives access in one direction to the tennis court and to natural woodlands in the other. The removal of trees south-west of the house revealed the village church.

This is a masterly scheme where Jellicoe has transformed an apparently severe loss of tree cover into a positive advantage to create a better structured and much improved series of differing gardens.

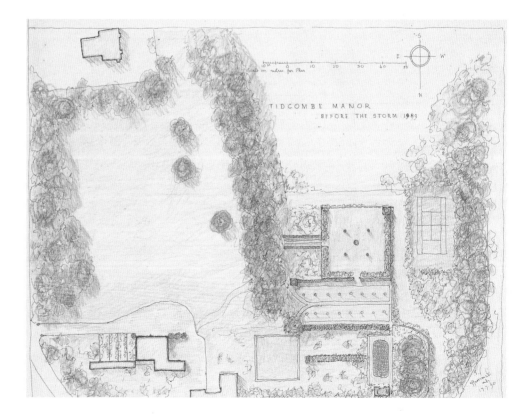

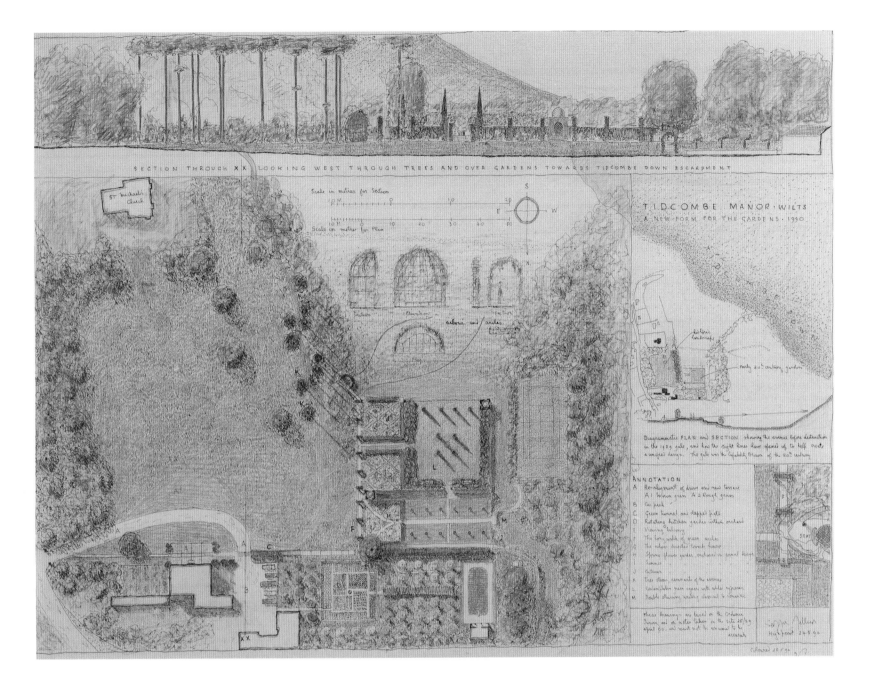

EARLY IN 1989 Jellicoe was invited to prepare drawings for the landscaped park of a civic sports centre in the Turin area. The site adjoined a football stadium and lay close to a primary distributor road.

The first drawing, dated 12 March 1989, shows the initial scheme. Jellicoe used a plan derived from the work of Piet Mondrian, cruciform and severely linear. This key concept was to be implemented in landscape terms by the creation of a massive yew hedge, trained and trimmed to a triangulated section, in two parallel lines running across the site. At the south end would be a flower garden (*continued on p.200*)

Turin, Italy

LEISURE PARK PLAN (uncompleted)
1989
Pietro Derussi

The first design (right) for a sports park in Turin, dated 12 March 1989, is considered to be one of Jellicoe's greatest concepts. As the legend in the upper left-hand corner notes, the strong grid lines of a Mondrian painting were very much in the architect's mind when this drawing was done – lines which are clearly repeated in the perimeter planting and the rill axis. The second plan (below) of 28 February 1990 is altogether simpler: the allotments in the south-west sector, retained in the first plan, have now disappeared.

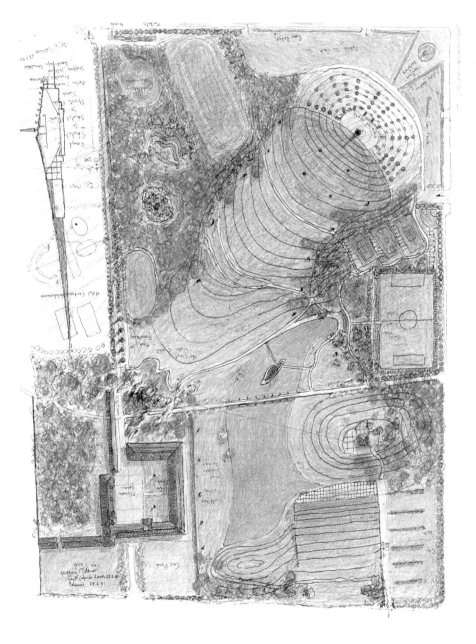

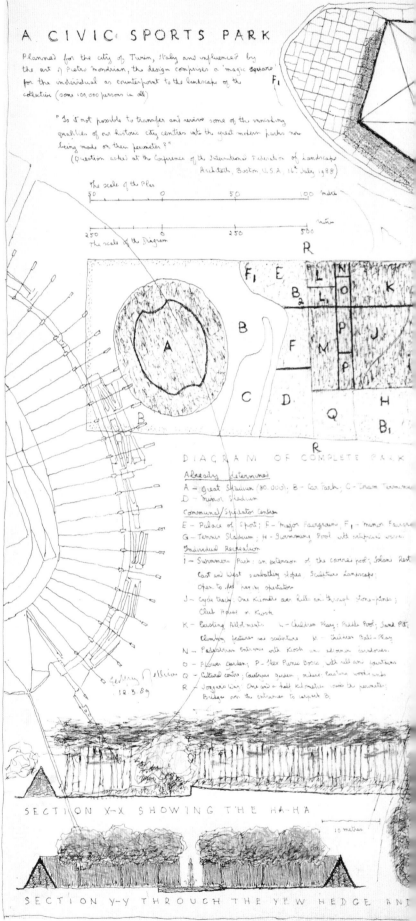

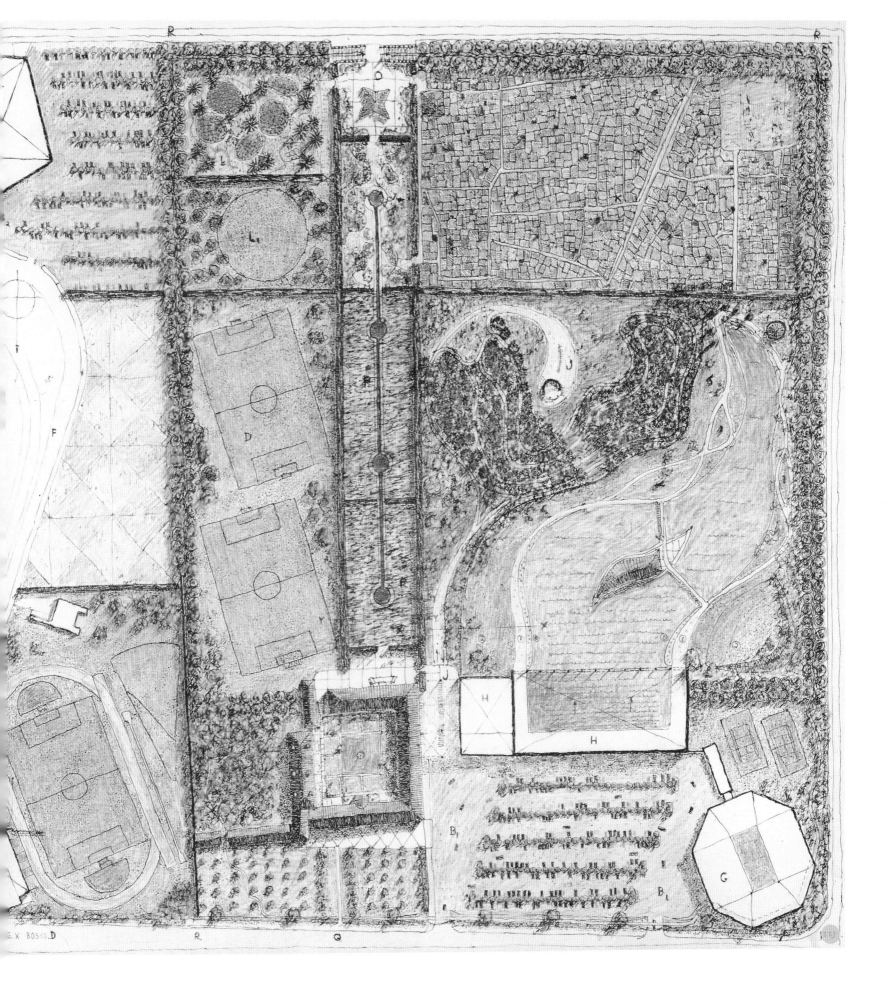

and an ilex *bosco* for picnics, with a rill and fountains. Adjacent would be a childrens' paddling pool. A mass of private allotments sited in the south-western sector were to be retained. Jellicoe was in any case intrigued by their seemingly random pattern. Close to these he planned a cycle track and a large outdoor swimming pool, flanked by the Mondrianesque axis of yews to the north-west and abutted by ample car parking amidst shady trees.

The second Turin scheme was drawn up on a reduced scale, when it became clear that the Italian architects engaged on the project did not wish to proceed in full with the first project of 1989. The allotments were now abandoned and the site incorporated wholly in the leisure park. A massive auditorium was designed with a landscaped roof forming an elevated mound. Jellicoe re-oriented the other leisure facilities and the cycle track to fit the new requirements. However, the originality and drama of the first project do seem rather to have been lost in the second scheme.

G.A.J. Until this commission Mondrian had been the only artist of world (and architectural) reputation to whom I could not respond. His abstracts seemed lifeless and pointless. The site of the proposed Turin Sports Centre and Park however is part of the city grid-iron plan, and because of the multiple-use programme it was instinctively to Mondrian that I turned for help to ensure order out of chaos with a classical grandeur of conception. The plan was rejected, and a romantic solution proposed one year later.[12]

Blue Water, Kent

SHOPPING CENTRE, SITE PLANS (uncompleted)
1991
Blue Water Company

IN APRIL 1991 Geoffrey Jellicoe was invited by Blue Circle Cement Industries PLC (formerly Blue Circle Cement Ltd) to prepare outline proposals for a major shopping centre to be located in a quarry site in Kent. He rapidly prepared a concept combining both simplicity and grandeur; mindful of the micro-climatic effects of such a location, he introduced a major water element around the buildings. The plan for these and the adjoining car parks was characterized by remarkable simplicity of form. The whole site is surrounded by chalk cliffs – so water would have an invaluable role to play in helping to maintain an equable outdoor temperature in an environment which could run to extremes in summer and winter. The expansive green lawn incorporates a cricket pitch and clubhouse. The total area of retail space amounted to 812,000 sq. ft., or 18 acres in all. In addition, some 15 per cent of the total was set aside for open public land. There was also parking space for 13,000 cars.

In the initial concept, Jellicoe had planned to flood the whole floor of the quarry as a lake, creating in the centre a shopping island with cars

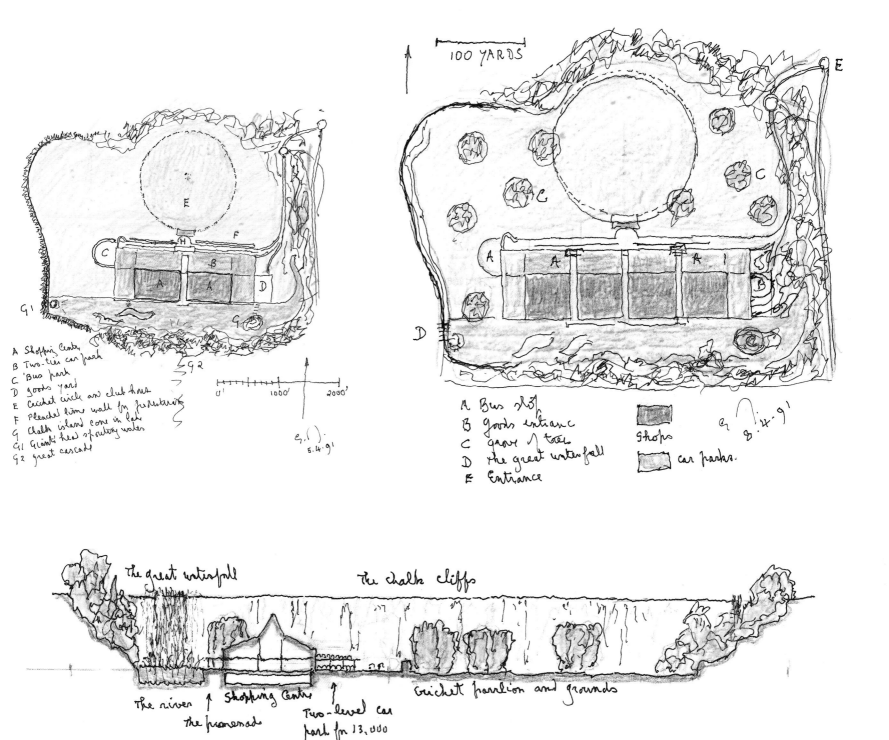

A Shopping Centre
B Two-tier car park
C 'Bus park
D goods yard
E Cricket circle and club house
F Pleached lime wall for promenaders
G Chalk island cone in lake
G1 Giants head spouting water
G2 great cascade

G.J.
5.4.91

A Bus stop
B goods entrance
C grove of trees
D the great waterfall
E Entrance

Shops
car parks.

G.J.
8.4.91

the great waterfall the chalk cliffs

The river
the promenade Shopping Centre
 Two-level car
 park for 13,000 cricket pavilion and grounds

stacked on the immediate south shore running down three levels from site datum level. These car stacks would thus be protected from the weather and yet benefit from direct single access via a bridge to the retail 'island'.

An intermediate version, dated 5 April 1991, shows pleached limes lining the northern periphery of the retail centre, while the waterfall is replaced by a giant's head water spout.

Geoffrey Jellicoe's preliminary sketches for a shopping centre at the Blue Water Quarry site in Kent.

The design for Danemere Park, Kent, was originally developed in 1986, but only realized in 1991. It incorporates a planting scheme by Valerie Winter.

Danemere Park, Kent

GARDEN DESIGN
1991
June Harrison

THIS SCHEME was designed in 1986 but only commissioned in 1991 by a former member of Geoffrey Jellicoe's landscape practice. Subsequently detailed planting plans were drawn up.

At the upper left of the plan is a spring garden designed to be planted with various bulbs. The three arches are overgrown with *Clematis montana* (white), jasmine and *Rosa* 'Mermaid' respectively, while at the other end the terrace reaches a climax with a strawberry tree surrounded by square pavings. The beds abutting the house are raised up. A gravel path leads between groups of paved stones to a fountain, which plays close to a large-scale garden chessboard. While the fountain plays, the game goes on. The box hedge was already established before the scheme was drawn up.

G.A.J. The project is essentially conceived in linear form, that of the path followed by the pedestrian through various sequences of planting and paving: texture is important. The various forms that this created are essentially close-grained and make for a variety avoiding monotony.[13]

Cairo (Giza), Egypt

GARDEN DESIGN
1992
Mohammed Mansour

IN FEBRUARY 1992 Geoffrey Jellicoe travelled to Cairo to examine the possibility of designing a new garden on a site surrounding Sheikh Mansour's new mansion which had a distant view of the Pyramids.

Scheme design was virtually settled within three days, and presentation drawings were ready within two weeks. In his rapid execution, masterly marshalling of key elements, and practical resolution of local problems, Jellicoe demonstrated here all the skills of a master of landscape at work.

G.A.J. The drawing will have shown you that there will be three experiences that together form a whole: 1) the garden of contemplation east of the mansion, 2) the spectacular gardens for the many, west of the mansion and 3) the underworld below and beyond the Water Pavilion.

The Garden of Contemplation

This is an enclosure of fountains, flowers and topiary first seen through a confusion of pillars of the shade-giving pergola walks whose colourful climbing plants screen the outside world. The inner garden is mystical, an offshoot of the Persian Paradise garden.

The Pleasure Gardens for the Many

The theme is water, cascading from the mansion, embracing the swimming pool and vanishing into the underworld.

 The upper terrace overlooks the treed slopes below towards a distant view of Cairo (and the Pyramids were it not for intervening trees). At either end is a pavilion to view obliquely the mansion, the terraces, the splash of the cascade and the colourful movement of people. Before descending to the garden pleasure centre, some of us might peel off to enjoy the shady vine walk below the terrace with its wild flower gardens, if only to pass under the waters of the cascade.

 If you are purposeful you can cut through the wild woods to your material objective; but if you are not, you can leisurely descend beside the cascade, enjoying the cool water pleasures of sound and sight. You reach the flat lands of bathing pool, pavilion and the music theatre and climb the steps into the mansion from which it has emerged. The water gushes under you and down a chute to the

Water is the key unifying element in Mohammed Mansour's garden, designed by Jellicoe in 1992, bringing together three contrasting elements into the complete composition: The Garden of Contemplation, The Pleasure Gardens for the Many and The Underworld below the Water Pavilion.

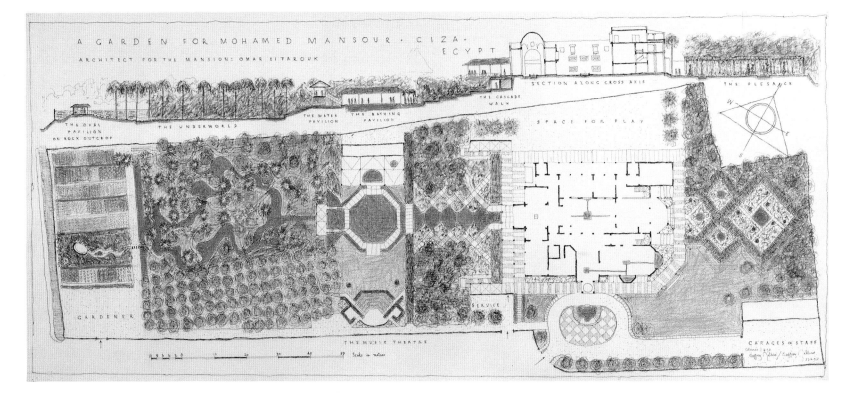

A GARDEN FOR MOHAMED MANSOUR · GIZA · EGYPT

ARCHITECT FOR THE MANSION: OMAR II FAROUK

underworld. You are at the centre of a great idea: the junction of present, future and the deep past.

The Underworld

You can take a boat and paddle your way through the beginning of life. You may clamber out and up to the Oval Pavilion on its rock outcrop. Here you may ponder on the first rational efforts of man for survival: the patterns of agriculture which were ultimately to inspire the Islamic garden art of the Paradise garden and, in due time, the pleasure of gardens we have just visited. The more imaginative amongst us might conceive that we are inside the functional white of an egg which feeds the yoke from which life begns. Why not?[14]

Denbies, Dorking, Surrey

GARDEN DESIGN (uncompleted)
1992
Mr and Mrs Adrian White

IN EARLY 1992 Geoffrey Jellicoe received a commission to redesign the grounds of Denbies, previously the site of a house designed by James Cubitt *c.* 1848, which had later been demolished. In Jellicoe's plan the former position of the house is filled with an oval lake (J). Gilbert Scott's fine Victorian church (1859), with its 150ft. spire, had fortunately remained intact and Jellicoe proposed that this should be the main westerly focus.

Jellicoe is seen working here on two scales, both clearly indicated on one drawing: the Garden Plan and the overall Landscape Plan. The former shows the embellishments planned for the area immediately adjoining the new house – a conversion from the old Cubitt outbuildings. This is linked to a modern swimming pool to the east. The front terrace of the house gives on to a stone maze, itself to be linked by a formal covered way of pleached limes to the east to the curving walkway which overlooks the 'lake' and terminates with a gazebo at its northern end. Eighteen flower beds are planned between the walkway and the swimming pool and beyond in the direction of the house. Jellicoe makes no recommendations concerning the two-acre space of the former Cubitt kitchen garden (F), rather envisaging it as a pure green space within its 14ft. wall.

An axial path extends southwards from the geometric centre of the house, terminating at a statue of a Greek god, with double viewing seats (reminiscent of those at Ditchley). As this path enters the southerly woodlands, it becomes swathed in wild flowers (surely here Susan Jellicoe's preference for natural species was not far from Jellicoe's thoughts). In Jellicoe's design paths through woodlands are often meant as an allegory of man's passage through life, and therefore the further the path advances into the woodlands the greater the premonitions of death become. But perhaps redemption is represented here by the summer house in a westerly clearing which has a view of Scott's spire to the north-west.

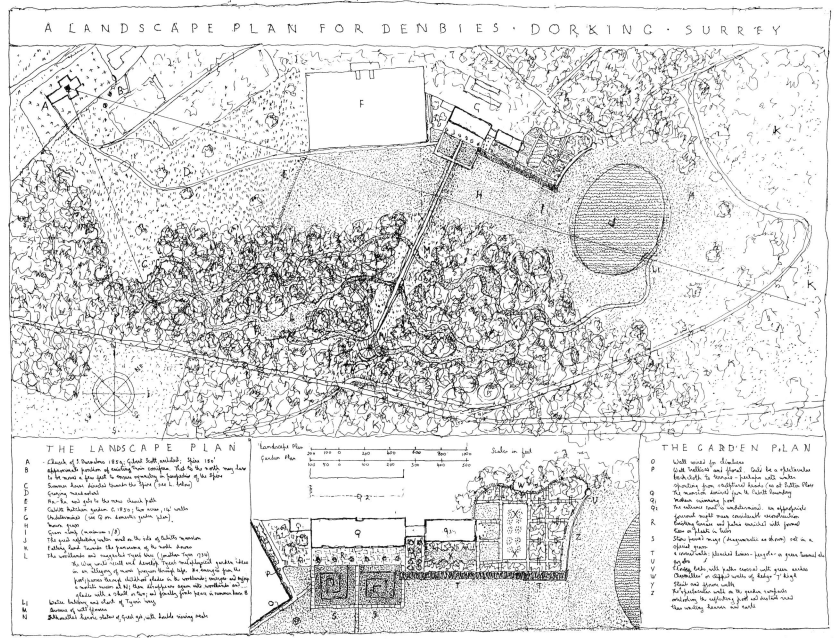

This is a low-key set of proposals; the elements are disposed economically around the void left by a substantial house. Jellicoe fills the vacuum cleverly by the sky-reflective lake, the green void of the rectilinear former walled garden, and the clearly readable allegorical sequence through the woodlands. Denbies can be seen as an immediate relative to the much larger scheme for Atlanta, especially in the suggestion of sequential movement along paths and water-courses. Heraclitus is poised just around the corner. Denbies deals with the passage of time, flux (the house which is no longer there, the passing clouds reflected in the pool) and human mortality, but with a possibility of redemption near at hand.

The Denbies plan of 1992 shows Jellicoe working in detail on two scales, the garden and the broader landscape. These two elements aptly reflect the architect's concern with order and enclosure in juxtaposition to a freer, but nevertheless heavily symbolic landscape.

Conclusion

WRITING IN 1990 *in memoriam* of a friend, the late Pietro Porcinai, an Italian landscape architect of distinction, Jellicoe took time to speculate upon the relationship of landscape design to architecture: 'I see this fine artist feeling his way towards emancipation from architecture, and groping his way to the deep roots that the scientists unearthed some forty years ago. Platonic geometry is no longer accepted as the structure of the cosmos. Beneath the atoms lie amorphous wayward particles, each individual and so small that to be seen by the naked eye it would have to be magnified in the ratio of a grain of sand to the milky way. The hard edge has become soft. . . . landscape design will soon transcend architecture as the mother of the arts.'

In the seventy years of his active career, Jellicoe has always been an innovator. Latterly, he has found the philosophical corollary for his approach to landscape design. In the development of the concept for Atlanta (1992) he had considered creating a grove dedicated to Plato as a finale to the sequence of paths. Re-reading the works of Bertrand Russell in February 1992, however, he came across a passage where Russell sought to explain the thought of the Greek philosopher Heraclitus, whose world-view that 'everything is in flux' closely reflects Jellicoe's own intuitive understanding of the universe. And so, Atlanta will now have a Grove of Heraclitus.

Jellicoe emerges, finally, as a true Modernist, yet as one who has revised his philosophy in keeping with the changing perceptions of the late twentieth century, though always retaining a strong measure of historical understanding. The admiration for human endeavour apparent in the text of *The Landscape of Man* (1975), which he wrote jointly with his wife, the late Susan Jellicoe, derives from a well-documented insight into the millennia of human effort to adjust the requirements of advancing civilization to the constraints of the natural environment. Jellicoe is best understood, perhaps, as a Classicist-Modernist, yet one who has stoically resisted the blandishments of the Post-modernist culture of recent years.

In October 1993, Geoffrey Jellicoe was commissioned by the Council of Europe to write a keynote address in article form, *The Seduction of Landscape*. The closing passage perfectly sums up his view of landscape design, and it is against this last prognosis that he himself would wish ultimately to be judged: 'In centuries to come our world will be divided into three parts: seas, nature resources and humanized land crammed to capacity. Let us guide the present into the future with vision and judgement. Let us ponder on the rise of the landscape profession since the beginning of the century, and pause and wonder if the rise were not spiritual as well as material.'

Notes to the Text

Part One
The Early Works 1927–1960

1 *The Guelph Lectures on Landscape Design*, Guelph, 1983.
2 *Gardens and Design*, London, 1927.
3 Tree, Ronald: *When the Moon was High: Memoirs of Peace and War, 1897–1942*, London, 1975.
4 Geoffrey Jellicoe, article in *Garden History*, October 1960.
5 *The Guelph Lectures*, op.cit.
6 *idem.*
7 *idem.*
8 Geoffrey Jellicoe, *Garden History*, op.cit.
9 *The Guelph Lectures*, op.cit.
10 Geoffrey Jellicoe, unpublished papers.
11 Report by GAJ, 1943, quoted in *The Guelph Lectures*, op.cit.
12 Geoffrey Jellicoe, unpublished papers.
13 *The Guelph Lectures*, op.cit.
14 *idem.*
15 *Denatured Visions, Landscape and Culture in the Twentieth Century*, ed. Wrede and Adams, New York, 1991.
16 *Studies in Landscape Design 2*, London, 1966.
17 *The Architectural Review*, no. 709, Jan. 1956.
18 *Studies in Landscape Design 2*, op.cit.
19 *The Guelph Lectures*, op.cit.
20 *Studies in Landscape Design 2*, op.cit.
21 *Studies in Landscapes Design 1*, London, 1960.
22 *idem.*

Part Two
A Philosophy of Landscape and Garden Design 1960–1980

1 *Studies in Landscape Design 2*, op.cit.
2 *Denatured Visions*, op.cit.
3 *The Guelph Lectures*, op.cit.
4 *Studies in Landscape Design 2*, op.cit.
5 *The Guelph Lectures*, op.cit.
6 Geoffrey Jellicoe, unpublished papers.
7 Geoffrey Jellicoe, interview with author, 1989.

8 *Studies in Landscape Design 3*, London, 1970.
9 Geoffrey Jellicoe, unpublished papers.
10 *The Guelph Lectures*, op.cit.
11 Geoffrey Jellicoe, unpublished papers.
12 *Denatured Visions*, op.cit.
13 *The Guelph Lectures*, op.cit.
14 Geoffrey Jellicoe, interview with Leslie Geddes Brown, *Homes and Gardens*, December 1990.
15 *The Guelph Lectures*, op.cit.
16 Geoffrey Jellicoe, interview with author, February 1991.
17 Geoffrey Jellicoe, unpublished papers.
18 *Studies in Landscape Design 3*, op.cit.
19 *The Guelph Lectures*, op.cit.
20 *Studies in Landscape Design 3*, op.cit.
21 *The Guelph Lectures*, op.cit.

Part Three
Full Flowering: the Master Period from 1980

1 Geoffrey Jellicoe, article in *Landscape Design*, no.145, October 1983.
2 *The Guelph Lectures*, op.cit. The order of the features described has been changed for the present publication.
3 Geoffrey Jellicoe, article in *The Architectural Review*, no.1033, March 1983.
4 *idem.*
5 *The Landscape of Man*, London, rev.ed., 1987.
6 *idem.*
7 *idem.*
8 *The Landscape of Civilisation*, Northiam, 1989.
9 Geoffrey Jellicoe, original text for article in *Landscape Design*, no.221, June 1993.
10 *idem.*
11 *idem.*
12 Geoffrey Jellicoe, interview with author, November 1992.
13 *idem.*
14 Geoffrey Jellicoe, unpublished papers.

The Complete Works of Geoffrey Jellicoe

With the exception of those marked with an asterisk, the schemes listed below were wholly or partly executed.

1927–49 Bingham's Melcombe, Dorset
Appraisal and Recommendations
Lord Southborough

1929 Gordon Russell Ltd Workshops, Broadway, Worcestershire
Workshop Design
Gordon Russell Ltd

1929–31 Kingcombe, Chipping Campden, Gloucestershire
Garden Steps
Gordon Russell

1933 Broadway, Worcestershire
Advisory Plan
Parish of Broadway

1934 Goldsmiths' Estate, Acton, Middlesex
Landscape Plan
Goldsmiths' Company

1934 Cheddar Gorge, Somerset
Visitors' Centre with Restaurant
Viscount Weymouth

1935–39 Ditchley Park, Oxfordshire
Garden Design
Ronald and Nancy Tree

1935 Wigmore St., London
Shop Design
Gordon Russell Ltd

1935–36 Stanmore, Middlesex (with Russell Page)
House
Anonymous

1936–39 Royal Lodge, Windsor Great Park
Terrace and Garden Design
T.R.H. The Duke and Duchess of York

1936 Regent's Park, London: The Holme Gardens
Garden Design
Mrs Pleydell-Bouverie

1936–37 Gordon Russell Ltd, Park Royal, London
Factory Design
Gordon Russell Ltd

1936–37 Kelmarsh Hall, Northamptonshire
Garden Design
Mrs Lancaster

1936–39 *Boughton House; Drumlanrig
Garden Designs
Duke of Buccleuch

1936–39 Mottisfont Abbey, Hampshire
Garden Design and Revision on Appraisal
Sir Gilbert and Lady Russell

1936–39 Pusey House, Faringdon, Oxfordshire
Garden Design
Mr St. J. Hornby

1936–39 Hever Castle, Kent
Garden Design
Lord Astor of Hever

1936–39 Overbury House, Gloucestershire
Garden Design
Mrs Holland-Martin

1936–39 Cottesbrook Hall, Northamptonshire
Garden Design
Mrs Macdonald-Buchanan

1936–84 No. 19 Grove Terrace, Highgate, London
Garden Design
The Jellicoes' own garden

1936–92 St. Paul's Walden Bury, Hertfordshire
Appraisal, Revisions to Layouts, Restoration
Sir David Bowes-Lyon, Simon Bowes-Lyon

1938–40 Calverton Colliery, Bestwood, Nottinghamshire (with Richard Wilson)
B.A. Colliery Co.

1939–43 Theale, Berks.; Hereford; Newport, Mons.; Cardiff; Worcester; Poole, Dorset
Housing schemes
U.K. Ministry of Supply

1943 *Motorways for Britain* exhibition, British Road Federation, London
British Road Federation

1943–46 Mulgrave Castle, Whitby, Yorkshire
Garden Design
Marquis of Normanby

1943–93 Hope Cement Works, Peak District National Park, Derbyshire
Landscape and Conservation Plan
Earle Cement Works (now Blue Circle Industries PLC)

1944 Pitstone Cement Works, Buckinghamshire
Landscape Plan
Pitstone Co.

1945 Wolverton, Buckinghamshire
Town Plan
Local Authority

1945 Guildford, Surrey
Town Plan
Local Authority

1945 *Wilton, Yorkshire
Landscape Plan
I.C.I. Co.

1946 *Mablethorpe and Sutton-on-Sea,
Lincolnshire
Landscape Plan and Recreational
Centre
Local Authority

1946 Wellington, Shropshire
Town Plan
Local Authority

1947 Sandringham House, Norfolk
Garden Design
H.M. King George VI

1947 *Hemel Hempstead, Hertfordshire
Town Plan
New Towns Commission

1947–50 Livingstone Airport, Zambia
Northern Rhodesian Authority

1947–50 Broken Hill Hospital, Zambia
Northern Rhodesian Authority

1947–50 Schools in Copper Belt, Zambia
Northern Rhodesian Authority

1949–52 Church Hill Memorial Gardens,
Walsall, Warwickshire
Garden and Housing Design
Local Authority

1950 Lusaka, Zambia
Town Plan
Lusaka Authority

1951 Ashmore, Benson and Pease
Engineering, Stockton-on-Tees,
Cleveland
Works and Office Design
Ashmore, Benson and Pease Ltd

1951 Heron's Beach, Barbados
House Design
Ronald Tree

1951 Cement Works, Shoreham-by-the-Sea,
Sussex
Landscape Plan
Cement Company

1951 Lansbury Neighbourhood Housing,
Poplar, East London
Garden Design
1951 Exhibition Authority

1951–52 Ridgeway Hotel, Lusaka (with R.
Rutherford)
Costain

1952 Bennett's End, Hemel Hempstead,
Hertfordshire

Housing
New Towns Commission

1954 Cadbury Bros. Estate, Moreton,
Cheshire
Landscape Plan
Cadbury Bros.

1954 Levylsdene, Merrow, Surrey (with F.S.
Coleridge)
Housing
Local Authority

1954 Soho, London
'So High, Soho' Project
Pilkington Bros.

1955 Uckfield, Sussex
Garden Design
Lord and Lady Rupert Nevill

1955 *Volta River Project, Africa
Landscape Plan
H.M. Government

1955 *University of Nottingham
Landscape Plan
University of Nottingham

1955 *St. Margaret's Bay, Kent
Landscape Plan
Local Authority

1955–56 Sylvania-Thorn Colour Television
Laboratories, Enfield, Middlesex (with
Alan Ballantyne)
Industrial Plan
Jules Thorn

1956 *Ballater, Scotland
Garden Design
H.M. The Queen Mother

1956 Basildon New Town, Essex
Housing
New Towns Commission

1956 Barry, South Wales
Landscape Plan
Local Authority

1956–57 Harvey's Department Store,
Guildford, Surrey (with F.S.
Coleridge)
Building Plan
Army & Navy Stores

1956–57 Harvey's Department Store, Guildford
Roof Garden
Army & Navy Stores

1957–59 Hemel Hempstead, Hertfordshire
Water Gardens
New Towns Commission

1957 Totnes, Devon
Civic and Market Hall
Local Authority

1957–58 Ruskin Park Club, St. Helens,
Lancashire
Recreational Park
Pilkington Bros.

1957–62 Plymouth, Devon (with Alan
Ballantyne)
Civic Centre
Local Authority

1959 Motopia
'Glass Age' Project
Pilkington Bros.

1959 Park Royal, Middlesex
Landscape Plan
*Guinness & Co. and Gordon
Russell Ltd.*

1959 Digbeth St., Walsall, Warwickshire
Development Plan
Local Authority

1960 Rutherford High Energy Laboratories,
Harwell, Berkshire
Landscape Plan
*United Kingdom Atomic Energy
Authority*

1960 Oldbury Power Station, Avon
Landscape Plan
*United Kingdom Atomic Energy
Authority*

1960–63 Queen Elizabeth II Hospital, Welwyn,
Hertfordshire
Landscape Plan
Ministry of Health

1961 Gloucester City (with Hal Moggridge)
Central Town Area
Local Authority

1961 Crystal 61 (with Hal Moggridge)
'Glass Age' Project
Pilkington Bros.

1961 Cornwall County Hall, Truro (as
consultant; with F.K. Hicklin)
Landscape Plan
Cornwall County Council

1961–64 Civic Centre, Chertsey, Surrey (with
F.S. Coleridge)
Architecture and Landscape Plan
Local Authority

1962 Cliveden, Buckinghamshire
Rose Garden
Lord Astor

1963 *Christchurch Meadow, Oxford
Landscape Plan
City of Oxford

1963 *River Thames, London (with Hal Moggridge)
Bridge Design (Crystal Span)
Pilkington 'Glass Age' Dev. Committee

1964–65 The Kennedy Memorial, Runnymede, Surrey
Landscape Plan and Memorial
H.M. Government

1964 M4 Motorway, Berkshire
Report
Landscape Committee

1965 *Tollcross, Edinburgh (with C. Davidson)
Development Plan
Local Authority

1965 Westcliff Estate, Scunthorpe, Humberside
Housing
Local Authority

1965 *Isles of Scilly
Conservation Plan
Local Authority

1965 Horsted Place, Sussex
Garden Design
Lord and Lady Rupert Nevill

1966 *Oaklands Development, Nassau, Bahamas
Report
Private Company

1966 English Cities
Report on Height of Buildings Policy
Private Company

1966–67 Crematorium, Grantham, Lincolnshire (with F.S. Coleridge)
Crematorium Design, Chapel Building and Landscape Plan
Local Authority

1967 *Armagh Cathedral, Northern Ireland
Garden Design
Diocese of Armagh

1967 Isle of Sark, Channel Islands
Landscape Plan
The Chief of Pleas

1967–69 Wexham Springs and Fulmer Grange, Buckinghamshire
Garden Design
Cement and Concrete Association

1968 Durley Park, Keynsham, Avon (with F.S. Coleridge)
Control Building and Office Block
Central Electricity Generating Board

1968–71 Sports Centre and Park, Cheltenham, Gloucestershire
Landscape Plan and Building Designs
Local Authority

1969 *Villa Corner, Treviso, Italy
Garden Design
Anonymous

1969 Tidcombe Manor, Wiltshire
Terrace Design
Earl Jellicoe

1970–71 *Castle Green, Norwich
Preliminary Landscape Plan
Personal

1970–72 *The Hussey Memorial, Scotney Castle, Kent
Memorial Design
Mrs Christopher Hussey

1970–93 Shute House, Wiltshire
Garden Design
Michael and Lady Anne Tree

1971 *Cardiff
Urban Road through Cardiff Report
Local Authority

1971 Framingham Hall, Norfolk
Estate Plan
Coleman Family

1971–72 Wisley, Surrey
Central Gardens Design
Royal Horticultural Society

1971–74 Fish Hill, Broadway, Worcestershire
Country Park
Local Authority

1971–75 Bridgefoot, Stratford-upon-Avon, Warwickshire
Landscape Plan for River Area
Local Authority

1972 *Warwick
Landscape Plan for Bypass
Local Authority

1972 Chequers, Buckinghamshire
Landscape Plan
Chequers Trust

1972 *Chevening, Kent
Landscape Plan
Chevening Trust

1972 New Palace Yard, Westminster
Landscape Plan
Ministry of Works

1972–75 Delta Metal Works, West Bromwich
Landscape Plan
Delta Metal Co.

1972–77 Fitzroy Square, Bloomsbury, London
Landscape Plan
Local Authority

1973 Leicester
Landscape Plan for Central Roads
Local Authority

1973 Stratfield Saye, Berkshire
Terrace Design
Duke of Wellington

1974 Kishorn, Western Ross, Scotland
Landscape Development Plan for Oil Platform Construction Works
John Howard Co.

1974 Everton Park, Sandy, Bedfordshire
Landscape Plan
Lord and Lady Pym

1974 Exeter Cathedral
Processional Way
Diocese of Exeter

1974 No.27 Grove Terrace, Highgate, London
Garden Design
Mrs A. Smith

1975 The Grange, Northington, Hampshire
Garden Design
Sir John Baring

1976 Dewlish House, Dorset
Garden Design
Mr and Mrs Boyden

1977 Buckenham Broad House, Norfolk
Landscape Plan
Mr Bruce Giddy

1978 Aberford Court, Yorkshire
Garden Design
Anonymous

1979–89 Hartwell House, Aylesbury, Buckinghamshire
Garden Design and Restoration
Cook Trust et al.

1980 *University of California, Berkeley
Landscape Suggestion
Personal

1980 *Modena, Italy
Civic Park Plan
Local Authority

1980–86 Sutton Place, Guildford
Garden Design
Stanley Seeger

1981 Fish Hill, Broadway, Worcestershire
Country Park Feasibility Plan
Worcestershire County Council

1981 **Barnwell Manor, Northamptonshire**
Landscape and Garden Design
H.R.H. The Duke of Gloucester

1981 ***Brescia, Italy**
Public Park
Local Authority

1982 **Wilverley, Hampshire**
Garden Design
Anonymous

1982 **Luntley Court, Herefordshire**
Landscape Plan
Martin Boulton

1984– **The Moody Gardens, Galveston,**
present **Texas**
Botanical and Historical Gardens
The Moody Foundation

1985 **No.35 Upper Addison Gardens,**
London W4
Garden Design
Lady Rupert Nevill

1988 ***Asolo, Italy**
Garden Design
Stanley Seeger

1989 **Tidcombe Manor, Wiltshire**
Garden Design
Earl and Countess Jellicoe

1989 ***Turin, Italy**
Leisure Park Plan
Pietro Derussi

1991 ***Blue Water, Kent**
Shopping Centre Site Plans
Blue Water Company

1991 **Danemere Park, Kent**
Garden Design
June Harrison

1992 ***Denbies, Dorking, Surrey**
Garden Design
Mr and Mrs Adrian White

1992 **Cairo (Giza), Egypt**
Garden Design
Mohammed Mansour

1992–93 **Atlanta Historical Gardens, Atlanta,**
Georgia
Historical Park
Atlanta Historical Society

1993 **Shute House, Dorset**
New Garden Design
Mr and Mrs J. Lewis

A Chronology

1900 Born, Chelsea, London, 8 October
1902–5 Lives at Red House, Rustington, Sussex
1905–7 Lives at Willows, Rustington
1907 Preparatory School, Ruddy Roofs, Farnham Common
1910 School moves to Beaudesert Park, Henley-in-Arden
1915 Awarded Exhibition to Cheltenham College, Gloucestershire
1919 Enrols at the Architectural Associaton School of Architecture
1923–24 Rome Scholarship finalist; travels with J.C. Shepherd to study Italian Renaissance gardens
1926 Joins office of Tubbs, Son & Duncan, Architects; establishes private practice as Shepherd & Jellicoe
1929 Founder Member, Institute of Landscape Architects
1929–34 Studio Master, Architectural Association School, London
1931 Establishes own practice at 40 Bloomsbury Square, London
1930 Bernard Webb Student, British School at Rome; six months European travel
1936 Marries Susan Pares, daughter of Sir Bernard Pares, and moves to Grove Terrace, Highgate
1939–42 Principal, Architectural Association school of Architecture
1939–49 President, Institute of Landscape Architects
1954–68 Member, Royal Fine Art Commission
1954 Life President, International Federation of Landscape Architects
1967–74 Trustee, Tate Gallery, London
1963 Awarded C.B.E.
1979 Knighted (Knight Bachelor)
1981 Awarded medal of the American Society of Landscape Architects
1984 Sells Grove Terrace house and moves to Highpoint, Highgate
1986 Death of Susan Jellicoe; Awarded the medal of the Institute of Landscape Architects
1990 Awarded the gold medal of the Australian Society of Landscape Architects
1991 Royal Academy elect
1994 Exhibition of drawings and plans at the Royal Academy, London

Select Bibliography

WORKS BY GEOFFREY JELLICOE

1925 *Italian Gardens of the Renaissance*, with J.C. Shepherd, London.

1927 *Gardens and Design*, with J.C. Shepherd, London.

1932 *Baroque Gardens of Austria*, London.

1936 *Garden Decoration and Ornament*, London.

1937 *Gardens of Europe*, London and Glasgow.

1948 *Conurbation: Report for the West Midland Group on Post-War Reconstruction and Planning*, London.

1958 *Motorways: Their Landscaping, Design and Appearance*, London.

1960–70 *Studies in Landscape Design*, 3 volumes, London.

1961 *Motopia*, London.

1968 *Modern Private Gardens*, with Susan Jellicoe, London, Toronto and Paris.

1971 *The Use of Water in Landscape Architecture*, with Susan Jellicoe, London and New York.

1975 *The Landscape of Man*, with Susan Jellicoe, London and New York.

1983 *The Guelph Lectures on Landscape Design*, Guelph, Ontario.

1983 Articles in *Architecture Review* (London); *Country Life* (London); *Landscape Design* (London).

1989 *The Landscape of Civilisation*, Northiam.

1991 'Jung and the Art of Landscape: A Personal Experience' in *Denatured Visions*, ed. Wrede and Adams, New York.

1992 SPENS, M., *Gardens of the Mind*, Woodbridge.

1993 SPENS, M., *Jellicoe at Shute*, London.

211

Index

ABERFORD COURT 147, 150–51
Alberti, Leone Battista 48, 51
Architectural Association 10, 12, 38, 40, 44, 49, 56
Armagh Cathedral 84, 132–33
Asolo (Villa Seeger) 16, 195
Atkins, Peter 161
Atlanta (Historical Gardens) 34, 154, 157, 188–91

BARING, SIR JOHN 144
Barnwell Manor 16, 192
Bath, Marquess of 38, 44
Bellini, Giovanni 29, 160, 161
Benevolo, Leonardo 154, 158, 161, 176, 178, 179
Bentley Wood 13
Berkeley, University of California 130–32
Bernard, E. 132
Bernardini, Villa 50
Bingham's Melcombe 12, 40, 41, 42–3, 54
Blue Circle Cement Works (Hope) 36, 40, 41, 60–5, 202
Blue Water, Kent 200–1
Bowes-Lyon family 24, 55, 106, 154
Brescia 16, 34, 106, 154, 178–79
Broadway, Worcs. 38, 40, 60
Buckenham Broad 16, 84, 139, 147, 148–49
Bunyan, John 20, 92

CADBURY LTD 41, 72, 83
Cairo (Giza) 9, 34, 154, 202–4
Capponi, Villa 12
Caro, Sir Anthony 33
Casson, Sir Hugh 158
Cement and Concrete Association 133
Cheddar Gorge 12, 14, 16, 34, 36, 38, 40, 44–7, 82
Cheltenham (Sports Centre) 134–35
Chequers 84, 138
Chermayeff S. 15, 44
Christchurch Meadow 90–1
Church Hill Gardens, Walsall 66–7, 139
Circle (1937) 56
Cliveden 16, 26, 34, 88–9
Cook Trust 124
Corner (Cornero), Villa 16, 84, 136–37, 139, 156
Country Life 48
Crowe, Dame Sylvia 133
Crystal Span 85
Cubitt, James 204

DANEMERE PARK 154, 202
Dante 93
De La Warr Pavilion, Bexhill 44
Denbies 204–5
Dewlish 15, 84, 146
Ditchley Park 12, 14, 16, 17, 18, 19, 33, 34, 36, 40, 48–51, 204

EVERTON PARK 15, 16, 85, 102–3
Exeter Cathedral 132, 143

FESTIVAL OF BRITAIN, The (1951) 41
Fonthill 106
Framingham Hall 139–41
Fulmer Grange 133

GALVESTON, Texas 10, 155, 157
Gamberaia, Villa 10, 11, 50, 136, 158
Garnock, Jamie 190
Garzoni, Villa 10
Gibbs, James 48, 49, 50, 124, 125, 127, 128
Gloucester 15
Grange, The, Northington 84, 144–45
Gregotti, Vittorio 176, 178
Grove Terrace, No. 19, 33, 38, 39, 58–9, 82, 158
Grove Terrace, No. 27, 38, 194
Guevrekian, Gabriel 13
Guinness & Co. 41, 79, 83

HARRISON, June 88, 202
Hartwell Ho. 16, 34, 124–29, 139, 154
Harvey's store, Guildford 15, 75–7
Harwell (Rutherford High Energy Labs.) 82, 86–7
Hemel Hempstead 16, 41, 69–72, 142
Heraclitus 157, 190, 205
Hitchcock, Henry-Russell, Jr. 12, 34, 44
Horsted Place 14, 16, 98–101, 154
Hudson, Edward 48
Hussey, Christopher (memorial) 139

INSTITUTE OF LANDSCAPE ARCHITECTS 36, 40
International Federation of Landscape Architects 36
Italian Gardens of the Renaissance (1925) 9, 10, 38

JELLICOE, Earl 196
Jung, Carl 183, 206

KANDINSKY, V. 33
Kennedy Memorial (see Runnymede)
Kent, William 115
Klee, Paul 33, 69, 80, 84, 88–9, 105
Koch, Henry 158

LANDSCAPE OF MAN, The (1975) 154, 183
Lante, Villa 10, 11
Le Corbusier 12, 38, 49
Le Nôtre, André 12
Lloyd Wright, Frank 49
Longleat 106
Lucretius 179, 182, 183

MALEVICH, Kasimir 33, 131, 132
Mansour, Sheikh Mohammed 202
Marx, Roberto Burle 13
Mendelsohn, Erich 12, 44
Modena 15, 16, 34, 106, 154
Modern Movement 14, 34
Mondrian, Piet 197, 200
Moody Botanical Gardens, The 34, 156, 157, 181
Moody Foundation, The 10, 15, 34, 106, 154, 157, 163, 180–87
Moody Historical Gardens, The 154, 157, 183, 184–87
Moore, Henry 13, 33, 158, 161, 163
Mottisfont Abbey 54–5

NATIONAL TRUST, The 89
Nebot, Balthasar 124, 125, 127, 128
Nevill, Lord and Lady Rupert 99, 154, 197

New Towns 41
Nicholson, Ben 158, 162, 164, 171, 177
Nottingham, University of 16, 41, 73–4.

OLDBURY (power station) 82
Ovid 179, 182

PAGE, Russell 38, 40, 44
Painshill 163
Park Royal, Middlesex 79
Picasso, Pablo 12, 33, 49
Piccolomini, Villa 50
Pilkington Bros. Ltd 41, 78, 83, 85
Plymouth (Great Square) 84
Pollock, Jackson 60, 61
Poplar, London 41
Pym, Francis (now Lord) 84, 102–3

REPTON, Humphry 99, 100, 102, 103, 154, 195
Royal Institute of British Architects 38
Runnymede (Kennedy Memorial) 15, 21, 34, 82, 84, 92–7, 139
Ruskin Park, St. Helens 78, 88
Russell, Gordon 38, 40, 44, 46
Russell, Sir Gilbert and Lady 54

ST. PAUL'S WALDEN BURY 13, 22, 23, 24, 25, 41, 55–7
Sandringham 68, 83
Schutze, Philip T. 188
Scotney Castle 139
Scott, Elizabeth 40
Scott, Sir Giles Gilbert 79, 204
Seeger, Stanley 154, 158, 161, 195
Shepherd, J.C. ('Jock') 9, 40, 42
Shrive, Hilary 16
Shute House 16, 30, 31, 32, 80, 104–29, 156
Stourhead 106
Stratfield Saye 15
Stratford-upon-Avon 34, 35, 40, 142, 156
Sutherland, Graham 161
Sutton Place 15, 16, 27, 28, 29, 34, 146, 152, 156, 157, 158–73, 176, 183, 197

TIDCOMBE MANOR 15, 16, 154, 196
Tree, Michael and Lady Anne 105–129
Tree, Ronald 12, 40, 48, 49
Tunnard, Christopher 13
Turin (Leisure Park) 34, 151, 154, 197, 198–200

UPPER ADDISON GARDENS, No. 35 154, 195

VIRGIL 179, 182
Voysey, C.F.A. 9

WALSALL (Church Hill Gardens) 66, 67, 139
Weston, Sir Richard 54, 158
Wexham Springs 15, 84, 133–34
Wilverley 15, 193
Wisley (Royal Horticultural Society Gardens) 16, 84
Wyattville, Sir Jeffrey 52

YORK T. R.H. The Duke and Duchess of, (later King George VI and Queen Elizabeth) 40, 68

212